T0311080

GERMANY 1945

GERMANY 1945

VIEWS OF WAR AND VIOLENCE

Dagmar Barnouw

INDIANA

UNIVERSITY

PRESS

Bloomington & Indianapolis

© 1996 by Dagmar Barnouw

All rights reserved

First paperback edition printed in 2008

No part of this book may be reproduced or utilized in any form or by any means, electronic or mechanical, including photocopying and recording, or by any information storage and retrieval system, without permission in writing from the publisher. The Association of American University Presses' Resolution on Permissions constitutes the only exception to this prohibition.

The paper used in this publication meets the minimum requirements of American National Standard for Information Sciences—Permanence of Paper for Printed Library Materials, ANSI Z39.48-1984.

MANUFACTURED IN THE UNITED STATES OF AMERICA

Library of Congress Cataloging-in-Publication Data

Barnouw, Dagmar.
Germany 1945 : views of war and violence /
Dagmar Barnouw.
p. cm.
Includes bibliographical references and index.
ISBN 0-253-33046-7 (cl : alk. paper)
1. Germany—History—1945–1955.
2 Reconstruction (1939–1951)—
Germany. 3. World War, 1939–1945—Germany.
I. Title.
DD257.25.B336 1996
943.087—dc20 96-11185

ISBN-13: 978-0-253-33046-8 (cl.)
ISBN-13: 978-0-253-22043-1 (pbk.)

3 4 5 6 7 13 12 11 10 09 08

CONTENTS

ACKNOWLEDGMENTS

For their support of the research and writing of this book I thank the Getty Grant Program and the University of Southern California. I have had generous help from the staffs of many photographic collections, especially the Getty Center for the History of Art and the Humanities, Santa Monica; the International Center of Photography, New York; the National Archives; the United States Holocaust Memorial Museum, Washington, DC; the Military History Institute, Carlisle; the Hoover Institution, Stanford; the Ruhrland Museum, Essen; the Archiv Preußischer Kulturbesitz and the Landesbildstelle, Berlin; and the Imperial War Museum, London.

PHOTO CREDITS

*Unless noted below, all images reproduced in this book
are the property of the National Archives, Still Pictures
Archive, College Park, Maryland.*

Archiv der Stadt Pforzheim: 2.17

Bildarchiv Preußischer Kulturbesitz, Berlin: 4.6; 4.7; 4.10; 4.13;
4.18; 4.19; 4.20; 4.21; 4.22; 4.23; 4.24; 4.25; 4.26; 4.32; 4.33

Bourke-White, Margaret. *"Dear Fatherland, Rest Quietly."*
A Report on the Collapse of Hitler's "Thousand Years."
New York: Simon and Schuster, 1946: 3.1; 3.2; 3.3; 3.6

Capa, Robert. *Sommertage, Friedenstage. Berlin 1945,*
ed. Diethart Kerbs. Berlin: Dirk Nishen: 3.10; 3.16; 3.17; 3.20

Courtesy of Ray D'Addario, Holyoke, Massachusetts: 2.16; 3.39; 4.1

Hoover Institution, Stanford, California. From the Foto Willinger Collection:
1.24; 1.25; 1.26. From the Lewis Anderson Frederick Collection: 3.27; 3.28

Imperial War Museum, Department of Photographs, London: 1.4; 1.17; 2.4; 3.18

Landesbildstelle Berlin: 3.11; 4.9; 4.11; 4.12;
4.14; 4.15; 4.16; 4.17; 4.28; 4.29; 4.30; 4.31

LIFE Magazine. Reproduced from the 9 April, 7 May, and 15 October 1945 issues:
Introduction; 2.20; 2.21; 2.22; 2.24; 2.26; 2.27.

Fotoarchivs-Ruhrlandmuseum der Stadt Essen: 4.2; 4.3; 4.4; 4.5; 4.8

U.S. Army Military History Institute, Carlisle Barracks, Pennsylvania: 3.4; 3.5

United States Holocaust Memorial Museum, Washington, D.C.:
1.1; 1.2; 1.6; 1.16; 1.18; 1.19; 3.8; 3.9

INTRODUCTION

VIEWS OF WAR AND VIOLENCE

Verbal eyewitness reports on Germany's collapse in 1945 differed in their approach to the moral and political implications of "the German question," but they tended to agree on the near impossibility of seeing the situation clearly. German cities were reduced to rubble; a highly evolved culture had regressed to stone-age living conditions; chaotic, large-scale migrations pushing in different directions seemed to mark the final loss of all order, security, and civility. And, perhaps most difficult to understand, the revelation of German "atrocities" signified what might be called a rewinding of civilization back to barbarism. Extreme cultural dissociation had created enormous obstacles to "objective" observation and recording.

The difficulties of observing and forming views at the end of that total war, when the destruction of German culture had also disrupted conventions of seeing, are intimately connected with the troubled symbiosis of witnessing, memory, and historiography in postwar Germany. I am interested not so much in revisiting the meanings of that "German catastrophe" as in looking at expectations about how Germans as a group could or should cope with it. Stated from a variety of positions in abstract and often contradictory terms, and questioned only rarely, these expectations had a profound impact on German culture in general and on the politics of the Federal Republic of Germany in particular. In instructively different ways, they are clearly reflected in both the Allied and the German photodocumentation of that collapse. I did not gather the images reproduced here as reminders of what happened half a century ago. Reminded abundantly ever since, Germans have experienced difficulties remembering; viewers looking at these events through the victors' perspective, too, have remembered selectively and exclusively. Rather, I have approached the enduring "German question," which was first posed in reaction to views of Germany in 1945, as a question of perception and representation. Verbal documents, of primarily American, British, and German provenance (reports, letters, diaries, essays, and memoirs), are enlisted to help anchor and clarify but also to question the meanings of the images—just as the images help to focus, enlarge, and question the verbal documents.

The inversion of private and public morals that is characteristic of all states of war, in which killing and destruction become cultural values, was particularly pronounced in the state of total warfare in Germany after 1941. In 1945, the resulting psychologi-

cal and physical chaos meant that the ways in which to look at and to select what was to be seen were restricted both for the vanquished and the victors. I am not interested here, or only marginally, in questions of German or Allied censorship and propaganda, but in a limitation of perspective that goes further and deeper.

The invention and technological development of photography was, until recently, firmly connected with a quintessentially modern desire for objectivity; the belief was that the camera does not lie, the camera eye is impartial. The Second World War was an eminently modern war, not only because of the technological sophistication responsible for a new level of physical destruction, but also because of the heavy involvement of photography for documentary purposes. The collapse of Germany was brought about by outside rather than inside forces—a fact of crucial importance for postwar German identity—and for the most part it was photographed from the position of the victors. Despite the control this position exercised over perspective, it was by no means uniform with regard to its general political and cultural attitudes. And from the beginning it differed with different subjects: children, young women, and sometimes old women and old men, as opposed to young and middle-aged men, especially in any kind of uniform. Moreover, the victors' perspective changed over time, often dramatically so, through closer contact with the German population.

Most of the Allied documentation came from the U.S. Army Signal Corps photography units instructed in the documentary ethos of the Farm Security Administration photographers. Charged with showing the culture of poverty in America "as it was," the photography of the Farm Security Administration had been shaped by the dichotomy of hidden and revealed truth. What had been hidden, invisible, in the vast remoteness of the richest, most privileged country in the world was now revealed in documentation for all to see and accept as their responsibility. We have come to admire increasingly the precise beauty of those sharp, clean images, elevating them to the status of art objects. We have also become aware of serious problems regarding the belief in unfailing objectivity that underlies the documentarists' desire to reveal the full and only truth of what was previously hidden. In the much more extreme situation of Germany's physical, political, and moral collapse, this desire could express itself in terms so stunningly literal as to obscure rather than to illuminate reality. Penetrating that German chaos, invading enemy territory, young Army photographers saw themselves as liberators. Everything they photographed—Allied troops, weapons, vehicles, ships, airplanes, bombs—was given the attribute "liberating" in the official captions. Liberation was predicated on invasion—invasion was absolutely justified by the desire to liberate. Fighting their way to the best, most telling "shots" of this military-moral mission, Army photographers were faced with the particularly powerful dilemma of great visual clarity and obscure meaning. After all, nothing was more clearly visible than the devastated, broken German army, cities destroyed and transformed into moonscapes, ghostlike people living in ruins, and the brutalized victims of the concentration camps. But what exactly did it mean, this absolute military and moral defeat of the Germans and victory of the Allies? Understandably, Signal Corps photographers tended to accept as truthful the visual clarity of what appeared in their images. In this situation, questions about choice of perspective or the interpretive nature of photographic representation were the least of their worries,

whether they were anonymous young soldier-photographers or seasoned, perhaps famous photojournalists such as Margaret Bourke-White. It was not the time or place to aim for pictures that would allow the meaning of what was pictured to remain fragmented, contradictory, or even diffuse. Their images were expected to answer questions, not to pose them.

The military terms used in photography—to "load" and "aim" the camera, to "shoot" the picture—have their justification. Like the soldier in battle, the photographer has to depend on and make the most of the moment: what can be seen now will look different, might have become invisible the next moment. This fact is an important reason for the photographer's characteristically complex attitude of identification with and indifference to the pictured—an attitude shaped by the intense desire for the good image. War photographers, whether highly skilled and well known or poorly trained and anonymous, demonstrate this attitude to a particularly high degree. Looking at Germany in 1945, they saw and photographed the bombed-out cities: houses broken up and broken open, an incomprehensibly altered cityscape in which what had been visible was now invisible and what had been invisible was now visible, in which what had been public was now private and what had been private was now public—all of this signifying deserved punishment. They flocked to the concentration camps, appalled and fascinated, to get good shots of the tightly guarded secrets now spilling out with the truckloads of corpses for "the German population" to see and believe. The destruction and victimization that were now so powerfully visible presented the trauma of cultural-political rupture in the clearest terms imaginable. Yet, as all-pervasive and omnipresent in the views of Germany as the ruins were—material, mental, and spiritual—they were too overpowering to speak for themselves. In a sense, they were too obvious, retaining, as they did, the ambiguities of guilt, retribution, and atonement.

Understandably, the certainty of absolute military and moral victory predicated on the absolute defeat of absolute evil made it more difficult for Allied photographers to look beyond German collective responsibility to the criminal acts committed in the Germans' name. With few exceptions, most of them British, Allied photographers showed little interest in the German experience of total war: bombed-out cities; the trek from the east with women, children, and old men—the youngest and the oldest— with a few belongings bundled together in the small hand-drawn carts that crowded all the roads of Germany; the men lost in the war—including hundreds of thousands of conscripted schoolboys—or crowded into POW cages. About every second German was on the road in those months, trying to find families but discovering instead that their families had been dispersed, their homes destroyed. This homelessness of unimaginable proportions was mentioned as a general phenomenon but went largely unrecorded. After all, Germans had "asked for it," they had "brought it on themselves"; it was more important to show as clearly as possible that Germany had excluded itself from the community of civilized nations. Photographs of the liberated concentration camps—in retrospect the most important, most effective justification for the American war effort and the most stunning evidence for Allied moral victory— appeared in such British and American "picture magazines" as *Illustrated* and *Life*. Among the material were photographs of the German population viewing Nazi

atrocities in order to see, accept, and repent their complicity in these acts. These images were to shape Allied and German perceptions of German collective guilt, perceptions that are still powerfully present half a century later and that form the subject of discussion in chapter 1.

Much photographed were the results of Allied air raids. Shot from the air, the devastated cities were hardly distinguishable. The well-known *Life* photographer Margaret Bourke-White took beautiful pictures of the destruction and thought that having seen one destroyed German city meant having seen them all. But the flattened cities were visually so attractive that she could not resist photographing every one of them. For many photographers, the fascinating aspect of shooting this total devastation—documented impressively in the *Life* photo-essay, "The Battered Face of Germany" (4 June 1945)—was the "superhuman" sharpness *and* distance of the camera eye. It allowed them to see clear but one-dimensional shapes in visually exciting constellations that were light-years removed from all human fears and hopes. These photographs showed that retribution was merciless but just, and in truth beautiful. Cities represent the culture of a country. Their total devastation—their "battered face"—is difficult to look at close up since all impression of humanity has been destroyed. The implication was that Germany was inhuman because its cities had been annihilated—its cities had been annihilated because German culture had revealed itself to be inhuman. No destruction could be sufficiently total or final in the face of this inhumanity, the full truth of which can be seen only from the great distance of the victor. This point of view is examined in chapter 2.

There were professional German photographers working for city administrations at the end of the war who documented the destruction of the cities and the great migrations in all directions, especially from the east. Taken together, their images show a perspective that differed in certain general tendencies from that of U.S. and, to a lesser degree, British photographers. Most notably, one could find in the German photo representation of ruined cities an intimation of absences, of the loss of past familiar order and structure; in the Allied representations, a focus on present chaos was meant to show the disastrous results of disastrously wrong choices. The streams of German deportees and refugees from eastern provinces where their families had lived for centuries, all in all ca. 16.5 million people, were the catastrophic result of Allied agreements at Yalta and Potsdam. If they were at all documented by U.S. photographers, the emphasis was on the general chaos and diminishing, deforming effects of mass dislocation. In contrast, German photographers—but also some very impressive British photojournalists—sought to show the misery of individual families, of the millions of women and their children who were uprooted and swept away in the gigantic migrations. These issues are discussed in chapters 3 and 4.

The differences in perspective are in many ways instructive but by no means unexpected; in a sense, what these images share is of greater importance to the later viewer than what separates them. Photo representation is characterized by the fact that it can and does record visual information different from that consciously sought by the photographer at the moment the picture is "shot." The photo image retains visual messages that have eluded the selecting choice, the interpretive control of the photographer. With all due caution regarding the question of objectivity: photographs can

usefully complement historiography because they have a more direct way of making and keeping accessible past ambiguities and contradictions and can thereby contribute to a less selective, less exclusive historical memory.

Documentary photography shares with verbal reporting the fact of perspectival control, that is, it has only partial objectivity. It differs in interpretive control and therefore interpretability not least because of the nonsequential, plural impact of photographic images. Both instantaneous and cumulative, this impact tends to undermine explanatory patterns worked out in verbal accounts contemporary with the events—patterns that can and do carry over into historiography. The powerfully immediate presence in the photograph of a fearful face, a gesture of utter frustration, a ruined building, is, at the same time, secure in its "pastness" since the attachment to the past moment at which the picture was taken cannot easily be broken. In the attempt to determine the significance of these images, the future viewer is more strongly moved to ask what they *did* mean, precisely because they make directly accessible more or less or different information than the photographer had consciously selected. Limited to one moment in the flux of time, photographs can retain some unadulterated traces of a past actuality. In combining a variety of verbal and photographic documents, I do not expect to have come closer to the true meaning of the cultural collapse of Germany. Rather, I would like to think this study recovers different meanings that seemed possible or plausible to different observers at the time. This recovery will not provide, from the hindsight of half a century, a new historical perspective on Germany in 1945. But it might make accessible more of the questions asked at that time—before they hardened into "the old questions" that still haunt Germans today.

Not unexpectedly, the politics of perspective have turned out to be the source for the politics of memory and history in postwar Germany, a subject discussed in chapter 5. Looking at the images of destroyed cities and desperate people, reading the first attempts to deal with "the German catastrophe" in private letters and diaries, in newspapers, journals, and books, one is overwhelmed by the degree and weight of destruction and finds incredible the determination to rebuild. From hindsight, it seems that there must have been an all-powerful instinct to set order against near total chaos. One also sees a striking symbiotic connection between destruction and reconstruction in the many images of women and children making neat piles of the rubble, sorting, arranging, cleaning, with their hands alone or with only the most rudimentary tools, each and every usable stone and stacking it carefully. *Wiederaufbau* means literally "building up again." With the bombs still falling and shattering buildings, bodies, and spirits, there was that driving need to appeal to the authority of the physical and mental culture that had existed before the bombs. What was gone could and would be reconstructed. At the moment of surrender—at different times in different cities—there were already, immediately, the seeds of what is in many ways an admirable cultural reconstruction. But what was it that was gone? That is, how was it seen by contemporaries? How can it be gleaned from these images of destruction fifty years later? There were arguments, starting before the war had ended, about whether the immediate clean-up did not claim too many of Germany's scarce human and material resources, whether reconstruction in the literal sense was really valid. But the clean-up

and the rebuilding, however slow and painful, could not be stopped; it had its own momentum. Despite the near unanimous restorative direction taken in the rebuilding of the cities, the politics of memory and history have been at best erratic in postwar Germany.

The notorious reluctance of that rebuilding generation to become involved with the remembrance of their own "unmastered" or "unredeemed" past has too often been cast in terms of some vast collective psychological denial and therefore of a somehow monstrous "inability to mourn" the victims of German aggression. Here Freudian simplifications, all too eagerly embraced, have harmed rather than helped. When the psychoanalysts Alexander and Margarete Mitscherlich diagnosed that "syndrome" in their influential book, *The Inability to Mourn: Principles of Collective Behavior* (published in German in 1967; English translation 1975), they overlooked perhaps the most important aspect of their "patients' " experience: their confrontation with the victors' forceful expectations regarding German collective responsibility, guilt, and remorse. The reluctance to remember has been connected with the confused meanings in 1945 of cultural-political rupture, that is, with simultaneous claims made by interpretive perspectives that are seemingly irreconcilable. Germans had to acknowledge both the suddenly obvious, powerfully visible enormity of the atrocities *and* the burden of their responsibility for these acts. The general cultural collapse was accompanied by the dissolution of a "normal," temporally constructed identity sustained by a "normally" selective and fluid complex of memories. Photodocumentation of German atrocities was, of course, crucially important because the "unbelievable" needed to be seen to be believed, and Germans needed to believe it. But what the evidence forced them to believe and thereby accept as their responsibility contradicted their memories of what they had "really" seen and believed at the time the events occurred. They were overwhelmed by the burden of responsibility because it denied them authority over their past, their memories, and their identity.

Like the buildings and the forms of civilized life, German history as a sense-making construct had been shattered. Ernst Friedländer, one of the most thoughtful contemporary commentators on the political-psychological difficulties of the immediate postwar years, reminded his readers in a 1947 leader for the new weekly *Die Zeit* that in 1945 most Germans had emerged from a false experience of twelve years of their own history. From 1945 on there would be different and contradictory German histories told from different perspectives. To some extent, such uncertainty has been symptomatic for modernity. But the explicit conflicts of memory in postwar Germany have made it a more troubling problem. Whenever history became an issue, it was in the context of what someone regarded as the undesirable politics of history—the most notorious example being the "Historians' Dispute" (*Historikerstreit*) of the late 1980s. Fragmented and uncertain or, rather, deeply uncertain about its fragmentation, German historiography of the recent past has reflected quite accurately a general cultural and political inability to deal with Nazi aggression, particularly where it concerned Jews, as a historical and therefore nonsingular phenomenon whose cultural significance is not exempt from change, like all things, over time. Here, modern acknowledgment of the historicity of human agency has seemed curiously suspicious: it is as if any critical historical inquiry into events that were later subsumed under the

monumental concept "Holocaust" would permanently diminish or deny, rather than temporarily explain, their cultural meanings. Instructively, the historians' debates were brought to an end by the German president's political promise that the uniqueness of "Auschwitz" could and would never be questioned; the Holocaust commemorations of 1995 were to affirm him. Still, half a century after the events, it might be useful to remember that not only do historical events, acts, and actors look different to different people at different times, but that they did so at the time of their occurrence. The changes, the plurality of perspective brought about by the passing of time is grounded in the multiplicity of views, the uncertainty of meaning at any given time—the time of the past as well as the time of the present.

To look at one minor but instructive example: in an attempt to introduce its readers to that strange and troubling phenomenon, "The German People," *Life*, then arguably *the* voice of mainstream America, put on the cover of the 7 May 1945 issue a photo of three grim-looking German civilians—two very young, one an older man (fig. 1). The caption for this image states:

> The faces of these three German civilians show they know at first hand the bitterness of defeat. For 84 hours they huddled with 7,000 others in a mine slag pile while Allied bombs wrecked Wehofen. They tried to hoist a white flag, and their troops Tommy-gunned them. These faces are unhappy but hard and arrogant. Not yet had these Germans, whose reactions to defeat are described on pages 69–76, been forced to see the atrocities . . . committed in their name. (22)

Fascinated with the potential of what was still a fairly new medium, Kurt Tucholsky once declared that one good photographic image can tell us more than a thousand words—a generous assessment coming from one of the most famously shrewd and inventive journalists of the Weimar period. He knew, of course, that to a large extent a picture's meanings are interdependent with the words it has the power to call up. The most direct examples of such interdependency are the "photographic essays," combined photos and text, that had become increasingly popular in Weimar Germany and that provided a model for illustrated magazines such as *Life*. "The German People" was only one of that magazine's photographic essays in 1945 about the puzzling "German question" that read general attitudes into the faces or "body language" of individual German civilians and soldiers at the end of the war: German arrogance and fanaticism as well as German servility and eagerness to please; German refusal to acknowledge the enormity of the country's shame, but also German despair bordering on panic over that shame. A juxtaposition of extreme attitudes and reactions must have seemed the best way to represent such extraordinary events, acts, and actors. From the position of hindsight, we have a disturbing and exhilarating advantage when we bring together images that froze a momentary facial expression or gesture with words which at the time extrapolated from that moment and extended it by "thawing out" its meanings into the future. The ambiguities, contradictions, and confusions were there at the moment, as if caught, arrested in the image of those three faces: *what people saw* is what the contemporary photographer saw; to some degree, the photographer shared a perspective with other contemporaries—viewers who might even appear in the image, looking at what the photographer looked at. In the case of the *Life*

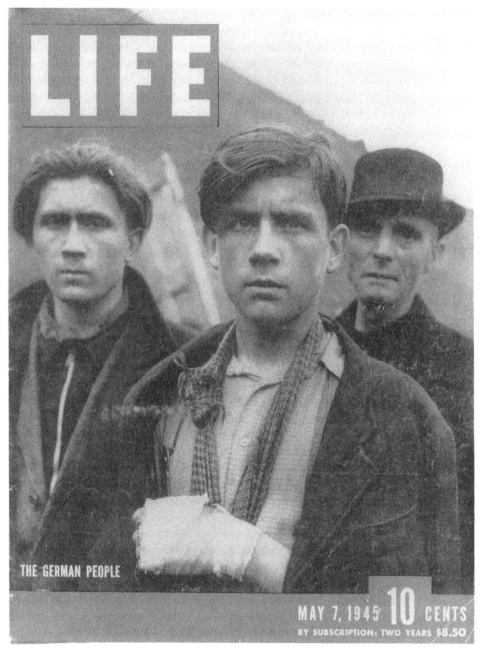

FIG. 1

captions, the "unpacking" or opening up of the meanings of that moment was intended to control a future viewing of it: German civilians should not be perceived as victims of war but as guilty aggressors.

To the person who looks at these three faces in a different time and place, they seem to reflect grimness rather than arrogance. Going back to their present: like many

Germans, these boys and this older man have just barely survived. How should their faces have looked if they had already been forced to look at, to view the atrocities? Should they have shown it, and how? Should their faces have revealed acceptance of responsibility, emotional acknowledgment of guilt? Should they have expressed somehow that for them this might not be the end but the beginning of the German catastrophe? Because only now do they see—and this will register in their faces—the full extent and meaning of the crimes committed in their name? On the other hand, what did the photographer see in those faces when he took the picture that enabled the caption writer to see such arrogance and demand such insight? From which position did the caption writer read this image and feel free to interpret it as he did? What conflicting emotions did he condense into the impression that the faces were "arrogant" and "no longer able to be arrogant"? Who could be seen, and from whose perspective, as victim during those chaotic months in 1945? How did the photographer's and the caption writer's perspectives combine? Were they the same person or did they collaborate? Had the photographer simply handed the contact sheets over to the editor and thereby authorized their use with any caption?

The important issue here is that of the intriguing, often ambiguously and misleadingly symbiotic relationship between the photographic image and the caption that extends to all links between pictorial and verbal documentation. The relationship is fraught with tensions and lacunae and can thus distort but also enlarge meanings since it can help project interpretive control. However, if it is true that the peculiar interpretability of images in their dependency on language can limit as well as open up understanding and, consequently, memory, then viewers need to be aware of their own interpretive perspective. In some ways, historical perspective allows for more comprehensive vision because of the historian's particular attitude toward the potential of the past moment: when we look at that moment for signs indicating the future, we already know where to look. By the same token, we also tend to adjust the past moment's future potential too smoothly to our present, disregarding the full measure of its pastness. This general historiographical problem is exacerbated where the period under consideration is one of cultural discontinuity and crisis. A critical, comparative look at different contemporary views of Germany in 1945, a mosaic of impressions recorded in images and words, might usefully reactivate some past indecisions and contradictions. Different photographers thought different views worth "capturing" and, if they pictured the same or a similar subject, there were different ways of picturing it. In the case of U.S. and British Army photography, there was the added interest of changing perspective as the months went on; the invasion of alien spaces and their obscure meanings gave way to a more relaxed approach with increasing familiarity, creating a perspective that could more easily tolerate obscurities because they had become less threatening.

To a degree, such changes could also be found in the images of German photographers reacting to a gradual lifting of the heavy strangeness of chaos. Their photographs of the immediate postwar period were the result of an often hauntingly private perspective, in which certain things seem to be hidden or only alluded to, addressing the visual sensibilities of a specific, that is, middle-class, educated group of viewers. They attempted to represent the initial confusion and helplessness in subtly melan-

cholic, sometimes ironically juxtaposed images that took stock of absences or of transformations—buildings to ruins, residents to migrants, wholeness and health to frailty and fragmentation, order and shape to chaos and shapelessness.

These visual messages provide a useful comment on the question of German collective guilt and atonement as it was posed in the still "pure," "existential" situation before the reestablishment of political parties and the ensuing conflicts of political interest, ambition, and power dynamics. They seem to encourage a dialogue, over the distance of half a century, between historians debating the significance of the past for Germany's future at the end of this century, and the intellectuals who tried to envision a future evolving out of the chaotic present of 1945. Seen from the perspective of that future, their present turns out to be the beginning of contemporary Germany's still "unmastered past." The historians' debates about these issues have been driven by a moral imperative derived from the meaning of the past, an imperative grounded in the temporal self-centricity of late twentieth-century hindsight. Opening up and connecting the spaces of memory, the photographs that recorded that past may help to question some of our current certainties.

GERMANY 1945

To Make Them See

PHOTOGRAPHY, IDENTIFICATION, AND IDENTITY

HANS FRANK, the notoriously brutal Governor General of Poland, was arrested on 4 May 1945 and taken to prison in Miesbach, Bavaria. The American soldiers who arrested him had just seen pictures of the opening of concentration camps and made him walk through a double line nearly seventy feet long, beating him to a pulp. He tried to commit suicide but survived to be hanged at Nuremberg, having admitted his responsibility and his guilt. One of his sons, who visited him shortly before the arrest and was still unsure of what was to come, later told an interviewer that everything changed after the family saw photographs of the atrocities: "From this moment on, the war was lost, my father was lost. Until that time no one thought we had done anything wrong. I knew the pictures in the newspapers were real. I never thought it was Russian propaganda like a lot of other people. It was the truth and I knew it. American soldiers guarded the house after some displaced persons looted our home. After the pictures from Auschwitz, I felt it was all justified. It had not been a war. It was worse. These crimes changed everything."[1]

Most Germans who were adults during the Nazi period have been reluctant to speak about their lives during those years, especially to their children, who are the parents of the generation coming of age at the end of this troubled century. Fearing accusations of complicity with a criminal regime, they have tried to defend themselves with assertions that they did not really know its true nature, that is, did not know the truth about the scale and method of persecution. A pervasive sense of not being able to explain the objective circumstances of their lives without appearing to excuse their lack of active criticism has made them evade requests for explanation. Even though in many cases their own suffering was considerable, what they were told and shown in 1945 was so extraordinary as to seem unbelievable, beyond human endurance. "Was

not that truth enough to drive you mad?"[2]—this question sums up their dilemma. For only full acceptance of the truth could enable the Germans to emerge from the madness of the Third Reich. Whether they were forced to go to the places of crime and look at the results of what had been done in their name, or whether they were ordered to look at its photographic documentation, they could not escape the meaning of what they saw, the evidence.

Erich Kästner, a satirical observer of literary and political Weimar culture and much loved childrens' writer (*Emil and the Detectives*, e.g.) watched his books burning in 1933 but stayed in Berlin (where he was eventually bombed out) in order to be a witness. In February 1946 he went to see *Die Todesmühlen* (Mills of death),[3] which was based on Allied documentary films of the liberation of 300 German concentration camps in April and May 1945 and which was shown all over Germany. First he recorded what he saw: the grotesquely bent and charred cadavers hanging in the electric fences, the trucks and trains filled to capacity with neatly stacked skeletal bodies, rows of corpses laid out in an orderly fashion in the meadows, tons of material for "recycling" and reuse: bones for fertilizer, hair and clothes in big sacks, piles of gold fillings and jewelry, mountains of shoes to be sold. Nothing had been wasted. Then he described the audience, noting that "fortunately, children were not permitted to see the film":

> Most of them do not speak. They go home in silence. Others come out and seem pale; turning their faces to the sky, they say "look, its snowing." Others mumble "Propaganda! American propaganda. Propaganda before, propaganda now!" What do they mean by that? They can hardly think that these are propaganda *lies*. After all, what they saw had been photographed. They can't very well assume that the American troops had shipped several trainloads of corpses across the ocean to film them in German concentration camps. So, are they saying: propaganda based on facts that are true? But if this is indeed what they mean, why do their voices sound so reproachful when they say "propaganda"? Are they implying that they should *not* have been shown the truth? Do they *not* want to know the truth? Would they rather turn away their heads as did some of the men in Nuremberg when they were shown this film?[4]

For Kästner, these images of literal reduction of human to material value—"the human being, I believe, is worth about RM [*Reichsmark*] 1.87, in case Shakespeare was short and not very heavy, he might have been worth RM 1.78"—raise unanswerable questions. As the feature editor of the *Neue Zeitung*, the official Munich-based newspaper for the American sector that began to appear in October 1945, Kästner had intended to review the film. Having seen it, he felt unable to do so. All he could do was describe some of the most striking visual evidence of human degradation, taking care to emphasize the need to see it before coming to conclusions about the issue of German responsibility. Though he distanced himself, the observer, from "them," the audience, he was concerned not so much with their reluctance to accept the meaning of the evidence as with their unwillingness to look at it. Notwithstanding his remarkable fairness and psychological common sense, he did not grasp the audience's anxiety about expectations that Germans as a group should feel in some large general way responsible for these horrible facts, and therefore guilty. They could not articulate

their profound shock at the evidence without fearing that answers would be demanded from them to explain "how they could have let it happen."

Kästner's text shows very clearly the link between collective guilt and collective silence. Taking risks with his personal safety, forbidden to publish for twelve years, Kästner had been openly critical of National Socialism and thus was cleared of responsiblity for the regime's crimes. (Kästner was troubled that some journalist colleagues who had gone into exile did not understand or approve of his staying in Germany and that some officials in the allied Military Government did not think his reasons for staying were satisfactory.)[5] But apart from that "objective," demonstrable distance to the Nazi regime, Kästner had developed, by virtue of temperament and journalistic style, a curiously effective if not entirely unproblematic subjective distance. It is true, it helped him to reach young people who did not see any way out of the catastrophe brought upon them by their parents' generation. With a balance of coaxing, explanation, and encouragement, his articles about the problems of young people after the war were as thoughtful as they were timely. Yet, despite his adult realism, he confronted the physical, psychological, and moral chaos after the war with what seems to be, in retrospect, an almost childlike resilience and simplicity of perspective. He spoke from a position that tended to circumvent the obscurities and complexities of crucially important cultural issues. As he saw it, Germans simply had to believe their eyes, no matter how much it hurt; it was "good for them" because necessary for their future moral and political health. Castigating them for their attempts to deny the evidence, he underestimated the powerful mechanisms of denial that sprang from their realization that suddenly "everything was changed." They had lost their cultural identity. Kästner, on the other hand, with more hope, spontaneity, and generosity than most Germans could muster at the time, looked at the evidence to remember it and then to move on into a different, and by definition better future. Instructively, he closed his reflections on the Holocaust film with the remark: "We Germans will certainly not forget how many people were murdered in these camps. And the rest of the world might do well to remember now and then, how many Germans perished there." But half a century later, this relating of different groups' painful experiences is more than ever rejected as an attempt to "relativize" or "minimize" the singularity of Judeocide and German guilt.

The general self-accusations that followed hesitant acceptance of the evidence often repressed individual memories of how Germans had lived their lives during years when the regime's criminality had taken hold and spread to the point where criticism of a more or less "normal" kind had indeed become nearly impossible. The notorious German reluctance to mourn, as a group, the atrocities committed in their name was intimately connected with their difficulties in accepting, as their memories, events which they did not remember having known of at the time they occurred. Whether or not they "must all have known" — an assertion that will probably have to remain speculation — they *were* victimizers because they had no authority to deny their past knowledge of terrible acts of victimization and thereby their complicity. Collectively, they were stripped of the authority of their experience — an authority that was granted collectively to the victims. Collective guilt and responsibility is symbiotically linked with collective memory. In a recent interview, Adam Michnik expressed his respect for the social philosopher Jürgen Habermas's "belief in the uniqueness of the German

experience," since this is how many well-intentioned Germans have dealt with the troubled German-Jewish past. Given the extreme nature of victimization, this may indeed be the best solution—for the time being, and if it does not continue to limit the historiography of the Nazi period. But Habermas's single-minded belief in such uniqueness, though morally reassuring, does not capture the psychological and political complexities of the situation.[6]

The question of collective guilt and responsibility, as it was put to the Germans in 1945, was from the beginning shaped by a collective desire to construct that memory so that it could be used for political reconstruction. "Unmasterable," the German past had become a divisive issue before the final collapse of the Nazi regime, with the Allies asking, "How could you have done it?" and the Germans answering, "We did not know what was being done." Collective guilt and reeducation were central to the political schooling received by German POWs in American camps; many of them were involved in the cultural rebuilding of Germany after the war, especially in the news media. Understandably, but not very usefully, intellectual exiles in the United States confirmed the notion of an all-pervasive German psychosis. In 1943, the exile newspaper *Deutsche Volkszeitung* in New York published an article, "The Psychotic Third Reich," arguing that a defeated Germany would need teachers and psychologists above all. It was an argument that, based on the Freudian equation of individual and mass psychosis, also anticipated massive denial.[7] Confronted with the victims' memories of extreme victimization at the hands of Germans, Germans should not be allowed see themselves as victimized by a total war and the near total destruction of their country's culture. It was not the Germans who brought about the collapse of the Nazi regime but the Allies; if they had suffered under that regime, they had "brought it on themselves."[8] The endurance of a pervasive if highly generalized notion of collective guilt has been intimately connected with perceived German activity in bringing into existence a criminal regime and passivity in bringing it down. Germans were psychotic patients suffering from totalitarian criminality—hence the Allies', that is, the Americans' fears that though they acted guilty, Germans had not "really" acknowledged their responsibility and thus accepted their guilt.

American prescriptions for collective guilt, collective denazification, and reeducation had the useful practical goal of making sure that the newly emerging social and political elites were free of Nazis. It is true, these procedures created their own conflicts and contradictions and put into office a large number of politically unsuitable or administratively incompetent people.[9] But in certain important ways they prevented or mitigated the sociopolitical chaos that seems to have plagued almost all the former Eastern Bloc states in the 1990s. And that despite the fact that postwar economic anarchy, driven by the corrupting forces of the black market economy, was halted only when the currency was reformed in 1948. However, these political purging procedures produced their own destructive confusion regarding guilt and responsibility. They invited and rewarded denial of the past where they professed to bring about honest confrontation. And they held up the goal of democracy as a religiopolitical commitment while using distinctly undemocratic means to achieve it.

What might be called a quintessentially American "perfectibility complex," a utopianist belief in instantaneous transformation into a new identity, has brought

about many desirable social and political changes, but not without some curious and not always gentle ironies. Denazification measures ordered Germans to undergo a democratic rebirth complete with a totally changed perspective on past experiences. Germans, who were forced to fill out the notorious *Fragebögen* (questionnaires) about their activities and affiliations during the Nazi period, had to accept a past constructed from the hindsight of the Holocaust—a past in which, as often as not, they could not recognize themselves. It did not seem possible to resist this self-alienation of memory, since to achieve the desired rebirth they had to shed their former selves voluntarily. Moreover, German collective memories of having participated, at least passively, in the most brutal acts of victimization were constructed to endure—for reasons that related both to the nature of the construction and these acts. These memories remained alien but inescapable, removed from the "normal" gradual changes in time. Small wonder that few people wished to touch or to stir them.

The children of Germans who were adults under the Nazi regime, the student generation of 1968, were spared this traumatic collective and individual identity crisis. Their own identity was most clearly defined by their difference from their parents, which led to the forceful insistence that parents acknowledge their guilt and thereby redeem the past for their children. The parents' greatest failure, largely unavoidable under the circumstances, had been to protect their children from having to become adults. Rebuilding at a frantic pace, creating the *Wirtschaftswunder* in a magically short time, they created what looks, from hindsight, like a curious suspension of time. It was as if their "normal" temporality had been ruptured in the physical and political collapse of their country.

This disruption profoundly affected their children's passage to adulthood. For these children, the parents could never have been different people: younger, more hopeful, less certain, less lucky as survivors, more vulnerable. Their identity was frozen, defined by their involvement with the Nazi regime then and their denial of it now. Projecting their parents back into a past largely unacknowledged by them, the children could acknowledge neither their parents' nor their own temporality. But an even partially successful passage into adulthood signifies at least a tentative under-standing of the temporal instability of identity. Failing in that respect, the children also failed to understand that the ambiguities of guilt and atonement had their source in the changing symbiosis of past and present. The resulting, sharply divisive generational conflict was in some ways reminiscent of the situation in 1918/19, when sons accused fathers of starting a war that cut off their lives before they themselves could become fathers.[10]

The parents, burdened with the expectation that they accept their identity as guilty Germans, had not wanted to see the evidence of terrible deeds done in their name because, on some level, the issue of guilt seemed to become more concrete the more unbelievably horrible the victimization: the victims were so clearly, purely, nothing but victims. Across the generational divide, children responded precisely to this aspect of total victimization—to the extraordinary, repulsive violence—and it made the de-mands on their parents all the more forcefully absolute. Ironically, the childrens' perspective on their parents was in certain instructive ways similar to that recorded in the photographs shot in 1945 by the young American Army photographers who,

charged with revealing all of Germany's horrible secrets, had penetrated the country with the invading Allied forces. From the perspective of hindsight, both shared what is for us a seductive, for the parents a terrible innocence: like travelers on another planet, in a totally different time and space, they saw certain things very clearly, and others not at all. Two generations after these pictures were taken, they can still show and tell us much—as long as we are aware of the self-righteous obscurities of that innocence.

Under the rubric "Confrontation," the Washington Holocaust Memorial Museum photo archive holds a large number of images showing German civilians forced to view the results of Nazi atrocities so that they would understand and accept the guilt of their defeated regime. The majority of these pictures were taken by soldier-photographers of the U.S. Army Signal Corps photography unit, which provided roughly one half of all the images of that much-photographed war published in books or in the press. Though the Signal Corps photographic service had been established in 1917, its military value was not sufficiently clear at the beginning of World War II. However, this changed dramatically in a situation in which large numbers of selectees had to be turned into soldiers overnight and the use of film and still pictures was propagated by Chief of Staff General George C. Marshall for training and indoctrination.[11] The photographic media proved so successful in that respect that training officers referred to photography as their " 'secret weapon.' "[12]

Despite a notable lack of direction and coordination during the first half of the war, Signal Corps photography quickly became popular. Expected to be all things to all people, it had to meet a host of different demands coming from the War Department: "Army regulations charged the Signal Corps with the provision of still and motion pictures for information, historical records, training identification, photomail service, and other purposes." Much sought were visually effective still pictures of combat and war or occupation-related activities to be released by the Bureau of Public Relations for publication in the press. The Army Pictorial Service, which administered Signal Corps photography, was also responsible for "providing combat photographic service for the Army ground forces . . . for custody of all foreign military and naval motion [and still] pictures; and for the development, coordination, standardization, procurement, storage, issue, and repair of all photographic supplies and equipment except for certain activities reserved for the Air Forces."[13] Formal training of combat photographers and photographic technology increased steadily, especially after the establishment of the Signal Corps Photographic Center at Astoria, Long Island, in 1942. But there was also informal learning-by-doing wherever technicians worked. After July 1942, when the officer situation in general was improving, all officers assigned to photographic duty were given extensive training through cooperation with New York press photographers volunteering to help the soldier-photographers achieve a better sense of composition and the capacity for making split-second decisions (Thompson et al., *The Test*, 395).

The shortage of still-picture camera personnel, film, and equipment lasted for the duration of the war and into the period of occupation. The Signal Corps issued the still photographers large numbers of Speed Graphics, the stand-by of press photographers, and some Rolleiflexes and Leicas. During the war, American civilians were requested

to sell their cameras, and after the war photographers attached to the occupation forces were encouraged to complement army-issue cameras with cameras bought on the black market. Because of these shortages, stricter editing procedures were adopted, and of the hundreds of thousands of pictures received by the Army Pictorial Service Still Picture Library during the last years of the war, only the best were retained. Steadily increasing requests for prints also had to be edited rigorously due to critical shortages of paper and materials.[14]

Despite all these difficulties, the value of Signal Corps photography for military and civilian purposes alike was fully realized by the end of the war: "Combat photographers served as the eyes of the public as well as of the Army."[15] The "greatest war in history," more horribly destructive than even the "Great War" of 1914–18, could be witnessed by the American public as they read their papers in their kitchens or living rooms. There was the normal official wartime censorship coordinated by the Supreme Headquarters Allied Expeditionary Force—every print of every photo that had passed censorship bore the stamp SHAEF. Perhaps even more important, there were collectively shaped directions of perspective that would anticipate too unquestioningly what A. J. P. Taylor later referred to as "the Nuremberg Consensus," the historical perspective of the victors.[16] Signal Corps photographers were infused with the productive energies, but also the fallacies, of the Depression documentarists' professional ethos to "show it as it was."[17] In photographing atrocities committed by the Germans, they wanted to make clearly and fully visible what had not been seen before. Revelation of heretofore hidden evil would prepare the ground for a complete transformation of German identity.

Photographs documenting the confrontation of German civilians with German atrocities are, by their very nature, visually self-conscious since their goal was to show that what needed to be seen was indeed seen. Not surprisingly, the photographic spaces of these images are constructed around the the topos of looking. Through the lens of his camera, the photographer looks at groups of Germans looking at large numbers of piled-up or lined-up corpses, using the perspective of one or more American or British soldiers who are shown observing these prescribed acts of "viewing the atrocities." Positioned at different points of observation, the witnesses to these acts are themselves witnessed by the photographer, reaffirming the photographic evidence of the German population's obedience. The vast majority of Germans did not live close enough to a camp to have a shocking and sobering look at the physical evidence of terror in Nazi Germany. For them, photographs of atrocities were published in newspapers or posted on billboards, or they were marched to an army cinema to watch films about Buchenwald and Belsen (figs. 1.1 and 1.2).[18] Significantly, these acts of looking at one remove were also documented by Signal Corps photographers who took pictures that show Germans viewing photographs of other Germans who, guarded and observed by American soldiers present in the picture, obediently view the results of criminal acts carried out in their name (fig. 1.3).[19] The object of these photographs is to make clear that showing evidence of German atrocities will ensure German obedience in accepting, along with the new authorities, their new identity.

The significance of showing that evidence, then, cannot be overrated. It did indeed "change everything." Mostly young, relatively inexperienced, and often surprisingly

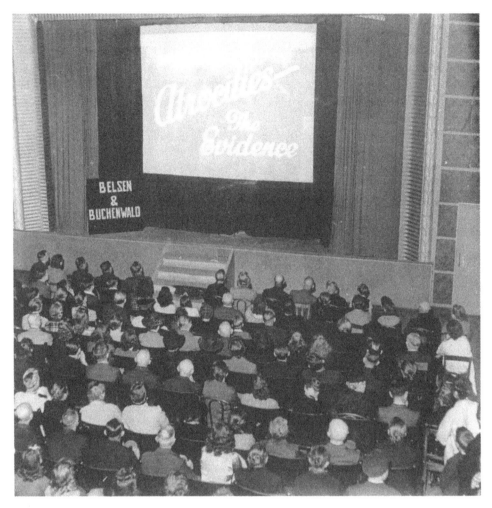

FIG. 1.1

good photographers, these GIs had themselves been forcefully "confronted" with what was revealed when the concentration camps were opened.[20] Almost all the photos documenting the results of "unbelievable" cruelty show at least one witness— a young American soldier, mostly seen from the back, standing upright, whole, inviolable in his uniform and with his gear, looking at inanimate bodies in front of him. The visual emphasis on that one reassuringly whole, vertical figure through which the viewer's gaze is directed at the frightening evidence in the horizontal is connected with the difficulties of looking that they themselves had experienced. But the presence of these soldiers in the images—the GI, the government issue warrior— also suggests the presence of a public perspective, a public meaning to making visible what was hidden: the evidence of German collective guilt. In his informative study of American reactions to the liberation of Nazi concentration camps, Robert Abzug takes issue with James Agee's essay on the atrocity films, which was published in the *Nation*,

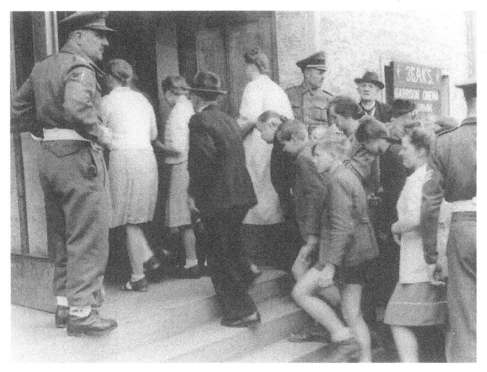

FIG. 1.2

19 May 1945.[21] Agee, who had not seen the films, argued against using them to assign unquestioned collective guilt to the German people and unquestioned collective moral superiority to the Allies, especially the Americans. He also warned of the danger of confusing vengeance with justice. These misgivings and warnings show that Agee, who never doubted the evidence, was very well aware of its enormous emotional impact. Even if the cameramen had sought to record truthfully "what was there," they recorded what they had seen with horrified loathing—and the viewers would see, and react to, both the horror and the loathing. This did not detract from the evidentiary significance of what they saw and recorded. Rather, it made this evidence an extraordinarily serious problem for the Germans. It had to be approached with an almost impossible moral sincerity and, in the case of the elites, with political intelligence; as Agee implied, it was an infallible weapon against all Germans.

Abzug examines the difficulties of "seeing" in such extreme situations, but he is reluctant to consider the consequences for the quality of witnessing. He describes the shocked reactions of the GIs overwhelmed by the sights and smells of the liberated camps and the resistance they met when they told friends and relatives about these "unbelievable" scenes. One GI who had taken his own photos of camp inmates, despite his initial reservations about intruding on the victims' misery, found that it was important to the people at home that these were not Signal Corps photographs: "I think it made up their minds for them if they had any doubt. Here was something taken by a strict amateur photographer in which there could be no doctoring of scenes and no

FIG. 1.3 .

faking of film. What I took was there. It was fact."[22] Abzug's aim is to discuss a widespread mistrust of evidence concerning these particular "unbelievable" events, a mistrust that an amateur's snapshots seem to have overcome more easily than professional photodocumentation. He does not pose in general terms the question of factuality with respect to amateur and private versus Signal Corps and public photography. Moreover, the larger and increasingly problematic issue of evidentiary photographic "facts" does not seem to hold any interest for him. Abzug focuses on the viewer's reaction to "the" evidence of Nazi crimes but fails to deal with the influence of photographic perspective. He disregards the significance of selection, focus, spatial organization—not to mention terrain, light, and equipment—coming together in the split-second decision that freezes what is pictured at a moment in time. The "fact" documented in the private snapshot is what that individual young soldier saw at that moment in his subjects' and in his own life. And the same is true of the "facts" produced in the photography of the Signal Corps. The images of both the individual amateur and the professional army photographer pictured the reality of horrible destruction of human life. The picturing differed—depending on individual temperament, training, situation, intention, equipment, processing—and so did the perceived "fact" of that reality.

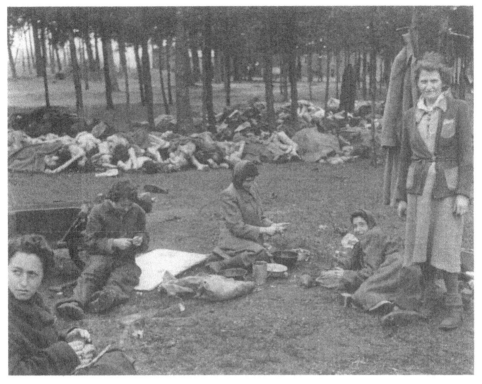

FIG. 1.4

Such differences may not seem very important, especially in the situation of stark subject matter and shared documentary intentions; but they are not therefore negligible. In his thoughtful introduction to the work of the "Sergeant-Photographers" of the British Army Film and Photography Unit,[23] Martin Caiger-Smith quotes Sgt. William Lawrie, who recalled that he was not given any instructions about what to film when he entered Belsen with his unit on 17 April 1945, shortly after it had been liberated. Struck by typhus and famine, the camp defied adequate description, verbal or photographic. Lawrie said that they merely "did what they saw at the time. The majority of the inmates . . . were incapable of coherent thought . . . it was very quiet, silent business. They sat about, very little movement. Some of them were too far gone to move. There was absolutely no way to rehearse a piece for us."[24] Another member of the unit, Sergeant Midgley, expressed similar feelings in a letter he wrote after his first encounter with the camp: " . . . there were hundreds of bodies lying about, in many cases piled 5 or 6 high. Amongst them sat women peeling potatoes and cooking scraps of food. They were quite unconcerned and when I lifted my camera to photograph them, they even smiled" (fig. 1.4).[25] Still, no matter how inadequate the camera seemed for documenting these extraordinary, "ahuman" scenes, people looked to photography, especially during those spring and summer months of 1945, to show the facts "objectively." They were more ready to believe what they could see than what they

were told. The photographer Midgley concurred: "No words can describe the horror of this place . . . I have read about camps like this but never realised what it was really like. It must be seen to be believed."[26]

Like the Americans, the British wanted the Germans to look at what needed to be seen to be believed. But when the leading British illustrated magazine *Picture Post* commented that Germans were confronted with "evidence that cannot be refuted," the real issue was not their refusal to look at and see the reality of the horror; it was, rather, their shrinking away from collectively accepting responsibility for that horror and showing remorse. Recording German witnessing, the Americans' cameras would seek out the presence or absence of remorse to make it visible, because it, too, needed to be seen to be believed. Samuel Glasshow, a medical officer with General Gavin's 82nd Airborne Division that liberated a camp at Wöbbelin near Ludwigslust, Mecklenburg, on 2 May 1945, later recalled his reaction to what he saw: large numbers of prisoners evacuated from camps further east, dumped into a hastily set up transit camp with no organizational structure, a dwindling supply of food and water, infectious disease of epidemic proportions, and everybody competing for survival, descending to the level of cannibalism: "This horror was of such a nature that that I couldn't wait to get away . . . and get that smell out of my nose and wipe the dirt off my feet. . . . "[27] The Germans, too, were visibly horrified. General Gavin ordered the entire population of Ludwigslust over ten years of age to view the camp and rebury the dead in a cemetry in town. They obediently did. But Glasshow was disturbed by what he saw as their unwillingness to show remorse: "They didn't admit responsibility, and the only sadness they showed, I think, was horror at what they saw. I think had they won the war, these people would have all been exterminated, without any remorse on the civilians' part. I don't think they had any remorse. They were all brainwashed to the fact that these people were subhuman species."[28]

Glasshow himself was frightened by the human degradation he saw in the camp:

> We walked inside and saw these skinny people who were still living, and one of the enlisted men who walked in with me realized they were starving and we had nothing but some candy bars, which we got in a ration, and one of my men gave the candy bar to one of these people who grabbed it and ran away and gulped it down so fast that he became unconscious and probably choked on it when he tried to swallow it before someone took it away from him. These Jewish people and these Polish people were like animals, they were so degraded, there was no goodness, no kindness, nothing of that nature, there was no sharing. If they got a piece of something to eat, they grabbed it and ran away in a corner and fought off anyone who came near them.[29]

It was very difficult for the GIs to witness the terrible conditions at Wöbbelin, said to be as bad as or worse than the "Little Camp" at Buchenwald. Some drew comparisons to combat experience to make the scene less frighteningly alien: "It was the same as coming upon where a mortar shell landed, and you come across eight or ten German soldiers who have been killed. You know there was no sense of identification."[30] But for Glasshow, who had treated many war casualities, some of them German, there was an important difference: "I saw all kinds of gore and blood and intestines and

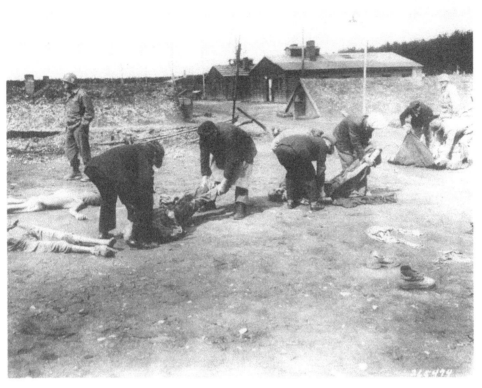

FIG. 1.5

whatnot. I never saw anything like this, because when I walked out of here, my feet were full of rotten feces, meat, garbage, and the smell was unbelievable."[31] He saw and smelled the complete breakdown of human culture, the result of both anarchic and systematic wholesale destruction of human life. In that sense, the situation was different in kind not only from a barbarous "state of nature," where the weak die and the fittest survive, but also from the battlefield, where death is largely ruled by chance and survival is determined by luck, group loyalty, and organization. Could forced confrontation of Germans with the results of this destruction, could carrying badly decomposed corpses with their bare hands, could holding them in their arms (figs. 1.5 and 1.6), "really" make Germans feel sufficient remorse? Moreover, how would such remorse be recognized and recorded by the photographer looking for its public display?

Remorse presupposes identification with and acceptance of the victim. Frequently, the liberators of camps insisted that the German population bury the corpses in individual graves, if possible in their own cemeteries, often after exhumation and in a state of advanced decomposition. A Signal Corps photograph of German civilians ordered to view the victims of Wöbbelin, now prepared for burial, shows them filing in orderly lines past the long straight line of open graves marked with neatly planted

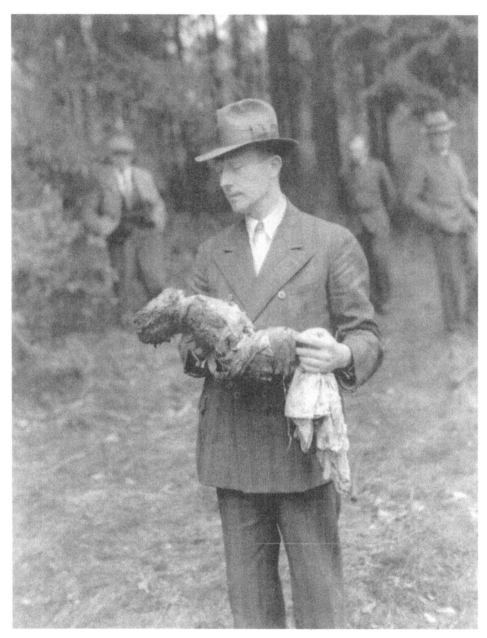

FIG. 1.6

white crosses. We see women, some children, a few old men, their faces turned to the lines of corpses or downward; many of them are looking ahead unseeing. Some are covering their faces, some are crying, some are straining away from the sight (fig. 1.7). Nobody is looking up at the photographer, whose camera is placed somewhere slightly above them—as are the figures of GIs who are watching them in the image. The

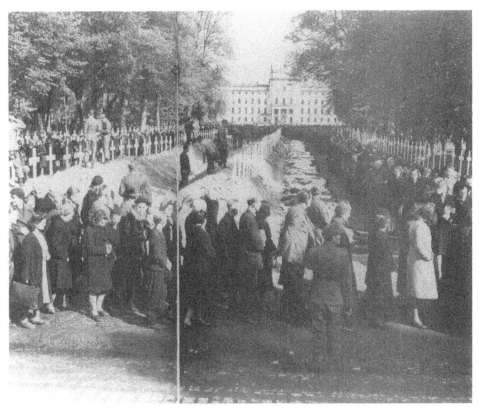

FIG. 1.7

perspective emphasizes the straight, thick, dark lines of people moving parallel to the straight thin white lines of crosses merging in the distance. These lines are halted by a dark mass of people in front of a large, light-colored, well-proportioned building which, flanked by huge trees, fills the whole background. The inviting baroque castle at the end of the dark allée, a vista composed in what must have seemed then an impossibly civilized past, holds in reassuring balance the vertical—the white crosses and light-colored shapes in the open graves—and the horizontal—the upright dark figures massed in the background and lined up in the foreground. The viewer's gaze is drawn across the dark horizontal plane in the foreground into and along the long line of open graves. The embankment is guarded by the line of crosses that seem to flow on underneath the dark horizontal block in the background through the portal into the white castle. This visual composition emphasizes reestablished human order and identity in death against the chaos and anonymity of the victims' lives. A viewer without any knowledge of the place and time of the depicted event might see a mass funeral for victims of some kind of natural or technological catastrophe to whom survivors are paying their last respects, thereby affirming the significance of these dead for their community. A German viewer at the time, familiar with its darkness and recognizing the prevailing expression of numbness on the witnesses' faces, might have been moved by the documented attempt at creating order and meaning out of chaos

FIG. 1.8

and confusion. But he might also have been sensitive to that visual closure's forceful control.

A series of photos of a "proper" burial of Nazi victims in the small town of Neunburg in eastern Bavaria, taken by Signal Corps photographer Pfc. Wendell N. Hustead on 29 April 1945, is instructive in this regard. One of them shows how inhabitants of the town "carry empty wooden boxes along a road leading from the town to a wooded site to pick up the bodies of about 120 Russian and Polish Jews killed by SS troopers and dumped into a common grave. The Military Government, XII Corps, Third Army, ordered the German civilians to exhume the bodies for decent burial. Chaplains of the Third Army will conduct Protestant, Jewish and Catholic services for the dead at the cemetery in town" (fig. 1.8). The carriers moving in small groups along a road winding through gentle hills on a spring day are framed by tall trees whose first small leaves are just coming out. The framing and the spacing of the groups is visually pleasing; the hills are partly wooded, mostly planted, and the overall impression is one of attractive patterning. The small figures carrying the still-empty boxes move easily through the pastoral landscape in informal groups. If it were not for the few bulky figures of GIs in their helmets overseeing the task, and a jeep parked by the roadside, the viewer might at first glance think it a photograph of a rural procession. Photographically the image is quite successful because it catches a moment when

the horizontal lines of the hills, the road, and the figures moving along it join the vertical lines of the intersecting trees in a particularly pleasing balance. This strangely peaceful composition is in stark contrast to other images in the series that document the actual exhuming and carrying back of the bodies (e.g., fig. 1.12; see below). How did the American soldier-photographer see German "reality"?

Viewers from outside were presented with a multitude of contrasts and contradictions, and what they saw depended very much on where they looked. A British war reporter, Alan Moorehead, had entered Germany in February 1945 during the Allied invasion of the rich Rhineland province, where "the border populations were mixed, more subject to outside influences and presumably less overborne by the Nazis." He was struck by the well-fed cattle in the "lush green countryside." The farms were "rich, wonderfully well equipped and managed"; the farmers and their foreign workers, many of whom had come to Germany of their own account for the higher wages and better rations, looked strong, healthy, and well dressed. In the villages and smaller towns he found a surprisingly "solid bourgeois comfort," from neatly arranged glass jars of preserved fruit and vegetables to silk stockings. The Germans, however, fully expected that their small private islands of orderly normality would be shattered and that everything would be taken from them:

> They had an immense sense, not of guilt, but of defeat. If a man's shop was entered and looted by Allied soldiers he never dreamed of protesting. He expected it. And the reason for this was that he was afraid. Mortally and utterly afraid. And so the German made the ordinary normal reaction of a man overcome by fear; he ran to obey. He was obsequious. And the women turned away their heads. They walked past with wooden despairing expressions on their faces, as though they were being pursued by someone. One saw few tears. For the Germans the catastrophe had gone far beyond that point. Tears were a useless protest in front of the enormity of the shelling and the bombing. And so one was always surrounded by these set wooden faces.[32]

Living without protection in farmhouses and small hotels, most of which were overflowing with refugees from bombed-out cities, Moorehead had at first been puzzled by the peaceful behavior of the Germans, whose sons, fathers, brothers, and husbands had been killed or captured by the Allies and whose houses had been wrecked or seized: "Never anywhere did any German civilian attempt to shoot at me or menace me or steal any possession of mine. We could not understand this at first, because in these early weeks in February we did not yet know the depth of the German fear" (196).

Another British war reporter, Leonard O. Mosley, encountered a very different situation in the city of Hanover in April 1945, hours after it had ceased to be a battleground. He saw a

> more sullen and desolate city than I have ever seen. Even from there, five miles away, the devastation was appalling. . . . Hanover looked like a wound in the earth rather than a city. As we came nearer, I looked for the familiar signs that I used to know, but the transformation that had been made by bombardment seemed complete. I could not

recognise anywhere; whole streets had disppeared, and squares and gardens and brooks with them, covered in piles of bricks and stone and mortar. . . . "[33]

Taking over a city almost completely destroyed and in chaos, the American Military Governor, Major Lamb, worked hard to prevent more damage, relying on a small staff and a quickly established civilian police force. In the center, almost no buildings were standing, there was no electricity, no water, no sewers. "The city was a gigantic open sore—and crawling about in that sore were . . . a vast population of peoples of all lands and tongues and temperaments" (Mosley, *Report from Germany*, 71–72). Of prewar Hanover's seven hundred thousand inhabitants, many had fled or been killed in the air raids, 28,000 in the last raid alone. But there was a new population of more than half a million made up of 250,000 Germans, 100,000 foreign workers, and over 50,000 British and Allied POWs: "They inhabited the ruins of this once prosperous city, and no Wild West town of the last century could compare with the lawlessness of the lives they lived. It was a town of drunkenness and murder" (72). The most destructive were the foreign workers, conscripted or not, because they thought the city their booty and tolerated no resistance to their drunken shooting, beating, raping, and looting. But the fever of social disintegration was contagious.[34] If Major Lamb and his staff could not afford to be too trustful in this situation, rigid nonfraternization regulations nevertheless proved rather awkward. Having finally found a good man for the position of *Oberbürgermeister*, Major Lamb was not allowed to shake the hand the man held out to him in gratitude for his rescue of the city and his trust in him (74).

The relationship between the victors and the defeated was indeed, as Moorehead remarked, "immensely complicated," a story that

> kept changing its plot, so that the farther you went on with it the more it altered its direction and was full of loose ends and contradictions leading nowhere. As soon as you discovered evil and malice in one place you were immediately confronted with kindness and innocence in another, and there was every nuance of these extremes and every kind of character from the villain to the fool. And all this, no matter where you went or what you did, was placed against the unending tragedy and physical ruin of the country (194).

Naturally, what the Allied invasion forces discovered also depended on their conduct—ways of behaving became more responsive to German behavior as it changed in response to Allied reactions. The "wooden faces" regretted by Moorehead were more common in the early stages of the occupation when the civilian population did not know what to expect. Their uncertainites are well documented in a photograph taken in Neuß, Rhineland, shortly after the town was captured on 2 March 1945 by units of the Ninth Army. It shows civilians with their children lined up for questioning by an American officer, a watchful GI looming over them, ready to shoot (fig. 1.9). Was the photographer who "shot" this scene impressed by their dejection, their docility, the combat posture of the GI? Or is the message of this posture, frozen at a moment in time, misleading? A photograph taken in nearby München-Gladbach, captured on 1 March 1945 by the Ninth Army, presents a completely different picture of German-

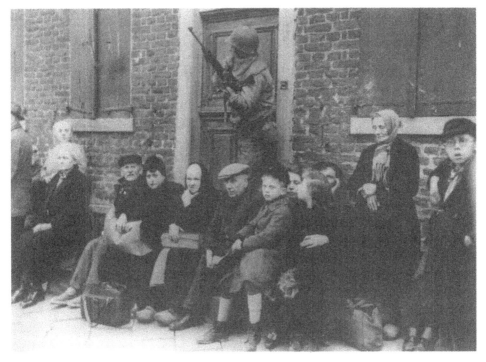

FIG. 1.9

Allied relations. Here a group of civilians "appears in a happy mood as they watch Private Albert T. Katzer . . . camera man of the Fifth Armored Division, Ninth U.S. Army, shoot a scene from the top of a jeep" (fig. 1.10). Smiling, even lauging, they look up at the photographer in the foreground, who directs his camera down at them—the invader as friend, indeed as liberator.

The photographs of the Neunburg series focus on a particular aspect of German-Allied relations, a particular kind of contrast or contradiction, and they use to advantage the incongruities between the peaceful setting and the documented events. One image shows a group of young boys carting a heavy load of coffins over the cobblestone lanes of a small, quiet country town that looks, if not prosperous, at least entirely untouched by the war, as do the children (fig. 1.11). In another image we see strong and healthy-looking women carrying the shallow open caskets, now laden with corpses (fig. 1.12). Moving awkwardly through the sunlit forest, they are straining under the burden. With the photographer immediately in front of them, they are looking down or to the side, away from what they carry and from the witness of their labor. With both hands engaged, they cannot cover their faces against the shocking sight, the smell, the shame. They will eventually deliver their ghastly cargo to the town's cemetery where the corpses in their caskets will be neatly arranged for viewing and proper burial—photographed by Hustead to show reestablished order and communal integration. Clearly, this documentation was meant to impress on the Germans that they could not just turn away but had to look at, touch, accept into their own space what the

FIG. 1.10

Nazis had brutally excluded in life and what was now coming back to them in death as the most horribly alien burden.

One of these burial pictures, an arresting visual composition of the conflicts and incongruities of the situation, is particularly effective in its tentative suggestion of ritual closure (fig. 1.13). Across a relatively large empty stretch of foreground, we look at two rows of still-open caskets lined up inside the walled cemetery. Occupying considerable space and sharply illuminated by a bright spring sun, they draw the gaze to the large shapeless boots on the feet of the corpses sticking out of the coffins, all pointing in the same direction: toward the people gathered in the cemetery, away from the wall, the photographer, the viewer. The half circle of caskets holds in a dense crowd of women, children, and old men. Waiting for the ceremonies to begin, people are standing close to each other, looking toward the photographer and the caskets. The picture was taken from a position slightly above the crowd in order to move the gaze from the corpses' boots, across a compact group of GIs with helmets, past a mass of indistinguishable faces all directed toward the caskets, to the well-proportioned shapes of several large, old barns just outside the back cemetery wall and, swerving right, to a pretty old chapel that continues the wall. Tall trees inside and outside the cemetery balance the graduated horizontal of caskets, crowd of civilians, and wall.

The perspective responsible for this impression of reassuring enclosure is comple-

FIG. 1.11

mented by some figures standing in the right and left foreground, outside the circle of
caskets, looking at the people inside the circle looking out. One of them is a GI
standing in the right foreground with his back to the viewer (and the photographer),
his helmet shining round and solid in the sun. Lined up with a tree in the middle
ground, past which he is looking at the wall in the background, he seems to focus his
gaze on the chapel, across a group of elderly men with bent bare heads. Like the
caskets, the chapel is light colored and sharply outlined by the sun. A group of young
men on the left, dark figures in the shade, are also looking in the direction of the chapel,
confirming that perspective. Next to the GI, however, is another sunlit figure outside
the circle, a stocky man wearing a striped concentration camp jacket, now a badge of
honor. Looking away from the caskets and the chapel, he might be perceived to disturb
or deflect the picture's compositional intimations of consolation and healing. The
strikingly composed image balances an abundance of visual clues to unresolved
tensions, demands, and responses. Like all "straight," undoctored photographs, this
image is a product of a split-second decision and chance, recording more or fewer or
different things than the photographer saw at the moment of taking it. But here the
incomplete control of perspective enhances rather than diminishes the picture's docu-
mentary effectiveness over time. It allows us to see, half a century later, what was
"really" there at that moment: something that might have been seen, understood,

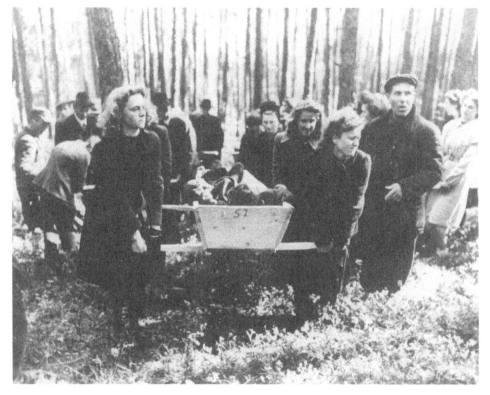

FIG. 1.12

asked differently. Even documenting public observation of private-forced-into-public acts of looking, Signal Corps photographs of confrontation have on occasion allowed the obscurities of what was pictured to remain present in the construct of the image. If they still show clearly the real evidence that needed to be seen to be believed, they have also recorded for us the real difficulties of seeing it that way at that time.

In the spring of 1945, with Germany's political culture discredited beyond belief, its cities shattered, millions of their men dead, wounded, taken prisoner, Germans — mostly women — could not explore the meanings of what they saw. Under the watchful eyes of the victors, they were photographed as they obediently exhumed and sorted the corpses, put them into caskets, decorated these with flowers, and buried them in their own well-tended cemeteries (fig. 1.14). In their very obedience and propriety they showed that they could not conceive of how it could have happened. At the moment recorded by the photograph, the visible results of victimization seemed to exceed their capacity to take responsibility, feel, or show remorse. Though they could show their horror to the cameras, they could make no sense of it (fig. 1.15).[35]

Signal Corps photographs of confrontation explicitly documented American expectations that Germans individually identify with the victims and collectively acknowledge their identity as victimizers. But, intentionally or unintentionally, they also captured the self-righteous, sometimes cruel innocence of such expectations. In the

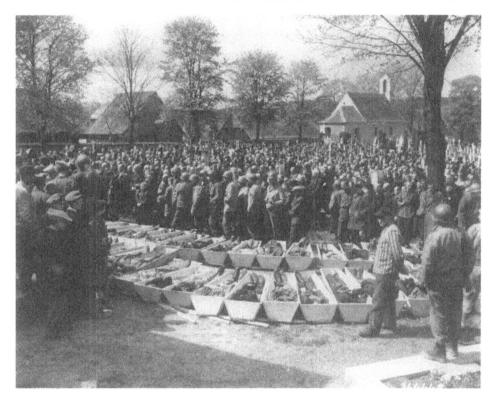

FIG. 1.13

images of British army photographers, these expectations appear more muted, some-
thing like visual moral grey zones. In April 1945, a Sergeant Oakes took a haunting
photograph of a group of German mayors from nearby towns ordered to view the mass
graves of Bergen-Belsen. Six elderly men, seemingly unconnected and uncertainly
arranged into two groups of two and four, or three groups of two, are shown standing
in the middle of a barren nowhere, as if dropped on the moon (fig. 1.16). There are no
graves to be seen, no prostrate corpses, no sturdy upright Allied soldiers, no trees,
bushes, or structures of any kind. Nothing but these formally dressed old men in their
bulky overcoats, hats in hand, accompanied only by their small sharp shadows. One of
them, in the center of the image, is holding his head with his other hand, looking down.
He connects and at the same time separates the groups: one step further would bring
him into another group, shifting the uneasy balance, but he appears unable to move, as
if paralyzed. The different directions of their gazes keep the men as much apart as the
positions of their bodies. There is a curious certainty that they are looking at some-
thing profoundly distressing that remains invisible. But its reflected presence in the
expression on their faces and the strain of their bodies appears more compelling than
would be its unmediated visible presence. They seem both fragile and inappropiately
solid, standing where the dead are presumably prostrate all around them. But their
standing is willed, weighed down as they are by the burden of incomprehension.

Photographing these men overwhelmed now by what happened, Sergeant Oakes

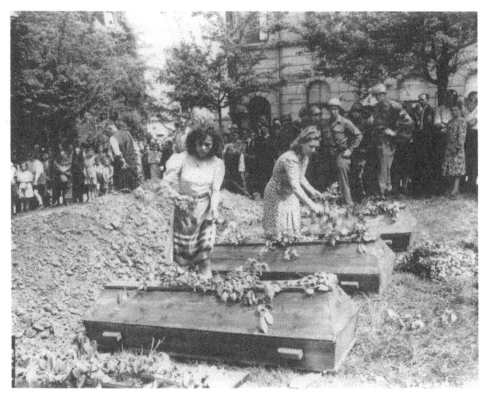

FIG. 1.14

made more believable their assertions that they did not "really" know then what was happening. But if he did not accuse or despise, he also did not exonerate or sympathize. Leaving them alone with evidence invisible to the viewer, he showed how the "unbelievable" that they saw made real and impossible claims on them.

Oakes also kept a sensitive distance in his photographs of camp survivors. One is of a young man, kneeling, his face framed by a square of barbed wire, bent down in intense concentration on cutting a small, half loaf of bread, a bowl with a spoon in front of him: "Men prisoners have their first real meal for months, supplied by the British"; the date is 17 April 1945. The man is thin but not emaciated, he is not shown in the act of gulping down the precious food but preparing it carefully for leisurely eating. Food is again a source of civilized pleasure rather than raw necessity of bare survival to be consumed furtively (fig. 1.17). Here as in the image of the six uncomprehending "dignitaries," Oakes's photography documents, more clearly and urgently than more direct, specific images of "atrocities," the magnitude of what Germans had allowed to happen, even if they had not known about it happening. More unambiguously than most Signal Corps photographers in that situation, Oakes took responsibility for what his photograph documented; if it was a matter of private acts of looking, these were not forced into public conformity or ritual. Looking at those unhappy elderly men who were ordered to "view" the atrocities but could not take in the meaning of what they saw, Oakes made his photograph of them show some understanding of

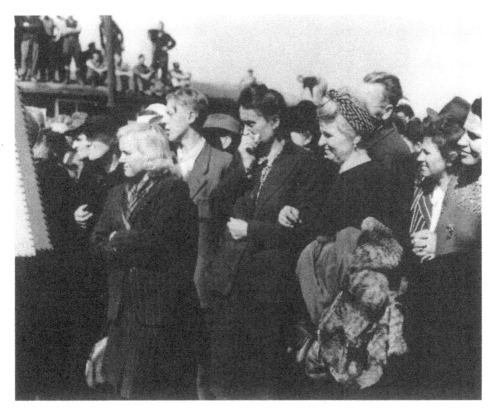

FIG. 1.15

their predicament. And, framing so perfectly in that square of barbed wire the thin concentrated face under the large cap bent down in anticipation of the pleasure of eating, he celebrated an intensely human moment—no matter what kind of person that man was in the past or would be in the future. Here, of course, Oakes sympathized deeply; but he also refrained explicitly from eliciting the viewer's empathy with a victim. Shaped by a perspective of private intensity, Oakes's images strike a balance in that precarious but important moment before the onset of public questioning that would divide, perhaps too sharply, good and evil, right and wrong, innocence and guilt.

Such hesitant perspective suggesting some degree of tolerance for ambiguities can be found more often in the British than in the American photodocumentation of Germany in 1945. On the whole, the British army photographers were less interested than the Americans in documenting insufficient German remorse when viewing atrocities. And their images of camp inmates show openness to a broader range of human behavior—for instance in the image of the women cooking and eating amidst the dead (see fig. 1.4). One of the most realistic photos of the Allies' clean-up of Bergen-Belsen in the wake of the typhoid epidemic, taken in April 1945 by an unnamed British photographer, shows corpses pushed into a pile by a small bulldozer, driven by a British soldier, beret pushed back, a cigarette dangling from the corner of his mouth.

FIG. 1.16

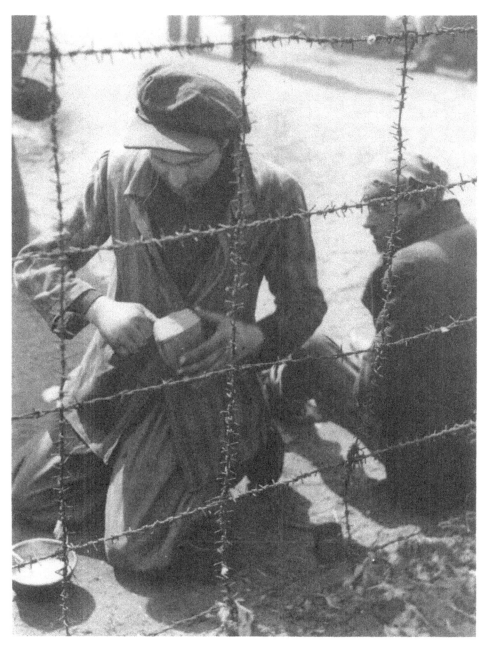

FIG. 1.17

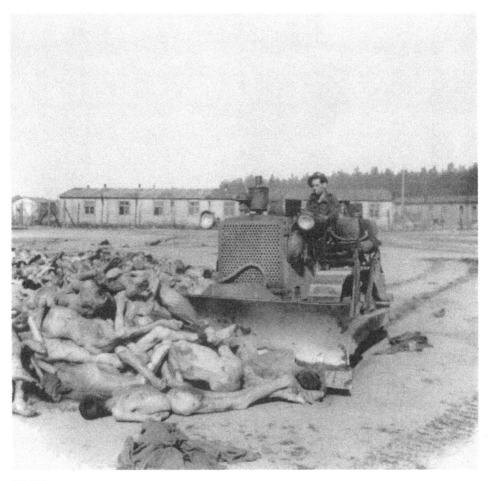

FIG. 1.18

(fig. 1.18) The viewer's gaze is directed to the corpses in the foreground, about to be picked up by the bulldozer's shovel, and from there to the whole and handsome young man who, sitting calmly above them on his vehicle, is unimaginably distant from them — for him, the distended corpses might as well be large rotting vegetables. No onlooker, British or American, no Germans viewing the corpses, mediate the shock of this distance, which is matter-of-fact rather than cruel. The young man is alone with the lostness and loneliness of the dead but, ordered to clean up remains dangerous to the living, he cannot possibly be sensitive to such considerations. The contemporary documentary purpose of this image, part of a group of photos illustrating a report on "Typhus at Belsen," was to show the catastrophic situation at the camp before and after liberation: to show what extreme measures had to be taken to remove the decomposing corpses strewn all over the camp. Its enduring documentary value is to make visible the ordinariness of such measures once they have become a necessary procedure. Precisely this ordinariness signifies the finality of the distance between the living and the dead.

The Signal Corps photographs of Germans confronted with Nazi victims was, among other things, motivated by the desire to undo this distance, prevent the reassertion of the ordinary, insist on absolutely clear distinctions between good and evil, victim and victimizer. These images transmitted expectations of German collective guilt that on some level have endured for half a century. Documenting the extraordinary nature of the evidence, they showed the ordinariness of the people who could not respond to it adequately, that is, who could not accept, by showing, their guilt. The dichotomy of the hidden and the revealed, which motivated Signal Corps photography in general, is here played out on several levels, and not without leaving some contradictions intact: the crimes that had been hidden before and were now revealed were expected to shock the Germans into an awareness of who they "really" were, that is, of their true criminal identity. But their shock was the result of the utter alienness of the horrible, its core dimension was "unbelievable," "unimaginable"—the extreme opposite of familiarity.

What did that say about German identity in collective guilt? The assertion "we did not know," always doubted and compulsively repeated, was put to question by these images in ways which left space for further questioning. Their visual openness to the central contradiction of evidence so overwhelming that it seemed unbelievable has made them valuable for the attempts of future viewers to understand "what happened" in terms of "how it could have happened." Clearly, these young soldier-photographers were fascinated by the stark morality play of victimizers forced to confess—a scenario from which, by showing it, they could distance themselves behind their cameras directed at the Germans from above. And yet, even with their strongly pedagogical emphasis on making "them" see—Germans viewing German atrocities watched by GIs who themselves were viewed by the photographer—they still constructed photographic perspectives that would relate the different acts of looking. Over and over again, these images show GI observers standing squarely, hands on hips, watching the German women and elderly men physically shrinking, straining away from the evidence forced on them, appalled, incredulous, fending off the imposition of an impossibly alien collective guilt. There are images of mothers trying to protect their children from having to see what the grown-ups can hardly bear to look at. The caption of one of them reads: "German mother shields eyes of son as she walks with other civilians past rows of exhumed dead Russians outside the town of Suttrop [Westphalia]." She does not walk but hurries, bent over, putting one of her hands over the eyes of the younger child and holding on to an older one, all three looking down grimly. Watched by two GIs, she is trying to get through the horrible assignment as quickly and with as little damage to her children as possible (fig. 1.19).

There is also a group of Signal Corps photos shot on 17 May 1945 showing women and children from the town of Namering; they had been ordered by the Third Army to view the corpses of 800 former Russian, Polish, and Czech prisoners of the Flossenburg camp. One image, taken by William A. Scott, shows two women and a small boy looking at a badly decomposed body, one of the women lifting a sacklike cover from the corpse and holding herself away as far as possible. The small boy of about five or six is closer to the corpse and leaning back in fear. The women seem very small in relation to a GI who is watching them, sitting close to them on the ground. He is half turned

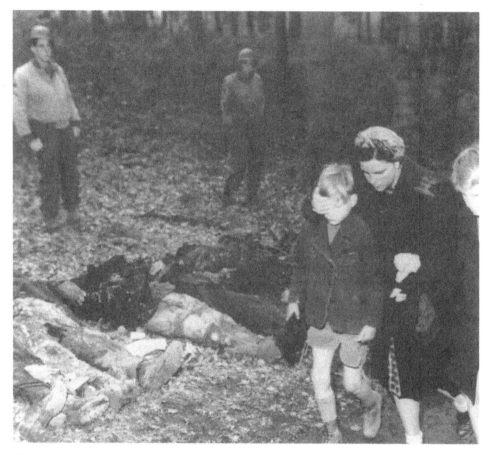

FIG. 1.19

away from the camera, which is focused on the appalled, shrunken Germans and the white, bloated corpse. Did he sit down because he did not want to tower over the women and children and intimidate them, or to better control their "really," closely looking, or simply because he was tired of standing? There is a curious kind of intimacy between him, the three people, and the gruesome matter that once was a human being. It is an intimacy that might suggest elements of kindness, some kind of understanding of their dilemma, but also cruelty, the control of their identity as victimizers (fig. 1.20).

Flossenburg, a major concentration camp in the Bavarian Forest near the Czech border, was deep in the country, far from any city. It was liberated by the Third Army at the end of April 1945. But a week before the liberators arrived, the theologian Dietrich Bonhoeffer was executed there, and some days later a large number of prisoners were evacuated to other camps, many dying on the forced march. The inhabitants of Namering denied any knowledge of the evacuation and of the mass graves around the camp.[36] The remoteness and beauty of the heavily wooded setting of the camp must have made the liberators' discoveries even more shocking. Another Signal Corps

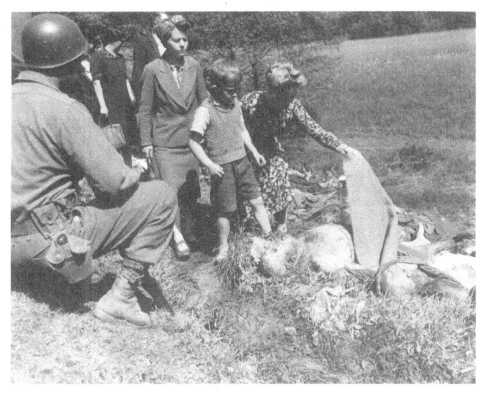

FIG. 1.20

photographer of Germans viewing the Flossenburg dead "caught" the incongruity of
the setting by allowing the landscape a strong, spatially organizing presence (fig. 1.21).
His picture shows small corpses arranged in rows going up a hill, and small figures of
women, children, and some men standing among them toward the bottom of that hill.
They are in the left middle ground, dwarfed by the lush field behind them that is lined
by huge old trees filling the left background. The focus is on the foreground, a cross at
the top of that hill to the left, and a group of farming people to the right, two men and
two women in their work clothes. Half turned to the camera, they are looking at the
wooden board nailed to the cross, which tells them about the death march from
Flossenburg, and past it to the evidence at the bottom of the hill. A GI, standing next to
the cross with his back turned to what they see, is looking at them expectantly,
pointing out each word on the board with a long rod. The farmer closest to the GI is
reading the message aloud with the others listening glumly. The reader, an older man
holding himself straight in front of his stern teacher, is slightly to the right, the GI
slightly to the left of center. His posture is relaxed, but his handsome, firmly molded
face—the only face fully visible in the picture—is quite impenetrable. The two men
together, the victor and the defeated, the innocent and the guilty, the one who gives
orders and the one who obeys, create the visual center of the image. The lesson is
watched by three GIs, one to the left, one behind the pointer, one to the right. Through
the gap between the two central figures, we see other GIs slightly downhill, observing

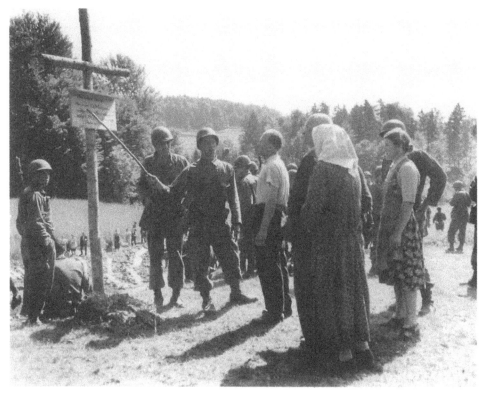

FIG. 1.21

from above the small figures viewing corpses at the bottom of the hill. On that bright spring day in that beautiful landscape, these forced acts of learning and looking seem to make the "unbelievable" even more difficult to believe, if not less real.

A photograph taken by Cpl. Edward Belfer at the bottom of the hill shows "a German girl overcome as she walks past the exhumed bodies of some of the 800 slave workers murdered by SS guards near Namering, Germany, and laid here so that townspeople may view the work of their Nazi leaders" (fig. 1.22). A young woman is walking by herself, holding her hand over her mouth and nose, presumably crying— though she may simply be horrified by the sight and the smell; the next viewer could be quite close, slightly ahead of her. She is watched by a large group of GIs in the background, behind the rows of corpses. The spatial organization of the image strongly emphasizes that lone figure perceived to be a German civilian openly mourn- ing German atrocities. Another photo of the same rows of corpses, this time unattrib- uted, is a rarity among images of confrontation because here the viewing is observed by the photographer only. We see an older woman and a little girl walking by the corpses, the woman lifting a handkerchief to her face — she could be praying, crying, or protect- ing herself against the stench. She moves slowly, bent over, looking down. The barefoot child walking right behind her is in a neat dress and apron, with blond pigtails and a wreath of flowers in her hair (fig. 1.23). Looking at the corpses with hesitation, taking

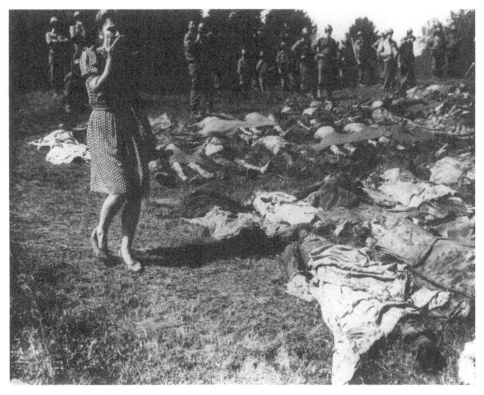

FIG. 1.22

very small steps, her arms hanging down at her sides, she seems an impossibly healthy, pretty little girl—a child of the type chosen to be photographed offering flowers to some high-ranking Nazi or Hitler himself. The photographer must have been struck by the absolute contrast between that child's wholesomeness—emphasized rather than weakened by the bare feet placed on ground poisoned by corrupt matter—and the scene of death and destruction.[37] His spatial relating of the woman and child walking by the stretched out corpses emphasizes this profound incongruity. In the reality of Nazi madness, of course, there would have been a profoundly connecting justification. The destruction was brought about by an ideology that had held up the vision of the complete oneness, the well-being and wholeness of the German *Volk*. For the people inside the confines of the healthy body of the *Volk*—Nazi rhetoric was notorious for its use of organic imagery—this vision was utopian, promising nurture and growth. For all others the vision meant dystopia, a state of affairs in which they would be diminished, removed, and finally destroyed.

Nazi propaganda is instructive in this context, especially in the medium of photography. Its messages were all too easy to read, but in visual terms these images were often not as crudely or grotesquely manipulative as we might wish to think today. News agencies were well stocked with wishful pictures of a population whose physical and mental wholeness and healthiness was holding up under the most severe testing. These photographs were intelligently attractive and more persuasive than the predictable

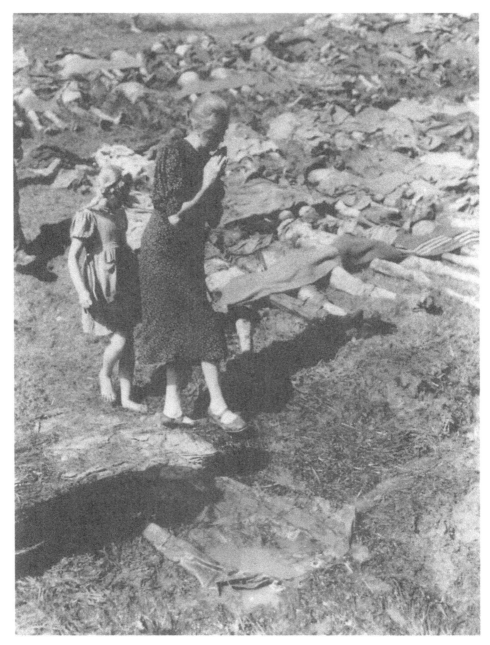

FIG. 1.23

ideological cant of Nazi speeches. With more and more bombs falling on more and more cities, they celebrated community by "documenting" spontaneous cooperation after an air raid, showing healthy, handsome, laughing young people piling rescued books on a table in front of a collapsing building. Or they showed young but competent nurses overseeing the orderly exodus of patients to the hospital's well-constructed,

FIG. 1.24

comfortable air-raid shelter. A photo of several well-dressed children wearing gas masks shown beneath a large poster of a pretty, smiling, resourceful young woman in her air-raid helper's helmet and uniform impressed on the viewer both the treacherous dangers of gas bombs and their manageability. Notoriously "competent" German women were trained as nurses, air-raid helpers, antiaircraft personnel, and firefighters to deal with all eventualities of Allied "terror bombing" (figs. 1.24, 1.25, and 1.26).[38] German identity, if not German buildings, would be safe in their capable hands. The caption of the air-raid photo reads: "Everyone remains cool. All possessions are rescued from the rubble with self-control [*Fassung*] and good morale [*Haltung*]." Many of the women pictured here half a century ago could have been used today as models for upscale outdoor clothing and activities. They would be presenting the same attractive mixture of type and individual, urban sophistication and small town whole-someness as a counter to the enduring problems of twentieth-century technological complexity and cultural pluralism. Fifty years ago they "modeled" the self-deceiving perception of a well-managed modern Germany, its essence untouched by the chaos created on the home front by Allied attacks. The wholeness suggested by *Fassung* and *Haltung* is held up against panicked self-destruction: posters with the inscription, "Our walls are broken but not our hearts," were attached to many bombed-out buildings, especially in Berlin, and duly photographed to spread the good message.

But these images and this sentiment also stand in absolute contrast to the physical and spiritual destruction recorded by German photographers who documented the

FIG. 1.25

air-raid wreckage for city administrations before the end of the war.[39] Their images and Allied documentation of broken Germany point to the characteristic *corruptio pessima optimi*, the devastating self-destruction which is common to many utopian communities and which is intimately related to their notorious self-separation from the rest of the world. The Nazi regime had brought about, in the eyes of many, a revolution into a utopian future that then promptly disintegrated into dystopia—a disintegration all the more explosive because of the extraordinary exclusiveness of that German "new order." Ever since Thomas More's *Utopia*, the orderly island of "no place" as a counterprojection to social chaos in early sixteenth-century England, utopia has offered itself to the visitor as interesting and attractive in its difference from the familiar. The 1936 Berlin Olympics, which presented a whole, handsome German people in sharp contrast to the fragmentation of the last years of the Weimar Republic, were a model of such utopian attractiveness in a stunningly literal sense. In the case of dystopia, the nonfamiliar is abhorrent, difficult to look at, repulsive. In both cases the past is to be rejected; but in the case of utopia, such rejection means hope and wholeness, in the case of dystopia, guilt and disintegration.

In a curiously symmetric way, the Allied, or rather American insistence on collective guilt and collective showing of remorse indicated a utopian projection of radical change. German rebirth would touch the spiritual and the material aspects of the collective, a recasting of the mind and dissolution of the body of the *Volk*. The images of confrontation suggest that German guilt was measured not against German wartime "normality"—during the last years of the war an almost total inversion of

FIG. 1.26

peacetime "normality"—but against a general inclusive ideal of western civilized conduct and the particular, exclusive utopianism of National Socialism. Germans were guilty of succumbing to utopian promises that had promptly been revealed as dystopian threats. Seen through the American eye, German identity was defined by the results of dystopian criminality, and Germans had no claim to their memories that they themselves had experienced on their own bodies how these promises turned into threats.

There are many verbal reports of the inhabitants of German cities lined up in the streets greeting the "liberators"—almost as enthusiastically as the French crowds cheered them. But if such welcoming was recorded by the Signal Corps photographers, these images—in contrast to the photographs of the happily liberated French—were not shown. Strictly forbidden to "fraternize," the Allies "liberated" the Germans from National Socialism by "invading" their cities, as they "fell" to them one after the other. Reports from Germany during the spring of 1945 habitually emphasized German sullenness and obsequiousness, arrogance and abject shame. There were implicit but also explicit accusations that Germans were all too eager to shed their dystopian Nazi past, but little understanding of their confusion about what to feel and how to act—beyond showing their enormous relief that the war would soon be over. To the Americans in their double role as "liberators" and "invaders," it was unacceptable that Germans should feel relief above all at being liberated from a "total" war that they equated with the dystopian part of their past. In the eyes of the victors, this equation was escapist since Germany had started the war and had not fought it honorably—a fact that painfully surprised many Germans emerging from the horrors of that war. On some level, the intimate and contradictory connection between invader and liberator echoed that between utopia and dystopia (fig. 1.27).[40]

The double role of the Allies created a double perspective that resulted in serious ambiguities—with respect both to German hopes regarding Allied conduct and Allied expectations regarding "the German question," that is, German identity. In the Allied, or rather American view, German self-perception had to be redirected from passivity to activity: from "see what has been done to us" to "see what you have done." The crimes committed in their name had been barbarously literal in their physical brutality—from the hanging opponents of the regime on meat hooks, to the stunningly primitive, so-called medical experiments with whatever could be pulled out, cut off, stuffed into, torn apart, or stuck together. German response to the revelation of those crimes was therefore also physical: remorse in the literal sense of being "bitten back" by what they had done (Lat. *remorsus* from *re-* and *mordeo*, bite), wounded by the wounds they had inflicted. The punishment meant to produce remorse would also have to be stunningly physical: you, the civilian population, will cleanse yourself from your crimes by carrying with your bare hands and pressed against your body the rotting corpses of the victims, because they are your responsibility (see figs. 1.5 and 1.6).

Documenting these ultimate confrontations, Signal Corps photographs also suggested that though they might inflict some psychological or physical wounds, these probably would not be transformed into wounds of conscience that might bring about a new and therefore better identity. No matter how much they "must" or "ought to" have known: the victimization with which they were forced to identify was too

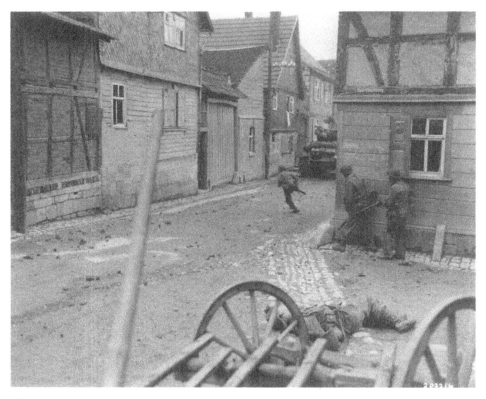

FIG. 1.27

extreme and the redirection of their self-perception was too shattering. Abzug quotes from an American report, based on extensive interviews, about the relations between the people of Dachau and the camp: they had guessed some of what went on, known little and, fearing repercussions, mainly tried to stay out of it. The predominant response was: "What could we do?" Disturbed by the report's "conciliatory . . . warning against judging a whole town," he draws the following conclusions:

> How, after all, could one judge these people? They lived in a different universe from the camp, and the connection between town and camp became more tenuous with every new interview, with every attempt to assess responsibility. No matter that Dachau's prisoners and camp had been an integral factor of the town's growth and prosperity, that all the citizenry of Dachau lived within the camp's orbit. The two worlds were connected in ways unrevealed by interviews. Yet frightening in its very human dimension was the fact that army officers, outraged by what they had seen in the camp, still seemed more able to comprehend the moral dilemmas of Dachau's citizenry than they ever would be able to understand the ghastly histories of those they liberated. (103)

Given Abzug's overall argument in *Inside the Vicious Heart,* his shock seems somewhat surprising. The moral dilemmas of people who were, on the whole, ordinary citizens of Dachau would of course be more accessible because they were predicated on mutual expectations of civility. The accusatory question "How could you

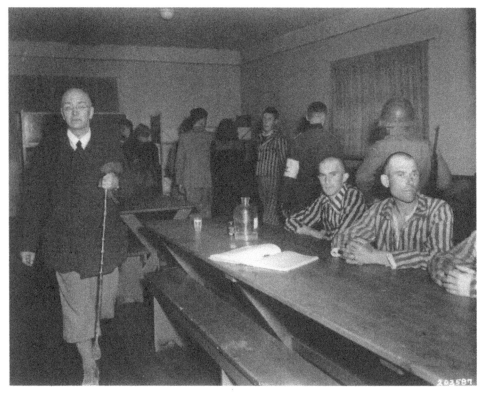

FIG. 1.28

have allowed it?" and the evasive answer "We did not know" derived their particular urgency precisely from the fact that Germany had been known as a civilized country—not unlike the officers' home culture. The "ghastly histories" that were so difficult to understand for both groups came out of experiences beyond civilized imagination. How, then, could Germans be made to "really" accept them as part of their cultural identity?

Very few Signal Corps photographs document visual confrontations of German civilians with camp victims who were not damaged beyond the capacity to return the viewers' gaze. One of them shows "citizens of Weimar . . . forced to view the starved victims of Nazi brutality at the Buchenwald concentration camp" (fig. 1.28). Several male camp survivors are sitting on one side of a long table. Thin but not severely emaciated, they are not difficult to look at. In front of them is a carafe with water, some water glasses, and what seems to be a visitors' register. The room would look strangely "normal" if it were not for the men's striped suits and a GI with a rifle slung over his shoulder. The GI and several German civilians are viewing objects and pictures mounted along the walls of the room, their backs turned to the photographer. The two former inmates at the table, a roundish man in camp clothes standing in the right background, and a well-dressed older German civilian in the left foreground look directly into the camera. The civilian, carrying a walking stick, moves briskly past the

two men sitting across the table without looking at them; nor do they look at him. After viewing the evidence of his regime's crimes, this respectable, probably well-educated citizen of Goethe's Weimar is now free to leave. His face is frozen in that "wooden," unseeing expression familiar from many photographs of confrontation.

In this case, the photographer was literally "on the side" of the victims: the three former inmates are all in one line of vision on the right side of the room, the German is alone on the left. But a diagonal line created by the three brightly lit faces turned towards the camera connects the man walking toward the photographer with the two men sitting at the table. Had he intended to "catch" the German's expression to have a visual record of the absence of remorse? Or had the man's face changed in the split second between being seen and "shot" by the photographer? Had he been moved by what he was forced to view? Had he resisted being overwhelmed by his shock and confusion? Had he resolved not to appear overwhelmed to the invasive photographer? Trying to show it "as it is," documentary photographs show what was seen but also what might have been seen at a given moment in time. Unable to remember or anticipate, they cannot record the moments before or after. But they can record and preserve that one moment's uncertainties.

The Quality of Victory and the "German Question"

THE SIGNAL CORPS PHOTOGRAPHY ALBUM AND *LIFE* PHOTO-ESSAYS

THE SWAN GALLERIES catalogue of its Public Auction Sale in New York on 15 October 1990 described item no. 193 under the heading, "A Searing Chronicle of World War II":

> (World War II.) A limited edition album, given only to members of the American Top Brass, with 75 Photographs depicting a panorama of images, both celebratory and shocking, relating to the war. Silver prints, 7 1/2×9 1/2 inches, each mounted onto linen, most captioned on verso. Small oblong folio, leather; contents clean. 1940s (2,000/3,000) Includes: surrender of the Japanese * U.S.O. acts * combat scenes in France * Airborne Invasion of Holland * Eisenhower, Churchill and De Gaulle * Crowds lining the Champs Elysées * and images of the Survivors at Buchenwald.

The photograph reproduced in the catalogue is of a Russian slave laborer at Nordhausen (liberated on 14 April 1945 by the 3rd Armored Division) pointing out a former Nazi guard (fig. 2.1). The album was bought by the photography department of the Museum of Modern Art in New York, a collection not usually interested in intentionally, that is, exclusively documentary photography.[1]

A compilation of Army Signal Corps photographs, the album may have been influenced by Edward Steichen's publication of a handsome volume titled *U.S. Navy War Photographs*, which was dedicated to "the officers and men of the Navy" upon their leaving, to remind them "of a job well done"—making the Navy "victorious in the greatest war in history."[2] In charge of all Naval combat photography during World War II, Steichen had brought to the job his organizational and promotional skills and his interest in the visual challenges of combat photography.[3] He had recruited into his Naval Aviation Photography Unit crack photographers as well as experienced laboratory technicians, looking for a variety of skills and experiences, not just in photojour-

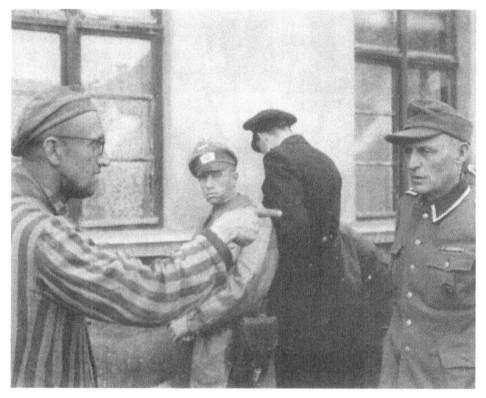

FIG. 2.1

nalism or documentary photography.[4] The volume bore his name and all the images reproduced in it were attributed to individual photographers, announcing authorship and authority. During the last years of the war, when the volume of pictorial material had risen dramatically, the Army Pictorial Service generally gave up attributing photographs to individual Signal Corps photographers.[5] In accordance with this policy, the Army album presented mostly unattributed images, and the compiler was not named.

The selection of images was based on suitable topics and appropriate representation: warfare, civilians in war, ruins, "German atrocities," and American soldiers as occupiers. Both the anonymous Signal Corps photographers and the anonymous compiler show impressive visual imagination and discernment. At issue was clearly the accuracy of the picture, that is, its effectiveness in recording and elucidating the pictured. Such accuracy is, of course, to a large degree inseparable from the photograph's effectiveness in terms of spatial structuring, lighting, angle, and perspective. The images chosen are both good photographs and a good indication of how the army wanted to present this entirely just, indeed "holy" war against evil fascism—a war that could not but be won. Moreover, the victory appeared so certain and total that it suspended contingency and accident for the victorious forces. Despite the obvious losses and sacrifices on the American side, this war did not create but liberated victims to make them whole again—in the American image. There is a curious quality of individual wholeness and inviolateness that enhances the physical presence of Ameri-

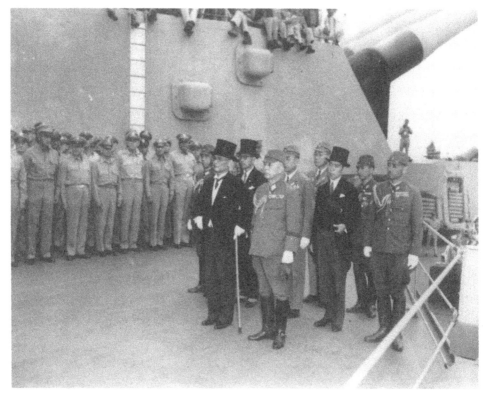

FIG. 2.2

can soldiers in these pictures, beyond the usual kind of propagandistic insistence on sturdy and enthusiastic, or at least stoic warriors.[6] In contrast, the German civilians "confronting" the atrocities seem physically diminished, slumped over, crumbling, a collective of anonymities. Representing the expectations justified by a total military, political, and moral victory that was affirmed by the enemy's unconditional surrender, these images erased, for good reason, the ambiguities and contradictions inherent in the concepts of collective dishonor, guilt, remorse, and atonement.

The Signal Corps photographs collected in the album do not glory in the fact of victory; they tend to emphasize American informality, even "coolness," especially so where ceremonious representation of victory is concerned. The introductory sequence of photographs of the formal Japanese surrender proceedings aboard the SS Missouri in Tokyo Bay in September 1945 makes this quite clear. One of them shows men crowded together on different decks, neither orderly nor chaotic, in a state of relaxed attention to something invisible—as the caption points out, the crowds obscure the dignitaries, including General Douglas MacArthur. Visually broken up into different groups distinguished by their different uniforms, and seen together with the ship's powerful guns pointing upwards towards the viewer, these crowds suggest a curiously symbiotic spontaneity and efficiency.[7]

In another image from this sequence (fig. 2.2), the Japanese delegation appears in

full uniform or formal European attire, erect and tense in anticipation of the moment of signing the surrender. The group is held together by the fact that they are looking in the direction of the table, invisible to the viewer, where they will have to make final with their signatures their defeat. The uniformity and intensity of their regard separates them from the American officers, who are lined up at ease in their unceremoniously open-collared summer uniforms, some looking at the Japanese (none of whom returns the gaze), some in the direction of the table. Accenting their relaxed pose, the feet of men observing and photographing the ceremony from the next higher deck are seen dangling above the officers' heads.[8] The placement of the Japanese group in the right foreground, black and dark grey figures, pulled toward that fateful moment of signing, and of the line of Americans in the left background, uniformly light grey figures distinguished by different postures, contrasts nicely the acculturated formality and tenseness of the defeated Japanese with the acculturated informality and physical looseness of the victorious Americans.

This contrast goes beyond the fateful moment of marking victory and defeat and impresses on the viewer the victor's intrinsic physical and material power, visually underlined by the huge guns in the right background pointing upward. Underneath them can be seen a man aiming a camera, across the heads of the Japanese delegation, at the invisible table. This photographer, though a tiny figure in the distance that emphasizes the largeness of the deck and the gun, shares his vantage point with the Japanese and thereby reenforces the significance of what they see and will have to face.[9]

Charles Fenno Jacobs, a member of Steichen's photo unit, photographed a "Japanese Prisoner Bathing on the U.S.S. New Jersey" (1944), extrapolating cleverly from the visual contrast provided by a group of well-fed GIs watching with condescending amusement a naked, very thin Japanese POW squatting in front of a bucket (fig. 2.3). Their faces turned toward the photographer, their grins and smirks are clearly visible. The prisoner was photographed from the back, the most vulnerable aspect of his nakedness exposed to the sailors but invisible to the viewer. However, there is another crouching person, who is photographing the scene from the position of the captors. Their attitude appears to be derisive rather than threatening. But making this intensely private act a public comic spectacle, their physical advantage is very great. There are many of them, standing, larger, and clothed; in comparison to the prisoner's body, theirs take up an enormous amount of space. Remarking on the contrast, Max Kozloff argues that Jacobs, if he expresses here the American point of view, also "inadvertently turns the sailors' object of derision into a subject for our pity"—because his opponents are incomparably more powerful. In addition, there is the presence in the photo of the other photographer who shoots the prisoner "from *their* perspective. By choosing to shoot from the underdog's space, Jacobs makes that space—and vantage point—ours. The degree to which the polemic of war photographs depends very simply on the vantage point of the camera cannot be overemphasized."[10]

As a general rule this may be true but it is rarely the whole story. The vantage point of the camera is informed by sympathies and animosities that are exaggerated in wartime. Jacobs does not actually shoot from the "underdog's space" because that space is visually defined by the towering sailors to whose faces the viewer's gaze is directed across the squatting POW. Rather, he answers the shot of the other photographer to

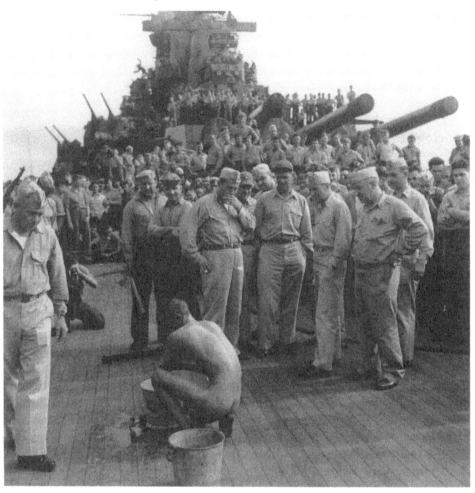

FIG. 2.3

whom the prisoner's vulnerable "private parts" are most fully exposed—most of the sailors see him primarily from the side. There is also a sailor in the left foreground who looks sideways at the prisoner and does not seem to be amused. More importantly, if Jacobs "inadvertently" turns the Americans' object of derision into "our" object of pity, he can do so only if he shows "them" to be wrongly derisive. That has to work on at least two interconnected levels: they have to be, or appear, less appealing than the prisoner, *and* they must seem an unfair match for him. (It would certainly not work with an SS concentration camp guard POW, perhaps not even with a young, underfed, "nice"-looking German Army POW). And indeed their largeness appears awkward rather than powerful, spoiled, unlikely to endure, unattractive. In contrast, the prisoner's body is tightly controlled, muscular despite its boniness, squatting with natural ease, an elegant shape despite the isolation and depravation imposed by burly victors whose assumed strength is really in their numbers.

This strikingly composed photograph suggests to me neither an expression of the

victors' point of view nor an attempt to draw the viewer into the underdog's space making that view "ours." It is left open to different kinds of viewings and "readings." Jacobs's vantage point was a matter both of visual and emotional, or moral control, and of chance. He decided to define the prisoner's space by the blocks of standing sailors and by the relation to them within that space of the prisoner. Since the resulting image is successfully articulate in its perception of power, the photographer was lucky that what he saw and wanted to be seen was not disturbed before he could "take" it. The block of sailors remained intact, the expression of derision remained (or became) fairly uniform, and that revealing spatial relationship between the other photographer and the prisoner came out clearly.

Were the captors aware of being photographed in the act of looking at their prisoner? They seem absorbed in their reactive group solidarity. But the sailor in the left foreground might have been aware of Jacobs's presence. One step further and he would have obscured the other photographer. Did he know about that person's presence and stop moving so as not to disturb Jacobs's picture? Or was Jacobs's split-second decision made luckily, at exactly the right time? The more complex the visual information and message of the photograph, the more complex the interactions of contingency and decision that made it possible. The other photographer's vantage point depended less on chance, and the resulting photograph presumably communicated the straightforward message: Japanese weakness in defeat. More complicated, Jacobs's perspective is more precarious and his message more ambiguous: Americans are now the all-potent victors and the Japanese their impotent prisoners. For the viewer, the quality of American victory is interdependent with that recorded view of the impotence of the defeated. How the photograph might move a viewer to think about that interdependency is a real question.

That kind of visual and moral sophistication in the portrayal of mutually confronting views of power and violence in war is rare. I have not seen it in any of the photos taken by Signal Corps photographers of German POWs and their captors—or, for that matter, by any other war photographer, anonymous or well known. Of course, this is one photograph taken by one perceptive *and* lucky photographer and one should not stretch its visual message too far. But with this warning in mind, the image does provide a suggestive comment on the fact that the quality of America's victory over Japan differed from the victory over the Germans. This became clear in 1945 when the German concentration camps were liberated.[11] Germans were collectively tainted by the enormity of that crime and thus their military aggression was seen and represented as more evil than Japan's, whose defeat was explained—by themselves but also, to a degree, by the victors—as the result of wrong military choices rather than collective moral-political perversion.[12] Carl Mydans, a war reporter for *Life* documenting the Japanese surrender at Kurihama Naval Base in September 1945, photographed the moment of the naval commander's surrender of his sword to an American naval officer. He later included the impressive image in a collective volume of his photographs and gave it the caption, "Never again in a world of changing warfare will such a scene of chivalry take place."[13]

Mydans's perspective ingenuously emphasizes the somber formality of the act shared by both sides: the smaller, sparse, erect Japanese commander in a simple tunic

and cloth cap on the left, and the taller, bulky, and slightly slouchy marine officer in overcoat, helmet, and gear on the right—both with their men lined up behind them. While it was shot from a position on the American side, the photo nevertheless also seems in some way to isolate the American officer. Where the Japanese appear close to their commander, the Americans seem further away, when presumably both sides had lined up at the same distance. Mydans's perspective causes the right foreground to appear empty—though the viewer assumes the line of Americans visible in the background to continue—whereas the Japanese are clearly visible in the left foreground. Standing opposite each other, handing over and receiving the sword, the two men together occupy exactly the center of the foreground. Yet the visual impression created by the perspectival shift has them appear slightly to the left, to the side of the Japanese. Whether this spatial strategy was exactly planned or not, it calls up a particular kind of sympathy for the particular kind of defeat—a sympathy affirmed in the caption: the defeated have lost something of great importance to them, a part of their cultural identity. The moment of surrender is somber for both sides, because the loss is acknowledged by the victors.

There was no such recorded moment when the Allies' accepted the surrender of German officers, because the loss of cultural identity was desired, expected, and enforced; it was certainly not worth a shared somber moment. A British army photographer, Sergeant Norris, expressed that view quite brilliantly in a photograph of the "Arrest of Dr. Speer, Admiral Donitz [sic] and General Jodl, Flensburg, 23 May 1945" (fig. 2.4). The three men appear as tiny figures in the background, watched over by a British soldier squatting high above them on a rooftop (?) with his gun pointed at them.[14] The viewer sees their smallness and dejectedness in defeat through the perspective of that large, looming figure in the foreground. If they seem to have lost their identity as part of a military and technical elite, this is a German problem only.

Kozloff states explicitly that in discussing questions of photographic perspective, he does not wish to ask "whether the judgments imposed upon the defeated are deserved or not. What I am saying is that on these occasions the camera inevitably enters into alliance with the captors." Yet he also asserts that

> to portray someone who had totally lost face, whose abjectness consists in being utterly prostrated before the enemy, is to construct an ambiguous narrative. For the defeated figures, generally the center of regard, must also be shown as vulnerable and intensely human in order to register the wounds inflicted by the vengeful power. Set off from the jeering or merely smug audience, they must have their own space, and their bared skin must be all the more tenderly described because it is exposed to so hostile a gaze. (216)

He may be right about the visual space given to the defeated to impress on the viewer the quality of their defeat. But the ambiguity of the narrative of their defeat depends on the perceived quality of the victory that reduced them to their present state, that is, the viewer's perception of a particular captor and a particular captive—namely, Kozloff's perception of the "beefy" overbearing GIs in contrast to the vulnerable "emaciated" Japanese (220).

There are some photographs of German POWs that present the defeated, especially if they are very young, with sympathy, often in contradiction to a hostile or derisive

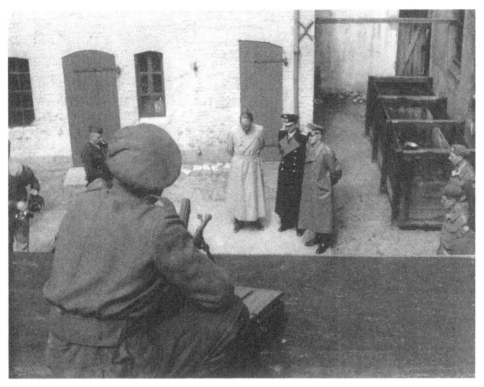

FIG. 2.4

caption. One of them shows a wounded boy, close to tears, with crudely bandaged arm and leg (fig. 2.5): "This Nazi 'Superman' appears to be in his 'teens' and his expression is not exactly that of the conquering hero as an American soldier looks at the lad's injury while awaiting the arrival of a medic."[15] Supporting the boy's arm, the American focuses on the wound, as does the boy. At that moment of kindness given and received, they are in a space outside that defined by victory or defeat. The viewer's sympathy for the boy is called up and sustained by his expression of pain *and* the GI's expression of serious concentration — his looking at what is painful to the prisoner and acknowledging the pain. The American is shown in the role of reassuring older brother, but there is no ambiguity regarding the significance of victory and defeat. This image evokes sympathy rather than derision for the defeated because it represents a pain already legitimized by the victor. Even so, it would not have been an image sufficiently clear about the quality of American victory to be included in a compilation such as the Signal Corps album.

Focused on the war in western Europe, the photographs gathered in the album naturally celebrated rather than questioned the achievements of the victorious. By contrast, the images recording the finalization of Japanese surrender, subtly introduce a dichotomy that informs, much more openly in the images of defeated Germany, the whole documentation of that victory. Legitimate power is set against usurped power resulting in impotence, individuality against anonymity, construction against destruc-

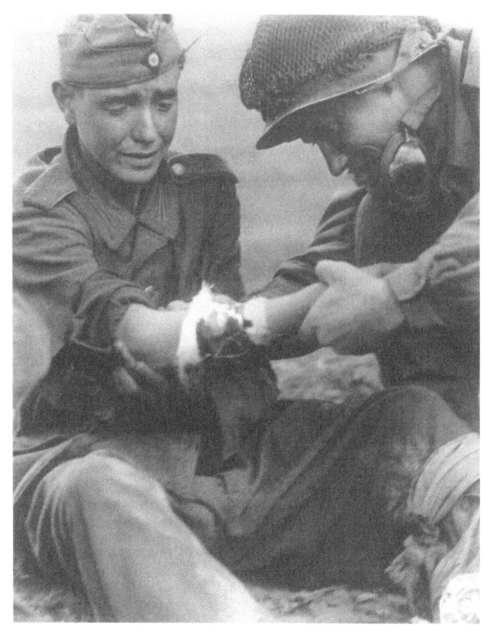

FIG. 2.5

tion, order against chaos, visibility against invisibility, familiarity against strangeness, moral and physical health and strength against sickness and weakness. Expectedly, the contrast shows up most clearly in the selection of images of "confrontation" which here emphasize American rather than German viewers of German atrocities. Moreover, "the German population" and German POWs appearing in these images have in a curious sense become a part of the confrontation as victims of their own victimiz-

ing—bad victims in contrast to the good victims of the camps. Informally grouped American soldiers, standing or walking, are juxtaposed with rows or piles of prostrate corpses and bunched together, bent over, crumpled, crestfallen Germans. The active, purposeful, well-fed individual GIs in their practical, comfortable outfits and well-made, well-fitting boots placed firmly on any ground they chose to step on are joined communally in their just and complete victory. They appear quintessentially different from both the anonymous victims joined in the collective passivity of death and the purposeless victimizers randomly collected to deal with them. Throughout the album the wholeness, wholesomeness, and individuality of the American soldier is consistently emphasized. While the photographers remain, on the whole, anonymous, the rank, name, and hometown of their subjects is recorded—whether they are first-aid workers searching for injured in the wreckage of a city (here, too, the importance of accounting for each and every individual American is stressed), or "cooking dinner on a G.I. stove under the World War I memorial near Verdun,"[16] or "ogling" a fruitcake one of their buddies has just received in a Christmas package from a girlfriend.[17] The name of the lucky young man in this last photo is Placide La Belle, a charming and gentle-looking boy whose youthful innocence would underline the naturally liberating rather than the invading aspect of the victory. How would he have perceived a group of "sullen prisoners of war" taken—also by the camera—in "fierce fighting"? Their sullenness is a fiction of the caption; the expressions captured by the photographer vary distinctly. But they do show the material, physical, and mental ravages of defeat in battle, providing a good subject for the celebratory purpose of the album.[18]

Holocaust photographs, thought to have "validated the war against Germany more effectively than any other evidence," make up a substantial part of the Signal Corps album.[19] The photo of the Russian slave laborer pointing an accusing finger at a guard used in Swan's catalogue to advertise the album, is an archetypical image of the irrefutable separation between good and evil, victim and victimizer (see fig. 2.1). The inmate in his striped jacket and cap is in the left foreground, only his head and extended arm showing; in the right foreground is the accused guard, an older man and smaller than his accuser. In the background are three more guards: one, half turned to the viewer, is looking at the accused and is about the same height and is wearing the same kind of grey uniform; one is turned away, a tall thin man in the black uniform coat of the SS; and another man, only partly visible, is in a grey uniform, bending over something that also seems to interest the man in black. The power of this image resides in the arm and hand with the long, pointing index finger arrested as it is thrust at the guard; set off by the darkness of the black coat, it reaches to the center of the image. Both guards' faces are grimly noncommittal. The viewer does not know whether the accusation was justified, but the composition of the image clearly authorizes the gesture of accusation.[20]

Despite the obvious value of concentration camp photos for justifying the effort and cost of the war, some U.S. officials were reluctant to release them, fearing that they might be inappropriate for civilian sensibilities and then get in the way of plans to rebuild Germany as a potential ally against Soviet power in Europe.[21] But generals such as Dwight D. Eisenhower and George Patton insisted that the images be made public not only to German but to American viewers. Joseph Pulitzer had his *St. Louis*

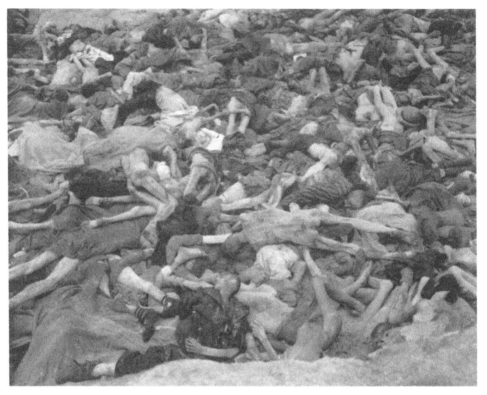

FIG. 2.7

Post-Dispatch mount a well-attended exhibition of life-size murals made from Signal Corps photographs, *Lest We Forget*, in cooperation with the federal government. It included many images that would be shown over and over again, in time becoming familiar Holocaust icons. These pictures might have influenced the selection for the Signal Corps album because they affirmed better than anything else the absolute necessity of American victory. The album contains, for instance, the often-shown, spectacularly horrible image of corpses of typhoid victims at Bergen-Belsen dumped into a mass grave, the long skeletal legs forming fantastic, surreal shapes and patterns. Photographed from a position above and looking down into the grave, the mass of tangled bodies suggests an abstract expressionist painting rather than a documentary photo of real, dead human beings (fig. 2.7). The dead, dangerous to the living, had to be disposed of as quickly as possible.[22]

The selection of images of "confrontation" shows Germans digging graves for mass burial, carrying the dead on stretchers (both from Nordhausen, Saxony, 14 April 1945), or viewing results of crimes committed at Buchenwald (16 April 1945).[23] The compiler did not choose images that explore the civilians' reactions to the atrocities by visual invasion of their space, though we see them watched by GIs as they obediently do as they are told. The composition of the first Nordhausen photo places a GI in the foreground, his rifle slung over his left shoulder, his posture relaxed (fig. 2.8). Smoking

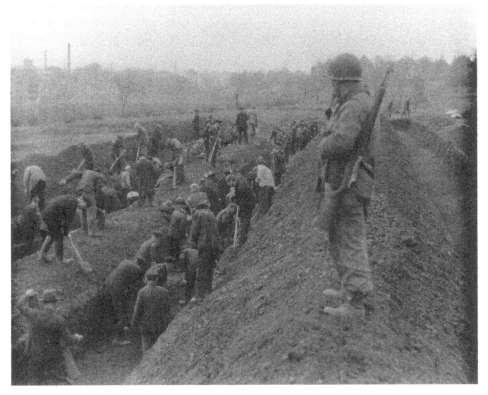

FIG. 2.8

contemplatively, he looks down at the bent backs of mostly old men who are digging the two long mass burial trenches that occupy the right side of the picture. Standing on an elevated spot, higher and much larger than the men working in the trenches, he takes up a sizable portion of the depicted space. Unable to overlook him, the viewer can look past him at the busily digging men whose activities can be "read" only through his watchful but also indifferent, imperturbable presence.

The companion picture shows a double line of civilians carrying crudely made stretchers bearing what look like lumps of decomposing bodies (fig. 2.9). A group of GIs is walking parallel to the stretcher bearers, not paying much attention to them. But standing exactly in the center of the foreground, larger than all the other figures, a GI seems to be photographing the stretcher bearers. His back is turned to the viewer but his posture suggests that he is looking into a reflex camera. There is a direct visual connection between him and one of the Germans, a teenage boy, the youngest in that line of mostly old men and the only one who is bareheaded. The perspective makes it appear as if he were alone at his end of the stretcher, breaking up the double line at its center—a visual distortion that singles him out and draws attention to the fact that his face, unprotected, is relatively close to the corpse on his stretcher. He is the only one who is not looking ahead with the usual "unseeing" expression but directly at the

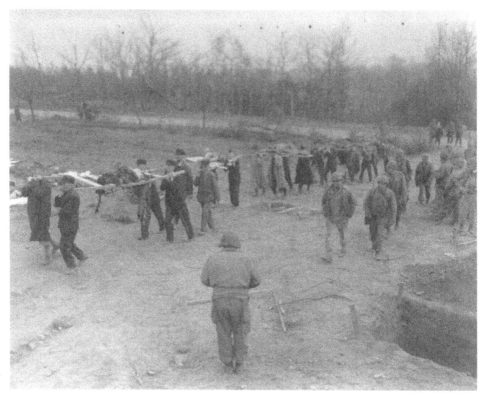

FIG. 2.9

GI in the foreground, whose camera would be aimed at him. The Signal Corps photographer who took the picture adopted the perspective of that other soldier in front of him, establishing some kind of connection between the viewer and at least one of those alien, untouchable Germans.[24]

Among the photos included in the Signal Corps album, this shows the closest physical contact of a German civilian with the corpse of a victim of German atrocities. In comparison with many other Signal Corps images of physical confrontation, the photographer's view here appears deliberately mediated—the perspective is authorized by another photographer in the picture—and relatively nonintrusive since the regard is focused on the boy who returns it spontaneously. One can only speculate about the reasons for this choice of focus, but some possibilities suggest themselves. Visual documentation of the handling of the dead as inanimate objects, as nothing but material, would have been deeply disturbing to American civilians whose limited historical experience with warfare on their own territory had left them unprepared for such views. Censors routinely stopped photographs that showed American war dead disposed of in that way, but also the documentation of enemy air-raid dead, often almost indistinguishable from the rubble of bombed-out German cities. For viewers thus protected, images of concentration camp dead piled into trucks or mass graves had an incalculable visual and emotional impact. Roeder reproduces a censored Signal

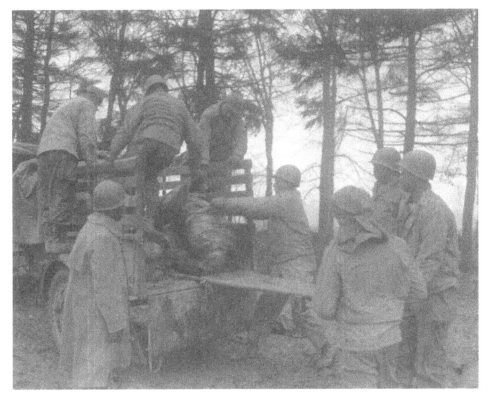

FIG. 2.10

Corps photo of GIs loading dead soldiers from the Third Army into a truck in 1945 (fig. 2.10).[25] Here, of course, every corpse is bagged, and the GIs handling the bags are protected by their clothing and by gloves. Instructively, too, six of the eight soldiers depicted here can clearly be recognized as black. Roeder points out that censors "had no desire to circulate evidence that officers often assigned African-American soldiers to such unpleasant tasks as burial details."[26] Images of German civilians touching or carrying decomposed corpses without the protection of bags, sturdy clothing, and gloves might have seemed inappropriate in the context of the celebratory documentation of such a clean and complete victory—might have suggested a punishment which, though deserved, was in some ways unworthy of the victor.[27]

In this context it was enough to show them digging graves, carrying the dead on stretchers or viewing them, and to control the photographic perspective for minimal intrusiveness. In the photograph that documents "the German population" forced to view the atrocities in Buchenwald, a group of Germans occupies the foreground looking at a truckload of corpses in the right background, their backs turned to the camera (fig. 2.12). They are shrinking away, shrunk into themselves, in a confrontation that seems to have less to do with the dead matter on the truck than with the burly MPs on the left. Looming, scowling, hands on hips, they are much more substantial than the Germans whose attention and remorse they demand. The spatial relation

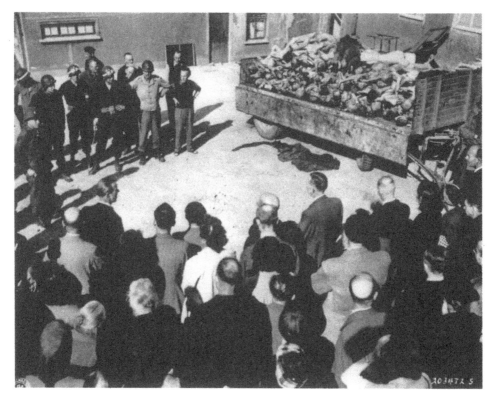

FIG. 2.12

between the three groups—the dead victims; the diminished, obedient victimizers; and the vital, forceful victors who establish and uphold the irrefutable line between good and evil, between victim and victimizer, creates a representation of confrontation that delivers its message in the simplest, clearest visual terms.

Perhaps even more than the images of piled-up skeletal corpses signifying the reduction of humans to mere materiality, the photographs of burnings at Thekla (near Leipzig) and Gardelegen (near Magdeburg) have become archicons of the Holocaust. Representations of grotesquely metamorphosed human shapes, they have greatly influenced works of art commemorating the destruction of European Jewry. The Thekla photo included in the Signal Corps album is of "victims of mass burning of Polish and French slave laborers at Nazi camp near Leipzig on April 19, 1945, the day before the city was captured by 69th Division of U.S. First Army. The victims were herded into a building which was set afire. Men who broke doors down to escape were machine gunned by Nazi troops. 4/20/45."[28] According to a report in *Time*, 30 April 1945, the burning of the several hundred prisoners remaining in the small labor camp after its evacuation on 15 April 1945 took place the following day.[29] The men who escaped the burning building were shot down and the photo shows their charred shrunken trunks, sticklike arms and legs raised at contorted angles, lined up along the

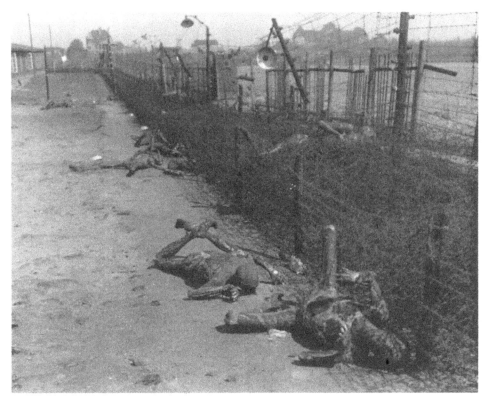

FIG. 2.13

barbed wire fence (fig. 2.13). The photographer brought out the alien, inhuman quality of these shapes by shooting along the length of the fence: crablike in the foreground, they become smaller and smaller in the distance till they look like nothing so much as large, exterminated insects.

The Gardelegen killings on 13 April 1945 involved about 500 to 1,000 prisoners whose transport from the east was caught in the American advance. SS guards burned to death 150 men in a fuel-soaked barn and gunned down the prisoners who tried to escape. The album includes several harrowing photos of the burned corpses inside the barn; in contrast to the Thekla dead, they retained their human shape, but they seem to consist of immaterial ashlike substance.[30] According to information provided in a caption of a photo from a different source, "Residents of the town of Gardelegen, 27 miles northwest of Magdeburg, were immediately compelled by U.S. officers to disinter approximately 700 partially buried dead and to bury all the charred victims."[31] A photograph of "Three German burgomasters [who] examine a mass execution victim of Nazis at Gardelegen" taken on 18 April 1945 (fig. 2.14) is the only picture in the Signal Corps album that shows German "dignitaries" viewing atrocities.[32] The photograph of three men crouching and kneeling before a charred corpse in the barn is not as powerful and suggestive as Sergeant Oakes's image of German

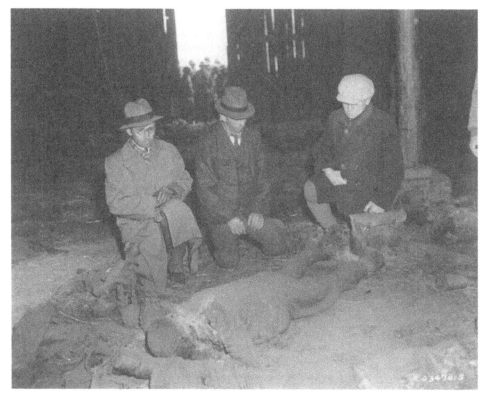

FIG. 2.14

mayors ordered to view the mass graves of Bergen-Belsen;[33] but it does convey in visual
and moral terms these three men's *Betroffenheit* (from *treffen*, to hit, strike): their
being taken aback, as if dazed, struck by the evidence in front of them.

The men's facial expressions are examined only by the camera. There is a group of
GIs in the background, looking into the barn through the large half-open door; they
can see only the mayors' backs. Dressed in coats, jackets, and hats, one of them holding
a satchel-like briefcase, these middle-aged men might at first glance look incongru-
ously normal to the viewer who knows the circumstances. At the same time, their
characteristic posture—pulled foward and shrinking back—and their set, unseeing
faces would tell even an uninformed viewer that they were not investigating some
crime in a professionally detached manner but were somehow, and painfully, involved.
Larger and lighter than they, the corpse in the foreground is not so much horrible to
look at as frightening because of its human shape and alien material, as if formed out of
air, something made in the image of man to mock him. Had these men been ordered to
take a close look at the corpse and therefore to get down on the ground? Or had they
thought that this position would placate the victors, indicating their willing obedience
when ordered to view the atrocities? Or had they spontaneously wanted to make
themselves smaller, not to stand tall in the midst of all that destruction? Or had they

FIG. 2.15

fallen to their knees, like Willy Brandt at the memorial to the victims of the Warsaw ghetto in 1970, simply because "words failed them?"[34]

Fraternization between Allied troops and "the German population" became an issue in September 1944 when American troops began occupying the area around Aachen and photographs were published of German women and children "fraternizing" with U.S. soldiers—greeting them, speaking to them, sharing meals with them (fig. 2.15). A telegram from General Marshall transmitting a message from President Roosevelt to General Eisenhower on 22 September 1944 informed him of the existence of these photographs and that they were "considered objectionable by a number of our people. It is desired that steps be taken to discourage fraternization by our troops with the inhabitants of Germany and that publication of such photos be effectively prohibited."[35] Fraternization between occupying troops and enemy civilians is of course an age-old problem, and orders prohibiting it have always been difficult to enforce. But this war, this population was a special case, and the guidelines sent by the Civil Affairs Division to American commanders as early as the summer of 1944 were emphatic: Germans needed to understand that they had been found guilty and were held in contempt by the rest of the world. They had to be made to see "the error of their ways" and to be "held at arm's length" till they had learned their lesson. Public contacts

should be restricted, for instance by not billeting troops in German households and by forbidding Allied personnel to eat in the same restaurants as Germans or to attend German religious services.[36] The Civil Affairs Division "Pocket Guide to Germany" instructed the troops: "There must be no fraternization! This is absolute!" But it also reassured them that this warning did "not mean you are to act like a sourpuss or military automaton." Ziemke comments: "As if dubious of success either way, the booklet also included the regulations pertaining to marriages with foreigners and a section on venereal disease" (97).

There is much anecdotal evidence that "the average American soldier had no feelings about Germans one way or the other." This is how it was put to me by a friend who had gone to Germany with the Counterintelligence Corps in August 1945 at the age of twenty-one. He also concurred with the often repeated observation that, on the whole, American soldiers preferred Germans to French civilians or soldiers. It was easier to learn some German and to understand the Germans; moreover, the Germans, apprehensive and therefore eager to please, were on average nicer than the somewhat "testy" French. He would probably agree with Ziemke's assessment of that "average soldier's" attitude to the nonfraternization policy: largely unenforceable despite the staffs' "manful" attempts to depict it as a "righteous, even noble enterprise"; it was an order about which the troops, "unconcerned with presidential or public opinion, preferred to develop various and mostly scurrilous ideas of their own" (98). Jokes abounded and everybody knew that something had to have gone badly wrong when large signs warning "Don't Fraternize" showed up every fifty yards.[37] Percy Knauth, in his essay for *Life*, 2 July 1945, titled "Fraternization. The Word Takes on a Brand-New Meaning in Germany," pointed out that in contrast to France, where the Army had "raised no moral howl" over fraternization but had left it up to individuals, it was "officially a matter of high policy" in Germany. Not so for the GI faced with "the $65 question" (the amount of the fine for transgression) — not even the issue of "going out with girls who used to go out with the guys who killed your buddies. You don't talk politics when you fraternize. It's more a matter of bicycles and skirts waving in the breeze and a lonesome, combat-weary soldier looking wearily around the corner to see if a policeman is in sight" (26).

Fittingly, nonfraternization did not come to a clear, decisive end but self-destructed gradually. Eisenhower's announcement, made on 14 July 1945 and effective 15 July came after much back and forth in the matter and despite expectations of serious trouble over food and heating material shortages during the approaching winter. (The shortages would be severe and even worse in 1946/47; but there would be little trouble. In that respect Germans had "learned their lesson," namely, that they had brought hunger and cold on themselves.) Referred to as the "fraternization order" by the troops, the announcement was endearingly unrealistic: "In view of the rapid progress which has been made in carrying out Allied de-Nazification policies [which in fact were rapidly becoming a major embarrassment for the occupation] . . . it is believed desirable and timely to permit personnel of my command to engage in conversation with adult Germans on the streets and in public places" (Ziemke, *U.S. Army*, 325). The *New York Times* correspondent cabled a description of happy fraternizing on July 15: "There was a new watch on the Rhine today — by handholding

American GIs and German girls taking advantage of the relaxed restrictions on fraternization. In the hot sunshine of a Sunday afternoon they sat on grassy riverbanks, chugged up and down stream in American boats, and zipped around streets with the zest of a child diving into a box of candy previously accessible only by stealth."[38]

However, there was still some life in the nonfraternization issue because of the slippery concept of "public spaces"—what exactly were they? Clearly, they were parks, streets, railroad stations, theaters, galleries, marketplaces, shops, city halls. Clearly, they were not private homes, hotel rooms, brothels. But what about halls for General Patton's organizational dances, or cabarets? Frustrated by the many demands to be perfectly clear in this tricky matter, Eisenhower advised his major commanders that he considered them "fully competent to interpret and define the term 'public places' within the spirit of his intentions" and that he did "not wish to publish any further definitions or interpretations in this connection."[39] Fraternization within and outside the limits, however unclearly stated, was blossoming and abundantly photographed. Perhaps more strongly even than images of death and destruction, these photos of spontaneous encounters amidst the ruins between young American soldiers and German girls in that legendary beautiful hot summer of 1945 impress on the viewer the incomprehensible idiocy of war and wholesale violence. Ray D'Addario, the young chief Signal Corps photographer at the Nuremberg trials, took a charming photo of two very young GIs standing opposite several young women, one of them walking toward the two men with a pleasant, open smile, pushing a pram which is exactly in the center, between the two groups, providing the focus of the image. Is it the young woman's child? Is it legitimate? Are these "good girls" of the kind Patton wanted to attract to his dances? The modest white pram enhances rather than undermines the "innocence" of the encounter because the young people seem so guileless (fig. 2.16).[40] The German caption under D'Addario's photograph suggests that the unenforceable nonfraternization regulations revealed the weakness of an occupational policy based in its early stages on too rigorous a distinction between victor and defeated. But such distinction would have been true for the early stage of any occupation after a major war. In this case, the policy was based on the quality of a victory and of a defeat that called for moral, not just social separation. (After a different kind of victory and defeat in World War I, U.S. General Headquarters in the German Rhineland prohibited troops from fraternizing but allowed them to be quartered with German civilians.) Before the decision to tolerate fraternization, these smiling approaches would have been seen as forbidden, punishable flirting. The New York Times reported on 13 June 1945 that in the Fifteenth Army area a Counterintelligence Corps detachment had been sent to watch a security guard detachment ordered to "shadow an MP private who was suspected of flirting with a German girl."[41]

A survey of American soldiers in November 1945, after six months of occupation, showed that nearly 80 percent favored the Germans: they liked German cleanliness and industriousness even if they disliked their "air of superiority and arrogance." Of the respondents, 43 percent blamed the German people for the war, and 25 percent held them responsible for concentration camp atrocities. However, few of the soldiers had associated with older Germans and even fewer with men their own age (most of whom were killed, wounded, or in a POW camp). Their positive reactions were based

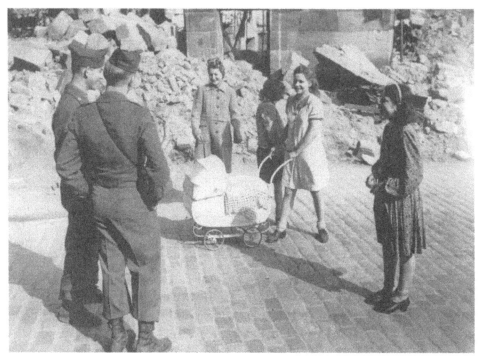

FIG. 2.16

mainly on conversations with young German women with whom they probably did
not talk much politics. I asked my friend whether he had discussed "the German
question" with the highly educated family whom he had met when his group requisi-
tioned their baroque country house in Bavaria. They had let the family stay because the
house was filled with friends and relations who had fled the bombed-out cities or the
Russian advance in the east. But of course they had let themselves be persuaded because
the family spoke excellent English and was gracious and interesting. With the requisi-
tion turned into an informal and still not quite legal fraternizing billet, the family had
"adopted" my friend. He never did raise "the German question," though they talked a
great deal and he found their world fascinating. For Christmas he was given a book of
famous German watercolors with the inscription, "this is to convince you that not all
Germans are bad." "I was puzzled by that," he said later.

He was puzzled because to him Germans were like other people, only at the time in
the extraordinary situation of being occupied by his people—the result of an ex-
tremely destructive war that had involved a large part of the population. With his
informed admiration for European high culture, he was, of course, not "the average
soldier," nor was the family who befriended him "the German population." But who
and what was "average," and especially in that situation? He was as young and
inexperienced as most of the American soldiers and many of the counterintelligence
interrogators who were sent to Germany to gather information in order to settle "the
German question." However, this professional interrogation was, he explained, a

different situation. Here the questions were preestablished, formulaic, even before the interrogators had available the notorious *Fragebögen* or the army handbooks containing already collected Counterintelligence Corps material on Nazi functionaries and the military. His curiosity in a professional situation was narrowly focused and controlled. In a personal situation, the questions he asked were spontaneous reactions to individuals and to their reactions to him. Here he did not have to form an opinion on "the German question" (for instance, the role of the German elites under totalitarian rule); young and speaking for nobody but himself, he had the luxury of "taking it all in." In that he was not unlike a particularly open-minded photographer who took pictures to record his part in what could be seen then so that it could be looked at again, perhaps differently, later.[42]

American eyewitness reports of Germany in 1945 tended to suffer more than British reports from expectations that they tell the "whole story," everything that could be seen, in order to answer "the German question." In the perspective of Saul Padover as recorded in his *Experiment in Germany: The Story of an American Intelligence Officer*, the solution of "the German puzzle" was to recognize that all Germans were morally and physically despicable, actually not unlike Nazi stereotypes of Jews, down to details like uncleanliness, selfishness, and dishonesty. Convinced that his reports had "caused something of a sensation" at headquarters, Padover sincerely believed that his "all-Germans-are-bad" clichés were hot news to his "colleagues at Verdun and Luxembourg and Paris and London" who "found it almost hard to believe. It took many months and many other witnesses to corroborate our findings."[43] In fact, many foreign war reporters sent to Germany in 1945 stated that they went with a host of preconceived ideas about the situation—it proved more chaotic even than they had expected—and about the people—they turned out to be less solidly "bad" and more deeply traumatized. Observers also apologized routinely if their reports were less than unambiguously negative.

Padover is an extreme and quite troubling case of psychological denseness and moral-political self-righteousness, beating "the Germans" to pulp on paper when he could have given some thought to their dilemma. But the situation in Germany in 1945 was indeed difficult to assess, not the least because on some level, and for some observers more than others, it tended to increase a curiously unreflected belief in instantaneous and infallible judgment. There is a counter story to that of Padover by another American intelligence officer, the middle-aged German exile Walter Hasenclever, who interviewed German POWs in 1945. Reconstructing the interviews from memory in the 1970s (his notes had been lost), revisiting the old questions and answers from that later position, he used to advantage a temporally composite perspective on the dilemmas of many of those young soldiers. Hasenclever was not so much "understanding" as shrewd and without condescension, and unlike Padover, he was more interested in the people he questioned than in his own all-powerful position as questioner. Focusing on their stories of loss and fear rather than his own anxieties and grievances—admittedly a difficult thing to do in 1945 and yet necessary—he managed to elucidate certain important complexities, ironies, and tragedies that many other reports had lost sight of too quickly.[44]

Percy Knauth, a member of the American press colony in Germany from 1938 to

early 1941, was sent by *Time* and *Life* magazines "into the Reich behind the invading Allied armies to report on Germany's downfall." The motivation for his book, *Germany in Defeat*, written in late 1945 from his notes and articles published in these magazines, was a perceived threat to the Allied "experiment" of running Germany — in his view a "test for running the whole world." Deeply troubled, he saw that experiment endangered by the dissolution of "the German question" in the increasingly positive attitude of individual Americans toward individual Germans. At the end of his report, Knauth insisted that "the attitude of the Germans" was of crucial importance for peaceful Allied, that is, American rule of the world, but that Germans, emerging from totalitarian rule, were not prepared to sacrifice enough for democracy. And here his argument showed a curiously rigid perspective intent on illuminating his American difference from "the Germans" rather than differences among Germans:

> At this writing, the impression I get from our newspaper dispatches is that the Germans, who six months ago were killing us with all their might, are now the people we like best on the whole continent of Europe. Our soldiers, coming back from Europe, despise the Italians as dirty, the French as cheating and ungrateful, the Poles as filthy and degenerate, the Russians as untrustworthy, uncivilized and brutal. By contrast with them all, the Germans appear patient, friendly, and much closer to Americans in their love of order and industrial efficiency and their normally high standard of living. The Germans, far from being the instigators of this war, are rapidly beginning to look like its victims.
>
> That is a terribly dangerous trend, the same one that built Hitler up into a demigod who sought to rule the world. It is a trend that must be stopped at all costs now if we are to secure the victory we won. It is a trend that can be stopped if we but see the Germans for what they are: a people of diligence, cleanliness, orderliness, friendliness, and high standards, a dangerous number of whom have a fatal tendency to believe that the world owes them a living, a belief so strong that it has twice within a generation led them to fight the world to get the living they felt was due them.[45]

In Knauth's unhappy view, the clean, moral separation of the defeated from the victorious was being muddied by everyday contacts between them. This strengthened the illegitimate appeal of the defeated and weakened the victor's legitimate moral authority. Liked by too many Americans, the Germans were useless to the American plan to build an enduringly peaceful world. "In proof" — and as a conclusion to his report — Knauth quoted in full a long letter he had received from a woman whom he described as a "lifelong democrat, a friend of England and America, an anti-Nazi who nevertheless somehow made her peace with her own soul and Adolf Hitler, and who is German right down to her toes" (225). The letter that upset him so had been sent to him because of the woman's American connections; she hoped to arouse special interest in the common plight of a Berliner under occupation. The letter is indeed both irritating and pathetic in its self-pity and self-righteousness. She presents herself as one of "the decent Germans" who are now "spiritually prepared to take the burden of their fellow citizens' guilt on their own shoulders" (231). She warns darkly that this cannot be done if the Americans continue to behave like indifferent occupiers rather than friends of Germany. That hint is, of course, as undiplomatic as her claim to citizenship among the "good Germans" — an honor not to be assumed by her but to be granted by the victors. However, Knauth might have been expected to recognize the difficult

situation of an elderly woman overwhelmed by her share of chaos, deserved or not: her apartment requisitioned first by Russians, then by Americans; the occupiers' random destruction and irrational regulations; their breaking up of her furniture, taking of all her possessions, tearing up of her books and papers, and the erasing of her life's work; her weakness from hunger, and long years of British air raids. (Knauth and his family had more than enough of them in early 1941 and left Germany.)

Knauth was unable to recognize that this person—not too bright, lacking in all the civilized virtues of generosity, humor, charm, self-irony—was simply at her wits' end; he did not think her panicked frustration morally permissible. In response to her rhetorical wish that she "could induce an American correspondent to come and see the cellar of our house for himself, so that he could get an idea of the condition in which the Russians left it," Knauth remarked sternly: "I never did go to see it; after you have been through the Buchenwald barracks you are not likely to mourn over the condition of a German cellar" (227). Obviously. But his comparing levels of victimization here clearly stems from his own sense of moral superiority. Privileged with being safe, warm, and well-fed in the chaotic, dangerous Berlin of 1945, Knauth had no trouble keeping "the Germans" and their difficulties "at arm's length." Insisting on their sameness in collective guilt made it easy for him to judge and dismiss them. The letter writer, hanging on to her identity as "the decent German," resisted being judged and dismissed so easily. That was her real crime.

Knauth was not interested in the social and psychological ambiguities, lacunae, and contradictions of this particular life. He thought "the terrible thing about this letter" was its "absolute sincerity." She really believed that she would be exempt from collective guilt and deserved punishment without having proved her willingness to die for her faith in democracy (231–32). Knauth was mainly interested in indicting her, and all Germans, for their "blindness, or stupidity or plain unwillingness to think the Nazi problem through and draw the ultimate conclusion: that faith in democracy in a Fascist country is something for which one must be prepared to lose not only desk lamps and armchairs, and home, but even one's own life" (231). His righteous Americanness swelling to an uplifting conclusion, he may not have realized the implications of his argument: all those pleasant and cleanly Germans were dangerous by the very fact that they were still alive. Had they been truly good Germans—and nothing but truly good Germans would suffice for Americans running a truly democratic world— they would not have survived to charm and thereby corrupt the unsuspecting young soldiers overseas.

Knauth's perspective on "the Germans" was immutably shaped by his visit to the Buchenwald camp described in the second chapter of his book. In the course of his effective, repeatedly quoted account of German atrocities, he dealt with the question of responsibility by declaring that all Germans were "responsible for Buchenwald, each and every one, the German prisoners of Buchenwald alone excepted. In any land, with any form of government, the citizen must be held responsible for what his government does, for in the last analysis his government is of his own creation" (62). He also asserted that "the moral and the principle do not end with Germany and the Germans," referring to European and American governments' support for Hitler and his government until the outbreak of the war. But somehow this did not translate into

any concrete responsibility for the individual American, for himself (62–63). In a chapter on Allied area bombing and the tremendous cost to the German population, he insisted both on accepting responsibility for the wholesale devastation *and* on removing the acts—and thereby the issue of responsibility—from further questioning:

> We must keep in mind not *who* did it or *why* it was not done in cleaner fashion, but why it *had* to be done in the first place. We must remember that we are living in an age of total war, and that we cannot escape its consequences or responsibilities. When the argument begins about the ruthless bombing of civilians, we must take our full measure of the responsibility, acknowledge that we did it, and realize that we could not have done otherwise.[46]

Such "realization," of course, would not decide an argument between peers; it has been "really" acceptable only to the defeated, who were in no position to talk back. The devastating air raid on Pforzheim on 23 February 1945, on a medium-sized town in Baden-Württemberg that had gone largely untouched for lack of any war-related importance, was carried out by the chief of the British Bomber Command, Arthur Harris, for no other reason than that he wished to demonstrate the effectiveness of area bombing and in the process show what the Bomber Command could do (fig. 2.17). He decided on the attack that in nineteen minutes destroyed the city and killed about 20,000 people, despite the fact that many officers in the RAF, notably his immediate superior Sir Charles Portal, favored precision bombing. The introduction of fighter plane P-51 Mustang in 1944 had made possible better protection of bombers, which in turn made precision bombing more feasible. Moreover, the effectiveness of area bombing in shortening the war had become increasingly doubtful, even though it was devastating for the civilian population. Harris's costly decision was the result of his notoriously ambitious aggressiveness, encouraged rather than controlled by complicated military and diplomatic politics.[47]

For the victor in 1945, such an "unjustified" attack would have been merely another example of the wartime moral inversion Germany had brought on itself. "The Battered Face of Germany," a powerful photographic essay on the destruction of German cities (*Life*, 4 June 1945), makes that quite clear. The coolly, eerily beautiful aerial shots of total devastation do not even moralize since they transcend what is difficult to look at from up close, the "battered face." From the great distance of the victor's view, destruction appears as structural rearrangement. If this matter-of-fact conjuration of total change seems inhuman, this merely reflected the inhumanity of Germany—a criminality so extraordinary that no degree of physical destruction would be sufficiently punishing. But almost fifty years after the attack, Harris's family and his old division decided to erect a monument honoring his and the Bomber Command's achievements. In the eyes of many, this was a cruelly superfluous reminder of wartime morality, but the appeals of the citizens of Pforzheim in Bonn and London were defeated.

More clearly than many other reporters, Knauth was energized by the victor's power to accuse and to absolve on his own terms exclusively. On several occasions he expressed his desire simply to kill on the spot persons exhibiting what he thought

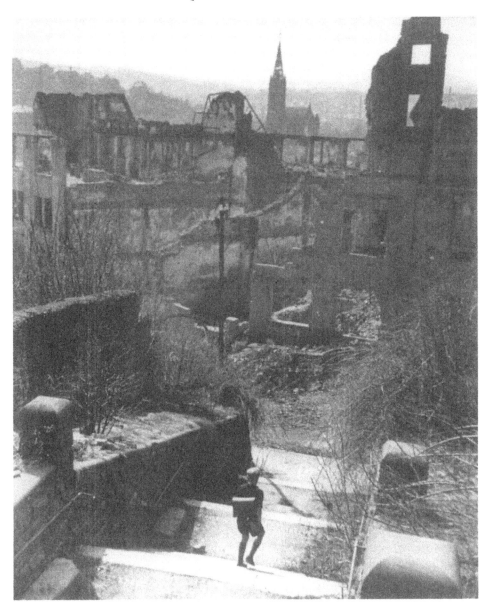

FIG. 2.17

Nazi-like traits—disobeying his own "reasonable" order by obeying somebody else's "unreasonable" order (15). He said he wanted to beat "any SS man" (regardless of what he had done or how he had joined the SS), "till his insides spilled out of his body." He knew, and approved of the fact that he was "not alone in that feeling. One evening when I was at the camp, some Buchenwalders brought in a few German prisoners, boys in *Wehrmacht* uniforms who had been picked up, unarmed, outside the camp. Before

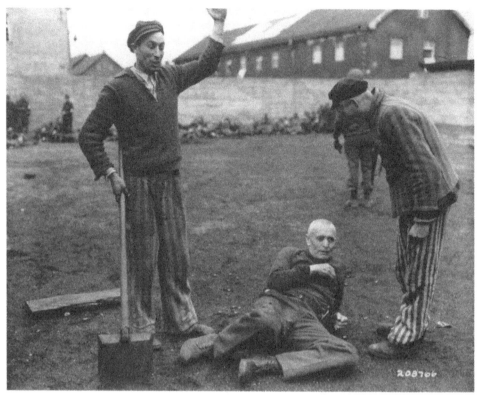

FIG. 2.18

they could be properly put in jail, American GIs who had been through the camp that day fell on them and beat them bloody, just because they had German uniforms" (65); other observers reacted more maturely. Mosley described the treatment by British soldiers of guards left behind at Belsen against their will, men and women about whose backgrounds they knew very little. Enraged by the enormous piles of corpses of German and other political prisoners who had died of typhoid, the result of panic and neglect, they first beat the guards and then ordered them to collect the bodies:

> all day long, always running, men and women alike, from the death pile to the death pit, with the stringy remains of their victims over their shoulders. When one of them dropped to the ground with exhaustion, he was beaten with a rifle butt. When another stopped for a break, she was kicked until she ran again, or prodded with a bayonet, to the accompaniment of lewd shouts and laughs. When one tried to escape or disobeyed an order, he was shot.[48]

Under the circumstances, Mosley found it impossible to have sympathy for the guards, even though their punishment "was in the best Nazi tradition." Few of them survived it, almost all of them dying from typhoid contracted when carrying the corpses without any protection. But it made Mosley "pensive to see British soldiers beating and kicking men and women, even under such provocation." These SS guards

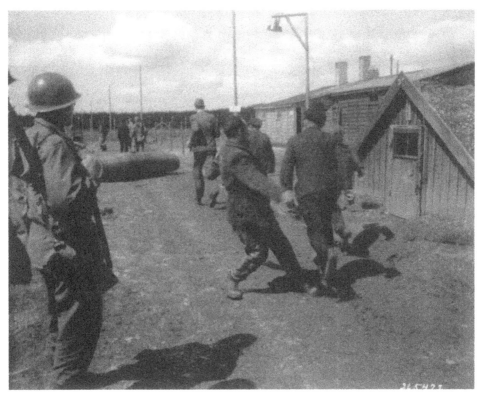

FIG. 2.19

were "a brutalised and inhuman lot," but it emerged from the victims' stories that in many cases they had not been as bad as the ones who had managed to escape, probably never to be caught (93–94).[49] I have seen no Signal Corps photos of GIs (or British soldiers) beating or kicking former guards, much less shooting them. But there are Signal Corps images of guards kicked, beaten, or knocked down by former inmates (fig. 2.18). In one of them, a GI, providing the official "legitimizing" perspective, watches a former French inmate kicking civilians to make them move faster as they carry the dead to burial (fig. 2.19).

Acknowledging the "inevitable resentment which all men [of the occupying forces] felt against the Germans," Mosley understands tolerance of such behavior but thinks that "it certainly did not produce the atmosphere conducive to impartial or even thoughtful reporting of what was going on inside the Reich" (47). He did his best; and Stephen Spender's *European Witness*, W. Byford-Jones's *Berlin Twilight*, and Alan Moorehead's *Eclipse*, as well as the diary kept by the American captain H. E. Saunders of his trip to Germany from October to December 1945, show the effort to maintain a certain degree of fairness, though not, perhaps, of impartiality.[50] All these reports, regardless of their authors' political and social sympathies, observational skills, psychological intelligence, or writing talent, reflect a degree of openness to a variety of voices. Up to a point, they all listened in ways which did not immediately shut out all the troubling questions posed by the complexities and conflicts of the stories they

heard—stories whose accuracy they could most often only judge approximately. Given the situation and the war propaganda, it was very difficult to avoid stereotyping "the Germans," but the writers of these reports were at least aware of the danger.

Knauth, in contrast, was not. With the notable exception of his Buchenwald chapter, his descriptions of events, situations, and people are rigorously reductive, recording certain facial and other physical traits as well as certain habits of speech in order to search them for clues of some sort of complicity with an evil regime or, in some rare cases, to affirm them as indicative of active resistance. Nothing in between—the whole unreliable, unpredictable scale of human behavior—was worth his attention. In Frankfurt, Knauth interviewed one of the more interesting, if difficult, Germans, the Protestant theologian and leader of the oppositional Confessional Church, Martin Niemöller, whose aggressive frankness had to be shocking but also instructive. Rescued by the Americans after long years of Nazi imprisonment, he had given an ill-fated interview to the Allied press admitting his early sympathies for some of the goals of the Nazi regime. The press had not taken kindly to that statement and Niemöller, according to Knauth, had turned into "an utterly bitter, utterly negative man," unable to see anything of value in the American plans for Germany's rehabilitation. Knauth's quite skillful verbal "snapshot" of the man would certainly have supported a dismissive caption: "He was small, lean, and brown, and incredibly deep lines were graven on his dark face. He wore GI pants and shirt and a white linen jacket, and he had American cigarettes and a Zippo lighter (something I had been trying to get for years). His thin hair was brushed back from his high forehead, and his eyes were dark as coals, but with no trace of fire or passion in them until he started talking about the Americans and the treatment he had had since his liberation" (144). Clearly, such a man did not deserve American cigarettes, the real wealth in the Germany of 1945, much less a Zippo lighter. Having wasted "at least a quarter of an hour" of Knauth's valuable time disputing the reaction of the press, he still

> could not see why his frank admission of having volunteered for the Nazi Navy, his statement that he had "nourished the hope that National Socialism, if it had gone the right way, might have developed into a system creating good for the German people," and his disbelief in the possibilities of a democratic Germany had changed world opinion of him. (144)

More importantly, it was Knauth who still could not see why it might have been more intelligent not to reject Niemöller simply as someone "utterly immoral in his politics," in whom "no one could put any faith . . . as a democrat, an anti-Fascist, or an ally in the political rehabilitation of the Reich—in short, as what some of us chose to call a 'good German'" (145). A submarine commander in World War I and an ardent nationalist, Niemöller, had resisted the Hitler regime for reasons of religious rather than political freedom. Though this distinction, drawn very sharply by Knauth, might have been misleading at the time, Niemöller certainly was not "a good German" in the stringent terms of the latter's safely orthodox concept of American democracy. Five years later he would send an open letter to Chancellor Adenauer, denouncing German rearmament and calling for a neutralist position. This made him, in the eyes of the Communists fighting West German rearmament, an outstanding pacifist—mil-

lions of copies of Niemöller's letter were distributed in East Germany. But Knauth, who liked his "German question" wrapped up neatly, would probably not have appreciated the considerable ironies—or consistencies—of that situation.

Life, which was *the* voice of mainstream America at that time, had sent several staff photographers to Germany in the spring of 1945; one of them was Margaret Bourke-White, who worked closely with Knauth. Technically brilliant, notorious for her rapid "snapping" and huge consumption of film, but also for the intrusive staging of her documentary shots, Bourke-White raced from one theater of war to the next, from one hot spot to the other—battles, concentration camps, the most photogenically surreal piles of ruins. Judging from her memoirs and from the book based on her photography during the *Life* assignment, "*Dear Fatherland, Rest Quietly*," she captured extraordinary sights in Germany but did not have much time to reflect on what she saw.[51] One of the images in the book's first section of photographs, "Faces: The German Look," juxtaposing Nazis and anti-Nazis, is of a middle-aged woman teacher; the caption, explicitly authorized by Bourke-White, reads: "Professor Koch has the eye of a fanatic. All her life she had worshipped Germany, as she had been taught to do. Germany alone still claimed her concern, and she had utterly no interest in the suffering and hardship Germans had brought to other lands. Most of all, she could not realize that the Germany for which she had prepared her pupils during the last decade existed no longer. 'America must supply food, or Stalin will have an easy time,' she said."[52] The middle-aged, rather mannish, assertive woman depicted in the photo could be any self-assured professional woman of the time, matter-of-fact rather than fanatical. She is described at some length as the perfect example of "German equals Nazi" in Knauth's *Germany in Defeat* (140–42) and in his essay "The German People: A Few Anti-Nazis Face Appalling Job of Redeeming a Country that Feels No Guilt or Shame" in the *Life* issue of 7 May 1945—an issue important for bringing to its audience the first photos of liberated concentration camps in Germany. Bourke-White's own text, on which the caption drew, echoes Knauth's evaluation. But if her photograph of that woman is meant to document the equation "German = Nazi fanaticism," her double photo portrait (the first of "The German Look" section) of a Frankfurt protestant minister and his wife who "organized a secret anti-Nazi church to keep the faith alive," depicts two strongly molded "Germanic" faces of a type quite similar to Koch's. They too are meant to illustrate the stubborn strength of unquestioned beliefs. Yet where Koch's face is photographed to bring out the fanatic badness of her belief, their faces are photographed to show the heroic goodness of their belief because it enabled them to resist the Nazis. In "*Dear Fatherland, Rest Quietly*," Bourke-White tried to capture existential differences between good and bad Germans—which is understandable in that situation of a near total sociopolitical breakdown whose extraordinary, compelling visual clarity obscured its many meanings. She succeeded in a text that depresses the later reader with its awkwardly rigid self-righteousness. For the later viewer of the images gathered in the book, however, her failure to show such clear and enduring separation usefully illuminates the difficulties of "the German question" then and now. Inadvertently, she recorded in those photographic moments similarities as significant as the differences.

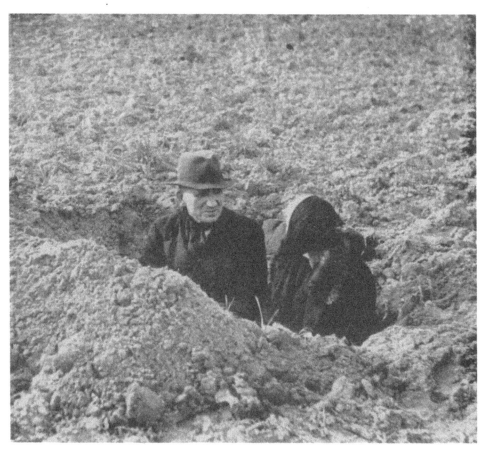

FIG. 2.20

William Vandivert's impressive cover photo of three exhausted German civilians, two teenage boys (one of them wounded) and an older man, introduced readers to the visual and verbal views of "The German People" that followed. The caption indicated that the three had just emerged from a mine slag pile after endless hours of bombing; it also asserted that they had survived with their arrogance intact, contradicting to a large degree the much more complex, composite visual message of this image. If anything, the three look exhausted, grim, numb, and anxious.[53] But the caption's message was in line with Knauth's essay and the camp photographs, which were intended to show the quality of German defeat and thereby of American victory. The camp photographs were important because the strongest possible proof of German collective guilt was necessary in order to show the criminality of enduring German arrogance and unwillingness to accept defeat. Four of these photographs—of inmates from Belsen and Buchenwald—were Bourke-White's (*Life*, 7 May 1945, 33); but *Life* did not run her portrait of the woman "Nazi" to complement Knauth's piece. Instead, his essay was prefaced by a Robert Capa photograph of a "frightened" elderly couple squatting in a "safe foxhole. Unlike the young people, older Germans were friendly

FIG. 2.21

and anxious to please Americans" (fig. 2.20)—a reference to the cover photo. Capa's compelling image shows the two properly dressed elderly people crouching in a hole in the earth in the middle of nowhere, talking, or perhaps smiling at each other anxiously. With their upper torsos visible and, as suggested by the intriguing perspective, not much room for them to duck into the hole, they appear vulnerable rather than safe. Capa's shot clearly emphasizes the cruel contrast between the empty, raw earth that will not give proper shelter and the fragile, bourgeois propriety of the two old people who are desperate for a place safe from gunfire.

 Life had published another Capa photograph of civilians under fire in the issue of 9 April 1945: "A German family in a foxhole finds protection from the shooting. The foxhole was dug by paratroopers and taken over after they moved by this mother, daughter and son. At left is a brand-new pair of shoes, apparently the most valuable possession this family could bring" (fig. 2.21). (It probably was since shoes, especially for children, were almost impossible to obtain in 1945 and for years to come.)[54] This image was part of Capa's photo-essay, "The Last Round of Airborne Landings East of the Rhine Helped Start the German Collapse on the Western Front" (27–37). It was placed below a photo showing German soldiers and civilians "brought in by para-troopers," lying down under two little trees in order to escape the gunfire sweeping the fields. The young soldiers look tense and fearful, uninterested in the photographer. But the mother, though perturbed, and the shyly smiling little girl seem to respond to him; and the little boy looks skeptically into the camera. Here, too, the hole in the earth seems too shallow to give much protection and, like the elderly couple, the mother and her children appear to have been dropped into it—coming from nowhere and having

FIG. 2.22

nowhere to go. Wherever they turn there will be danger and chaos. Having "brought it on themselves," do they deserve it? The captions here do not raise this question, at least not explicitly; and the visual messages are too complex and ambivalent to sustain it.

The question of German guilt and deserved punishment is raised emphatically by the photographs of atrocities committed in concentration camps located in Germany, six pages of powerful, harrowing images, their confrontational effectiveness enhanced by *Life*'s large format (32–37). Knauth's essay clearly derived its authority from the implications of that evidence. However, the visual information of the images directly connected with the text seems to diffuse rather than affirm Knauth's judgments. Apart from the elderly couple in the foxhole, there is a photo by Johnny Florea of a group of children watching "as Ninth Army jeeps enter their wrecked village. Putting his hands over his ears, one small boy shuts out the noise that comes with being conquered (fig. 2.22). Most cities were found empty of youth. Hitler Youths over twelve were delegated to dig emergency fortifications around cities, girls to work in remaining factories." The caption is neutral in tone; there is, for instance, no mention of the danger of young "Werewolves," a Nazi guerilla group romanticized and much exaggerated in the foreign press, Knauth's essay included.[55] But there is also no mention of the vulnerability evident in the different reactions of the children who *are* there, standing by the side of the road emptied in anticipation of the victors' invasion. Some are curious, some apprehensive, hiding behind the corner of an old, half-timbered house, clearly not eager to see what is roaring down the narrow dirt road of their village; one small boy is sucking his thumb for comfort. The children's perspective on the first advancing jeep with the two helmeted GIs and protruding gun is cleverly established:

though they are in the left foreground and much larger than the jeep in the right middle ground, the vehicle carrying the large-headed figures appears threatening in its alien compactness—a threat reinforced by the second jeep approaching in the background.

Knauth concluded his essay with an emphatic warning that the "Nazi" Koch, like all Nazis big and small, would be a serious obstacle to a future democratic Germany. But his pessimism is not supported by a Bourke-White photo, placed at the end of the text, of a "Cologne trolley car inspector" in uniform, with Hitler mustache and the most marvelously "inexorable" expression. (The phrase "unerbittlich," inexorable, uttered in Hitler's emphatic intonation and his characteristic response to situations that required just the opposite, would be ringing in the ears of Germans cleaning up the mess caused by it for years to come.) Leaning on a bicycle, he looks like Charlie Chaplin playing Hitler rather than the "typical small Nazi" of the caption, who had "confidence in Germany's victory until bombings stopped his cars." The rogues' gallery of Nazis in the first section of "*Dear Fatherland, Rest Quietly*" does not inspire much confidence in Bourke-White's face-reading since, as even some of the captions admit, Nazis do not always look the part and, by the same token, neither do anti-Nazis. Not known for her sense of humor, she might have seen in this minor official's momentary expression of comical pomposity a direct connection with the grotesque and dangerous self-importance of Hitler and the Nazis. From today's vantage point, this image ridicules the subject so successfully, no matter what the photographer's intentions, that it is of little help in Knauth's efforts to indict all the thoroughly bad Germans.

Bourke-White and Knauth were particularly interested in Koch, the teacher, because they saw in her the perfect realization of "the German" who would have to be made over completely before she could be accepted into the new democratic Germany. Bourke-White's book text notes the woman's "pale blue eyes peering at us intently through rimless spectacles" and her talking "with such rapidity and with such a lecturing manner [in fluent English] that it was difficult for Percy or me to interrupt with questions" (149). The greatest shock to them was her insistence on the positive meanings for the common people of some of the social ideas and institutions during the earlier phase of National Socialism. How could she say that in the midst of her defeated country's ruined cities and destroyed lives? With her arrogant rigidity and her "impossible" claims to know more about Germany's past than the victorious questioners, she was German to the core. Though not a member of the Nazi party, and known as a steady, loyal member of the oppositional Confessional Church, this essential Germanness made her an incorrigible, dangerous Nazi, no matter how she saw her past, herself.

But what was she "really"? Knauth and Bourke-White had met her at the Frankfurt cemetery at the funeral of a family that had died by suicide and about which Niemöller said in his funeral sermon: "Their act of self-destruction was as much an act of fate as the death of the thousands buried as victims of Allied air raids." Privately he told Knauth: "There you have four real victims of propaganda"[56]—an interpretation that, in Knauth's understanding, fitted this incident neatly into "the German question." When the order had come from Berlin for all women and children to evacuate the cities and all men to stay and resist with their last breath, the father—who for

health reasons had so far been able to escape combat duty—killed his teenage daughter and baby son and then committed suicide with his wife. He could not bear to see them become refugees, joining the huge stream of migrants that, perhaps more than anything else, separated the civilized past from the brutal chaos of the present. Knauth seemed to be surprised that "neither he nor his family ever questioned the order or considered the possibility of simply staying in Frankfurt" (69).

Crazed though it was, the order could not be questioned in any meaningful way; it could be disobeyed, and many people did—though the streams of evacuees from the cities contributing immeasurably to the misery and confusion continued to grow. If one stayed in the city illegally, there were no ration cards, there was no way to obtain food or any other services. If one left with a fistful of ration cards, there was no food to buy on the way. There were the reassuring "official" photographs of women and children, waiting expectantly in orderly offices, to be handed special ration cards for an orderly evacuation by motherly women clerks who, miraculously, had found flowers among the ruins to put on their orderly desks.[57] But these were cruel fictions. For most people in the beleaguered, bombed-out cities, there was no way of knowing what would be the better solution. Where Knauth emphasized the family's failure to disobey—a crucial flaw in all Germans—Niemöller, who had disobeyed, emphasized the concrete victimizing power of propaganda. These four people were its "real" victims because propaganda—utopian scenarios rather than realistic assessments—continued to control and destroy their world to the point where nothing, no decisions, would make any sense. This dilemma was understood by Niemöller but not by Knauth, who had brought with him his own, if well-meaning, utopian assumptions.

Occasionally Knauth did seem to understand that the people he was sent to describe were in a state of shock but, inevitably, that their shock, too, had a German flavor:

> Their homes had been bombed beyond all description and in the last days they were frequently shelled. Their lives, in a sense, had come to an end; what lay ahead of them none knew. Like automatons they scrambled warily out of the ruins and stood blinking in a world without an all-powerful government to regulate and dictate their lives, a world in which they sensed, some dimly, some powerfully, the first breath of freedom. In those first days the Germans mostly tapped their way uncertainly toward the new authority, the Allied Military Government. (70)

They were extraordinarily obedient: they lined up to read the announcements of curfew hours and the orders to surrender all vehicles, firearms, radios, and cameras (fig. 2.23); they lined up in front of the almost empty stores to buy food. If supplies ran out, they lined up patiently in front of the Military Government offices, "waiting like children for their new masters to feed them" (70). They gave directions freely to the GIs roaring through their streets, "some in an almost embarrassingly servile way, tipping their hats, gesturing wildly, anxious to please." Old men scrambling in the ruins would "straighten up when an American soldier came, smile apologetically and ask 'It's all right for me to look for things, yes?'" These older men, Knauth observed, were "almost uniformly anxiously friendly. It was only in the eyes of some of the women that the Americans saw bitterness or hostility" (71). There were no young men and

FIG 2.23

women; teenage boys had left with the troops to be deployed in some "last effort" (*letzter Einsatz*) in some other town, and teenage girls conscripted for factory work had been evacuated. With all the young people and the men gone, the rest — women, children, and old men — were in Knauth's eyes thoroughly infantilized, expecting to be taken care of by their "new masters."

With the exception of the two adolescent boys on the cover photo and the comical trolley car inspector, all German civilians appearing in the photographs of this issue are women, children, or old men, but the context established by the images of German atrocities made it clear that their relative weakness or helplessness would not absolve them from collective responsibility and guilt. The verbal perspective on what the photographs of civilians show — in contrast to the visual perspective discernible in the images themselves — was shaped by that message. *Life* warned its readers that the pictures taken by four *Life* photographers of liberated camps in Germany were "horrible. They are printed for the reasons stated seven years ago when, in publishing early pictures of war's death and destruction in Spain and China, *Life* stated, 'Dead men will have indeed died in vain if live men refuse to look at them' " (33).

The section titled "The German Atrocities" is introduced by George Rodger's full-page photo of a small boy walking toward the photographer along a road, lined with corpses, that emerges from a wood (fig. 2.24). The bodies are laid out neatly side by

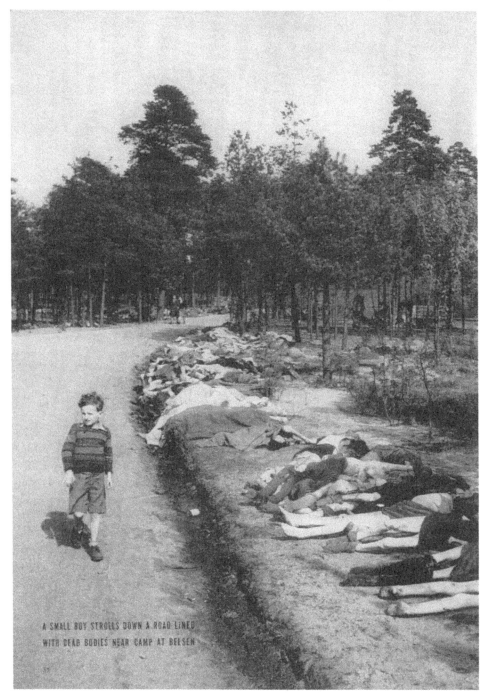

A SMALL BOY STROLLS DOWN A ROAD LINED
WITH DEAD BODIES NEAR CAMP AT BELSEN

FIG. 2.24

side on the grass, some of them covered, some not, and the long, thin legs point toward the child, whose head is slightly tilted away from them. The caption reads: "A small boy strolls down a road lined with dead bodies near camp at Belsen." Behind the boy, at some distance, are two women walking arm in arm, looking deliberately ahead, away from the corpses. They may be the boy's mother and older sister. The interesting question is why the photographer chose to focus on the child, and why the *Life* editor working with his contact sheets chose to introduce the first photodocumentation of "The German Atrocities" with this particular image.[58] The photographer's choice resulted in a visually intriguing image with a complex message about the difficulties of witnessing. The word "strolls" is oddly out of place. The boy, thin but not emaciated, dressed in clothes that are shabby but not ragged, seems ordinary but remarkably unchildlike. His head, too large and heavy for his frail body, suggests an old man rather than a child. With the sun in his face, he looks at but does not respond to the photographer, who must have been directly in front of him; he does not respond to the corpses to the side, either. What has he seen? What will he say to his mother and sister? Has he seen other corpses before, perhaps in air raids? Has his father been killed in the war? Have death and destruction become commonplace in his world? What have the grown-ups told him about it? *Are* there any grown-ups, or have they all been infantilized—by political ideology or by experiences too extreme to cope with intelligently?

The overall impression is one of profound isolation. The solitary figure of that child suggests not so much German denial of guilt or shame—understandably a much repeated concern of *Life* and America during these months—but numbness, an inability to understand the meanings of what is shown to him. In terms of its visually complex message, this photo was an excellent choice to prepare *Life*'s readers for the images to follow, which are indeed horrible—perhaps even more so now, half a century later, after they have become icons of cultural failure and we have been forced, or forced ourselves, to look at them again and again. But did the editor intend that kind of preparation, or simply misread the image, finding in it the demand for German acceptance of collective guilt and promise of collective atonement—the concerns of this issue?

Knauth connected the fact that the "Nazi" Koch felt "no sense of guilt, no sense of responsibility" with her enduring nationalist Germanness. Arrogant and rigid, she was not really a woman. Though she was, as he saw it, helpless without the nationalist doctrine of the collapsed regime, she did not share the childlike obedience of many other Germans. She, so Knauth's conclusion, is the reason "the workers and the small elite of intelligent bourgeoisie say, even as Germans, that their country needs Allied control. She is our problem and the world's" (76).

The problem with Knauth's and Bourke-White's reports from Germany in 1945 was their irrepressibly stereotypical sorting of everybody they met into large groups of very bad Nazis and small groups of very good anti-Nazis—helped, no doubt, by Germans who presented this scenario to them and whose guidance, under the confusing cirumstances, they could not afford to doubt.[59]

A letter to the editor in *Life*, 14 May 1945, complained about William S. Schlamm's piece on Hitler in the issue of 23 April 1945, quoting back to him his statement: "The

Germans are no savages. In fact, they are idealists. They step on your feet only because they are always reaching for the stars." The letter writer juxtaposes this statement with the images of German atrocities. In his response Schlamm expressed the hope that "at least a second look at my article will notice the irony—an irony which was and remains bitter for precisely the reason [of the atrocities] . . . " (8). This irony, deriving from what was, under the circumstances, an extreme dichotomy, did not explain the Nazi disaster but presented the issue in broad terms of cultural traits, leaving the dilemma intact. In contrast to Knauth, Schlamm did not claim to "solve" it by simply equating almost all Germans with all of National Socialism.

Among the images of German atrocities at Belsen, Buchenwald, Nordhausen, and Gardelegen in this issue of *Life*, William Vandivert's photos of "the holocaust of Gardelegen" (34 and 35) are perhaps the most impressively graphic. The burned and eerily immaterial corpse of a political prisoner leaning against the solid brick foundation beneath a beam, and the head and arm of a prisoner squeezed under the barn door, the rest of his burned body invisible inside the barn from which he could not escape, were "sights" much photographed by war reporters. The sitting corpse, for instance, was shot from almost the same position by Sgt. E. R. Allen of the Army Signal Corps (fig.2.25).[60] Florea's photo of the Nordhausen labor camp, with its skillful use of perspective, brings out very well the disturbing contrast between the rows of corpses laid out neatly along a bombed street for burial and the walking and standing GIs surveying what in the foreground looks clearly like human remains but in the middle ground and background more like harvested plants on a field (36).

The most harrowing image is by George Rodger: "Two German guards, knee-deep in decaying flesh and bones, haul bodies into place in the Belsen mass grave. The bald-headed SS officer worked at the camp before its capture by the British in mid-April. He is assisted by a strong-armed German SS girl wearing leather jack boots. British Tommies forced Germans to dig this pit and bury the scattered corpses" (37). The two guards are literally wading in decomposing matter, splattered by it, straining not to lose their footing. With the camera directly on the man's grim face, he pulls at one leg of a badly decayed corpse, the young woman half turned away from the camera holds on to the other, the body seemingly dissolving in their bare hands. Dressed in civilian clothes, her shirtsleeves rolled up, she does not look all that "strong-armed" and her "leather jack boots" are hardly visible. In the context, the man can easily be seen as brutal. Heavyset, uniformed, and with a large bald head, a cigarette in his mouth against the stench, he looks the part of the SS guard. The figure of the girl, her face concealed by her hair falling across her face and almost touching the gruesome matter, is more ambiguous (fig. 2.26). Whatever the photographer's reactions to the two people, shooting from that angle and from very close up he has created a perspective that forcefully draws the viewer into the horrible morass.

On one level, the image speaks for itself. But Mosley's description of this scene in his *Report from Germany* (cited above) and other photos of the Belsen women guards taken by Rodger add information that modifies its visual message. Mosley and a woman reporter in whose company he saw Belsen found it difficult to understand how the women guards could have been willing to do that kind of work. They found out

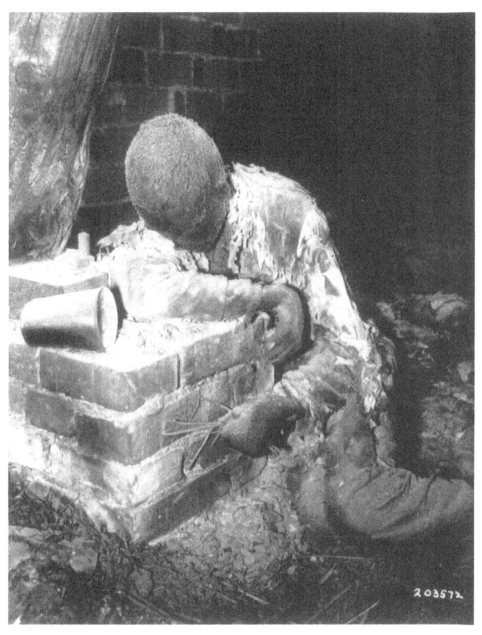

FIG. 2.25

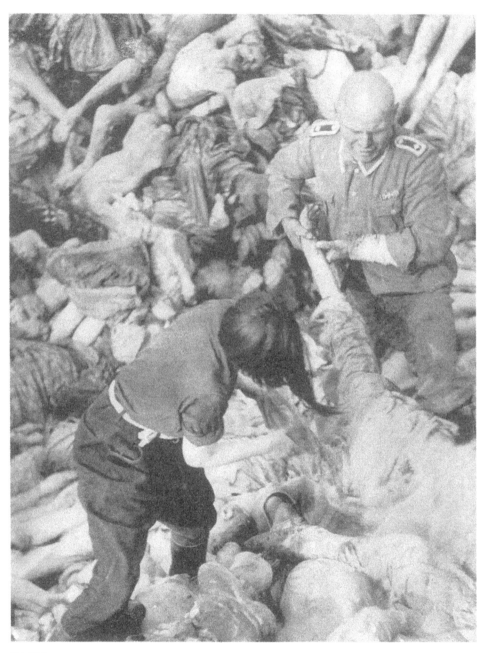

FIG. 2.26

from the inmates about a guard named Anneliese Kohlmann whose first job this had been. A pretty, dark-eyed, black-haired, half-German, half-French girl, she had left the camp with the majority of the SS staff; in love with another woman guard, she put on civilian clothes and smuggled herself back into the camp as an inmate. The inmates allowed her to stay with them unmolested till the British came but then revealed her

secret (94–95). She is the girl in Rodger's *Life* photograph. He also photographed her with other women guards, among them the head guard, Elisabeth Volkenrath, a former hairdresser who was later hanged, and Frieda Walter, a former textile worker who was acquitted. The women, all from lower middle-class backgrounds, look perfectly normal in Rodger's snapshots—in stark contrast to the "mug shots" taken by a British army photographer, Sergeant Siverside, as they awaited trial in Celle in August 1945; there, both Walter and Volkenrath look the part of inhuman camp guards.[61]

What, then, do these photographs tell us? Do they affirm the "German look" of Bourke-White's photos of Nazis? Mosley thought Belsen the proof that "given the sort of regime which thrives upon it, any man or woman can be brutalised and degraded into committing the worst kinds of cruelties." He also mentioned that many of his colleagues reacted with rage to Belsen, wanting all Germans wiped off the face of the earth, forgetting that many of the victims had been Germans. "Belsen, far from making us rage against all Germans, only made us realise once again that brutality knows no frontiers, nor nationality. You do not need to be German to beat and kick and torture. All you need is the regime that encourages the instinct; or, if it is wartime, the excuse of high-minded indignation" (95). Rodger's photos of the four women guards seem to make the same point.

This balanced attitude to "the German people" and "the German question" was rare in 1945. The situation did not encourage thoughtfully moderate views. But while the absence of such moderation is not surprising, it did have consequences for the memory and historiography of that chaotic period. The nightmarish scenes at Belsen were partly the result of the panicked incompetence of unintelligent, unfeeling people who, though dulled and brutalized, had not all been demoniacally cruel, pathological killers. Yet the images that have persisted in the cultural memory of these events are not of those dim figures who vanished with or without deserved or undeserved punishment. They are of the archetypical German officer in the Ishbitza ghetto recalled vividly half a century later by Mordecai Strigler, the author of influential, semifictional books about the Holocaust: "I saw a German officer go up and look over a pretty little girl of thirteen who had just been taken off a train. Then he calmly took out his bayonet knife and ripped up her belly. I saw this."[62] This officer, clearly visible in his archetypical inhumanity, has appeared in many "memory-stories" of the Holocaust.

The cover photo for the official end-of-the-war-in-Germany issue of *Life*, 14 May 1945, showing an infectiously jubilant "Victorious Yank," was Robert Capa's extraordinary image of a young GI standing high up on the main tribune in the "Zeppelinfeld" of the Nuremberg *Reichsparteitagsgelände* (stadium) in front of the large central emblem of the defeated regime, the swastika, his right arm flung up in an energetic salute, his victor's face all smiles (fig. 2.27). *Life*'s caption reads:

> The American soldier on the cover—a Virginian named Strickland—is one of the millions of G.I.s who have won the victory in Europe. When *Life* photographer Robert Capa took this picture, Strickland's detachment had just captured Nuremberg, Nazidom's shrine. This was a historic moment. But having just made history, Strickland proceeded to mock it. In a stadium where Hitler had often stood, he raised his right hand and, with a burlesque Nazi salute, proclaimed a G.I.s razzing epitaph on Hitlerism." (22)

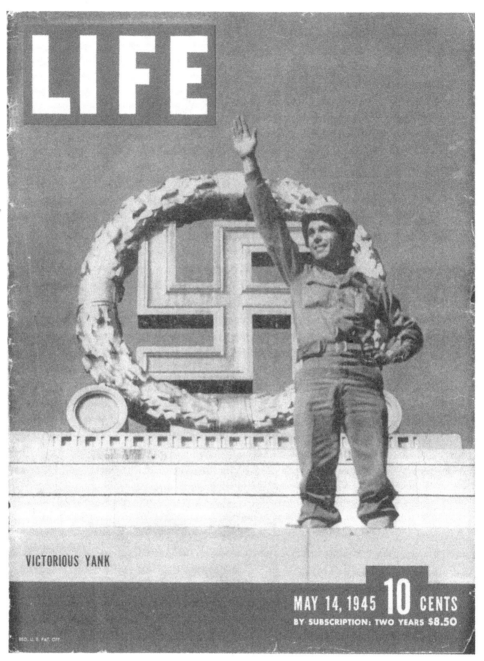

FIG. 2.27

Capa's photo, later reproduced in a collective volume, was severely cropped for the *Life* cover in order to emphasize the figure of the GI, the *individual* soldier whose *individual* contribution to the community's successful war against evil fascism was to be honored.[63] But the cropping changed dramatically the visual message of the image. Taken around 20 April, the day Patton's Third Army "took" and liberated Nuremberg, the image suggests more and different aspects of that victory. The city's large Gothic and Renaissance core almost totally destroyed by air raids, Nuremberg was a strikingly clear example of the political-architectural intertwinement of Nazi present and medieval past, which linked the huge stadium with its choreographed enactments of significant German community (captured brilliantly by Leni Riefenstahl) and the walled medieval castle that had protected a community's old urban spaces, wealth, and cultural splendor. With this intertwinement, the city illustrated quite literally the Nazis' simultaneous move "back to the roots" and "on with modernity" — arguably the most important key to their success and quite in keeping with late twentieth-century cultural anxieties and desires. The radiantly young GI with the swastika and the open sky behind him is in the upper half of the image. The whole lower half (most of it cropped for the *Life* cover) is taken up by part of the white, upper wall of the tribune which, partly draped in dark burlaplike material, suggests an enormous stage. On this stage was presented the sinister, grotesque, for a time all-absorbing drama of National Socialism, which was ended by the victors. In its sheer exuberance, the victor's salute suggests not so much mockery as the energizing exhilaration that comes with the completion of defeat. In comparison with the *Life* version, the smallness of the human figure in relation to the huge, now empty stage does not diminish the power of its presence: for the moment it is all that counts. About a year later, D'Addario shot a tame replay in a scene showing a GI about to photograph his German girlfriend at the bottom of the main tribune, now renamed "Soldiers' Field." Three laughing GIs above them raise their arms in the Nazi salute. The extraordinary moment of victory has changed into the routines and emblems of occupation. Beneath the dominating sign of the victorious Third Army painted on the tribune wall — an enormous white A (for Army) in red and blue circles (for occupation) — the unsoldierly GI is fussing with his reflex camera, his woman friend demurely waiting for him to shoot.[64]

Life's photographic essay in the issue, "The War Ends in Europe" (27–38), is accompanied by Sidney Olson's "Defeated Land: Germany's Cities Are Crushed, Her People Are Frightened and Servile." Olson, who "traveled fast from place to place and saw many of the final ruinous scenes," brought out the theatrical aspect, the "fantastic show" of Germany's collapse:

> Germany is a chaos. It is a country of crushed cities, of pomposities trampled on the ground, of frightened people and also glad people, of horrors beyond imagination. Through the ruins of the great cities move the most motley crowds Europe has seen since the Crusades. The greatest number are Germans. You can tell the Germans by their manner; they are stunned and tired and beaten and frightened; they start when spoken to, they smile timidly, ingratiatingly and beg information most humbly. Even a German in the greatest of distress does not stride boldly up to any American to ask for help or direction. He plucks your sleeve softly. (39)

FIG. 2.28

The photodocumentation in the section "The People: They Have Nothing Left without Nazi Masters," however, suggests that the "new masters" in many ways expected and encouraged such behavior. Frankfurt civilians are shown lining up patiently in front a food store that looks distinctly unpromising; but we also can see the American Military Governor of Frankfurt, Colonel Crisswall, in a moment of intense anger that the new Frankfurt city council had allowed stores, which were essential for the city's survival, to open without their first being investigated and licensed by the Military Government office. The burly, screaming colonel, inflated by rage, is in every respect all-powerful vis-à-vis the thin, anxiously shrinking bespectacled member of the city council who, quite courageously, nevertheless seems to be trying to argue his point (fig. 2.28).[65]

The images are quite matter-of-fact where Olson was moved by the extraordinariness of the situation to be more colorfully emphatic. Observing how German civilians cooked over open fires then took their food down into the "innumerable caves and cellars" where they had been living for a long time, he conjured up an image of their life there: "They live like people will perhaps when the ice returns over the earth,

huddled together for warmth and comfort . . . with someone outside in the night guarding the hole that leads down to their caves. In those caves life is exactly what you imagine it to be: foul and pitiful, but at least warm and safe against the bombs and the terror outside" (39).

In Olson's view of Germany, the ice age had returned; moreover, it would stay for many years to come. In Dachau, viewing railroad cars full of dead inmates, he encountered a German civilian who rode his bicycle up beside him, crying and trembling. Like most Germans, the man said, he had never believed stories about the camps until he saw this trainload of political prisoners evacuated in a panic from other camps to be left on a siding to die from lack of water and food. This German, Olson thought, did "not even care if the angry G.I.s around him killed him; he was so desperately, abysmally ashamed of being a German" (103). Germans, he told his readers, were shocked by the American nonfraternization policy, horrified to learn that they had not fought an honorable war. Finally realizing that they had lost their sons for a "cause unspeakably dirty," German parents were filled with a despair that would "mark the rest of their lives" (110).

But Olson also concluded that these Germans, "at the bottom of the list of civilized nations," living in stone age conditions, emaciated from lack of food, typhoid and other epidemics, would persist in their state of indoctrination: "It will take years, perhaps generations to undo the work that Adolf Hitler and his henchmen did" (110). Olson, in many ways a thoughtful, not unsympathetic observer, responded to a situation of physical and cultural chaos and pervasive despair. His predictions that it would endure for years to come may have seemed perfectly plausible at the time. It is to the victors' credit that political and economic order was established more promptly than most people thought possible. Whether or not West Germans could be expected to be "good Germans" in the terms of 1945, they did become good citizens of a stable democratic society. But because of the quality of Allied victory half a century earlier, which determined their identity in defeat, important aspects of that chaos and despair have remained unarticulated in their memory and therefore insufficiently explored in their history.

What They Saw

GERMANY 1945 AND
ALLIED PHOTOGRAPHERS

ONE OF THE greatest fascinations of photography is the closeness of the viewer to the viewed, often the result of the camera's disrespect for the subject's "territory." It is true, in many cases it is precisely the photographer's aggressive exercising of intrusive power that produces socially relevant visual messages. Nevertheless, a remarkably pervasive cultural tolerance of imposition and trespassing for the sake of the photographic image raises some instructive questions. In Max Kozloff's words:

> We condone unreflectively such inveigling, prying, or surreptitious behavior, for we've come to think we have a natural right to the images it affords us. For the photographer, this signifies that ends disproportionately command any means that are required. A certain insensitivity sets in, a mark of the professional who could be disregarding personal safety in an effort that is uninvited or in officially off-limits or forbidden places. Nothing so begets desire as prohibition. Embedded in much photographic activity is a kind of selflessness mixed with an implied prurience.[1]

Photographs of war and conflict reflect this mixture to a high degree, and the practice of Allied photographers in 1945, who habitually took photos of the German population without any concern for their privacy and dignity, not to mention their consent, provides good examples. In such situations the frequently noted military vocabulary of photography is particularly appropriate, direct, and non-metaphorical: "shooting" the picture, "taking" the shot, "losing" the picture. Here, somebody else's turf is invaded more freely and rules of civility are more easily broken because documentation of military and political victory—the particularities of the loser's defeatedness—carries its own unquestionable justification. Here, too, the urgency to record what can be seen now, this moment, but what will have changed or disappeared very shortly, exacerbates that combination of selfless absorption in what can be seen

and the desire to see and record it at any price. Margaret Bourke-White, whose book *"Dear Fatherland, Rest Quietly"* presents the most substantial photodocumentation of Germany 1945 produced by an individual photographer, describes that curiously mixed active passivity when photographing in the camps, snapping away rapidly: "No time to think about it or interpret it. Just rush to photograph it. . . . Record it now—think about it later. History will form the judgments."[2] She had to take her effective images of camp inmates "with a veil over [her] mind," working, like many other war correspondents, in a kind of "self-imposed stupor." Their position, she thought, was "privileged and sometimes unhappy"—because of what they could but also had to look at; their "obligation" was to pass on to others what they saw (259–60).

Like victory, this obligation is not easily doubted. One of the sights not to be missed by foreign war correspondents in the Germany of 1945 were the streams of displaced Germans who had come to Berlin hoping for shelter after harrowing forced migrations from the east. But once they had reached their goal, having barely survived the extraordinary hardships en route, they were immediately directed to leave again since the city, damaged beyond belief, could not accommodate them. On the road for many months, they had been unable to rest, cook, wash, or change their clothes. Carrying all their possessions in a few sacks and bundles, holding their underfed, sickly, fretful children, they rushed frantically through the bombed out Anhalter Bahnhof, trying to catch one of the few, erratically scheduled trains that would take them away from Berlin. Disappointed again and again, hungry, exhausted, confused, they were indeed, as Bourke-White saw them, scarcely human in their panicked self-centeredness. She photographed Red Cross girls on the platforms, collecting food for German POWs from people who themselves had very little or nothing, and who handed what they could gather "bit by bit through windows crowded with unshaven faces under rusty green caps." She overheard them admonishing the hungry soldiers not to be greedy and she also heard bystanders expressing their negative feelings about her recording the scene: "It's awfully sad now. . . . Foreigners taking pictures of us and sending them to the newspapers." They sensed that these photos would not show them sympathetically; they would not be seen as appeals for help. One of the soldiers crowding for food at the window voiced his resentment more strongly. When Bourke-White realized that his remark, "I would like to shoot her!" was meant for her, she felt "uncomfortable" and "walked a short distance away."[3]

But she did not stop shooting. And the soldiers caught in that train, behind that window, could not escape her camera. Nor could the women, crouching among their bundles and their children on the platform, again defeated in their attempt to board a train that would get them out of the hellish mess. A conscientious reporter, she also recorded her subjects' bitterness at being "taken" without their consent in their current diminished state of desperation. But she did not let this influence her overriding "obligation" to observe and record. Moreover, this obligation was inextricably tied up with her professional perfectionism: all means were justified to produce "great" photographs. An admiring interviewer, who asked her about her admitted "savagery" in going after the pictures she wanted, got a savage answer: " 'If anybody gets in the way of what I am doing, making a picture, for a few minutes I think I could commit murder.' A picture, she pointed out, is 'very perishable.' For an instant people

fall into a relationship with the environment that is uniquely pictorial. Suddenly the picture is there. In a moment it will be gone — forever."[4]

This sense of self-conscious visual urgency combined with great technical skill made her a remarkable photographer but an uneven documentarist. The camp inmates who posed for Bourke-White, lined up behind barbed wire in striped jackets and trousers, may have had a clear sense of their victimization and wished it to be recorded for the world to see, that is, to respond to. In one of her best-known camp photographs, these "living dead of Buchenwald" appear fully clothed and not visibly malnourished — in notable contrast to the archetypical vulnerability of camp victims who were usually shown in their skeletal nakedness.[5] But the appeal of these men's victimization seems strengthened rather than weakened by their relative physical sturdiness because it allows the viewer to focus on their faces. Bourke-White came up with a brilliantly unsettling selection and arrangement of faces, all disturbed, strange, isolated, but connected in their power to both repulse and attract.

The photo was clearly staged. Bourke-White was notorious for arranging and rearranging her victim-subjects, even where her relentless search for the "great" picture would cause them severe distress. The high-minded documentarists of the thirties disapproved on principle of her staging as bad documentary photography, regardless of the circumstances or the results. And even Bourke-White's largely uncritical biographer, Vicki Goldberg, expressed, if indirectly, some reservations in that matter.[6]

In the picture of the camp inmates, however, the staging arguably helped to illuminate the painful, alienating "truth" of the results of inhuman treatment — a truth the inmates would presumably have wished to make clearly visible so that it would not be forgotten. If the picture was staged without their explicit and fully comprehending consent, it was still done in the spirit of their own, if dim, perception of their situation.[7]

When Bourke-White was shooting German refugees, she found impossible even momentary identification with the situation of her subjects. Germans were not victims since they had "brought it on themselves." There was nothing that engaged her, not even disturbing strangeness, in their commonplace struggle to stay alive. Instructively, in the refugees' own understanding of their situation, the question of victimization was ambiguous. Waiting endlessly for a train, any train, they dimly hoped they might somehow get somewhere and regain the ability to orient themselves. They had been evacuated or had fled from areas such as East Prussia and East Pomerania, escaping from advancing Russian troops who, in retaliation for German war crimes in the east, were notoriously hard on the civilian population. Or they had been deported by Poles and Czechs at very short notice from places where their families had lived for centuries. These deportations and the arbitrary killings of relatives and friends had happened for no other reason than that they were German — as Poles had been deported and killed by Germans.[8] Their migrations, which lasted many months, cost over two million lives, especially during the terrible winter of 1944. But the German eyewitness reports of these events, despite all the desperate details, particularly of Russian atrocities, show on the whole a resigned understanding that there would be no response. The world, indifferently looking at their fate as self-inflicted, owed them nothing.

Cool and detached, Bourke-White's gaze bears out the realism of that resignation. Beautifully coiffured and made-up, in her smart war correspondent's uniform,[9] she calmly photographed shabby, dirty, exhausted people scrambling for food or a place on the grotesquely overcrowded trains. At the moment they were "shot," some of her unwilling subjects may have resented her recording presence very much. Nevertheless, while the text of her chapter, "Berlin: A River of Wanderers," and the captions of her images reaffirm that Germans were owed nothing but punishment by the world, some of her images do not bear this out—at least not unambiguously. Not only do the pictures she shot at Anhalter Bahnhof tell a number of different stories, they also offer more and different views than those indicated by the captions. In general, her subjects appear less prejudged in her images than in her text because the photographic medium sustained the disjunction between what she let the camera picture and what she felt about the pictured. She was in the habit of declaring that going after good pictures she was going after "the truth." Even if her "truthful" photos do not really "show it as it was"—the actual experience of the people pictured—they still seem to show much more of it than her verbal descriptions. Some of the images recorded the chaos at Anhalter Bahnhof, a microcosm of the larger German chaos, in ways that help the later viewer understand its traumatizing, diminishing impact. And it is not even clear whether this effect was helped or hindered by her explicitly distancing perspective.

Watching the train leave without most of the people who had been waiting for its arrival for many hours, often for days, Bourke-White aptly described the visual impression created by the overcrowding on the train: women, children, men, many of them wounded soldiers, hanging on to every imaginable protuberance, crouching on top, on the running boards, the window sills, the fenders of the locomotive:

> The engine began gathering steam now. White swirls licked up around the bare legs of the girls and rose, hissing, to envelop the entire human cargo on the locomotive. As the engine wheels started turning, I noticed a boy who clung in a peculiar leapfrog position to a small metal footplate at the head of the locomotive. With both feet on this plate, his hands grasping something above his head, his knees spread wide to maintain his balance, he faced a journey of an indefinite number of hours. No one ever knew how long the trip to Halle would last. [Normally a three hour trip, it could take up to twenty-four hours. Bourke-White got a shot of the teenager smiling back at her (fig. 3.1); his hold seems as precarious as she described it.] . . . The long train was rushing past now, and the people clinging to the top and sides lost their identity as human beings and began to resemble barnacles. As the train gathered speed it might have been a chain of old boat hulls, whipping into the distance. I turned back to the station platforms and found them as thickly studded with humanity as they had been before the train had carried anyone away."[10]

Her photo of that train shows people sitting on the top, shortly thereafter, looking like barnacles, and also the crowded platforms (fig. 3.2). Though its visual message, literally unbelievable overcrowding, is neutral in tone, and though the photograph was taken for the sake of the record rather than for the recorded, we still see people, if not individuals, in a clearly difficult and dangerous situation—regardless of what she thought about them. This is true for all the images she shot of that train with its changing bevies of passengers scared away by the conductors only to re-emerge in

FIG. 3.1

different configurations no less precarious.[11] At some point one of the men standing on the fender of the locomotive is holding a cart while the conductor seems to be lecturing him—perhaps for taking up too much space. The caption of that photo reads: "A baby cart can carry a good load, needs no gasoline" (fig. 3.3). It is a very busy image, showing people being helped and pushed onto the train though it is not only filled but also covered with passengers. The cart, upright, resting on two wheels, appears like a ship's figurehead attached to that "hull" of the locomotive layered with human bodies. The people who have made it onto the train, looking down at the frantically milling people and into Bourke-White's camera, do not seem to mind her taking photographs; the others, still pushing, protesting, pleading, don't even notice it.

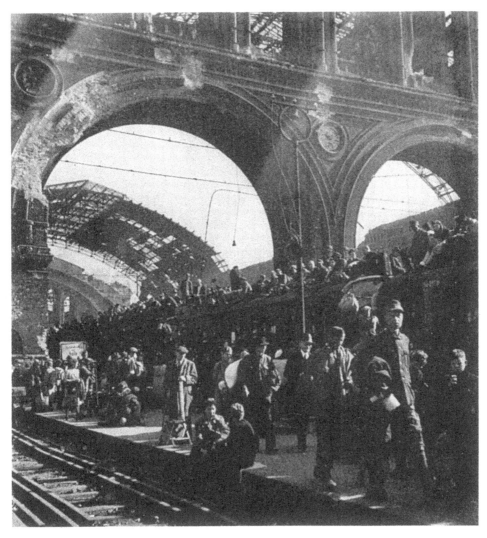

FIG. 3.2

Bourke-White's remote and simultaneously intrusive perspective on the futile attempts to escape might seem troubling to a viewer who looks at these images later, far removed from the panic and chaos. The caption to the image reproduced in fig. 3.2 reads—not surprisingly, given Bourke-White's perspective and visual interests: "Berlin's Anhalter Bahnhof had dignity despite its scars. Germans crowded it, quarreling and chiseling among themselves, overcrowding the few trains." Well photographed, the handsome ruin of the station has more presence, is visually more important than the hapless, frantic people. Yet no matter how much the person who took their picture disliked and condescended to them, she recorded them at the moment of their cultural and personal crisis. It is because they are still visible that the meanings of that crisis can be seen differently by different viewers. This is also true of the double-page image of

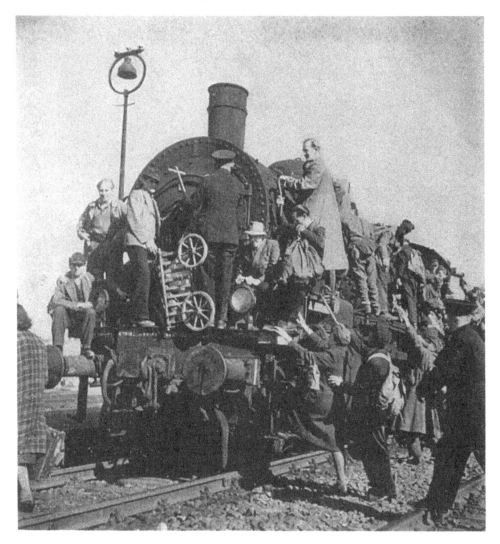

FIG. 3.3

crowded Anhalter Bahnhof shot along the length of the waiting train with every space occupied on top of the train and people standing in dense rows alongside it on the precariously narrow platform, holding on to window sills and handles, ready to jump up on the running boards the minute the train starts moving. In the foreground, their faces turned to the camera are visible, some laughing, some grim, and men and women, old and young are clearly distinguishable; in the middle distance they appear a blurred mass of vaguely human shapes, and in the background they have become part of the layered skin of the train.

After the train left, Bourke-White talked to a woman who had not made it and was settling her three children among their bundles on the platform to wait for the next train to Halle—she hoped the next day. Heading south, north or west, everybody had

to go via Halle and there face the same crowding and confusion. She explained that they had been expelled from their home in East Pomerania by the Poles and had spent months on the road, sleeping in the woods or in barns if they could find them. She had one pot for cooking and washing, which made it difficult to keep the children clean; they were getting skin diseases and there was the great fear of typhoid. She had been told that she could not stay in Berlin and was now trying to get to Hamburg, where she thought her older daughter still had a room. Bourke-White, who had seen "gutted Hamburg," did not want to upset her further by describing it; "but from her hopeless tone, I think the mother knew. It was just that there was nowhere to go, and beating their way along the roads and rails was the only thing they thought of to do" (169).

All of the family's belongings fit into their small cart, including a small supply of potatoes put there when they left home and replenished by farmers along the road; now, stuck in Anhalter Bahnhof, they are in serious trouble. The small carts, in all shapes and sizes for transporting sacks with clothing, cooking utensils, potatoes, children, and old people unable to walk, were omnipresent on the roads from the east and in the streets of German cities, especially Berlin, the conflux of the streams of refugees.[12] The cart had become the archsymbol of the collapse of the country, but also of the astonishing resilience of the people, especially the women still trying to stay together and get somewhere as a family, even creating, under the most unsupportive circumstances, a semblance of order—as did the woman on the platform, who rearranged her cart so that she could settle the youngest child in it right after her defeat by the train. There is also a Signal Corps photograph of older women sitting next to their wagons for a short stop on their endless trek from East Prussia, exhausted and dejected but with some flowers placed on a box in front of them—a contrast that obviously intrigued the photographer. Shooting an older couple with a neatly packed cart moving briskly across a sun-lit, completely empty town square encircled by the ruins of once handsome old houses and of a once beautiful large Gothic church, the man pulling, the woman pushing, an American photographer caught well the eerie desertedness of a once prosperpous city now fit only for migrants and their shadows (fig. 3.4). A similar cart with two iron wheels, also overloaded and neatly packed, being pulled by a middle-aged woman and pushed by an older man, is pictured in a photograph either taken or acquired by the Military Governor of Bremen, Col. Brian C. Walker. Known to take a personal interest in the people of "his" city, he noted on the back of the snapshot the place from which these refugees, expelled by the Poles, had come: "Öls 1000 km from Bremen on foot with cart, Aug. 1945" (fig. 3.5).[13] The juxtaposition of the couple's impossibly neat, whole, bourgeois presence—the smiling woman in a light-colored blouse, the man in jacket and tie—and their cart, the symbol of uprootedness and chaos, makes for a striking image, perhaps even helped by the artless directness of the photo.

There is no photo of the woman and her children, and despite the verbally recorded details of their difficulties, they remain largely invisible. Nor did Bourke-White include a photo of the woman's neighbors on the platform, a couple described for contrast as well-dressed and with a "beautifully equipped luncheon case." She ridiculed their intact bourgeois rituals—they carried plates and spoons for their "odd-looking violet pudding"—and suspected them of black-marketeering (169-70). There is, on

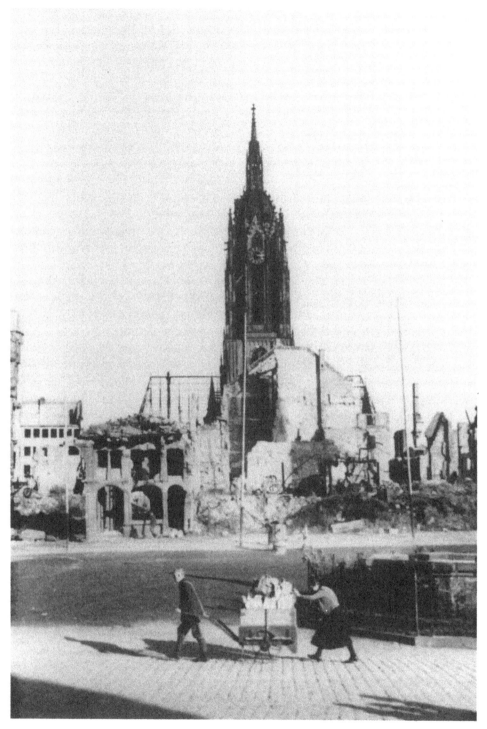

FIG. 3.4

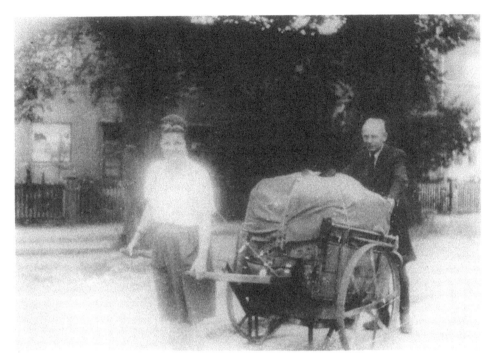

FIG. 3.5

the other hand, a photo of a group of people sitting a little farther down the platform.[14] One of them was a woman who had come to Berlin to buy small electric appliances for her store but had found nothing to buy and was now sitting among her bundles on an empty suitcase. In her "tweed suit, high halo-shaped hat, and shoes only slightly turned over at the heels, she was one of the best-dressed women on the platform" (170), and Bourke-White, suspecting her too of black-market activities, did not like her. She did like the woman's neighbor, who was sitting on a bundle, "a gentle-faced bespectacled man who was poking the track idly with his walking stick," exactly the pose in which he appears in the photo. "His striped trousers pronounced him an ex-inmate of a concentration camp, and proclaimed his unworldliness, too, for most men would have acquired something to wear in place of the hated penitentiary pants" (170). But this erroneous opinion is promptly contradicted by Bourke-White's text and the caption, which inform the reader that these clothes, signifying "the Good German," also entitled the wearer to all the important things that were otherwise inaccessible: shoes, clothes, food, shelter, medical attention, a seat in reserved train compartments.[15] The caption reads: "A concentration camp uniform brought a man special privileges. Other Germans hated him because of it. The woman came to Berlin to hunt black market supplies." The woman in the halo-hat looks like a skeptically determined business woman, the *Bibelforscher* ("Bible expert")[16] looks pensive. Bourke-White had no knowledge of the woman's black-marketeering or of "other Germans' " hatred of the *Bibelforscher*; but the rare good German had to be clearly separated from the overwhelming majority of bad Germans.[17]

Returning to Anhalter Bahnhof the next day to watch another departure of the train for Halle, Bourke-White found the platforms more crowded and the people more desperate because a new rule had been passed that banned them from traveling on top or clinging to the outside of the cars. The train she had seen leaving the day before had lost a number of passengers who had been swept to their death when their car passed under a bridge. GIs were sent to the station to prevent people from trying to ride on top but they finally had to fire warning shots, accidentally wounding one person seriously. She overheard German POWs comment that the GIs had acted within their rights, that the litter to carry the wounded man to an American hospital was of superior quality and that he would be well taken care of, above all well fed. She was surprised by their acquiescence and their preoccupation with food. Even more remarkable, she thought, was a young soldier, "his cheekbones protruding sharply from his tight-drawn face and his thin arms showing through his tattered sleeves." He talked longingly about his stay in a hospital " 'for a whole year, and it was wonderful. Just see what I look like now. Things were different then.' This young German, looking back and remembering his life as a soldier, found that the happiest year he could remember under Hitler was the year he had spent in a hospital." This is the last sentence of the last chapter. Did Bourke-White mean for this observation to carry some poignant insight that a young German soldier's fondest memory was not "fanatically" killing the enemy but tempo-rary safety from battle in a hospital after having been badly wounded? Since he was merely one of hundreds of thousands of emaciated, tattered, lost young POWs, she must have seen many like him on the roads and in the POW "cages." But she was not interested in showing to American viewers the boy-soldiers' vulnerability. With few exceptions (fig. 3.6), even the children she photographed appear somehow tainted by their "bad Germanness," especially in the captions.[18]

Bourke-White's perspective on Germany in 1945 now appears to us to have been obsessed with clear moral-political distinctions in a situation of almost total chaos which, in her verbal recording, she failed even to try to understand. Her Epilogue summed up her disgust succinctly: "This, then, was Germany after the Whirlwind had been reaped, a bottomless pit of malevolence and malignance. Cities and people were broken ruins together, but the venom the Nazis had distilled was virulent and held the power to hurt and to poison all men it touched. It touched Americans as well as Germans and it was frightening to see" (174). The Americans, she complained, GIs and visiting congressmen alike, cared more for looting and black-marketeering than for making Germany democratic; touched by Nazi poison, they had cheapened that beautifully just war. But at a time when she herself was in the position of unassailable victor, she too had given herself over to the exhilaration of "liberating," the term used for more or less officially condoned Allied looting of the possessions of the defeated. It would not have been as pleasurable without these "liberations," she thought, and the Germans had been worse offenders themselves.[19] In the "Diary of an Inspection Trip to Europe in October-December 1945," Navy Captain H. E. Saunders noted his observa-tions on excessive looting and marauding by Russian soldiers and Polish displaced persons, reflecting:

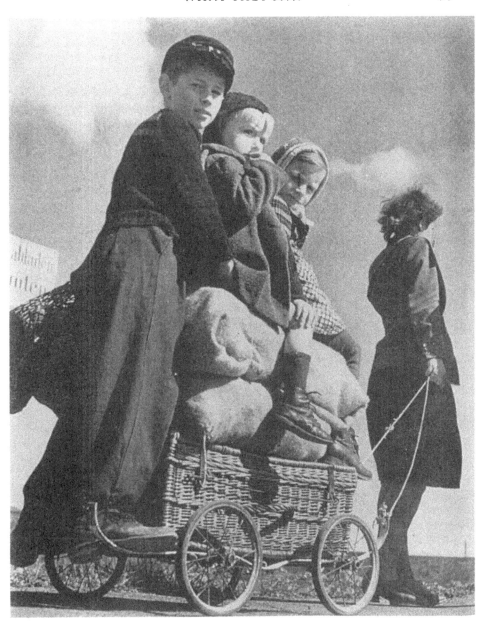

FIG. 3.6

War breaks down all sense of private property rights on the part of the conquerors, no matter who they might be. Although one is not supposed to take private property, an American in the American zone of Germany can walk off with almost anything he finds in the way of military or naval equipment, scientific apparatus, instruments, and records, commercial property, and public property. After a few weeks of filling our pockets and car with loot, what is to keep our sense of right and wrong from being

dulled, and what is to prevent our thinking that we can walk anywhere in Germany and take what we see and want, whether it belongs to a German Government agency, a German civilian, or even a Britisher or an American?[20]

Saunders was a sober, curious, and remarkably fair observer who respected the intelligence of many professional Germans he spoke to, if not always their political past, and accordingly he was troubled by some of the implications of the victor's position. Bourke-White was neither curious in that way nor troubled. In her Epilogue she lamented that Americans had given Germans nothing "to replace their Hitler-worship" except a few denazified textbooks, that they had not realized their "greatest opportunity to do something constructive with the youth of Germany," that they had no plan, no desire, no willingness" to teach a democratic way of life: "We poured our lives and boundless treasure to win a mechanical victory and now we had no patience for the things of the spirit which alone can save us from another far greater catastrophe. It was time to go home" (174–75). And so she turned her back on a people that in her description seemed scarcely human and almost certainly beyond democratic redemption. But her reaction, though in hindsight extreme, was in past actuality mainstream American in its profound disappointment that the Germans had behaved so abysmally and in the conclusion that they had to be remade completely and instantaneously. It was clearly reflected in the denazification program, which became a disaster precisely because it was so impatiently radical, that is, politically unrealistic.[21] Bourke-White herself normally had little patience for the "things of the spirit" — though her juxtaposition of the spiritual and the "mechanical" resonated strongly in what the bombs had left of German culture: spirituality blossomed among the ruins. However, Germans arguably did not need "things of the spirit" as much as political structures and a minimum of economic stability to become good democratic citizens, and in this respect the American victors, notwithstanding ideological vanities and political delays and mistakes, would prove to be very helpful.[22]

Bourke-White's disappointment may have been the reason why her assignment in Germany produced very few really good photographs, the image of camp inmates discussed above and some coolly beautiful areal shots of near-total urban destruction excepted. On the whole, the German abyss was too shabby to engage her visually. But there are many competent photos that present intriguing problems in connection with her texts. She wrote about her experiences in Germany from an openly personal perspective, favoring the anecdotal story over a coherently explanatory discourse. Encounters with individuals described in lovingly negative detail were meant to show them as representative of the "German question"; but since she staged and pared them down so relentlessly, her cardboard Germans yield little useful information. All the viewer of her photographs can do is agree or disagree with her, that is, read her strongly expressed opinions into or out of the photographs — or look at the photographs alone and disregard the text and captions.

Even though her images are more open than her text, the power of a particular perspective is clearly visible. Determined by her moral-political-psychological concerns, this perspective controlled her response to the fascination of the image as it

shaped her vision. And this vision was then reflected back on what she saw and needed to rearrange in order to make it more clearly visible, that is, more beautifully visual. It is entirely fitting that her most fully satisfying images of Germany 1945 are of "What Our Bombs Left."[23] She assumed that "cities and people were broken ruins together" because she could then forget about the presence of people amidst but distinct from the ruins, which for survival they tried to clean up as quickly as possible and "recycle." Bourke-White chose to focus on the ruins that were the victors' to leave behind, to be photographed and pointed at. There is, for example, the beautifully balanced shot of Cologne, "the first great German ruin that I saw. It measured the magnitude of the disaster that overtook the Nazis"; there is the beautifully drawn oval of twisted tracks surrounding the skeletal shapes of cars in the Nuremberg freight train station; unfortunately, "not enough was left of Hamburg to make an impressive ruin"; there are Bremen, Nuremberg, and Würzburg, with a few toylike shells of houses standing in the wilderness; and there is the tangled mess of beams and wires in the image entitled "Detail of Any German City." Here the fascination of the photograph was the distance that allowed her to see only one-dimensional shapes forming intriguing patterns undisturbed by human fears and hopes.[24]

Bourke-White's photos of the Anhalter Bahnhof are almost exclusively of the strangely overgrown, layered shapes of the train—the treacherous archsymbol of escape, of coming unstuck, but also of hope, and of change for the better. In contrast, Leonard McCombe's photographic essay on Anhalter Bahnhof, "Displaced Germans Driven from Their Homes by Poles and Czechs, They Pour Unwelcome into Berlin," published in *Life*, 15 October 1945, focuses on the fears and disappointed hopes of refugees and released soldiers not knowing where to go.[25] The text that introduces the images informs the reader that the deportees—dispossessed, unwanted, many of them sick and starving—were crossing the borders at the rate of 17,000 a day. By 1 September, according to *Life*, eight million refugees had arrived in Berlin, and there were two million more on the roads.[26] Refugees could stay in Berlin no longer than twenty-four hours; food was so scarce that during their stay they got only a few slices of bread and a cup of *ersatz* coffee—the ration distributed by the Red Cross workers photographed by Bourke-White. By the time McCombe took their pictures, there was no food left. Only refugees who could prove that they had family connections in the west were allowed to proceed to the desirable British and American zones. With all lines of communication down, they had no idea what they would find there: whether their families had survived, been bombed out, or were dispersed.[27] But without even these tenuous connections they literally had no place to go to and no place to leave from. Forced to keep moving back and forth between Berlin and the reception areas in Saxony and Mecklenburg, they were often just left in open fields to fend for themselves and their children without food and shelter, and with little more than the clothes on their backs. Some of them stayed on in Berlin illegally, disappearing into the ruins without documents and ration cards. Millions were expected to die in the coming winter months.

Told the facts of the refugees' situation, *Life*'s readers were instructed not to be moved by the images they were about to see:

The pictures on these pages, which were taken by British Photographer McCombe, are in detail terrible and shocking. But the millions of Europeans who were more terribly treated and degraded by the Nazis feel no pity or sympathy for the plight of the people who supported or permitted Hitler. These displaced Germans are being treated callously but not with the deliberate cruelty which their government once inflicted on others. They are, at least, allowed to live. These people allowed themselves to fall so low in the eyes of the world that the world, seeing their suffering, finds it hard to feel sorry for them.[28]

Notwithstanding this firm warning to uphold the hierarchy of suffering, McCombe's photographs were there for the viewer to look at, and they suggest that the vision of "the world" was not quite as uniform as *Life* would have liked it. Whether he felt sorry for these displaced Germans or not, he saw and recorded their misery and the desperate fact that in many cases they would not be allowed to live. Bourke-White's focus was on the shape of the train, blurred and thickened by the human appurtenances. She shot from a visual and emotional distance: along the length of the train and the people attached to it; from below, at the platform, up at the people crouching on top. The aggressive, intrusive aspects of her photography are linked to a remoteness that diminishes her human subjects—literally so in the case of the German refugees. McCombe shot from close up. Climbing up to the roof of the train, he got a good look at the people sitting there, bundled up against the October wind and rain if they had anything to wrap around them, a collar to put up, a pocket to warm a hand (fig. 3.7). The train is barely visible; the people covering it can be seen clearly. The caption says that "Germans from Eastern Europe swarm on top of a train in Berlin's Anhalter Station. Many have been here all night. Foreground: Released prisoners." Across some greyish human bundles and several similarly colorless crouching or reclining soldiers—the lucky ones in coat and cap—the viewer's gaze is drawn to a young woman in a dark coat standing in the left middle distance. Her hair blown about by the wind, frowning, hands on hips, she surveys the patient human mass. On her left, in the right middle distance, set off by her blackness, is a light-colored, incongruously civilized umbrella shielding some lucky people sitting underneath it. Luckily there are very few umbrellas to create even more difficulties on that extremely crowded roof. The woman and the umbrella together form a demarcation that separates the larger, individually miserable figures in the foreground from the collectively miserable rest in the background, over which looms the huge ruined arch of the station. Only a few people are looking in the direction of the camera, all of them grim, isolated, silent. The image draws attention to the concrete and enduring human discomfort by bringing the viewer very close to the individual figures in the foreground, the crowd's components. At the same time it shows the crowd's inhuman, material density in the background. Overall, it is unemotional, showing no women with small unhappy children, no visibly wounded soldiers, "normal" groups of people walking on the platform, a few with umbrellas, a small cart handed up to the roof with relative calm, no visible panic. But the depression of the people on that roof weighs palpably on the train, in fact obscures it. It seems improbable that this train will ever leave the station, that there will ever again be the cooking of food, washing of clothes, sleeping in a bed, being private and protected. (An observer returning from the United States to ruined Berlin in November

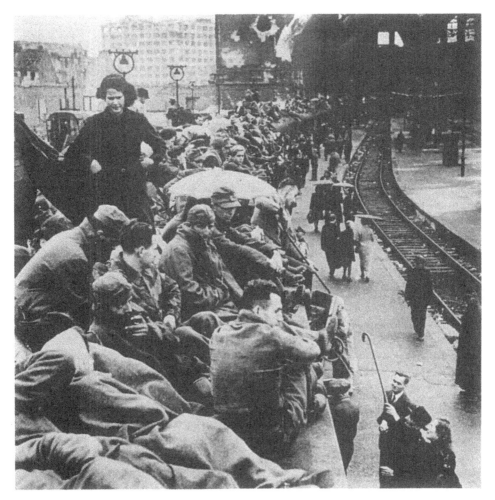

FIG. 3.7

of 1945 noted in his diary: "Never before have I felt so intensely how wonderful a house is, which provides shelter with its walls and doors and windows intact.")[29] The people on top of that train appear permanently stuck in their grey misery, as if transformed into bundles and sacks to be forgotten. Looking at them with McCombe at this dismal moment in their lives, "the world's" self-conscious pedagogical indifference to their plight seems faintly absurd.

McCombe also took a curiously affecting photo of a soldier who had lost both his feet—curiously because we have become used to depictions of much worse mutilation. The soldier's representation had to overcome, as it were, the viewer's projection that in reality the man could have been wounded much more disastrously. The caption to that photo reads, "Footless Soldier, who has been released by the Russians but without crutches, is taken off the train from the east. Several other amputation cases on train with him died on the trip. As an unusual exception, this group was lodged in a Berlin hospital, because forcing it to go any farther would have been imposing a virtual

sentence of death" (109). The decision to find hospital beds for these cases was indeed unusual since Russian treatment of German POWs was notoriously harsh. Few prisoners survived it.

The full-page reproduction of McCombe's photo forces on the viewer the shock of the soldier's complete helplessness—a shock produced by brilliantly controlled perception. Photographed from behind so that he and his carrier fill the entire center foreground, he rides on the other man's back, his face invisible. His arms are around his carrier's neck, invisible, his knees pressed against the man's lower back. His trousers are rolled up to reveal the bandaged stumps. In McCombe's perspective, the legs appear dramatically shortened and the soldier reduced to his trunk, which seems small in relation to his head. The man who carries him through the station is taking big, hurried strides past several groups of waiting people in the middle distance, all of them slightly blurred as if by the force of that long-legged stride. The group on the right is interested in something else, everybody looking away from the camera. The people on the left are watching the two men approach and, judging from the slight tilt of the soldier's head, he seems to be returning their gaze. Closest to him is a woman carrying several bundles who appears both drawn to and driven back by the sight. The focus is on the carrier's capable legs, moving along briskly, and the soldier's foreshortened useless legs pressing against him. Sharing one pair of legs, a composite being, they are a commonplace monster created by the familiar violence of war—to be looked at briefly and put out of sight till the next one comes along.[30] But not, luckily, for the viewer of their image in a different, safer time and place who can afford to look at them steadily. Shooting from up close, McCombe revealed without intruding. Here as in the picture of the dejected people waiting on top of the train, his view reflects a shock of recognition no less powerful for its intimation of resignation: something had happened that should not have happened. Strangely and yet appropriately, these memorable images did not call for remembrance. What had happened to these people needed to be shown and then forgotten. Looking back on these experiences from the future, they would have to leave the past where forgotten things belong. They would have had to change; they would want to leave these things behind.

McCombe had used these two pictures in a long photo-essay on chaotic Berlin for the British magazine *Illustrated* of 22 September 1945. The train at Anhalter Bahnhof is the title photo and is accompanied by the caption: "After agreement at Potsdam that transfers of Germans should take place 'in an orderly and humane manner,' *Illustrated* investigated facts, presents these seven pages—not to provoke sympathy for Germany but to focus attention on problem that extends far beyond her frontiers."[31] If the images and the text were not supposed to "provoke sympathy for Germany," they were still meant to help the reader and viewer understand the extraordinary difficulties faced by huge numbers of German refugees, between two and three million of whom lost their lives on the trek from the east: "Despair, exhaustion, crime, death, crowd scene at Berlin stations where refugees arrive, depart, live, die" (96). In their mostly straightforward, if not artless recording, McCombe's harrowing photos presented a "Gallery of misery: Blind, mutilated soldiers, homeless boys, grannies, starving, verminous mothers, infants" (98). The text, by Bill Fisher and Walter Gordon, explained the chaotically organized absurdities of their plight; for instance, the text next

to the photo of an old woman's utterly exhausted and dejected face informs us that "Aged people are no better off. This old woman from the Sudetenland was directed to Mecklenburg: ordered out, returned to Berlin, tries to go back to Sudetenland again" (98)—from which she will immediately be deported to Soviet occupied Mecklenburg, there to be ordered out again, to arrive in Berlin, etc. If she has the strength, she will again struggle frantically to get on the train—a scene viewed by Bourke-White with much disapproval and dispassionately photographed by McCombe: " 'All aboard'—the cry goes up at Anhalter Station and a frantic crowd of refugees scrambles to mount the cattle trucks which are to take them to reception areas" (96).

There is little if any moralizing in the text. The description (98) and photos (96) of Germans robbed, beaten, and raped at the Berlin stations by vicious, armed Polish youth gangs against whom unarmed police were helpless, is accompanied by the reminder that the Germans had ravaged defeated Poland. On the whole more distancing than the images—images do not represent the noises of panic and the smells of abused bodies that tax the sensory tolerance of reporters—the text does give a clear impression of the severity of the situation. The observers find themselves surrounded by "the rabble of ruined, broken people with twisted features, human flotsam in the sea of modern history," a

> verminous milling crowd which exudes the stench of starvation and disease of the body. . . . Here at the Stettiner Bahnhof, Berlin, in August, 1945, the German people experience the worst retribution ever to be visited on a nation. Although, by Allied order, Berlin had been officially barred to newcomers, roughly 550,000 Germans have passed through during one month alone in defiance of the order, creating chaos, and more are coming every day. . . . Theoretically there is an organization to take care of them, receive them, examine them medically, feed them, direct them. It is a German organization as, in authoritative Allied eyes, this is a strictly German problem. In practice. . . . (96–97, ellipsis theirs)

The terrible chaos was in part due to the provision of the Potsdam Agreement (signed 2 August) concerning the western Neisse—a provision reflecting the frictions about the eastern territories that arose at the Yalta conference, which Roosevelt, seriously ill, had not been competent to negotiate. In the eyes of a contemporary British observer, a

> passage in the [Potsdam] Agreement referring to "the orderly transfer of German populations" was an exceptionally cynical piece of face-saving. It recognized that the "transfer to Germany of German populations or elements thereof, remaining in Poland, Czechoslovakia and Hungary, will have to be undertaken." The time and rate of such transfer should be considered by the Control Council, and the transferred populations "equitably distributed" between the zones of occupation. As we have seen, the flight and mass expulsion of Germans from the East had already been in progress for months under disastrous conditions. The expression "orderly transfer," applied to some future date to be solemnly "considered," was pure hypocrisy. However, this section of the Agreement ended with a pious request to the Polish, Czech and Hungarian authorities to "meanwhile suspend further expulsions" pending an "examination" of the situation.[32]

Illustrated described the arrival by grotesquely overcrowded train of the victims of that provision:

> Slower than you would expect, human bodies peel themselves off. They stagger as they relax after many hours of agony. Questions are in their tired eyes. Trembling hands, often covered with cloth to hide the sores, cling to tiny parcels—all the belongings which are theirs now. Feet are either bare—and you see them swollen, blood-covered, black—or they are covered in rags. Some wear their best Sunday shoes; others have managed to rescue a pair of strong boots for the journey. (97)

McCombe photographed a "middle-class woman from Breslau, exhausted after long trek, [who] broke down as picture was taken, her hands and feet were covered with sores" (99). There is also an image of an old woman sitting on a stool, her head bent to her chest, "her feet naked, swollen and broken after the hundred-mile trek to Berlin" (96). Women walking barefoot long distances on the open roads and in ruined Berlin, pushing or pulling small carts with their bundles and children, were a common sight (fig. 3.8). Nobody was the better for it, but for the old it was particularly hard and painful.

Most of the people staggering from that train had been without food and water for several days. The few Red Cross workers receiving them had nothing to feed them, and the little water they had was mostly contaminated; there were no cooking facilities, let alone places to sleep, wash, and relieve oneself, a problem that is never mentioned. There were a number of transit camps in Berlin, some of them closed because of typhoid fever or because the Allies had requisitioned them for their own use. But the other camps could offer very little food, water, and medical help. Besides, located at considerable distance from the stations, they were difficult to reach for people who could barely walk and who would not be able to find their way in the immense wilderness of Berlin. Many contemporary accounts describe a city altered so dramatically that residents of long standing would get lost in their own neighborhoods. So the refugees just stayed at the station, many of the older people to die in the "death carriage," an old cattle truck pushed onto a platform. "Take a look inside!" the reporters advised. "A 'hopeless case,' an old man, has been taken there. He is slumped down by the side of two blanket-covered bodies. A notice says: 'these two dead are to be collected.' They may not be collected before the old man himself dies; and another or more" (98). Soberly and attentively, McCombe photographed them all: the corpse bundles, the scrap of paper with the scribbled reminder to remove them, the "hopeless case." The image of that old dying man sitting on a litter, his legs stretched out in front of him as if they were not attached to him, shows the strangely enveloping passivity of his crumpled body and deathlike face (97). The image of the middle-aged woman with her fine-featured, worn, bewildered face and bandaged hands, who broke down when he took her picture, shows her gently, frugally crying, saving her tears for the worse things to come.

Neither the images nor the text of that photo-essay seem interested in clean moral separations. If good Germans did not stand out in this chaos, the particularly bad ones did not either. For the observer, things had become relative. Some people were weaker, sicker, more helpless than others. The most spectacularly difficult to look at, maimed

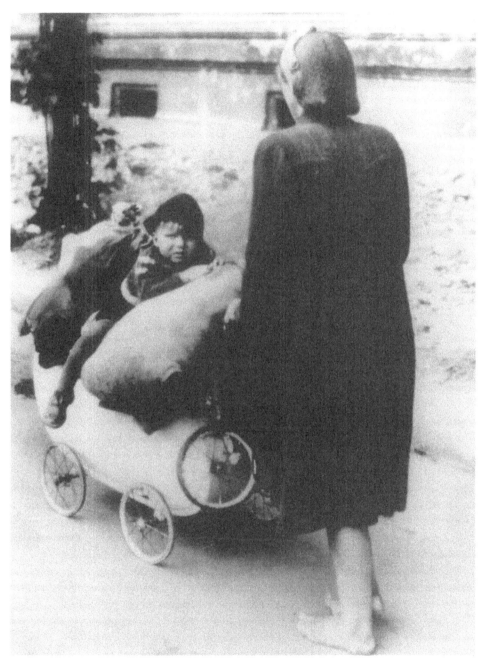

FIG. 3.8

soldiers without arms and legs, were not shown but briefly described, and the reporters expressed their relief that at least for these "specimens reduced to pathetic figures that can hardly be called human any more," hospital beds will be found (100). Given our ungenerous visual conventions as to what is "human," photographing in cases like that is notoriously intrusive and its effect on the viewer is difficult to control. In McCombe's photo of the still clearly human footless soldier, mutilation appears visually and emotionally mediated, composed, but war's impartial inhumanity of inflicting it is powerfully present. For that moment, it was enough to show what happened to these people and not take it lightly—not to deny them the hope that they might yet survive.

For three weeks in late July and August and once more in early September 1945, Robert Capa was on *Life* assignment in Berlin. A selection of the photographs he shot during that time was published much later in a slim volume entitled *Sommertage, Friedenstage. Berlin 1945* (Summer days, days of peace . . .).[33] The title was aptly chosen: the summer of 1945 was legendary for its enduringly beautiful hot weather and, despite the stench wafting from the dead rotting in the ruins, despite the contaminated water, the severe shortages of food, the lack of shelter, the unavailability of any kind of services, communication, or transportation, people were stretching and expanding in the sun, knowing in their bones that the war was over. Not, however, for the weak, hot, hungry and thirsty refugees carting all their possessions and their complaining or, worse, apathetic children through the stone desert of Berlin, often dressed in several layers of clothes because the only way to carry them was to wear them. In their frequently unsuccessful search for one of the reception camps where they hoped to find a little food or water, the beauty of these days was hostile rather than soothing (fig. 3.9). At Soviet Headquarters, if they got there, they waited endlessly to obtain the documents allowing them to try to leave Berlin, where they were not allowed to stay. This wait was just as chaotic and discouraging as that at the stations, and it is powerfully documented in McCombe's photos of people pushing, pleading, explaining their papers and stamped certificates, not understanding, not being able to make themselves understood, collapsing from exhaustion and frustration (100–101).

Capa's focus was different. His eerily peaceful images caught the sense of that almost magical, if shortlived, physical and emotional release. The tension of fighting for survival seems temporarily lifted, as if time were suspended, and winter and the reckoning of responsibility and guilt would never come. Even the women in the bucket brigade seem to be moving easily in the ruins that in the strong sunlight look more decoratively ancient than desolately contemporary (fig. 3.10). Everybody is sitting out in the sun. Two elderly ladies, for instance, are shown sitting in the window opening of a bombed-out fruit and vegetable store, smiling somewhat uncertainly at the photographer.[34] The store has an old sign, with *Kartoffeln* (potatoes) written much larger than *Gemüse* (vegetables) and *Salate*. Traditionally the most important food for working-class Berliners, potatoes were essential to survival in the immediate postwar years. There were piles of potatoes on the sidewalks, on the streets, and in carts, always surrounded by large numbers of eager buyers who carried them away in anything they could find (fig. 3.11). In fact, the streets of Berlin, of all cities with their increasingly

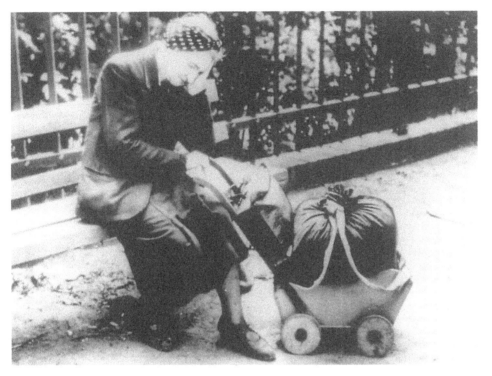

FIG. 3.9

serious food supply problems, were filled with people carrying these droopy sacks, themselves becoming sacklike—anonymous, slumped bundles stuffed with everything that might be useful in a world where none of the things needed for everyday living seemed obtainable or functioning. This transformation was often depicted by German photographers interested in the commonplace signs and symbols of the collapse.[35] It also attracted the attention of Signal Corps photographers, though usually in connection with some larger context of desolation—as in, for instance, the photo of the Brandenburg Gate, which shows the grandiose structure amidst ruins, looming over broken carts and weary figures bent under the sacks on their backs. This powerful image suggests a rewinding of time back to another war of epic proportions, the Thirty Years' War (1618–48), which effectively retarded the development of German political culture (fig. 3.12).

The images collected in *Sommertage* reflect a more generously hopeful perspective, especially on children and older people. Capa's photography was remarkably unintrusive in the intimate explorations of its subjects' cautious, still incredulous sense of relief and of possible new beginnings. He gently searched their faces for clues to their anxieties and desires, not to judge them but to restore to them the concreteness of the ordinary—for instance, in the charming photo of the elderly couple absorbed in their preparations for selling the first issue of the *Neue Berliner Rätselzeitung* (New Berlin puzzle magazine)—surely a sign, however frail, that normalcy might one day return.[36] In this manner Capa photographed the buying of newspapers as well as of potatoes,

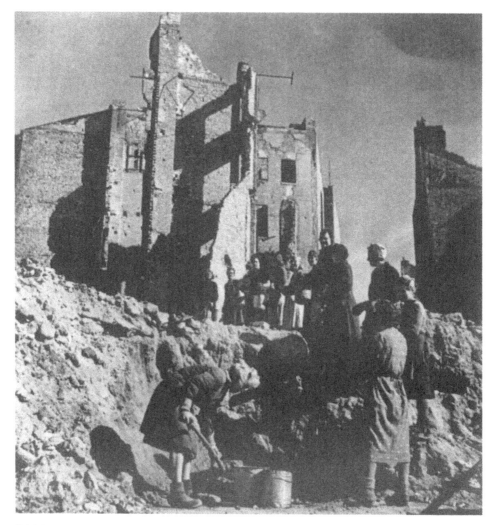

FIG. 3.10

arguably the two most important commodities during the summer of 1945. People
were naturally excited by the new availability of information and eagerly lined up for
newspapers whether they were sold or distributed by the Allies—these scenes, too,
seemed noteworthy to Signal Corps photographers (figs. 3.13, 3.14, 3.15).[37] But Capa
was more interested in the serious business of buying potatoes, which he saw (and
showed) as a transaction between individuals.

 In two companion photographs, of two men and two women, Capa captured very
well the attentive patience of older middle-class customers waiting their turn to buy
the precious staple food from a street vendor. A thin elderly buyer dressed in a solid,
three-piece suit with a watch chain but without a shirt collar, his brow wrinkled in
concentration, holds open his shopping bag in anticipation of the portion about to be
poured from a bowl filled with heavily sprouting potatoes (fig. 3.16). Shot from up

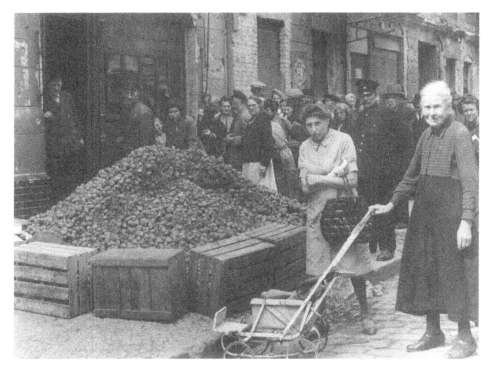

FIG. 3.11

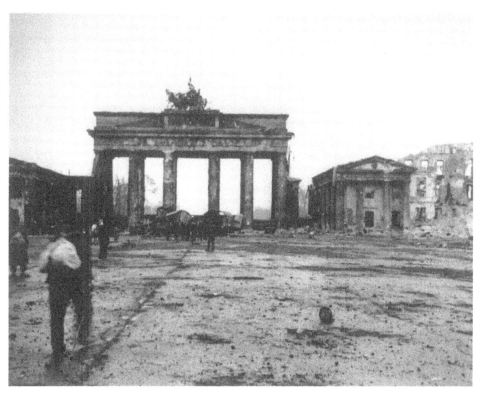

FIG. 3.12

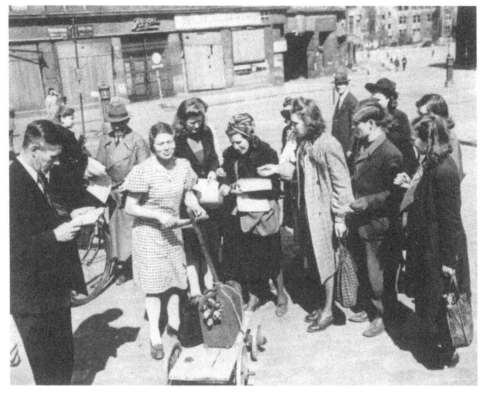

FIG. 3.13

close, the bowl forms the center of the foreground, and both men are watching it closely. The vendor holding the bowl is sturdier and taller than the customer—an advantage emphasized by the perspective. He has what the other man needs, because without him the ration cards necessary for the purchase are useless. But the picture's visual message is not, or not mainly, about uneven power relationships where food is concerned, a situation central to the immediate postwar experience of most city dwellers. Capa was not so much interested in showing the customers' vulnerability as in finding out how they coped, what concrete things were important to them. To the viewer who knows about the significance of potatoes at that time, this image is extraordinarily eloquent; it does indeed speak volumes. The German caption simply says: "Selling potatoes in a Berlin suburb"—this is enough in the context established by the other images. But it is true that this particular context, the collection of images, is needed to judge the quality of the photographer's perception. In photographing scenes of war and violence, Bourke-White went for the singular brilliant shot, claiming its documentary "truth." Capa, though famous for his "great" shots—the most famous, perhaps, the "Moment of Death" of a Spanish Republican militia man struck by a Loyalist bullet—seems to have been more interested during these first days of peace in recording a number of small, partial truths about the people of Berlin. We don't know who they were and what they were "really" like, whether they were Nazis,

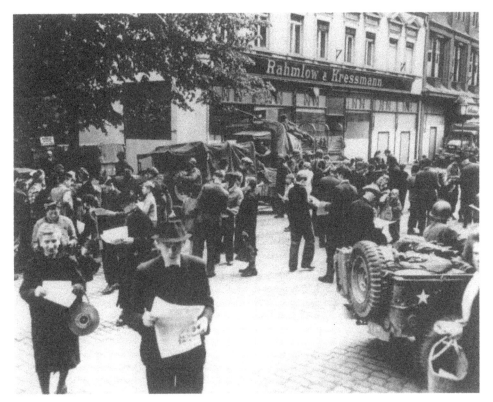

FIG. 3.14

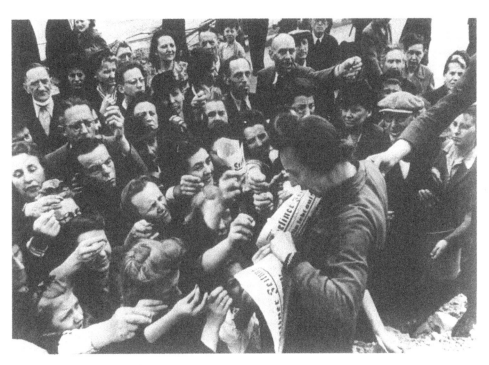

FIG. 3.15

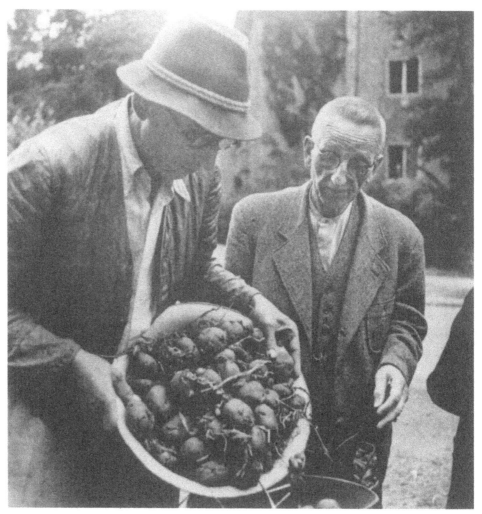

FIG. 3.16

for instance, or not. But shown how they lived, we cannot easily dismiss them and their concerns by labeling them.

In the companion photo (fig. 3.17), the two women standing in line and holding ready their ration cards seem to be looking at the transaction recorded in the other picture. Their handsome, worn faces arrested in patience, one more skeptical, the other more stoic, they appear both calm and harassed, together and separate in their polite and orderly waiting. Like the older man, they had dressed for doing their errands in the ruins, trying to look presentable. This habit of "keeping up appearances" found much approval with American and British soldiers, who liked the young German women's knack for making themselves look attractive with very little help.[38] In Essen, picking their way through the "filth and desolation" of the ruined city, the British war

FIG. 3.17

correspondent Anthony Mann and a colleague were "struck dumb by the sight of a girl standing in a cellar entrance: she was carefully starching her collar and cuffs in a pudding-basin."[39] And in Berlin the British photographer Sergeant Wilkes was clearly charmed by the two pretty, smartly dressed young women, nonchalantly carrying their daily water supply in a tub and buckets through the deserted heavily bombed streets, one of them even smiling at him (fig. 3.18).

But Gertrude Stein, who had traveled to Germany with Alice B. Toklas at *Life*'s suggestion at the same time Capa was in Berlin, did not approve. She found Germany in ruins "not so exciting to look at," and was "puzzled" by the people's behavior: in Frankfurt "the people were strange, very well dressed, was it that they all had on their

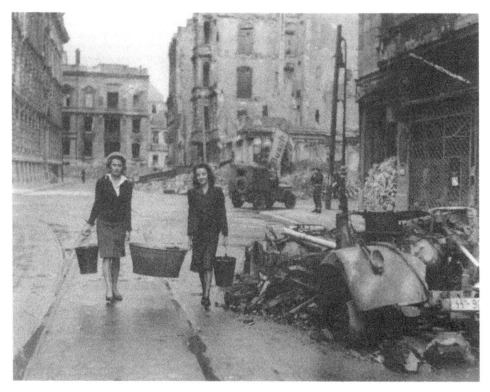

FIG. 3.18

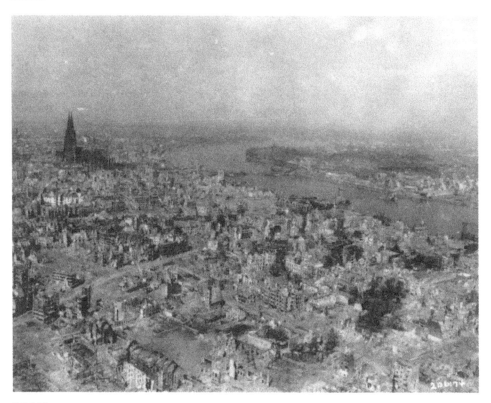

FIG. 3.19

best clothes because they had nothing else to wear, and shoes, did they not know what the French knew so well, better wear your old clothes and keep your best for later . . . "[40] Actually, living in France might have taught her that, even if in ruins, European urban culture required a certain degree of self-presentation in public spaces, and that women in Germany, if they could manage at all, would dress as well as possible for no other reason than to keep up morale—a form of self-preservation in circumstances that threatened it. Not unlike the American pioneer women on their way west getting down the piano from the wagon on a Sunday and putting on a starched lace collar. But Stein was not interested in finding out how Germans lived. When she looked at them at all, she looked for signs of defeat. She had learned in France, she wrote, where to look first for malnutrition. She noted her response when she saw it in Germany: "Was I pleased to see it, well a little yes" (56). Still, notwithstanding her self-centered, precocious-sounding self-stylizations, Stein did make an interesting observation. She noticed that the Germans in Frankfurt

> were all looking at Miss Toklas and myself and that some went quite pale and others looked furious. First I was puzzled and then I realized that we were probably the very first ordinary civilian women with American soldiers, not looking official just looking like American women with a group of talking soldiers and they realized for the first time that there were going to be thousands of civilians coming there just to look as we were looking. After all Germans believe in an army, an army is an army even if it is a conquering army but civilians, just simple civilians, oh dear. I thought perhaps I was imagining this but later on several of the boys spoke of it. When I was back in Paris I mentioned it to my French friends, and they said yes, that had happened in Paris, the army of occupation was bad enough but when the German families began to come then the iron entered the French souls. Civilians are more permanent and appalling than the army, yes they are. (54, 56)

Some more so than others. Under the headline, "Roofs are important, yes," Stein described Cologne, the most destroyed city they had seen yet, as a "whole spread out city without a roof. [This effect is well captured in the photograph taken by T4c. Jack Clemmer of the Army Signal Corps on 24 April 1945; see fig. 3.19].[41] There was a cathedral but it looked very fragile as if you pushed it hard with your finger your finger would either go through or it would fall over" (56). On Hitler's balcony in Berchtesgaden, she and her "adorable" GIs posed for the photographer with Hitler salutes and merry giggles (57–58). In Munich she found out that not all ruins looked the same (57) but, even better, Nuremberg was "more nonexistent, nothing really left but a piece of the old wall" (58). Yet she loved Heidelberg because it had not changed since she had been there on vacation as a college student. [A large enough number of Americans had nice enough memories of the lovely old town to save it from sharing the fate of other lovely old towns of no military importance.] In Heidelberg, after sightseeing, she got furious with the GIs, who admitted that they liked the Germans better than the other Europeans: "Of course you do, I said, they flatter you and they obey you, when the other countries don't like you and say so . . . and all you big babies will just be flattered to death, literally to death, I said bitterly because you will have to fight again" (58).

There is some truth to her connecting obedience and flattery, as far as it concerned the young Americans. But they loved her anyway and she forgave them.

Back in the plane, "the boys" proudly showed her what they had acquired and she responded tolerantly and ambiguously: "Where they had acquired, what they had acquired better not know. There are three million American soldiers there and each of them has to have at least six souvenirs. Dear me. They call these objects liberated. This is a liberated camera. Liberated they are" (58). Yet she wanted her "boys" to be as different as possible from the overly obedient Germans and Japanese, who would become worthy of American attention only if they learned to disobey—as she explained to an intrigued if bewildered general. At any rate, the trip was "a wonderful experience. And I really pretty well forgot about Germany and the Germans in the enormous pleasure of living intimately with the American Army" (54). A truly successful mutual admiration trip, if not quite as childlike and innocent as she made it out to be.

In contrast to visitors like Stein, Capa took the time to get a good look at quite a few Germans, who consequently ceased to look like "the Germans." A group of photographs he shot during that summer documented a memorial demonstration for the victims of fascism on 9 September 1945; it drew 60,000 of Berlin's citizens. It was arranged by the Magistrate of Greater Berlin and held at the "Werner-Seelenbinder-Stadion," which was named after a wrestler executed by the Nazis in 1944 as a Communist and member of the resistance. A group of Germans is shown standing pressed closely together on the outside of the stadium behind a large banner that states in German, that is, Gothic lettering: "Wiedergutmachung ist die Ehrenpflicht des deutschen Volkes." A worn-looking and serious crowd, framed by a huge old tree in the background and the large white banner in the foreground, they seem united in their intense concentration on the speeches made in the stadium (fig. 3.20). Presumably, the speakers promised that it would indeed be a German *Ehrenpflicht* (honor and duty) to bring about *Wiedergutmachung* (reparation, literally "to make well again"). The victims and their families, sitting and standing in relaxed groups inside the stadium, are much less attentive, looking in different directions, seemingly bored, talking to each other, smiling at the photographer. But were these two images meant to be juxtaposed? Are their visual messages sufficiently clear to be able to say anything about either group other than that these Berlin citizens seemed eager to show their good will and the photographer did not seem to distance himself from, ironize, or doubt that eagerness? (See *Sommertage*, 26, 27.)

The strength of the photos collected in *Sommertage* lies in an openness that supports a visual and emotional attraction enduring over half a century. Appealing rather than fascinating, these images were, and are, open not so much to different meanings as to different emotional shades of meaning. Germans in 1945 had different experiences, different pasts, would have different futures. At the moment they were pictured, their lives seemed suspended in time. Something had ended, the new had not yet begun. If they did not know where it would take them, neither did the person who photographed them presume to know. Following them as they went about their ruined city, absorbed in the challenges of daily survival, Capa's camera did not so much

FIG. 3.20

question or probe as reassure them. He understood that for the moment, they needed most of all to be affirmed as survivors. But this perspective could not last. In September *Life* published a photo-essay by Capa, "Black Markets Boom in Berlin," that showed a harsher, more desperate reality. Though here, too, he captured more gentle if some-what anxious moments, for instance in his photo of an older, well-dressed couple sitting on a "log in Tiergarten waiting to exchange some of their personal belongings for cash or goods. The woman is taking off a neck chain to offer." The man, wishing to help his wife pull what looks like an old piece of jewelry over her head without dislodging her hat but not knowing how, appears helpless in a peculiarly affecting way.[42] These quietly elegant, formerly privileged old people were, of course, lucky to

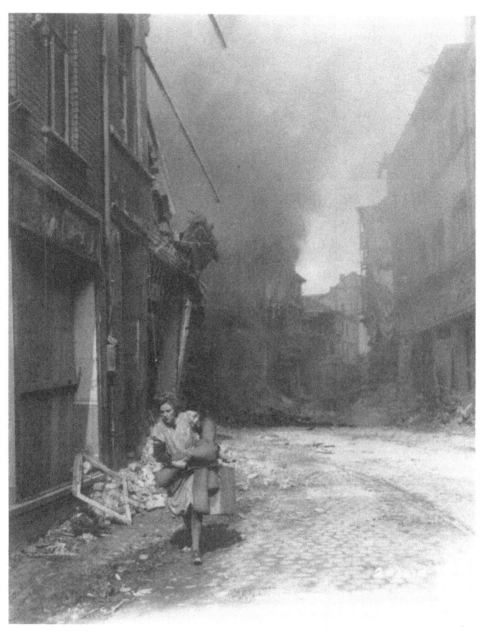

FIG. 3.21

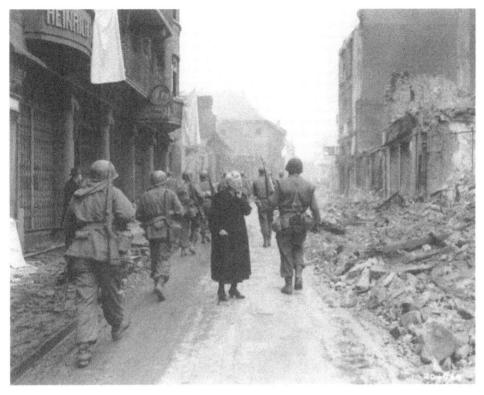

FIG. 3.22

have nice things to barter; but the way Capa's camera saw them did not suggest that they would do so successfully.

Some Signal Corps photographs shared Capa's openness, but not his visual talent for intimacy. Quite naturally, Signal Corps photographers were drawn to the more obvious, as it were, public aspects of living with the results of defeat, especially in the early stages of the occupation. But even here, the perspective was not uniform. There is the dramatic, well-composed photo taken by Signal Corps photographer T4c. Troy Peters on 13 April 1945 of a woman running away from a burning building, clutching some rolled up rugs. She is shown running, desperately straining under her burden, the houses literally going up in smoke behind her (fig. 3.21) The caption says that the fire was started by a "Nazi saboteur," which, true or not, explains the visual attention to the plight of the woman uncommon in Signal Corps photos of air raids. There is also the sympathetic shot of an old woman surveying the "wreckage of her property" during the invasion of the Rhineland (fig. 3.22). Standing between two lines of GIs seen from behind, greyish, solid figures in their battle gear, the old woman, putting her hand to her face in shock, is half turned to the photographer. Visually in the center of the image, with her white hair and black coat clearly defined against the GIs and the pile of rubble, her obvious unhappiness is also the emotional center of the picture.

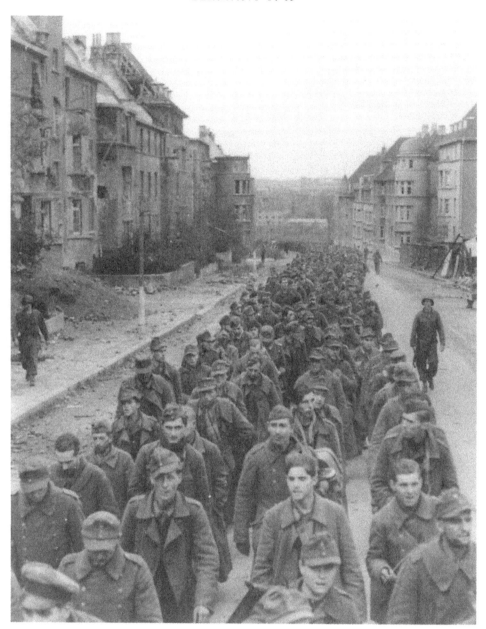

FIG. 3.23

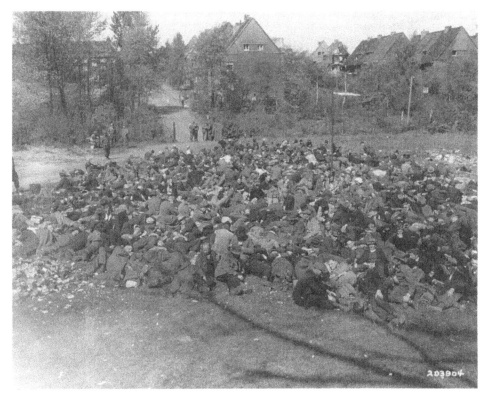

FIG. 3.24

A certain uniformity of perspective in Signal Corps photos might be expected where the subjects are German soldiers; they are shown marching in endless processions through the ruined streets of German cities (fig. 3.23), or cooped up in POW "cages" (fig. 3.24),[43] or humiliated when caught trying to escape (fig. 3.25). But there were differences here too—for instance, in the photo with the caption, "U.S. Negro Troops in Action," which shows a pleased-looking black GI holding a machine gun and what seems like a long knife while standing guard over a group of exhausted German soldiers willingly raising their arms in surrender for the photographer and looking rather unfit in their bulky, rough overcoats (fig. 3.26). The photo seems staged, but everybody appears to be taking the situation quite seriously. Not so in the photograph of four recaptured POWs—a pilot, an infantry captain, a sergeant "pilot" and a Luftwaffe medic who had tried to escape in, "of all things," a P-51 Mustang. The four enterprising young men are shown sitting on the ground, looking somewhat concerned but mainly disappointed. Looming over them, their machine guns readied, are the two MPs who recaptured them. But with the long peaks of their caps pushed back, the effort to look properly "serious" and "troubled" by the Germans' conduct does not succeed in reinforcing the victorious pose struck for the photographer (fig. 3.27).

"Shadows of Things to Come" reads the caption of a photo that shows "Silhouettes

FIG. 3.25

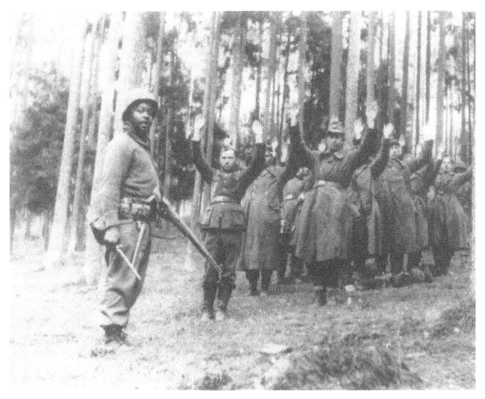

FIG. 3.26

of three of the 240 U.S. 8th Air Force B-24 Liberators that flew in at 200 feet to drop supplies to the 1st Allied Airborne Army" moving across areas east of the Rhine. "Parachutes from the troops already landed can be seen hanging from the trees around the house and on the ground. The airborne army was landed from 1500 transports and gliders on March 24th and almost immediately afterwards the Liberators flew in to drop cannisters of vital weapons, food, and medicines. The airborne troops were landed behind the German lines east of the Rhine, in the face of General Montgomery's Rhine-crossing ground troops" (fig. 3.28).

It is an intriguing but ominous image—just as Capa's photos of civilians in the foxholes left by these invading/liberating paratroopers were ominous.[44] What would "the things to come" mean for German civilians and soldiers—who could not even dream of such supply lines? There is a Signal Corps photograph taken 11 May 1945 showing how "Men of the 194th Glider Regiment, 17th Airborne Division wade ashore after Baptismal in Rhine River at Duisburg, Germany" (fig. 3.29) The men are wading to shore in their underwear, looking like civilian bathers rather than soldiers. They are watched with interest by a group of children and a baby in a pram. An incongruously peaceful scene of connection rather than separation.

Getting to know the "liberated" population in the ruins, Signal Corps photographers were to shoot many such complexly ambiguous scenes: women salvaging bricks

FIG. 3.27

FIG. 3.28

FIG. 3.29

from buildings bombed by the Allies,[45] or buying flowers near a building shelled by them (fig. 3.30). There is the image of the archetypical beloved GI in his truck distributing the coveted candy or chewing gum to a group of children, some hanging back, reluctantly longing to participate (probably warned sternly by their mothers not to beg), some eagerly stretching out their hands (fig. 3.31). There are images showing

FIG. 3.30

Germans scrambling for food—with old people butchering a fallen horse in the streets of Berlin (fig. 3.32), customers of all ages crowding poorly supplied grocery stores in a small town: "Yank keeps order while the stock lasts" (fig. 3.33; the people photographed do not seem to mind). And there is a dramatic image of Nuremberg ruins showing people coming over a mountain of rubble to join the endless food and water lines, themselves almost indistinguishable from the fallen stones, as if from an utterly alien place and time (fig. 3.34). There are also dramatic photos of Germans coping with the severe water shortage in most cities: a large group of women scooping up water in buckets from the street after the breaking of a water main (fig. 3.35); and another of four civilians drawing water from a pipe beneath a tilted statue of Dürer, flying a white flag—the center of this cleverly composed image—to indicate their peaceful intentions.

Finally, there are the photos that show people living, cooking, and washing in the ruins. Signal Corps photographers shot these scenes to document the degree of destruction but also because they were simply a part of their daily environment as occupation forces. One cache of Signal Corps photos depicting the abysmal living conditions of civilians in the devastated cities was among the papers of Albert Richard Behnke, a captain in the U.S. Medical Corps who researched the effects of severe

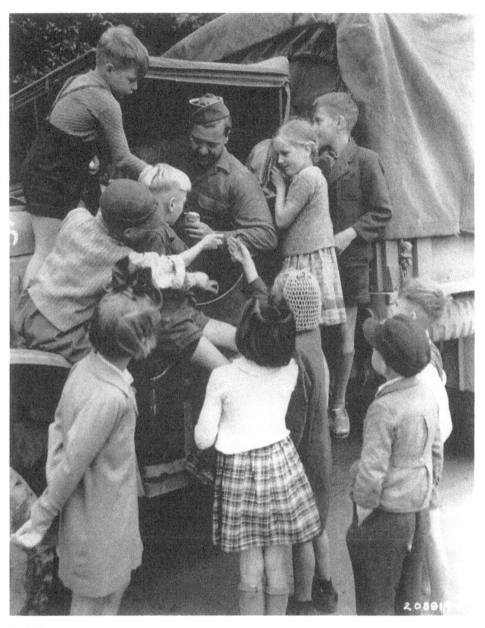

FIG. 3.31

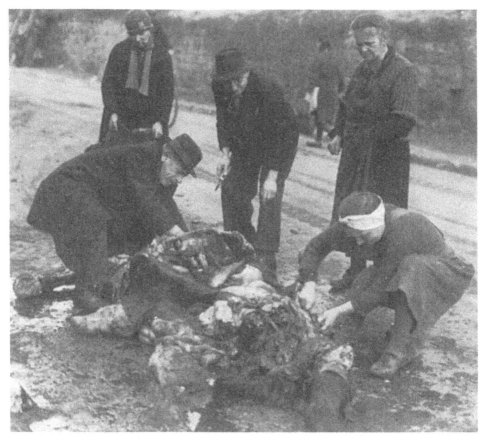

FIG. 3.32

malnutrition in postwar Germany. Where other officers acquired from Army Pictorial Services Signal Corps photos of planes, tanks, battle scenes, and the destruction of German military and industrial installations, Behnke collected images of severely malnourished children and workers. But he was also interested in a photo taken 24 April 1945 showing a number of women in Nuremberg who lived in "hastily constructed wooden shacks" and are shown washing clothes in the street (fig. 3.36); and in the picture taken on 19 September 1945 of the "wrecked entrance of the former home" of a family in Mannheim" — the very unlikely entrance to a cellar dwelling where that family had lived for the last two years. The companion photo shows the mother sitting in the extremely cluttered cellar eighteen feet underground (figs. 3.37 and 3.38).[46] Where she and her children would go from there depended to a certain extent on how the victors viewed them at that moment in their lives.

The photographs of the destruction of Nuremberg taken by the young Signal Corps photographer Ray D'Addario, chief photographer at the Nuremberg trials at age twenty-four, were seen only much later — in stark contrast to his widely shown but unattributed photos of the trial proceedings. D'Addario used a temporary abundance

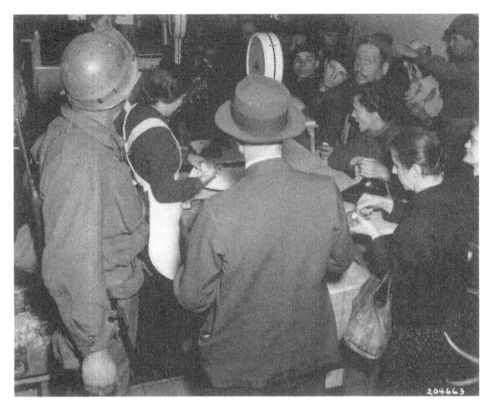

FIG. 3.33

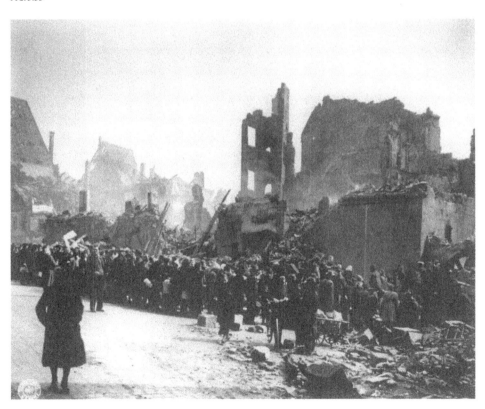

FIG. 3.34

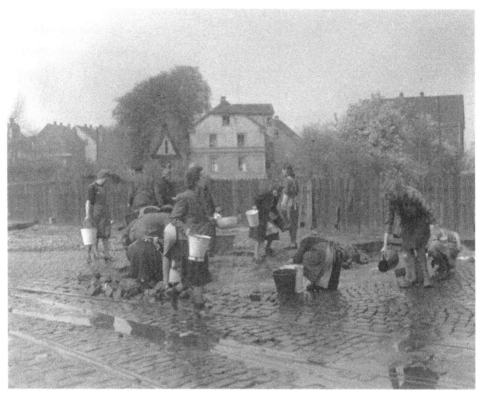

FIG. 3.35

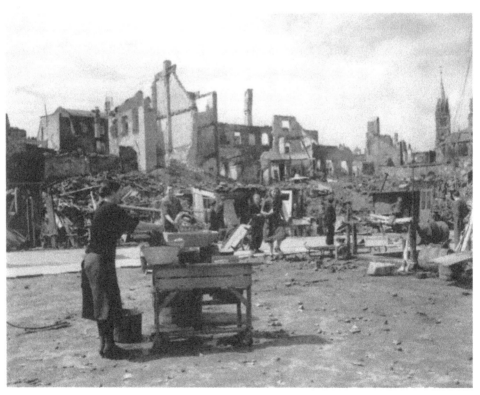

FIG. 3.36

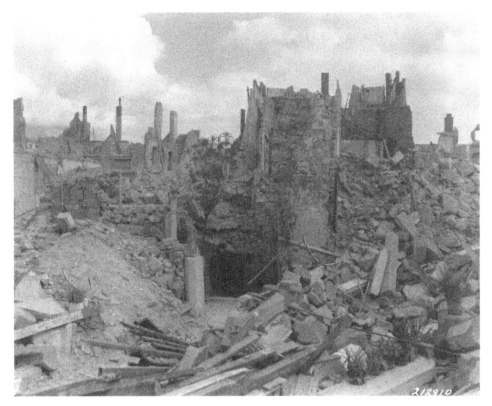

FIG. 3.37

of film and free time to record the ruins and the people living in them.[47] His images, some of them very good, are technically more sophisticated than most of the SC material (he had better cameras and, running the pictorial center for the Signal Corps in Wiesbaden, more control of developing and printing). On the whole, they also exhibit a greater openness to different, more private meanings that are nevertheless distinctly different from most of the German materials: these photos, taken by a young American, seem infused with greater matter-of-factness. The extraordinary seems less self-conscious. Asked whether he had been emotionally impressed by the degree and kind of destruction, D'Addario thought he had not; in a very short time that destruction had become commonplace. He most probably had felt and seen it that way at the time — yet the resulting images seem to suggest something beyond that. At the time, he clearly also responded to an extraordinary situation. "We thought it would take the Germans at least 25 years to rebuild, but then they got busy," he said.

They have been busy ever since, and their successful absorption in the task of rebuilding has often been blamed for their reluctance to remember — not so much the facts of destruction as the questions these facts posed. I will come back to D'Addario's work in the next chapter. But one of his images seems to me particularly fitting as a conclusion to this chapter. In the fall of 1945, he shot a large crowd of men and some

FIG. 3.38

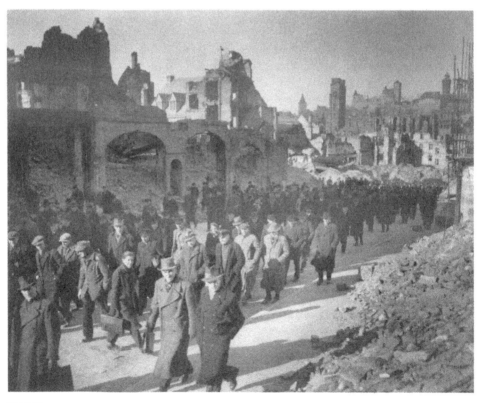

FIG. 3.39

women coming toward him through a shallow canyon winding through the ruins—
once, and now again, the handsome and prosperous Königsstraße in Nuremberg.
Following them, running ahead of them, he was excited by the contrast of the dark
somber crowd and the bright sunlight on the ruins, but also by the fact that he did not
know who they were and where they were going. In the photograph, some of the men
are looking in the direction of the camera, which is directed at them from a pile of
rubble slightly above them. Most of them are indifferent; but a young woman, the light
on her face, is smiling, and so is a young boy who is going in the other direction, his face
turned to look at the photographer (fig. 3.39). . . .

Words and Images

GERMAN QUESTIONS

OUTSIDE OBSERVERS looking at Germany in 1945 emphasized different aspects of the results of war and violence, but all reports resonated with the eerie alienness of what they saw. Ray D'Addario photographed a teenage boy standing by himself in a space cleared of rubble in front of a bombed-out church. The boy is wearing a military cap and the ubiquitous, clumsy wooden sandals in which no child, no matter how agile, could really walk, much less run or jump. He seems to be made just to stand there, the collar of his short, threadbare jacket turned up against the cold wind, his narrow shoulders hunched, his hands in his trouser pockets (fig. 4.1). Clearly focused in the foreground, photographed from slightly below, his pose, his body, and his face suggest a curiously ageless, androgynous softness. Looking past the photographer in front of him with a quizzical frown, he seems to shield from the observer's gaze what lies behind him rather than to guide him to it. It is a strangely affecting image, because the boy is both ordinary and remote. Emerging from the ruined city and retreating into it, neither sullen nor friendly, he asks no questions and gives no answers. A survivor of the frightening past, he is afloat in the confusing present. What was it about the boy that struck the young American photographer who had come into his chaotic world as to another planet, yet captured so well his skeptical passivity? (D'Addario would later choose this image for the frontispiece of his book of photographs on the destruction and rebuilding of Nuremberg.)[1] In another destroyed city, Essen, the local photo reporter, Willy van Heekern, photographed the moonscape of ruins from a perspective that made the people living in them appear as small as ants but not therefore inhuman. The few tiny figures walking about dejectedly in a large empty space between burned-out houses are clearly recognizable—the men characteristically hunched over, their hands in their pockets (fig. 4.2). What were they supposed to do now, so small in

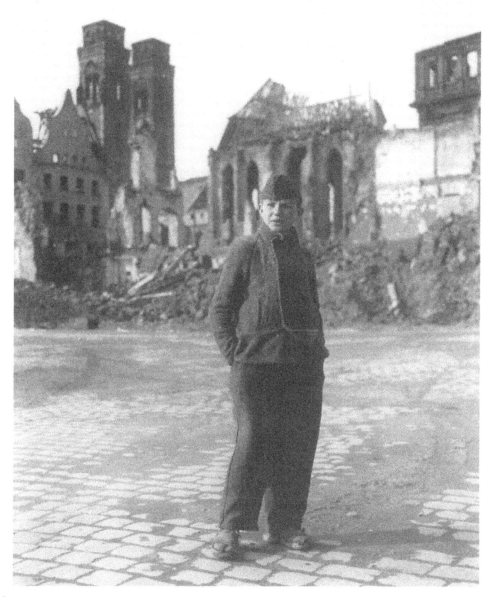

FIG. 4.1

relation to the mountains of rubble caused by a war of aggression for which they too were held responsible? The photographer, one of them himself, recorded their dilemma by presenting its literal dimensions.[2] Van Heekern also documented their bewilderment and lostness from close up in an almost surreal image of the most unlikely civilian-looking civilians in the ruins (fig. 4.3).

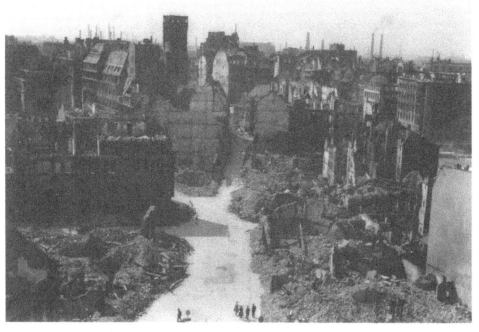

FIG. 4.2

The experience of alienness was particularly intense for the exiles coming back to what they had been forced to leave in the thirties—light-years away in psychological, if not chronological, reality. What they found was stranger, more alien, than they had imagined. But if they came as strangers, their distance to what they saw also differed from that of other outside observers. As it were, an "unnatural," shocking distance, it seemed imposed on them as their departure had been twelve years before:

> The first impression in Berlin, which overpowers you and makes your heart beat faster, is that anything human among these indescribable ruins must exist in an unknown form. There remains nothing human about it. The water is polluted, it smells of corpses, you see the most extraordinary shapes of ruins and more ruins and still more ruins: houses, streets, districts in ruins. All people in civilian clothes among these mountains of ruins appear merely to deepen the nightmare. Seeing them you almost *hope* that they are not human.[3]

This was how the sociologist and political scientist Hans Speier saw Berlin in the fall of 1945 after a twelve year absence. Like many of the emigrés, he came in the uniform of the occupation forces, in his case as policy adviser to the director of the Interim International Service. He offered his political views on U.S.-German relations in articles published at the time, and they reflect his American professional persona.[4] But half a century later, we learn more about this extraordinary period from his spontaneous personal letters to his German-Jewish wife; there he expressed his "mixed" political, social, and psychological observations of individual Germans, their physical survival, cultural activities, and political opinions. Meant to serve as records,

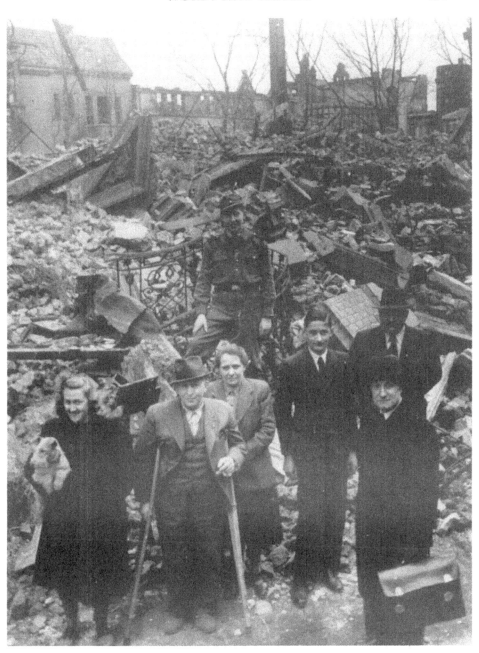

FIG. 4.3

these letters reflect his shock, his determination to make sense of the situation, his failure to do so and, perhaps most instructively, his inability to reflect on that failure.[5] He came as a victorious American but had intimate knowledge of the defeated, since he himself was German. But was he? And if he was, in what way? What did such a double perspective mean for the reality of negotiating a new, different, and unexpected German strangeness?[6]

In many ways remarkably fair and perceptive, Speier did have great difficulties seeing Germans in the complex and frequently obscure terms of their situation. Moreover, coming to Germany from the outside, especially in his role of returning German-American emigré, he was expected to turn acts of seeing and describing into acts of judging. All information coming out of defeated Germany was directly equated with judgment. It is true, of course, that information is always shaped by evaluation or judgment. But in the German situation of 1945, the whole chaotic country had turned into evidence against itself, inviting even the most thoughtfully cautious observer to sort out immediately the good Germans from the very bad ones; the repentant from the unrepentant; the many guilty from the few innocent; the evil past from the redeeming future. Speier did notice that the disorienting effects of moral and physical devastation caused him to feel a rapidly developing "urgent need for meeting people one knew a long time ago; it seems a natural anxious longing for life to assert itself" (26). "Life" meant continuity in the midst of all that rupture; it meant resumed conventions that would allow him to avoid the rule of the stranger who must make judgments about the Nazi past of every new person he met.

With people he had not known before, Speier could not relax his watchfulness, indeed suspicion, and his recorded observations of Germans clearly show the strain on the outsider trying to find his way on profoundly alien terrain. The strains showed, for instance, in his simultaneously melancholic and hopeful, almost tender enjoyment of reemerging cultural activities—concerts, opera, theater, lectures, and bookstores. But this enjoyment did not carry over into an attempt to see the situation as a whole. When he looked at Germans in terms of a past political culture he had managed to escape, they promptly became one-dimensional figures to be subjected to his frequently contradictory judgments of what they should have been doing, but were not, in order to redeem a guilty past for a more innocent future. Speier's response to the encountered strangeness, one common among emigré visitors to Germany at the time, gave a curiously limiting if illuminating sharpness to his perspective on those who had managed to survive Hitler's Thousand Year Reich in Germany. As long as one is aware of this, his observations are useful, precisely because of their clear subtext that Germans should not have been what they now were. No matter how the emigré answered the question of collective guilt, it retained a dimension of concreteness that tended to collapse the gradual changes between 1933 and 1945 into the shockingly alien last stage of the Hitler regime that had rendered a familiar world unrecognizable. Yet, like all visiting emigrés, Speier had come back with others' and his own expectations that he would know where and how to look and understand what he saw.

In Berlin, Speier visited the painter Karl Hofer, who insisted emphatically on the need to change the Allied policy of not distinguishing between Nazis and other

Germans. Speier, who had always admired Hofer's work, also found him impressive as a person: he had publicly attacked the Nazis in the twenties, and he had been ousted from the academy and had his works removed from the museums (though his monumentalist painting should not really have clashed with Nazi aesthetics). His position on the "Nazi = German" issue made sense to Speier, who commented to his wife: "If one has eyes to see and ears to listen, it takes less than three days to find out that Hofer is right" (25); but this was too hopeful. Hofer's complaint was echoed by the majority of Germans, who did not see themselves as Nazis even if they had sympathized with some of the regime's policies in the past. But it was by no means easy to follow his advice—either as a Military Government or as an individual Allied observer—and Speier's difficulties provide the best example of that. Talking to Germans he had not known before, he again and again experienced a profound uncertainty as to what and who they "really" were because he could not be sure that they had not "somehow" been Nazis.

In the eyes of the outside, and especially the American observer—and here the emigré's perspective may have had some general, preparatory influence—it was not possible for a German merely to have been "not a Nazi." To be accepted as "not a Nazi," a person needed to be perceived as distinctly anti-Nazi; otherwise that person could not but have been a Nazi—at least on some level, in some ways, by some sort of assimilation. Describing a visit with a German couple who were friends of a colleague, two highly educated physicians who spoke fluent English, Speier mentioned their urgent interest in the suddenly "real again" world outside—American newspapers, books, people, plans, opinions. But his first observation was that they were "said to have been anti-Nazis, and this seemed quite possible to me, although one never knows" (20). These people, he had been told, were representative of the politically desirable democratic potential of the middle class. He noted that they seemed to have some privileges—one of the rooms in their house was heated on that cold but not yet icy evening in late October (probably for the benefit of the visitors).[7] They also served apricot brandy, "something quite unattainable for people without connections." Still, they did suffer from the general dismal lack of food: day in, day out, potatoes and cabbage and roasted acorns for *ersatz* coffee and *ersatz* fat. The woman was reluctant to complain, but the man mentioned that in medical reports for the public health authorities he had "stressed the fact that except for the very high incidence of venereal diseases, the health conditions of the displaced persons are much better than those of the Germans" (21).[8] This comparison, ill-advised in the circumstances, might have influenced Speier's judgment of the German couple, whom he thought to have retained "certain reactionary attitudes." By way of example, he listed their contempt for "the common people" (which he shared); their warning not to allow "real" freedom of expression for all Germans before reeducation (he himself habitually invited but in fact did not welcome German "freely expressed" opinion on American occupation policies); their "ready" belief in "the many reports of rapes by Russians" (the Americans habitually dismissed all reports of rape by Soviet soldiers, even though it concerned an extraordinarily large number of women who differed greatly as to background and age);[9] their questioning of the policy and practice of denazification and expressions of

sympathy for a colleague who had lost his license because of party membership. Speier's comment on this last example of their "reactionary" attitude: "I don't think they have any idea of what the Nazis have done in Europe" (21).

This reproach seems somewhat gratuitous since denazification was already known to be ineffective and frequently unfair; besides, the couple had presumably been against Nazi policies. But to Speier, who self-consciously looked at that German chaos from the position of the occupying American who had once been German, the difficulties of understanding different degrees and modes of German "taintedness" by Nazism and the resulting questions of guilt and liability were considerable. Like all their compatriots, these people, "good Germans" in many ways, appeared to him simply "confused, ill-informed, and terribly eager to talk about their own problems." He thought them "entirely unaccustomed to discussion"; when contradicted, they "keep silent or apologize as though they suddenly realize in fear how much they depend on American friends" (21–22). Their reticence was presumably linked to their inability to free themselves from the thrall of totalitarianism. But as Speier's own reactions clearly showed, those American friends did not wish to be surprised by Germans who contradicted the victors' views on the German question: that question had been posed in terms chosen by the victors, and they were in no mood to consider changing them.

If the harsh realities of the war and its aftermath raised some inconvenient questions, these did not have to be taken seriously. As long as the Russians were still American allies, reports on the problem of rape simply had to be considered exaggerated, regardless of the evidence. When Speier, from his reserved seat in the first row of the improvised bombed-out Frankfurt opera, saw too clearly for comfort the "emaciated faces" of actors and musicians, he mentioned it to his wife (22). He also dreamed that a German told him how well fed he looked. Yet he would not ask what consequences enduring, systematic malnutrition might have for the people he observed and judged.[10] His lack of imagination in this respect may be understandable; but like the Germans' preoccupation with their own losses when they should have been grieving for the victims of the Nazi regime, it indicated an isolating self-centeredness. If the German view of what Nazis had done to Europe was inadequate, so was Speier's vision of what the war had done to the Germans. It could hardly have been otherwise: the victory was too perfect, too pure, and the distance between victor and defeated too great. It could do nothing but distort and further diminish the vanquished.

Only when visiting old friends could this distance be overcome and could the German experience of that total war be discussed in some detail since it concerned the survival or death of relations and friends. This experience seems to have been of no interest to Speier otherwise. He did complain repeatedly that none of the Germans he talked to had asked about the fate of emigrés—a sign, he thought, of their immature, even immoral self-absorption. There was one exception—the theologian Rudolf Bultmann, whose uprightness, lucidity, and lack of self-importance he justly admired (52–53). In contrast, Speier was negatively impressed by Karl Jaspers, who had once taught him Hegel. Preoccupied with the question of German guilt and eating his turnip dinner without complaint (though his Jewish wife, whom Speier found equally unlike-

able, complained mightily and declared all Germans to be hateful), Jaspers did not ask about anyone in the U.S.

Speier was above all irritated by Jaspers's fluent disquisition on the question of German guilt, which seemed to him to preempt all questions. It was the German professor lecturing the American guest. (At that time, Jaspers was working on his book, *Die Schuldfrage*, which was published in English as *The Question of German Guilt*; it was a book that would have great influence on the discussion of the issue in Germany.)[11] Speier also thought harmful the philosopher's distinction between German collective guilt and collective liability. Such a distinction, in Speier's view, had the effect of making it more acceptable to deny collective guilt and not encourage collective shame (38). And Jaspers's indeed overly pure "Protestant" separation of spiritual from political authority seemed to Speier another attempt "not to burden the Germans with too much responsibility for the continued existence of the Nazi regime once it had come to power" (38). These were the crucial questions then and still are now—hence Adam Michnik's interest in the implications for Poland and other former Eastern Bloc countries of the issues raised in the recent Historians' Dispute in Germany.[12] To Speier, who was viewing the piled-up German "ashes of disgrace" from a secure distance, it seemed quite clear that Jaspers did not face

> the moral problem of German behavior at the time of Hitler's rule, that at issue was not only the rigoristic and unrealistic alternative of heroic resistance to the regime and possibly death vs. support of the regime. Indeed this alternative was not the real dilemma for the vast majority of the Germans. Between these extremes lay the important questions for those people not made of the stuff of heroes or villains: When did I make an unnecessary compromise? When did I look away? When did I endorse something the Nazis did because I thought it was not so bad after all, or in fact, quite good? (38)

Making these reasonable suggestions, Speier, like most outside observers, did not take into consideration the temporal, gradually changing German experience of the Third Reich. In looking back at their former selves, Germans needed to ask these questions not so much in static moral terms—whether they "ought" to have acted differently—but in the fluid psychological terms of feasibility—whether perhaps they could have acted differently. These questions needed to include their past perception of past conditions: could the compromises they made have appeared unnecessary under the terms of their existence at the time. And, more importantly but also more precariously, might they not have been able to see at a certain point that things appeared different and that they could therefore no longer afford to look away. However, under the victor's, Speier's, watchful glance, they were not allowed such hesitations but were expected to embrace the terms on which they were now judged and to acknowledge they had been disastrously wrong from the beginning. In the absence of a full discussion of these terms—an understandable absence because of the scope of aggression and defeat—questions were more often than not replaced by summarily ordered and accepted collective responsibility and, by extension, guilt. But no matter how terrible the consequences of their compromises, the consequences were the result of decisions whose full wrongness could be recognized only from hindsight, from the position of

temporal distance. If the victors demanded the acceptance of collective guilt and shame on their terms, these were the relative terms of military and political power, though they were presented to the Germans as the absolute terms of humanistic morality set against the absolute evil of Nazi crimes.

In a situation of profound rupture between past and future, Speier and other outside observers saw "the Germans" as uniform products of a uniformly evil past that needed to be remade completely. In the chaotic present, suspended in that unreal moment of transition, they seemed not really human. The nature of the victory over Germany made it impossible to see the vanquished in their normal temporal complexity. Speier would like to have asked Jaspers why he did not leave Germany in 1933, since "any university in any country of his choice" would have welcomed him and his exile would have served as "a symbol of resistance" (38). In the terms established by the question, emigration would have been the responsible choice of a good German. But what kind of resistance does this imply? The "heroic" resistance Speier himself thought possible only for a very small number of people? Or the small-scale daily sabotage of the Nazi regime based on not looking away and not making what from hindsight appeared to be unnecessary, indeed dangerous compromises? At the time, even this kind of resistance appeared to be a dangerous option that the vast majority of "average" Germans—during the war mostly women trying to get their children through one day at a time—did not think they could afford.

Calling for collective responsibility, Speier expected too much of individual responsibility. He expected the individual who had somehow, despite everything, managed to be and remain what, after the collapse of the evil Nazi regime, American observers could call a good German. There was considerable irony in the use of this term since what Karl Marx referred to as "Deutsche Misere," German political backwardness, was caused precisely by the fact that most inhabitants of Germany, Jews very much included, had been excellent Germans and poor citizens. If any lesson could be learned from the German catastrophe, it was that in politically difficult situations, good citizens are more likely to be men and women capable of socially responsible conduct. In dark times of profound political polarization, violence, and total war, almost all people need some kind of psychological support from larger, sociopolitical or religious structures—hence the overrepresentation of Communists, conservatives (from the nobility), and Christians in the resistance to the regime. After its collapse, many of these good Germans would, like Jaspers, ask what this meant for Germans. Speier found this concern deeply disturbing: "Again, even men like Jaspers—who probably were among the best Germans we left behind us in 1933, or at least the most thoughtful ones—appear not to have realized what the Germans did to Europe. Instead, they concentrate on what the Nazis have done to Germany" (38). But these good Germans needed that focus because they wished to reject the equation German = Nazi, an equation that Speier and many, if not most, Allied observers accepted in 1945, at least on some level, despite statements and intentions to the contrary. From hindsight, both positions are understandable in that situation; they were also irreconcilable and the cause of much misunderstanding, then and later.

Shortly after the war, Jaspers's wife, Gertrud, was to complain to Hannah Arendt that her husband, sharing her restricted life in Heidelberg during the Hitler regime,

had tried to encourage her by saying, "Trude, I am Germany." She had found that "too easy." Jaspers of course had done so with the best of intentions; he had meant to emphasize that his Jewish wife was as German as he and that they must not allow the Hitler regime to convince her otherwise.[13] Notwithstanding his good intentions, Jaspers had not been able to understand in concrete detail the exclusion and isolation imposed on his wife and all other German Jews after 1933. Instructively, Jaspers focused the huge troubling question of "Germanness" and political responsibility on his own culturally significant person, a German philosopher trying to sort out the meanings of German guilt. Thus he wrote to Arendt that now, after Germany had been destroyed "in a sense and to a degree and with a finality which almost nobody here fully understands," it was again possible for him to be unselfconsciously (*unbefangen*) German.[14] Here, too, he spoke with the best of intentions, attempting to make clear to his former student that he had separated himself from his past position of what could broadly be termed cultural nationalism.[15] But if he had then seen himself too unquestioningly as the voice of German cultural greatness, he now seemed in danger of appropriating too easily the significance of the German catastrophe.

Discussing the German question in extensive postwar correspondence with her admired teacher, Arendt seemed to take in stride Jaspers's preoccupation with the meanings of being German.[16] His posing the "German question" from a position of personal identification with a German high culture both ruptured and enduring seemed less alien to her than to Speier, who was irritated by the elitist self-centeredness of this position. Though he did have a point, there was also a good deal of American democratic utopianism in his expectation that discussions of the highly complex and emotional issue might or ought to arise spontaneously everywhere, without guidance of some kind from the intellectual elites. Indeed, together with physical hunger, hunger for such guidance and for the reassurance found in renewed access to European high culture—theater, opera, concerts, lectures, exhibitions, books, journals—was the single most characteristic aspect of the immediate postwar period. Moreover, since the issue was not the "Nazi question" but the "German question," that is, the question of German guilt and shame, Germans needed to ask themselves to what extent and in what ways German political, administrative, scientific, and humanistic culture had contributed to the resistible rise of a criminal regime for whose atrocities, committed in their name, they were now held responsible. How could German culture have been coopted so rapidly? What had the Nazis' unprecedented exercise of political violence done to Germany?[17] Here Jaspers's treatment of the *Schuldfrage* turned out to be more realistic and useful in some ways than Speier might have expected.

It was not that Germans on the whole rejected the idea that they, as a people, had somehow shared in Nazi crimes. In *The Trial of the Germans*, Eugene Davidson rightly pointed out that outside the courts of law, where the question of collective guilt was avoided, many Germans felt it a burden they had to cope with. Christians met "in solemn sessions to confess their responsibility for what had happened"—Martin Niemöller's voice in support of collective guilt was one of the strongest.[18] Collective guilt "clung to millions of Germans despite the philosophical and historical demonstrations that it could scarcely exist."[19] Jaspers, in *The Question of German Guilt*, emphasized that "individual, criminally accused Germans" were on trial at Nurem-

berg. He pointedly quoted the Chief Prosecutor, Justice Robert H. Jackson, who stated at the opening of the tribunal that there was no intention to accuse the entire German people, who had not voted in their majority for the Nazi party: " 'Indeed the Germans—as much as the outside world—have an account to settle with the defendants.' "[20] Jaspers, who was intent on helping his readers face the double issue of their political victimization and moral responsibility, showed remarkable social and psychological insight. He explicitly put himself in the place of the many Germans whose attitude toward the Nazi regime had not been as unambiguous as his. He also explicitly granted the importance of experiences of danger and loss that he had not had. More importantly, he did so in the belief that such a temporary shifting of position would be a learning process for him, too. Even if he had not participated in most of the illusions and evasions of Germans during the Nazi period, he included himself in the German question and identified with the fall of Germany—into the hands of the Nazis, into the chaos of mass destruction—as a political and cultural catastrophe.

In Jaspers's inclusive view—one that was inaccessible to an observer like Speier, whose perspective was exclusive by nature of his experience and the situation—German acceptance of moral guilt would motivate the search for common ground in a situation he described as "common non-community."[21] After the collapse of totalitarian solidarity and its corrupt language, the greatest need was to talk to one another about the immediate past and to break the twelve year interregnum of silence. Thus articulated, the necessary common ground was a position that would enable Germans to acknowledge that no one was guiltless—this was the most important, much repeated message of the essay. And this message was helped immeasurably by the fact that, speaking about sharing moral guilt, Jaspers made it clear to his readers that he was speaking *to* them, not *for* them, that he saw himself as one of them:

> Morally man can condemn only himself, not another—or, if another, then only in the solidarity of charitable struggle. No one can morally judge another. It is only where the other seems to me like myself that the closeness reigns which in free communication can make a common cause of what finally each does in solitude. (39)

This respect for the individuality of the other person, even where the issue of German guilt was concerned, effectively helped to instigate and promote its discussion. Jaspers's approach to the German question was informed by a diagnostic and therapeutic empathy—he was a physician before he became a philosopher—with the psychological difficulties faced by Germans. Collectively accused of and held responsible for a uniquely aggressive militarism and anti-Semitism, they had come to resent the accusers. Sensibly, Jaspers dealt with these issues in psychological rather than moral terms, explaining that these difficulties were to be expected and could be overcome by a process of honest and spontaneous self-questioning (90). He also thought it permissible for post-Nazi Germans to bring up examples of unfortunate political decisions made by their accusers, decisions that had aided, at least indirectly, the ascent of Nazism.[22] But the point of this therapeutic approach was to help his readers acknowledge that as a nation, the Germans alone were guilty of starting the

war—even if as individuals they had not wanted it, that they were guilty of commit-
ting unparalleled atrocities against humanity—even if they had not been aware of it.[23]

Yet there were also certain serious drawbacks to Jaspers's insistence on moving the
whole question of German responsibility and guilt into the personal sphere where it
could be analyzed and clarified "independent of outside charges, however much we
may hear and use them as questions and mirrors"—even though the pressure of
outside charges was partly responsible for this move. If Jaspers shifted the emphasis
from understanding the issue of collective political responsibility to healing the minds
torn and soiled in the chaotic politics since the first war, he did indeed gain access to the
general experience of cultural confusion and conflictedness. But he also presented the
issue of collective moral guilt as something inescapably and therefore perhaps signifi-
cantly German: a shared spiritual Germanness had created greater susceptibility to
destructive political totalitarianism, and Germans would now contribute—perhaps
more than other people—to the "entire task of renewing human existence from its
origin" (81). In addition, Jaspers's position reflected a lack of political, historical
realism in that it did not encourage a more rigorous inquiry into the sociopolitical
genesis of German moral guilt.

The text on which Jaspers drew extensively for his *German Guilt* was Wilhelm
Roepke's *Die deutsche Frage*, first published in Switzerland in 1945 and translated into
English as *The Solution of the German Problem* in 1947.[24] Roepke was most emphatic
about the uselessness of a concept like collective guilt, whether in political, legal, or
moral terms. In his view, the majority of "Germans were the first victims of the
barbaric invasion which swamped them from below."[25] But he also insisted strongly on
specifying and defining the guilt incurred by certain groups. While only a minority of
Germans could claim to have lived up to their responsibility to dissociate themselves
from the criminal regime, another, much larger minority, consisting of political,
financial, industrial, and civil service groups, had indeed become guilty in concrete,
specific terms. And in his own comparatively large group, the intellectuals (in the
academic world, the media, and the arts), Roepke found an unpardonable abdication
of responsibility. Germans bear a "legal responsibility"—Jaspers's "liability"—for
the damage done by their regime in their name; as a group, they bear a "historical
responsibility for the faulty development of the German Reich since the time of
Bismarck":

> It is quite a different thing, however, to establish a collective responsibility of all
> Germans in the sense of a real partnership in a punishable crime for which we assume
> them to be guilty because they happen to have this passport and this domicile. Let us
> stress most emphatically that this is simply a barbaric notion that would lead us back to
> the darkest periods of mankind when group responsibility still took the place of
> personal responsibility. As Christians we ought to know that it is nonsense to speak of
> "collective guilt" because guilt is always personal.[26]

Yet such a concept of "personal" guilt was not fully accessible to outside observers
unless it was posed in legal terms. Their views of German self-questioning were
therefore shaped, at least in part, by expectations that it would result in the acceptance

of collective responsibility which, on this level of generality, could be easily equated with collective guilt. Speier observed one instance of such self-questioning when in November 1945 he participated in a test-showing of *Die Todesmühlen* (The mills of death)—the film Erich Kästner would see three months later, in February 1946, and find too difficult to review.[27] It was the first film about the concentration camps shown to Germans in the public space of a movie house. A number of good, or at least satisfactory Germans were there by special invitation: the Oberbürgermeister, the heads of political parties, some licensed newspaper editors, a Protestant minister, some officials from the Office for Displaced Persons, and former inmates of concentration camps—two of them Communists (who, according to Speier, dominated the discussion). In contrast to them, the general audience did not know that they were attending a test showing and that American soldiers placed among them listened in on their conversations to get a sense of their reactions. After the showing Speier led a discussion of the film attended only by the invited Germans (32).

In his brief description of the "contents" of the film, Speier, like Kästner, listed "all the horrors we are now familiar with." He found the film "almost unbearably powerful," precisely because, like Kästner, he responded to its emphasis on factuality over emotionality. He also thought the film refrained from preaching hatred or pity and in this respect seemed "far better" than the atrocity pictures or newsreels, both American and Russian, he had seen in New York. (Hatred and pity would, of course, inevitably be present in the messages of the harrowing images—hence their great power, feared by the experienced film critic James Agee.)[28] Speier noticed that he was trembling when the title appeared on the screen; the audience "sighed audibly at the worst scenes of horror. It laughed sarcastically once when a German officer hesitated to visit the dungeons and was complimented into them (gently) by a GI" (31). Nobody walked out. With everyone talking "freely and without any fear" during the discussion, several issues came up and were voted on: there was a unanimous "yes" for showing the film and for showing it "as soon as possible" and not, as had been debated, in connection with the war crimes trials or after the winter when people would be less preoccupied with the ever more severe daily difficulties of obtaining food and fuel. Those participating felt it should not be shown to children, but that attendance should be compulsory for adults; indeed, according to a vote that was unanimous but for one (the pastor's), it was decided that receiving food ration cards should be tied to attendance.

This policy would have been difficult to enforce, quite apart from the fact that, as Speier pointed out, there were not enough movie theaters to show the film. On the whole he declared himself to be greatly encouraged by the discussion because it showed that "misery does not necessarily blunt the mind or darken the heart beyond hope" (33). (This assessment was somewhat misleading since this select group was in better moral and physical condition—most of them would have had higher food rations—than many other Germans. Still, some of them seemed to him "affected by the totalitarian way of thinking," for instance in the way they talked about "the Germans." But here he evidently did not realize that, with very few exceptions, and he was not among them, this was exactly the Allied, that is, American perspective. Speier also found traces of totalitarian thought in the discussants' decision that people should "be *forced* to see the film." At the same time, he shrewdly pointed out their "need to

prove where they stood by aggressive anti-Nazism—a symptom of the difficulty any German has today in finding his moral bearing, in using his freedom, in proving his worth—particularly when Americans are watching him."[29] In his view, the discussants had not been overtly self-conscious in this respect, except for the former camp inmates, who had insisted on the absolute authority of their experience in all aspects of the "German question." At the end of the discussion, when an elderly woman asked quietly whether this film, if shown abroad, would not deepen the hostility toward the Germans, one of them "snapped back, 'Of course it will.'" Speier, who thought this man too assertively good a German, pointed out that projecting a general reaction to the film was as difficult abroad as it was in Germany: "Everything depends on the people who see it, their past experience, their beliefs, their ability to grieve" (33). He had meant to mediate the conflict; but there was no getting around the fact that such grieving would be essentially different in Germany and abroad—both because of the "German question," German collective responsibility for the atrocities regardless of individual conduct, and the degree of Germany's physical and psychological devastation. Clearly, Speier did not think that in 1945 Germans could afford to grieve for their personal losses, their dead relatives, friends, the loss of their homes, their culture, and their sense of themselves in a world that no longer existed. They were expected to focus on the losses of others caused by a criminal regime in whose place they now stood accused.

Speier's articulate, perceptive, and in many ways remarkably fair observations of Germany in 1945 were shot through with "oughts," directives, expectations—a moral voice he thought Germans would do well to internalize if they were serious about "mastering" the past. But this clear and distinct perspective on their responsibility and guilt was possible only from a great distance. Some of Speier's impressions were spontaneous—for instance, his shocked view of the eerily other-than-human life in the ruins. But he did not allow these impressions to have much bearing on his sense of how Germans ought to pose to themselves the "German question." When he came back in early March of 1946, he seemed less certain about what Germans should feel and do and more openly dismayed by what the Allies did not seem to feel and do. He was no longer required, as he had been in the fall of 1945, to put on a uniform when speaking to Germans. But if they were no longer seen as the enemy, their daily lives under the overpowering rule of hunger and cold were still totally separate from those of the occupation forces, and on this second inspection trip Speier would have almost no opportunity to speak with Germans. He was troubled by the British cutting further the already extremely meager food rations in their zone: "It will be *very* bad, and only God knows what will become of it all. How lucky we are! How unbelievably lucky everyone is who lives in America and not in Europe as a 'native'" (59–60).

But in March 1946, and for some time to come, Germany was not "Europe"—as Speier must have known. The British publisher and philanthropist Victor Gollancz, who was of Russian-Jewish background, wrote numerous articles and pamphlets on the difficulties faced by Germans in the immediate postwar years, especially on the food situation, which was quite desperate. One of the worst spots was in the British Zone, the industrial Ruhr area, where the official 1,500 calories per person in October

1944 had gone down to about 1,000 calories by May/June 1945 (it would drop to below 850 calories in the spring of 1947). Gollancz dedicated his 1946 pamphlet, *Leaving Them to Their Fate: The Ethics of Starvation*, to the "memory of my friends Renée and Léonce Bernheim, of Paris, who suffered and presumably died under the Nazi terror, but would have wished that, when the war was over, all suffering should cease."[30] In Gollancz's view, British newspapers provided clear documentation that those wishes were not fulfilled. In late March 1946 there were reports of workers in the Ruhr area collapsing from hunger, their faces "earth-colored and hollow-cheeked," and of long food lines in the ruins. Willy van Heekern, a photographer in Essen, recorded the effect of the starvation diet on children. The children are not presented merely as "objective" examples of severe malnutrition; the viewer sees these bony little figures and an equally emaciated physician sharing his and the photographer's concern (fig. 4.4). In Hamburg, starvation had become visible in late March in yellow faces and dejection; more than seventy percent of the population was without bread, having eaten the skimpy monthly ration during the first two weeks of the month. An aggressive advocate for greater fairness, Gollancz held British "willfulness" responsible for the deteriorating situation: "we are starving them not in the sense that we definitely want them to die, but willfully in the sense that we prefer their death to our own inconvenience." Since the official announcement of German placement "at the end of the world's food queue," Gollancz wrote (13), the choice between "discomfort for another and suffering for a German" had to be German suffering; the choice between "suffering for another and death for a German" had to be that the German die (4). This was indeed, as he himself admitted, "a grave charge," but he could substantiate it—if the basic assumption was that in the all-important question of food, no distinction should be made between the victors and the defeated.[31] This is a position difficult to accept at any time, but especially in a situation of British apprehensiveness, justified or not, that their own food standard might fall if more grain supplies went to Germany.

In a speech at Hastings in March 1946, Field Marshal Montgomery prefaced his announcement of the cut of rations in the British Zone to 1,000 calories by telling the audience that upon taking command of the occupied country he had reassured Germans that "getting their country right again was really a matter for them, but the British Forces would help them and give them food, housing and freedom from disease." Pointing out that the Belsen rations had been 800 calories, however, he asserted that "the big overgrown Germans have got to tighten their belts. . . . I believe that 75 percent of the population remain out-and-out Nazis." No food parcels were to be sent to Germany despite the spontaneous response in England to the miserable situation of refugees from the east: "The amounts would be too small to make any difference to the 23 million people concerned. If you have any food to spare in this country it is wanted here. I would not take any food from England to feed the Germans. Nor will there be any taken."[32] Where Montgomery was more rigid than might have been expected, Gollancz and others sharing his concerns were fairer than could have been hoped. One of the critics of British food policy quoted by Gollancz warned on March 10 that unless 150,000 tons of wheat arrived in Germany before the end of the month, the people's rations would not be 1,000 calories but 700 or even 450. Like Montgomery, he referred to Belsen—not in defense of British food policy but in

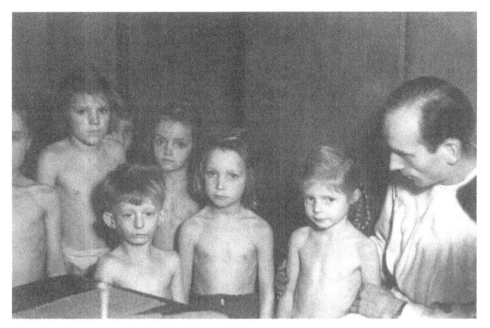

FIG. 4.4

order to clarify certain aspects of British retribution for Nazi crimes that would appear to imitate Nazi policies.[33] As British reporters discovered, hunger is an effective killer:

> Famine does not sweep a countryside like war—it creeps slowly through great cities and is realised only gradually as small stores of food dwindle and each week there is less and less to replace what has been eaten. Hunger is a grey thing and it kills drearily, masking its killing in a hundred ways. Famine must go on for months before this visible horror of starvation comes; there is a swelling tide of illness and death among people who do not get enough to eat. (17)[34]

For ordinary Germans in the British Zone, the actual calorie ration was 815, something like two or three slices of bread a day and a cup of bean soup. Miners, if they were lucky, got a canteen meal consisting of soup, three thinnish slices of bread, and one slice of sausage—against regulations they took some of it home to their families.[35] The most important and desperate shortages were of bread and potatoes: "between the Ruhr and complete economic collapse is the slender barrier of two slices of bread a day."[36]

Gollancz did not wish to criminalize and then punish Germans collectively because that would have meant making them a special category of humanity—precisely what the Nazis had done. For him the concept of civilized humanity signified inclusiveness. The issue was not "pro-German" or "anti-Soviet"—his critics' definitions of his critical postion—but "pro-humanity," and here the argument "but look at what they did to others" seemed irrelevant (33–34). Thus he argued that the imposition of unconditional surrender (agreed on at the Moscow conference in October 1943) carried with it Allied responsibility for Germany—a responsibility that had not been

taken seriously. The Ruhr area, for instance, had always depended on food imports from other parts of Germany and from abroad. The current famine, he said, had been produced "by our own acts, just or unjust—and I for my part think them abominably unjust—and a famine over and above what would in any case have resulted from war or acts of God." He thought it impossible for a civilized person to refuse now to help alleviate the results of the Potsdam agreements, which had cut off some of Germany's richest food-producing territories and divided the country into four strictly separate zones. Moreover, the Potsdam policy of mass expulsion of Germans from the eastern provinces had swelled disastrously the populations in the zones.

Approaching a morally and politically conflicted situation with an unusual degree of social intelligence and goodwill, Gollancz had learned from the German catastrophe that Allied victory over Nazi aggression and exclusion would not be complete if it bred its own kind of aggression and exclusion. In his view, British acquiescence in accepting a dramatically different food standard for Germany signified a serious threat to civilized values.[37] A similar argument had been made by Maurice Edelman, a member of Parliament, in an article published in *Picture Post* in late 1945: "Wanted: A Policy for Germany." Edelman found it unacceptable to respond to the suffering of the German civilian population with the comment: "you brought it on yourselves," or "the suffering caused by you was worse." "Those arguments, while being true, do not take into account that we should treat fellow human beings, not by Nazi standards, but by the standards of Christian civilisation; and that self-interest, quite apart from common humanity, demands that we prevent the Germans from suffering the disastrous epidemics which accompany famine and know no frontiers."[38] In an article published in the same journal some months earlier, "Report on Chaos," Lorna Hay had pointed out that she expected "the worst suffering, the greatest area of starvation" to be among the German population. "German misery this winter will be on a scale unknown in Europe since the Middle Ages. It may be that those who have not seen the beginning of this misery will not be impressed. They may say: 'The Germans deserve it. Why should we worry?' Maybe they do deserve it. But do our armies of occupation deserve to be set down in such country, or to be asked to face the consequences of the breakdown of civilised life among a population of nearly 90,000,000?' "[39] These are views found perhaps in some of the images but not in the texts published in *Life* at that time.

In early 1946, Germans in all zones had to cope with severe malnutrition, total lack of fuel, the absence of medical attention, medicines, a severely truncated, chaotic transportation and distribution system, erratic water and electricity supply, and a very high mortality rate among children and old people. But in addition, Speier noted, they were increasingly unsure about crucially important Allied policy questions involving, for example, the fate of the industrial Ruhr area, or a central government for Germany. Refugees from the east were still streaming into the skeletal, largely nonfunctional cities, armies of POWs released from British and American camps were still trying to find their families, and the whole population, including children, appeared to be in constant motion searching for food and fuel (figs. 4.5, 4.6, 4.7, and 4.8). In view of all of this, Speier felt compelled to point out "the futility and naïveté of our efforts toward 'reeducation.' " They are, he wrote, "quite a mess and I cannot help fearing that the

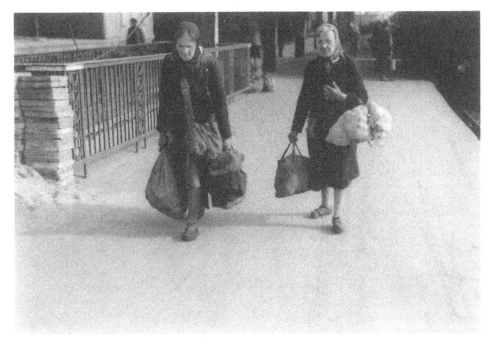

FIG. 4.5

Communists may be the winners in the end" (63–64). In Nuremberg which he found
devastated beyond belief, Speier suddenly heard the eerie sound of a child crying from
underground and wondered whether the ruins had caused him to hallucinate. He
quickly found the "simple" explanation: underneath mountains of debris, there were
people who had no place to live but the caves built as air-raid shelters. He did not see
them and did not search for the entrance to this "subterranean life" (64).[40]

Speier was appalled by the human cost of the destruction but also relieved that it
did not concern him after all. The mistakes made by the Military Government (pre-
sumably in the name of Americans), were not his. Without comment he described what
he saw in the early hours of a cold March morning at the Nuremberg station, which
was flooded with people who could not leave because of the curfew, who had no
control over what train they might get on: "There were women with black scarves
around their heads, children, dismissed prisoners of war with rucksacks, old men with
rucksacks, everybody keeping some belongings in a rucksack—all these people milling
about inside the station, or half-asleep on their rucksacks waiting for the morning"
(64). What he noted suggests that he did not think these perpetual migrants could
"really" be asked to grieve for what Germany had done to Europe. They were too
diminished by the effort it took merely to survive. They were also painful to look at; he
could not wait to get home.

Would Speier's view of Germany as a moonscape covered with the "ashes of
disgrace" have been different if he had met different Germans? It is intriguing to
speculate what he might have learned from an "inside" observer such as Ruth Andreas-
Friedrich; her diary entries from 1945 to 1948 give a vivid account of her and her

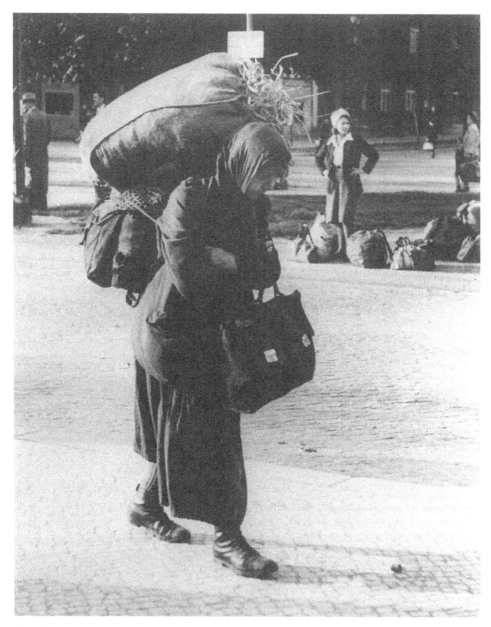

FIG. 4.6

friends' lives and thoughts in the ruins of Berlin. *Battleground Berlin* is the continuation of the diary she kept from 1938–45 on her underground activities in Berlin, where she helped people persecuted by the regime to emigrate or, when that was no longer possible, to go underground.[41] She had begun her journalistic career in the twenties, concentrating on women's topics; in the postwar years she was the licensed copublisher of the weekly *Sie*. At her death in 1977, *Israel Nachrichten* lauded her as "one of

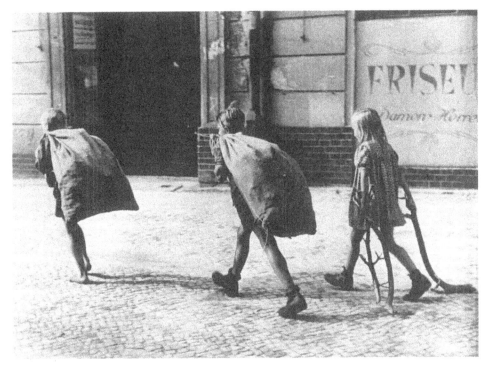

FIG. 4.7

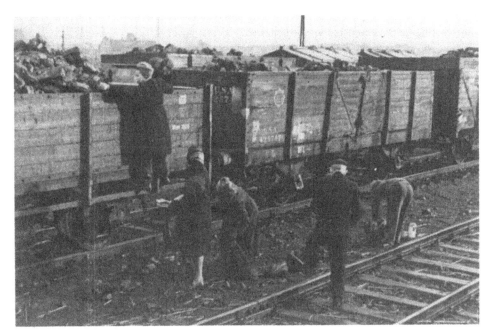

FIG. 4.8

those just Germans who saved the reputation of her people during its worst time. May her memory be blessed."[42]

Unquestionably a good German, Andreas-Friedrich would probably have been pleased by this appreciation but doubtful about whether she was *being* just, or merely acting justly in accordance with her perception of a situation. An unusually realistic activist, she would never have seen her group's work as "saving the reputation of her people." "Her people" were the company she chose, not a group she had been born into by chance. And she would not have presumed that their "reputation" depended on her acts. Had she done so, her diary would not have turned out to be useful to the reader half a century later. Its most instructive aspect is precisely its perspective of uncertainty, of dialogical openness, even confusion, where the large issues of the immediate postwar period were concerned: the quality of Allied victory and German defeat as it defined the "German question." Being a good German, she found, did not help all that much in the postwar mess; in certain important ways it had been easier when she was fighting her criminal regime and knew what was right, that is acceptable according to her standards, and what was not.

Andreas-Friedrich's diary begins with a forced evacuation by Russian soldiers during the last stage of the final battle for Berlin. Banished from their relatively safe, familiar cellar, four men and three women, the remnants of the resistance group "Uncle Emil," stumble onto a one-room basement apartment in a badly damaged apartment house. Dragging all their belongings in twenty-nine pieces of luggage across a cemetery that until recently had been a battlefield, they came across a number of dead German soldiers. The promise "Faithful unto death" inscribed on a tombstone makes her ask: "Faithful to whom? The Nazis? The Fatherland? The oath of allegiance? The silent dead are the silent answer. 'To yourself . . . only to yourself. . . . ' "[43] But recording her life in the ruins, even she cannot be sure who that might be and what "faithful" would mean in this case.

One of the photographs of *Notbestattungen* (emergency burials) preserved in the photo archive of the city of Berlin shows a cross made of birch branches with three helmets—three dead soldiers—taken in the summer of 1946 by the photo reporter E. Guilka (fig. 4.9).[44] They had fallen at the shore of the Havel, which, a year later, was busy with svelte and pretty young women in bathing suits working on a tan for the benefit of their American boyfriends. What did these three men die for? For the young women walking past their grave without even a glance, their death was part of a past that needed to be forgotten—the point of the juxtaposition of visual messages "caught" by the photographer. Left behind, the women would try to survive as best they could; if they were young, attractive, and unencumbered with children, they would do well. As the chaos ebbed, the separation of those who would be free to enter the future and those who would have to remain in the past became more clearly visible. The separation happened along the lines of age, of region (in some regions the traumas were much more severe than in others; what later became East Germany was left behind most literally), and of gender—millions of young and middle-aged men were dead, mutilated, imprisoned (see fig. 4.10). These unevenly distributed experiences of loss and the psychological difficulties caused by them added to the cultural and political problem of an "unmastered past." The young German-Jewish photographer

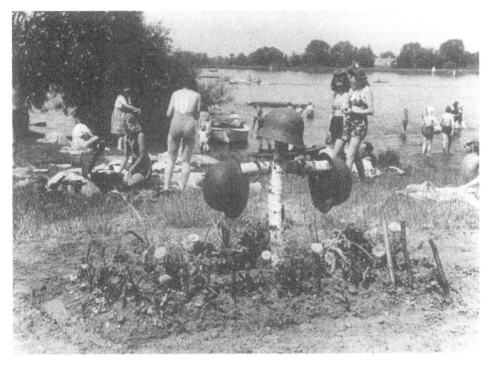

FIG. 4.9

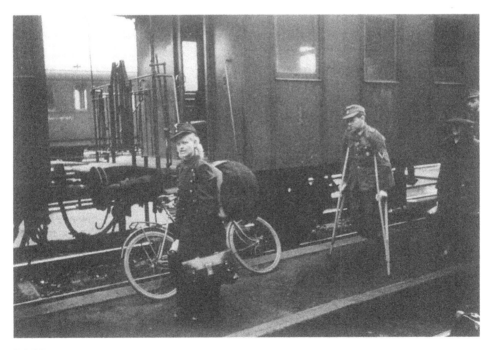

FIG. 4.10

Henry Ries, who left Berlin in 1938 and came back to Germany in 1945 as a photographer in the U.S. Army Air Corps, took a series of photographs at Anhalter Bahnhof in the summer of 1948.[45] People passing through the ruins of the station were still unsettled and disturbed, many of them continued to carry everything they owned in the omnipresent rucksacks—sitting on them, sleeping among them. POWs were still coming back from Russia, most of them aged and weakened beyond belief. But the worst confusion was over; the currency had been reformed; things and people had begun to sort themselves out.[46]

Among the images in this series are contrasting photographs of a young and an old woman.[47] The first shows a pretty young woman leaning against a railing, relaxed, legs crossed nonchalantly, holding a smart hat in one hand and a cigarette in the other (fig. 4.11). A light coat is hanging over the railing next to her, and a suitcase, remarkably solid for the times, is standing next to her. Photographed from below, half-smiling, enjoying the power of her prettiness, youth, well-being, and her American cigarette, she looks directly at the photographer and the viewer, blowing smoke at them. It is an intriguingly ambivalent image that can accommodate the viewer's conflicting responses. The young woman's attractiveness is ambiguous, her assertive intactness is both pleasing and repelling, her survival a challenge as much as a reassurance. She survived the disaster whole and can be expected not to look back except, perhaps, to reaffirm that the past was bad and did not bear remembering.

The second image is a frontal shot of an old woman sitting on the wooden bench of a third-class compartment behind a very large empty basket with backstraps, an old-fashioned tin lunchbox beside her. Where the young woman's physical ease and assertiveness is brought out by the perspective that makes her appear taller and her face even softer, the old woman's frailty, a sort of shrinking back into herself, is brought out by the camera's direct, frontal focus—aided by the light from the window—on her worn gentle face and work-roughened hands (fig. 4.12). The text indicates that the basket had been full of wildflowers that she picks to sell in Berlin—cheaply, because nobody has any money to spare; the generous tip to the conductor who helps her into and out of the train with the heavy basket and her train fare eat up almost all her "profit." She lost her husband to the Kaiser and her three sons to Hitler; the first one fell in France at twenty-nine; the second sank with his submarine a week after his twenty-seventh birthday; the youngest one is missing. She thinks he might still be alive in Russia, and whenever she sees returning POWs, she asks. A different kind of survivor, the past for her is not a storehouse of forgotten bad times. Uncomplaining and largely uncomprehending about how it all happened, she lives on with the memory of her sons, who were deprived of their future.[48]

Ries was a remarkably sensitive observer of such differences, taking care to see and impress on the viewer the specificity of difference: this particular young woman—this particular old woman. At the same time he illuminated the larger separations between those who remained whole and those who did not. Forty years later, in his preface to the German edition of *German Faces* (which includes most of the Anhalter Bahnhof images; see also chap. 3), Ries described his feelings on his first return to the city he had never wanted to see again. He was appalled not so much by the Germans he encountered as by the ghastly conditions in which they lived, by what he called the "gespen-

FIG. 4.11

stische Situation": it was a scenario of hunger, destruction, despair, and fear—a grotesque, "insane" contradiction of his memories of the city. He remembered himself in a group of well-fed GIs in clean uniforms, gathered on a Berlin street to salute the American flag, accompanied by the excited shrill of trumpets. A one-armed man had put down his rickety wheelbarrow in front of him and, taking off his cap, had looked at him with one remaining eye. For one moment Ries felt paralyzed by a rush of uncertainty: Who was that man? Who was he, Ries? Returning the suspicious or fearful gazes of the civilians on the sidewalk, who had made room for the American soldiers, he thought that he himself had been a civilian in this city when the whole mess started: "Was I better than they? Was the old man a Nazi? Or would he have been willing to help us, like my Catholic governess, who saved my life and my sister's? Did I have the right, would it not have been presumptuous, to judge these people whom I did

FIG. 4.12

not know?"[49] He did not judge; he photographed, content with recording what he saw. What he saw, of course, was a selection reflecting judgment. But what separated him from an observer such as Bourke-White was that he had not come to Anhalter Bahnhof to pose the "German question." He had come to look at individual Germans, and he showed their faces damaged by the violence of that terrible war; in terms of the damage done to them, the stories told by German faces were not really different from those of other groups.[50]

As Andreas-Friedrich dragged her heavy suitcases past the dead soldiers in a frantic search for a minimally safe place, the air still ringing with shots, she noted the senselessness of their death. Given the economic and political situation in which the Nazi party came to power, had there ever been any "real" possibility for them to be "faithful only to themselves"? Since they had been forced to fight, they needed to fight for something, if only not to let a buddy down. Andreas-Friedrich's diaries make it abundantly clear that what kept her going was the group whose ideas and ideals she shared. After the war, these ideas and ideals changed, the group eventually disintegrated, and she left Berlin for Munich to put the extraordinary experiences of war and its aftermath behind her. But while the group existed, it was crucially important to her ability to look at the chaos and record and reflect on what she saw. Talking to them, she could sort out the meanings of German defeat. Despite her group's active resistance to the regime, she was remarkably unconcerned about the question of collective guilt or shame, reacting instead to the concrete daily details of life under the occupation. The woman's perspective, too, might have helped her to see, hear, smell, feel certain things more clearly (she recorded the stench of the rapidly decomposing dead as well as of the slowly decomposing living, whose bodies reacted badly to indigestible food and even worse to its total absence). Freezing, emaciated, and weak from the starvation diet, a walking bundle of old clothes, she *was* one of the civilians Speier observed in the ruins, hoping that they were "not human" because they appeared so alien to him. Yet Andreas-Friedrich, absorbed in what could be seen and not unlike a photographer, seemed to be able to see herself from the outside as well. Establishing a double perspective, she was helped by the form of the diary with its spontaneous notations of events—notations that resist coherent narration, at least for a while. Like the photograph, a diary entry records and offers information in a sudden and fragmentary manner. It is only from the hindsight of having several entries over time that a gradual process becomes intelligible. The diarist is not self-conscious, or if she is, she is aware of her own self-consciousness, like a photographer who "plays" with perspective. Most importantly, like the photographer she is the one who sees and records, not the one who is seen and recorded; more precisely, she is seen only by herself, and this makes her more willing to risk being honest.

Looking at herself as well as at her companions and other Germans living in the ruins, she describes exploration trips for edible or otherwise usable things which the men are eager to search for and bring back to their "camp" in the basement. She also notes her uneasiness about taking things that others acquired for certain reasons, even if the reasons no longer exist. A Russian soldier tells them that things that belonged to others are called "trophies" (the GIs called them "liberated").[51] Where he has "trophied" wristwatches, lighters, gold rings, silver necklaces, they trophy boxes of

bouillon cubes and gumdrops, a horse blanket, a pair of rubber boots, small sacks of dried goods, some woolen vests, and finally, with Russian approval and bodily help, an ox they saw stumble into a bomb crater. The diarist's entry of 30 April 1945 reads:

> Five minutes later it is done. Five minutes later we all act as if we have gone mad. Brandishing kitchen knives, their sleeves rolled up, Frank and Jo are crouching around the dead animal. Blood drips from their hands, blood runs down their arms and trickles in thin lines across the trodden lawn. And suddenly, as if the underworld had spit them out, a noisy crowd gathers around the dead ox. They come creeping out of a hundred cellar holes. Women, men, children. Was it the smell of blood that attracted them? They come running with buckets. With tubs and vats. Screaming and gesticulating they tear pieces of meat from each other's hands. "The liver belongs to me," someone growls. "The tongue is mine . . . the tongue . . . the tongue!" Five bloodcovered fists angrily pull the tongue out of the ox' throat. Heike starts to cry. "How disgusting!" "Ah," a woman screams, and rushing away from the crowd, she spins around twice and then hastens away. Above her head she waves the ox' tail. (9)

Horrified by the intoxication of the slaughter, the diarist is also drawn to it, sharing the triumph of the woman running off to make soup from her booty. Combining repulsion and sympathy, her observational position is not much different from that of the Signal Corps photographer who took a photograph of a fallen horse on a Berlin street surrounded by a group of old people patiently and inefficiently hacking away at the cadaver.[52] Though the photo documents what hunger reduces people to, the caption on the back says simply, "Hunger in Berlin." The observer's perspective does not reflect incredulity or even lack of sympathy: along with the regression, he tried to show the vulnerability of the defeated. Being one of "them," Andreas-Friedrich is clearly troubled by the transformation of her group's seemingly harmless preoccupation with trophying into the bloody fight about pieces of raw meat. Yet she puts her feelings in the form of questions rather than judgments: "I sneak away. Never in my life have I felt so miserable. So that is what the hour of liberation amounts to. Is this the moment we have awaited for twelve years? That we might fight over an ox' liver?".(9)

Something has changed. Recounting a narrow escape from an intoxicated Russian soldier's attempt at rape, her expectations as to what might happen to her and to other people are now different. Where she was horrified by the psychological and cultural implications of the ox episode, a particular kind of dissolution that threatens to engulf all of them, she narrates the rapist's attack on her in the first person as a nightmare scenario so totally beyond her control that it is also beyond her ability to reflect on its implications (10). One of the men of her group "befriended" by Russian soldiers and observing their activities describes the collective rape in the ruins: "Like stuck pigs their victims were squealing in the cellars." The most frightening aspect of that night and many to follow was the inhumanity bestowed on the victim by these acts of aggression.[53] Her friend Andrik, who rescued her in the nick of time, was drunk: weakened from hunger and exhaustion, he was up all night drinking with the soldiers " 'so they would leave the girls. . . . ' The rest of the sentence is drowned by sleep. O Andrik, my dear guardian!" (10). But the hope that there might be guardians against this chaos is immediately perceived to be an illusion.

Increasingly Andreas-Friedrich felt that she could not impose her former identity on what she now saw and recorded. Living in the ruins of Berlin, she saw her expectations, plans, accusations, and excuses defeated. On the first day of May the war seemed to be over. She noted that the ruins were swarming with people who emerged from bunkers and cellars wearing white armbands. For the benefit of the Russians, women wore red kerchiefs fashioned out of Nazi flags. She was struck by this prompt refunctioning of symbols of alliance that seemed to indicate people's lack of trust in their own judgment. But she also acknowledged that her recent experiences—the slaughtering, the "trophying"—had done little to warrant such trust or, by extension, anybody's right to judge the other person (11). More than two years later, afraid of having to freeze and starve through another winter, it seemed to her that everything that had made their lives miserable since the end of the war had to do with the general unwillingness to put oneself in another's place: "Neither the non-Nazis in the place of the Nazis, nor the DPs in that of the non-DPs, nor the victors in the place of the vanquished." Instead, everybody was convinced that they would have acted differently, better, more responsibly, more effectively, criticizing everyone else, but never themselves (see page 189, 29 September 1947). There was a general feeling at the time that people had grown nastier rather than kinder after the war. Ernst Friedländer wrote a leader titled "Renazifizierung?" for the new weekly *Die Zeit*; in the article he quoted the proverbial man in the street, who spent most of his time waiting in line for the essentials, whether food or a stamp on a form: "Germans have never been as mean to each other as they have since the collapse." But in Friedländer's view this did not mean a trend toward renazification. In his opinion, the average German had been cheated of his own past by the Nazi regime: twelve years of a person's history turned out to be an illusion. The only effective denazification would be "disillusionment." Both the thesis of "collective guilt" and indictments of all of German history prevented rather than created greater understanding of the reality of the Nazi regime. The problem was not, in his view, to bring about radical change in individuals and groups, but to change values. Since the end of the war, the Allies' gravest mistake had been to see all Germans merely as Nazis and to seek punishment or revenge; in reality the issue was one of illusions. It was important to look at average Germans in their state of confusion and not to dismiss them as collectively bad. Very few people wanted Hitler back, but their enduring misery had not made them more judicious. In the opinion of Friedländer and many others, Allied and German attempts at reeducation had not worked; what was needed was radical rethinking.[54]

Friedländer, who had returned from exile in Liechtenstein in 1946, was an extraordinarily fair and realistic observer; his articles on different aspects of the German question in the first postwar years were among the most useful contributions to such rethinking. (*Die Zeit* was one of the few major publications to offer intelligent criticism of Allied policies, possibly aided by the fact that it was published in Hamburg, a city located in the British Zone and with solid democratic traditions of its own.) In contrast to Speier, Friedländer had come back to stay; he wanted to be part of a new German political culture, and his views were obviously shaped by this interest in a shared future. Like Andreas-Friedrich he was, to use the term coined by Harry Pross, an *Inländer*—as opposed to an *Ausländer* (foreigner).[55] It was a question of a deliber-

ately shared perspective, one that many intellectuals, including the clergy, did not think suitable. They weighed instead the different dimensions of collective guilt that others, less self-questioning and thoughtful, would have to confront. Like Andreas-Friedrich, Friedländer was sharply aware of the destructive polarization that arose because authority rested so exclusively with the victors; they had set up a rigorous class system of good Germans and different shades of bad ones, defined by the notorious questionnaires (*Fragebögen*) and divided by many things but, for the moment, most importantly by the type of ration card they held. (Photographing Berlin children at play in the ruins using whatever they could find to create an orderly world in their games [fig. 4.13], Friedrich Seidenstücker also found a group of little girls playing *Fragebogen* [fig. 4.14]. His image recorded very well their ingeniously comical and disturbing imitation of some grownups' self-aggrandizing need to categorize and reject others, and some people's need to show self-diminishing dejection.)[56] The enforced distance between victors and defeated did not help, as Sydney Jacobson had noted perceptively as early as summer 1945: "A scene that every German knows and is coming to hate: the lights that seem to mock his misery. In every Western German town, however ruined, there are some buildings that are whole. There the occupation authorities live and work. Outside, there is darkness and want. Inside there is light and comfort. How can we stop the hatred growing in the people outside? Can our policy in Germany now do it?"[57]

Traveling in Germany more than a year later, Gollancz did not think that policy appropriate. He noted the disastrous food situation, the problem of public health, the abysmal living conditions and, particularly close to his heart, the sorry state of children's footwear.[58] In need of radical change, the administration in the British Zone had been responsible for a serious decline of public morality in Germany. It was the result, as Gollancz saw it, of badly conceived attempts at reeducation, of the people's intellectual isolation, and of the hierarchical separation of the British occupation forces from the Germans.[59] Gollancz was particularly troubled about the younger generation, whose lack of hope and direction was cause for general concern. In an article on the German situation published in a German journal in 1947, Gollanez quoted a student who had implored him in the fall of 1946 (when he was gathering documentation for his book, *In Darkest Germany*): "Macht um Gottes Willen keine Nazis aus uns!" (For God's sake, don't depict us all as Nazis and thereby turn us all into Nazis).[60]

Gollancz declared himself to be more depressed by this plea than by the sight of starving people, the worn shoes of children, or the unhealthy, overcrowded, subterranean dwellings that were a breeding ground for dangerous, widespread ill-health. He thought the young man and his friends, hungry, isolated, and in bad health, were admirably dedicated to building a new political culture and that they were not getting much help. The ambiguity of this plea is evident: don't assume that we were (therefore "somehow" are) all Nazis and deserve to be punished by having to live as we do; do not, by allowing this misery to destroy us, cause us to regress again politically—an echo of Speier's fear that the Allies, with their harsh food policies, might lose not only the bodies but the souls of the Germans.

Andreas-Friedrich had adopted a "double perspective" that allowed her to look at

FIG. 4.13

FIG. 4.14

herself through the eyes of the only "normal," that is, civilized people in that situation, the eyes of the occupiers, who were adequately fed and clothed, warm, and reasonably secure. The brightly lit, warm, comfortable houses, islands of extraordinary privilege in Jacobson's description, were normal. The people living in the cold dark caves of the ruins were subhuman shadows. Andrik, newly appointed to the position of conductor of the Berlin Philharmonic, had made contacts with British and American officers. But in his concert hall, the derequisitioned Titania Palace, occupiers and occupied were not allowed to mingle. Eagerly accepted invitations from individuals provided an opportunity to "convince the victors that German people aren't necessarily different from them." This was the precondition for mutual fairness: "We are dying to be understood. To be understood the way we really are. We would like to get this message to all ears, all minds and hearts. We want to . . . for Heaven's sake what wouldn't we do in our passionate desire to clean up the mess. At seven o'clock a car sent by the English colonel is supposed to pick us up. He loves music. He loves Bach, Handel and Brahms. And he won't hate us and we won't hate him" (86).

This was written on August 23; the entry of May 18 had noted the first broadcast since April 24 of a British station: "A sharp voice is speaking against us. More sharply than we ever expected. Do they really want to blame us wholesale for the crimes of our government?" (30). On August 23 they were taken to the colonel's villa in Grunewald, where they sat in comfortable chairs, drank whisky, ate "unbelievably white sandwiches with unbelievably real meat," talked about German music, were listened to, and felt like equals among friends. As they were being driven home in their host's car, which as usual passed the American checkpoint without stopping, Andrik was killed. The sentry, blinded by the car's headlights and unable to read the English license plates, opened fire without warning, following a new regulation prompted by yet another shoot-out between Russians and Americans the previous night.

It was a real accident, caused by misunderstanding on several levels. And the question about who was to blame receded before the devastating fact of the death of a conductor who had, by making music, made the connection between the vanquished and the victors. The backdrop to the accident was the overpowering chaos and random violence of the aftermath of war.

In her comments on the effort to get Andrik a decent funeral, Andreas-Friedrich noted: "One cannot get anything done at all if one is German. They still take the dead bodies in handcarts to the cemetery and lay them, wrapped in a horse blanket, to eternal rest in a mass grave" (88).[61] Recounting the details of Andrik's senseless death, for her the most traumatically violent event of these violent years, she reminds herself that accusations cannot undo what happens as a result of contingency and wrong choices. All she could do was not accept the conditions of the life they had shared in Berlin in 1945—conditions that led to Andrik's death and now denied him a civilized burial. With the help of the British colonel, against all odds and just in time (given the beautiful hot summer), she finally got Andrik a coffin, a hearse, his own grave under an oak tree in a real cemetery, and even flowers. This was the most difficult achievement she recorded in her postwar diary—as this particular death was her most devastating experience.

One of the photographs filed under the rubric *Notbestattungen* (emergency buri-

als) in the Berlin photo archives shows a small emergency cemetery in a small park in the district of Charlottenburg ("Notfriedhof am Zoo") (fig. 4.15). The photograph was taken on a clear, sunny day in the winter of 1945 by a photographer named Durniok, who worked for the city of Berlin.[62] In its intriguing perspective and composition—taken from some distance and from above—the image emphasizes both the civilized attempt to provide an enclosure for the dead and its fragility. The delicate fencing around the area is very low, reaching only up to the hip of the few tiny figures visiting their dead; it provides a demarcation line, imaginary protection for what is now temporarily hallowed ground. There are broad community graves of varying sizes with varying numbers of crosses interspersed with a few individual graves with single crosses. The arrangement of the plots and crosses is irregular, unplanned, a response to need. But in the photographer's view it has become a settled, balanced configuration, soothing in its careful consideration of the interplay of horizontal lines—the plots and the fence doubled in space by their shadows—and the vertical lines of elongated, bare tree trunks. The slightly diagonal extensions of their long distinct shadows emphasize that balance rather than diminish it. The viewer's gaze is drawn into the enclosure along a paved path in the center foreground; it leads to the gate of the fence being opened by a couple about to pass through it. The viewer, in fact, follows that couple, and in its position slightly left of center, it creates a connection between the plots on the right and the left. The image establishes a sense of fleeting order and closure: for the time being, the living have done the best they could for their dead.

These graves are temporary; the light wooden fence will be easily removed, the small wooden crosses pulled out, the slightly raised plots leveled, the dead perhaps reburied. The carefully composed, emotionally reticent photo that documents the concern of the living for the dead also comments on the tensions between temporary and established order, between the absence of the dead and the presence of the living. Visually engaging, the image nevertheless also retreats; by showing what now is, it does not so much question as confirm it. For the time being, the extraordinary has become commonplace.

At about the same time, Durniok photographed a group of haggard-looking Berliners participating in "Aktion Wildgemüse" (wild vegetables, a euphemism for weeds) and for learning to distinguish edible from inedible plants (fig. 4.16). For the most part older men and women dressed respectably in coats and hats, they might have gathered in the overgrown neighborhood park or garden for an adult education course in botany, if it were not for their emaciated, anxious faces. Some of them are plucking weeds, others are looking on. They will take the weeds home and chop them up to make soup—if they have water and fuel. Durniok's photograph is composed around the "bed" of weeds in the center foreground. He saw and documented the poignant discrepancy between the middle-class appearance of these people and their intense concentration on the weeds. As in the image of the *Notfriedhof*, however, he presents such poignancy as ordinary, as just another moment in postwar Berlin. One formally dressed elderly man is pointing at one of the plants with his umbrella, another elderly man carrying a coat and a briefcase is bending down to it, his outstretched arm and hand parallel to the umbrella. The woman next to him is looking intently at the hand about to pluck the weed, reinforcing the perspective, which directs the viewer's gaze

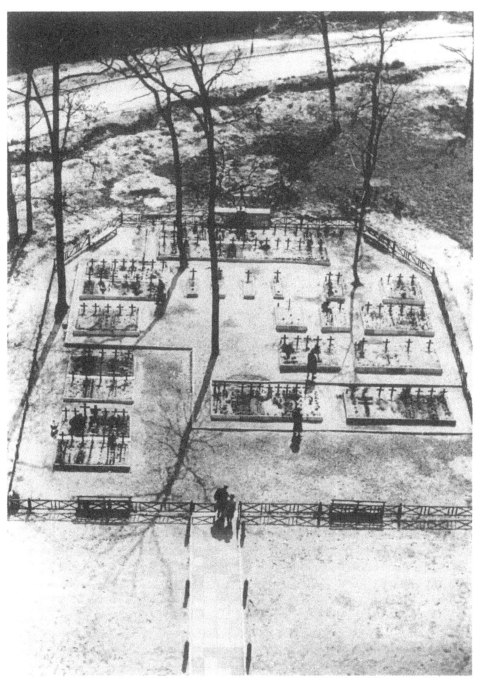

FIG. 4.15

FIG. 4.16

toward the patch of weeds, the most important presence in this image because it is something to eat. In another photo taken by Durniok, taken on a miserable day in the fall or winter of 1945, the focus is on branches cut for firewood and piled onto a cart being pulled by a woman (fig. 4.17). We see the woman only from the back, a dark shapeless figure. She and the cart with the wood are in the left foreground, on a muddy road leading to the Brandenburg Gate, which is dimly visible in the distance. In the right middle ground is a big car that appears to have been abandoned and some telephone poles without wires. Despite these objects, the woman and her cart appear to be suspended in space. Moving toward that former symbol of Prussian splendor obscured by fog, it seems to retreat; the space between them will remain the same. Nothing is distinct in the world of this image but the cart and its precious load; the woman pulling it is identified only by her luck at getting it.

In Andreas-Friedrich's perspective, the extraordinary collapse of civilized life never really became commonplace. (She would have liked the photograph taken by an unnamed photographer of the first mail delivery in the city of Berlin: the mailman incongruously confident in the ruins, as if moved along irresistibly by the sail-like wings of his coat [fig. 4.18].) Notwithstanding the intelligent realism of her descriptions, she did not accept what she saw. Hunger and cold retained their exotic, evil intensity.[63] She had found the violence visited on the Nazi regime's victims unacceptable, and she now found unacceptable the violence of the aftermath of war visited on the German population, including the remnants of the army. On 30 July 1945, she described one of the archetypical scenes of these years: the physical and emotional

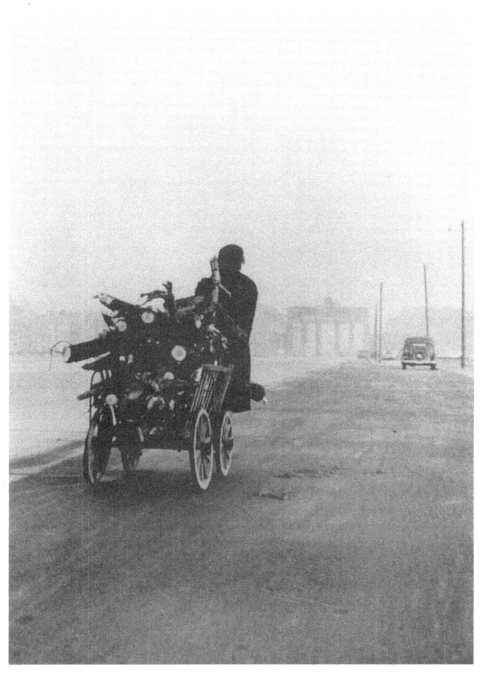

FIG. 4.17

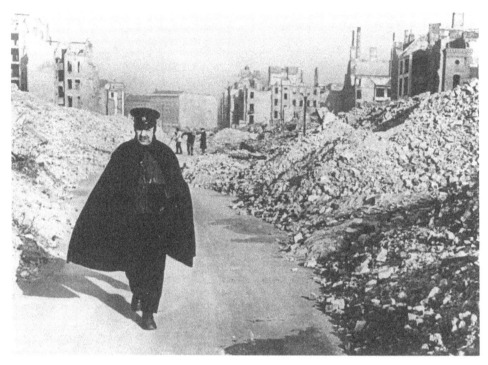

FIG. 4.18

ruins of soldiers spit out by the war, coming "home" to find their families gone or buried in the ruins of Berlin:

> Oh great God! How miserable can it get? Sometimes, when walking through the streets, one can barely stand to look at all the misery. Among the smart American uniforms, the well-fed figures in the occupying forces, the first German soldiers appear ragged and haggard, sheepishly looking around like caught offenders. Prisoners of war from who knows where. They drag themselves through the streets. Seeing them one wants to look away because one feels so ashamed of their shame, of their wretched pitiful looks. Are these the glorious victors whom Adolf Hitler years ago had sent into the war so well equipped? They shamble around like walking ruins. Limbless, invalid, ill, deserted and lost. A gray-bearded man in a tattered uniform leans against a wall. With his arms around his head he is quietly weeping. People pass by, stop and shyly form a circle around him. He does not see them. (77–78)

Images of returning POWs taken by German photographers, some of them as unabashedly emotional as Andreas-Friedrich's description, some more reticent or "objective", show very clearly the damage done to soldiers returning from Soviet captivity. Most of these photos were taken somewhat later when the trickle of emaciated, shockingly aged and lost *Rußland-Heimkehrer* had become a familiar phenomenon all over Germany. Friedrich Seidenstücker, one of the most soberly poignant chroniclers of people trying to orient themselves in the ruined spaces of Berlin, photographed several of them, struck by their isolation and alienness—as if, together

with their lumpy rucksacks and crutches, they had just been deposited there from the moon. One image shows a young man sitting in the corner of a bench at a tram stop, barefoot, his boots between his legs, wearing a long tattered army coat, his head on his knees, exhausted and depressed: "Heimkehrer aus der Kriegsgefangenschaft 1946" (fig. 4.19). Shot from the side, the bench penetrates the space of the image diagonally, a line emphasized by the placement of the man's two bare feet. His head bent very low and pointing to the boots directs the viewer's gaze to both the maltreated feet and the exposed nape of his neck which, always a highly vulnerable area and particularly in this position, appears even more so in contrast with the dark rough coat. His long-fingered hand cradling his right elbow is in line with the right foot and diagonally connected with the neck area. This hand, the two large feet, and the nape of the neck are all that is visible of the young man; importantly, we cannot see his face. Seidenstücker's perspective has created the affecting image of an abandoned individual in distress; his psychological and social isolation were also a significant phenomenon of the times. Increasingly habituated to seeing the results of social chaos and abandonment in U.S. cities, we may find it difficult today to respond to this image in these terms. But the sight of a young returning POW in such despondency struck a deeper chord of response from an observer like Seidenstücker, no matter how much misery he had seen. The "homecomer's" lostness and alienness was compounded by the "shame," not so much of defeat as of having fought a dishonorable war. Even though he has been lucky not to lose life or limb, to remain physically whole, coming home has done nothing to help him heal emotionally. When the photographer saw him, he appeared broken. What had he fought for and where were the people he left behind when he was forced to go to war?

Seidenstücker also photographed two somewhat older POW homecomers, possibly in their thirties, who seem ancient in their extreme passivity, a desolate apathy reflected both in their faces and their posture. Their crutches, a visual sign almost as common in the streets of German cities after the war as the omnipresent rucksack, indicate they had been wounded.[64] The physical damage combined with their age probably made it much more difficult to leave the past behind. Where the younger man might be expected to put behind him that moment of despair and remember it later as painfully different from his new life, the older men's devastation and separation may have been enduring. One of them, sitting stiffly upright, unseeing, as if paralyzed at being lost in the new world of 1948 (around the time of the currency reform), has attracted the gaze of a woman striding by in a colorful summer dress; if her face exhibits any emotion it is dismayed aversion. The contrast between her energetic presence and the prematurely aged man's physical silence and remoteness must have caught the photographer's attention and determined the composition of the image (fig. 4.20). Along with the POW's lostness, it captures the woman's inability to empathize: people no longer gather "shyly" around *Heimkehrer*, asking questions, offering whatever food or consolation they might have. Increasingly those returning home are seen as demoralizing remnants, reminders of the bad past. The situation is described succinctly in the caption: "Rußlandheimkehrer obdachlos; ohne Zukunft" (homeless; without a future)—lost in a new Germany where everybody's goal is to have a home and a future.[65] The viewer's gaze goes directly to the woman in the left middle ground,

FIG. 4.19

FIG. 4.20

past the rigid figure in the center foreground and then back to the returned POW, following the diagonal line that the photographer's perspective established between her wholeness and the human ruin. Looking at it, the woman does not respond but seems to quicken her steps to pass by the disturbing sight as rapidly as possible.

The German army, which inflicted and sustained huge losses on the eastern front, was criminalized collectively after the war. This created enormous social and psychological problems for the homecoming survivors and their families, because there was nothing in that transitional culture that could have helped them to work through the experience of that shameful war. The experience was one that did not bear remembering; but it had shaped them so profoundly, they could not simply leave it behind. In certain ways similar to the problems of Vietnam veterans in the United States, it was, as a group phenomenon, infinitely more conflicted, untouchable, and obscure—qualities well reflected in Seidenstücker's affecting but unsentimental images; like Durniok's, they confirmed the normality of what could be seen everywhere, the evidence of individual and cultural distress.

Benno Wundshammer, tactfully reticent, photographed a boy about fifteen or sixteen years old; he is carrying all his possessions in a rucksack strapped to his bike, returning from one of the "last effort" assignments to find his home gone, his parents dead (fig. 4.21).[66] The boy is shown with his face buried in his hands, crouching in front of a pile of rubble behind a flimsy wooden barrier put up to restrict access to the badly damaged street. His bike is leaning against this barrier, which points toward or away from him. The viewer's gaze moves across the pile of splintered wood in the foreground to the small desolate figure in the center of the image along the diagonal line of the barrier to the rucksack strapped to the bike—symbols, as it were, of the migration he is about to join. The caption reads: "Auf der Flucht nach Westen. Abschied von den Trümmern seines Elternhauses" (Fleeing west. Taking leave from the ruins of his parents' house). What will become of him? Many of the children conscripted for that "last effort," if they survived, were the first troubled "homecomers" to find their world destroyed and to become flotsam in the streams of humanity flowing all over what was left of Germany. However, the visual message is not as clear in this image as it is in Seidenstücker's photo. The rucksack and the bike pointing away from the pile of rubble suggest the risks of migration but also the promises: the bike might carry him west safely; there might be a safer future from which to look back on that moment of loss and enforced transformation.

Hilmar Pabel's photographs of *Rußlandheimkehrer* are more openly emotional revelations of vulnerability and fear about the future.[67] There is an impressive photograph of a man standing at the window of the "Entlassungslager" in Ulm a camp that had been set up to receive the men coming back "home" to the unfamiliar. The expression on the haggard face taken in profile, a kind of stoic apprehensiveness, speaks volumes; and the shadowy reflection of the profile, slightly abstracted, emphasizes the man's loneliness and isolation. He does not recognize what had been home and cannot be sure that he will be recognized (fig. 4.22). Though the long years of imprisonment have become part of the past, he is an anxious visitor to the future, and is unsure of his welcome. The perspective makes the window appear to be moving toward him, pushing him back into the room rather than inviting him to look outside.

FIG. 4.21

FIG. 4.22

The viewer's gaze moves along the dark, rough, tattered coat toward the well-lit face and its reflection, responding to the appeal to sympathize with this particular German POW's predicament. The strength of the image is in this focus on the individual encounter of the homecomer with this strange and threatening world. By contrast, the faces in Seidenstücker's photos are either concealed or so remote that they seem almost inhuman. This man was one of a group of *Heimkehrer* Pabel photographed at the bombed-out Ulm station. The photos show the men painfully dragging their bodies and the lumpy bags that seem to have become part of them, emphasizing their mental and physical exhaustion. The visual message of these group photos is one of collective defeat and vulnerability (fig. 4.23).[68]

Pabel had been a war photographer and contributed to the German army publication *Signal*. He later "recycled" some of these photographs, explicitly assigning them a visual message dramatically different from that implied in the original print. This raises the intriguing and troubling question of the photographic medium's openness to different readings in politically charged situations; images can be used for radically different purposes, and in such situations that fact alone can become a political issue. In Pabel's 1954 collection, *Jahre unseres Lebens*, with an introduction and captions by Willi Steinborn, presumably speaking for the photographer, impressed on the viewer the idea that these images of the war and its aftermath were "documents of a heart." Pabel's gaze had always been drawn to the suffering of the anonymous, average person abandoned to the destructive forces of history, a helpless pawn in their inhuman game.[69] This existentialist view, common at the time, reflects the attempt to make sense of the experience of war and violence by attributing higher meaning to its senselessness. In his images Pabel did not raise such questions; what he saw made sense insofar as it was there to be seen and to be recorded. But what he saw depended, of course, on how he looked and on how the viewer of his images would respond to his perspective.

During the war Pabel had photographed a young German soldier taking a rest during his battalion's advance in the Caucasus ("Deutscher Soldat während einer kurzen Rast auf dem Vormarsch im Kaukasus").[70] In *Jahre unseres Lebens*, he would juxtapose this photo with the image of a sleeping teenage girl crouched between bundles and the inevitable big rucksack. The caption links the two young people, the refugee girl with the young soldier now retreating westward, emphasizing their shared exhaustion, vulnerability, and lostness: "Whereto? We were all refugees" (26). But this generalization is misleading: many were and many were not; the young soldier may not have survived to become a refugee. Yet, when Pabel originally took his photo, he was attracted by the sight of the young man abandoned to the sleep of exhaustion, his horse watching over him as the "victorious" army awkwardly advanced in the background, their tools of destruction piled high on horse-drawn carts. Even then, the image may have suggested vulnerability and lostness rather than the affirmation of a quick, restorative nap.

A similar question is raised by Pabel's photo of a wounded Hitler youth taken at the end of the war and also included in the later collection. It shows a badly hurt teenage boy and a stern-looking officer, his goggles strapped to his cap, pointing energetically toward the viewer, apparently giving directions (fig. 4.24). In the photo collection of

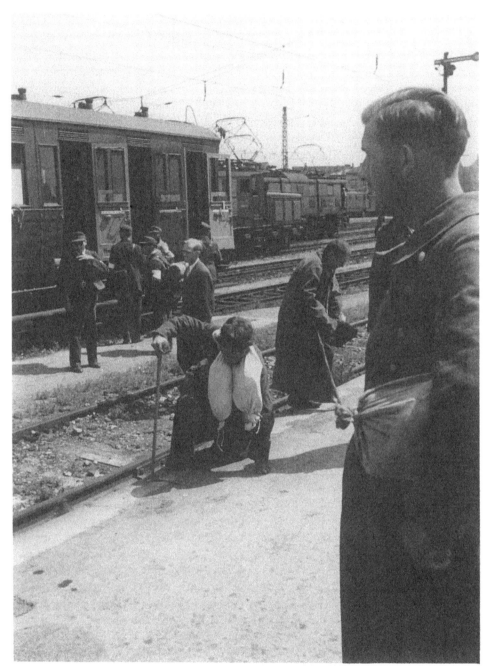

FIG. 4.23

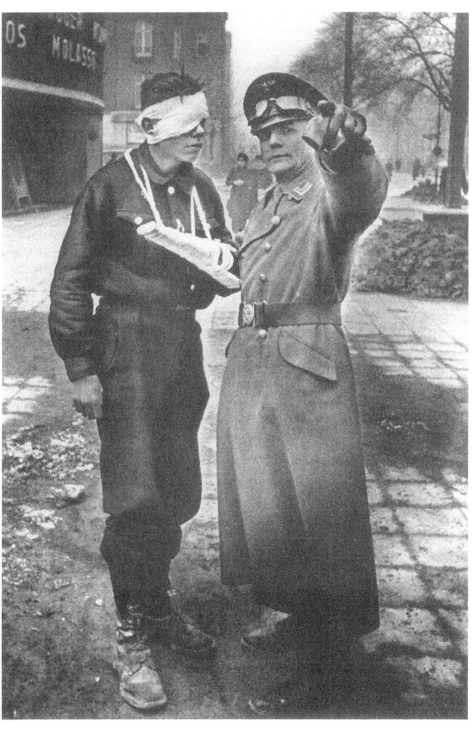

FIG. 4.24

the Archiv Preußischer Kulturbesitz, this photograph is the second in a set of three: in the first one the boy and the officer are seen standing together, the boy in shock; in the third photo he is shown slumped on the seat of a motorbike. Information on the back of the first photograph identifies a wounded member of Hitler's youth corps (*Hitlerjunge*) and a political leader from the National Socialist Party on Kurfürstendam at Lehniner Platz in Berlin after an air raid. A handwritten note on the third photo states that a wounded *Hitlerjunge* is "resting" after an air raid, giving the same location and a date of early April 1944. In the context provided by the visual and verbal messages of these two images, the meaning of the middle photo is clear: the officer is not giving a command to the boy, who appears to be in shock after having been hurt. Rather he is pointing out the location of his motorbike, where the boy can sit down and rest.[71] The print of this second image (the most interesting of the three in terms of visual organization and information) is in the Pabel collection of the Folkwang Museum, Essen, in a folder labeled: "Letzter Einsatz Berlin Kudamm Ende—Anfang April 1945." In the absence of the other two shots, the viewer is free to see the boy sent right back into the battle, the "last effort" against the Allied armies. In this "reading," the officer's gesture signifies unthinking, unfeeling force and the boy's posture does not suggest physical shock but a mental attitude of dejected, stoic obedience.

It seems unlikely that this image was meant and used to document the heroic nature—in Nazi terms—of that "Letzter Einsatz." The boy appears to be much too hurt and diminished not to suggest victimization in a war waged by adults. In addition, a viewer would then have to read the expression on the officer's face as unyielding and unfeeling; but that reading is not supported by the context of the other two images. In *Jahre unseres Lebens*, the image appears without a caption but along with other photos of enforced "last efforts" involving old men and boys; these photos have captions that explicitly draw attention to the criminal waste of lives at the end of a war that had clearly been lost in political, military, and moral terms. These images could also have been the result of a desire to document the last effort "neutrally"; they could inadvertently have revealed the lack of reason in visual messages that would later be emphasized verbally. More significantly, we might now see them as indicative of the illusion that prevented too many Germans for too long from understanding the true nature of their regime: using his camera, Pabel saw and documented Nazi aggression against Germans. Did he understand what he saw? Did those who saw his images at the time understand them? Is it possible to ask such questions in any other way than intuitively, subjectively, speculatively?

One photo shows a boy and an older man, both in uniform, crouching in a trench, two hand grenades (*Panzerfäuste*) between them, looking both anxious and perhaps determined. A photograph of a sign saying, "Männer im Alter von 16–70 Jahren gehören in den Einsatz nicht in den Bunker," is superimposed on the left upper half of the image. The image is one of a set of *Volkssturm* drills photographed in the fall of 1944 to document the mobilization of the civilian population against the Allied armies advancing on Berlin from all sides. Did the montage support a critical view of the desperate senseless mobilization order posted all over Berlin and other cities—a view already implicit in the depicted expressions of the boy and the older man? Or had Pabel intended, or been asked, to produce an image affirming the message on the sign? In the

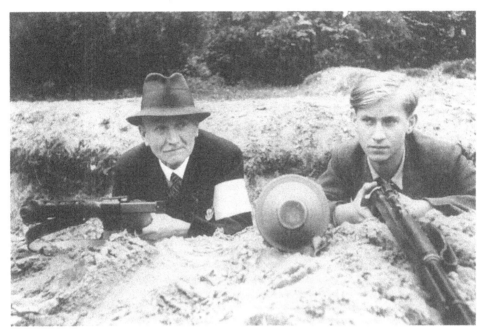

FIG. 4.25

1954 collection, the caption for this image firmly directs later viewers to distance themselves from the message on the sign: "Grandfathers and grandsons side by side. 'Men from 16 to 70 years,' this last conscripted reserve was horribly thrown into battle with or without weapons. *Volkssturm* was expected to save what whole armies had not been able to save. Russian tanks were already rolling through the streets of Berlin" (25).[72] Several images in the set picture civilians, always an older man and a boy, all of them well dressed, crouching in a deep trench. A *Panzerfaust* between them, they are stiffly pointing their machine guns at the viewer, appearing neither eager nor sullen but apprehensive (fig. 4.25). The dominant impression is one of improbable normality; only the weapons do not seem out of place. The viewer's gaze goes first to the *Panzerfaust* and then to the old man and the young boy, who are both separated and linked by it. The participants in the drill were posing for the photographer, as we can see from the older man's attempt at a faint, courteous smile. Pabel documented the incongruity of their squatting in that trench and their tenuous connection with the weapons put into their hands: incongruously they had remained civilians through years of "total war"; just as incongruously, they, too, would now be sucked up into it. As the photographer saw them, their faces reflected the fearful uncertainty of transition. Outside observers would write of old men's and young boys' "fanatical" resistance to the bitter end; U.S. and British photographers shot pictures of young boys to show their incorrigible stubbornness and arrogance.[73] Pabel showed polite old men wearing hats and ties and boys imitating their carefully upheld composure in order to keep from being overwhelmed by fear. He also showed weeping children in their outsized uniforms, breaking under the pressure of outsized expectations (fig. 4.26).

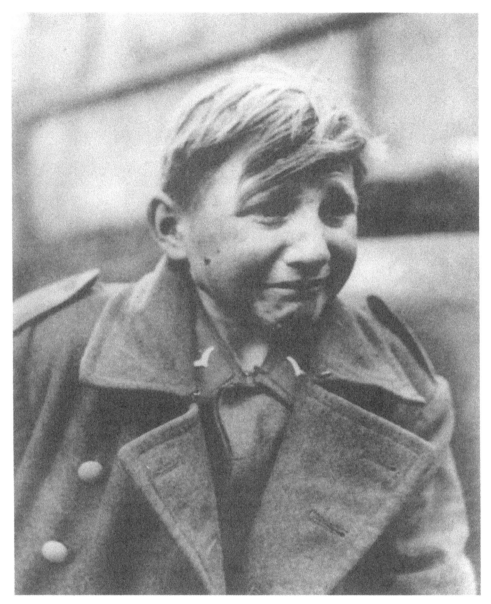

FIG. 4.26

Even if they survived, lucky enough to surrender to the Americans, they would bear emotional scars.[74] But in the postwar years it would be difficult to acknowledge them.

Hundreds of thousands of the soldiers conscripted out of school to be sent to the eastern front had not been much older than those children. In an entry of 10 March 1947, Andreas-Friedrich would note that two to three million men were still missing on the eastern front, some since the battle of Stalingrad, and that the persistent silence on that subject on the part of the Russian Military Government was hard to take: "Did

they die? Have they been wounded, captured, deported, killed, or starved to death?" (166).[75] But beyond the private pain of uncertainty, the question was, could Germans, who had fought a dishonorable war, "really" complain about Russian retribution? On the other hand, the armistice was twenty-three months old, and the Nuremberg tribunal had passed judgment on German war crimes, among them treatment of Russian POWs that violated the Geneva Convention. Andreas-Friedrich noted people's complaints that prisoners were kept back for their labor, a kind of advance payment of reparations: "There is a lot of shrugging of shoulders and head shaking in Berlin about this manner of settling accounts. So much so that our own guilt is almost forgotten" (167). Still, that guilt did not, in her view, automatically cancel out the POW question.

Robert Härdter's 1946 "Playdoyer für die Kriegsgefangenen," (Plea for the POWs), a balanced, thoughtful report on the difficult and confusing situation of German POWs in the Soviet Union and in France (though in a different way and here with U.S. involvement) did not see much hope for repatriation before a peace treaty had been signed.[76] According to article 75 of the Geneva Convention on the treatment of prisoners of war, POWs were to be returned only after completed peace negotiations; the American position, though sympathetic to the problem, was against early return. In 1945, there were approximately ten million prisoners of war; a year later the number had been reduced to between five and six million. France retained a labor force of 1,600,000 POWs, and the Soviet Union was holding at least two to three million (general opinion put the number considerably higher). The Soviet Union had not signed the Geneva Convention and did not feel bound to give any information about how many men were being held, prisoners' names, or whether a prisoner had been wounded or died. Germany, as Härdter did not fail to point out, had not honored the Convention in its war with the Soviet Union. The release of the five to six million prisoners was highly important for the survival of truncated Germany; Russia had released only groups of men who were seriously ill or otherwise unable to work.[77] Since the rapid release of all POWs was not to be expected (it would take nine more years for the last surviving prisoners to return from the Soviet Union), Härdter suggested working toward the improvement of their situation—treatment, working conditions, and communication with families. Following a suggestion made by Pope Pius XII, he asked whether France could not treat them as free workers rather than keep them behind barbed wire. Härdter projected serious difficulties with the reintegration of returning POWs, especially if their imprisonment continued, warning that they should not be seen and treated as a burden but welcomed by their communities. Precisely by sharing their often traumatic camp experiences they could set into motion political learning processes, both for themselves and their communities (212).

However, such learning processes could not be set into motion spontaneously, and the POW problem did not become a general preoccupation among more educated Germans as had the question of German guilt during the first postwar years. Like refugees, returning POWs were strangers to be somehow accommodated but then left to their own devices. The generally harsh conditions did not contribute to healing; worse, they did not encourage acknowledgment of the need to heal.[78]

Allied attempts to exorcise German militarism once and for all contributed to the difficulties of returned soldiers. The issue was explored by Ernst Friedländer in one of

his leaders for *Die Zeit*, "Militarismus" (8 May 1947). Almost a year after the Americans had turned denazification over to the Germans with the signing in Munich of law number 104 on the "Liberation from National Socialism and Militarism" (5 March 1946), "demilitarization" of industry and personnel was still in the hands of the military government. Zone Executive Instruction No. 54 of 7 February 1947 defined "militarists" as career officers and other members of the German Wehrmacht whose attitude, former activities, and professional military knowledge would cause the Military Governor to believe that they might stimulate or support the military ambitions of the German people. Friedländer thought such categorization a political rather than legal definition and as such too broad with regard to the military and too narrow with regard to the rest of the population. Historically, he pointed out, militarism had been an attitude shared by many Germans: "In Germany, the soldier has not been the first but rather the last militarist. Political leaders and civil servants, historians and teachers, industrialists, even some journalists, writers, poets, film directors have been far ahead of him in that respect." The "technical obedience" essential for the functioning of any army had been practiced in too many areas outside the military, and it was these areas more than the military proper that were in need of correction and reeducation in this respect (47). Officers were collectively degraded to second-class citizens; their pensions were taken away, and access to the universities was denied. Unable to pursue an education that had in many cases been interrupted by the war, they found it very difficult to obtain work and, if they were successful, had to cope with protests against employing "militarists." Friedländer found seriously flawed much of the discussion of "militarist" obedience within the chain of command during wartime since it disregarded the question of both actual conduct at the time and the difficulties, much underrated from hindsight, of engaging in acts of disobedience. He argued strongly against collective evaluations and policies: "the surest way to make a militarist out of a former professional soldier is to deny him full citizenship. . . . Do we really want to educate or are we still at war?" (48).[79]

Not unlike McCombe's photography of war and its aftermath, Pabel's images tended to stress human suffering in war, to see general human passivity rather than agency in history.[80] This emphasis on victimization, no matter how perceptive and effective in terms of showing the inhumanity of war, excluded of necessity the huge and complex issue of individual and group responsibility for bringing it about. Wars are waged, even if, in the end, they seem to wreak devastation by their own momentum. Germans were responsible for their country's war of aggression—could they "really" be its victims as well? Recognition that this question was unanswerable seemed most troubling where it concerned civilian refugees, deported from the eastern provinces; for them, as for many POWs, war was still being waged in the summer of 1945 and for some time to come. In June 1945, Andreas-Friedrich saw a stream of refugees moving west on the Autobahn close to Berlin, wretched-looking women and children, a miserable little boy trying to walk on the heels of his bare, bleeding feet, an old woman in a child's wagon pulled by an old man unaware that she was about to die.[81] She and a physician friend talked to a nun who had set out from Kreuzburg in East Prussia with twenty-nine children; eighteen of them had died underway. Andreas-Friedrich, ap-

palled, asked her physician friend what was to become of them; nobody had any idea and nobody was going to assume responsibility. The comparison with what the Nazis had done in the past could not help but shape the views of what was being done to Germans in the present (54). The abstract vastness of German collective guilt relieved the Allies of responsibility for a civilian population made homeless by Allied endorsement of mass deportation.

But this balancing of accounts did not silence the questions. Bicycling through Berlin on 18 July 1945, Andreas-Friedrich noted newly posted signs: "Attention, refugees! Newcomers banned from settling in Berlin. Use detours. Avoid entering the city limits. Continue westward." Troubled, she quoted it in her diary and commented: "Like pendulums the refugees from the East go back and forth between the towns. No settling, no admission, no accommodations, no ration cards" (73). In an entry of 2 January 1947, recording news of fifty-three frozen bodies pulled from a train of Germans deported from Poland, she remembered the little boy from Silesia, perhaps already dead, who had turned up his bleeding feet (150). Again she agreed with her friend that these experiences concerned only those living through them. The question of·Allied responsibility for the deportees' misery was easily countered by reference to the "German question": who among the Germans had objected to the Nazi regime's moving forced laborers from the east? People in Berlin were saying that the Poles, who were forcing Germans to leave their homes in midwinter—one of the most bitter winters on record—without food or water, and who were not even allowing them blankets or straw, had wanted them to die. Reminded of Nazi atrocities, "they look at you angrily and fall silent. Stool pigeon! says their angry look. Allied lackey!" (149). She decided that the answer to this reaction, which on some level was understandable, had to be compassion for all people who needed it—Jews then, Germans now, other groups in the future. The fifty-three frozen bodies were but a tiny fraction of the millions who had died fleeing their homelands during recent decades. But they needed to be seen as part of that catastrophic migration; they too needed to be mourned. The diary entry of September 1947 described a group of deportees from Königsberg arriving in Berlin:

> Their hollow-eyed faces look dead. Of two hundred thousand Germans, six thousand are still alive, they report. In cellars, in holes, like moles under the ground. Subsisting on garbage, sometimes dead bodies, they look like animals rather than humans, corpses rather than living people. Those who recount it also bear little resemblance to living people. Displaced persons! . . . A freight train rolls through the Russian zone. Overflowing with tattered figures. Children and women, a few old men among them. "Who are you, where do you come from?" people on a train running in the opposite direction call out at them. "We're the last Breslauers," cries a feeble, toothless old woman. . . . How is one supposed to integrate if one is out of place? For two thousand years the majority of the Jews have been out of place. For twenty years some Europeans, for two years a majority of Germans. It must be a terrible fate to be like the Wandering Jew, without a home, without an objective, to be lumped with the displaced persons (186–87).[82]

Berlin photographers saw and photographed the refugees on the outskirts of Berlin in July 1945, just after the announcement banning all new arrivals from entering the

city. A month later Robert Capa shot a picture of a refugee family—a mother, a grandmother, and three boys, the youngest barefoot—their belongings piled haphazardly on two rickety carts. He saw them against the background of a ruin that in his perspective appears to be a fantastic, wild, dangerous ravine, and his image captures brilliantly the chaotic momentum of that migration. The family has stopped for a quick bite to eat, the older woman is already eating, the mother is cutting a piece from a loaf of bread, the boys are moving toward the food. At any moment the ravine could spill large rocks on them, the carts could start rolling downhill. Gravity itself appears to conspire against them: there is no place for them to go and stay for even a moment. Standing or moving around their carts, unaware, it seems, of the photographer, the family focused on that piece of bread is abandoned in the wilderness, profoundly threatened by the collapse of civilization.[83]

On the whole, the images of refugees taken by German photographers did not convey this sense of pervasive, almost exotic danger. They tended, rather, to emphasize the migrants' general vulnerability, desolation, separateness and, perhaps most disturbing, anonymity. There is a set of three images taken by an unknown photographer who followed two old refugee women on a sunny day in July as they pulled their carts through an empty street cleaned of rubble and lined with tall, handsomely ruined houses. Alone with their sharply outlined shadows in what resembles a theatrical set—the remarkably clean street, the impressive structures of the ruins—they seem to be treading in place, not going anywhere. The focus is on their neatly piled up bundles and the wheels of their carts, both archetypical signs of migration (figs. 4.28, 4.29). The women in their long, dark dresses are interchangeable; the arrangement of their bundles is different.

On 20 July 1945 a photographer named Iglarz, who worked for the city, documented a group of women refugees and their children who had just arrived in Berlin to the news of the ban. He showed them cooking on fires in what looks like the courtyard of abandoned barracks, sleeping on the bare cobblestones, the pots tied to their cart dangling above their faces, the iron-clad wheels dangerously close. Everywhere there are piles of bundles with children sitting on them, waiting patiently, or standing near their carts or their mothers, too bewildered to play.[84] The most impressive image of this series is of a largish cart piled high with a disorderly assortment of bulging sacks on which a young teenage boy is sitting (fig. 4.30). The viewer expects him and the sacks to fall off any moment; but he is holding on, looking calmly and quizzically at the photographer. Two of his siblings are sleeping on the ground in a most uncomfortable-looking crouching position, their upper bodies resting against a large lumpy sack. (Children sleeping in this position were a common sight wherever the refugees stopped; they appear on many of the photographs documenting the migration.) The youngest child is awake and, like the oldest brother, looking seriously at the photographer. All four children are wearing clothes too heavy for the season and do not look much different from the sacks and bundles; in fact, the composition of the image suggests a skewed pyramid of bundles.[85]

Iglarz also photographed a group of small carts pulled up in some alley or yard, some of them empty, others piled high with the usual sacks, bundles, baskets, and pots. He took the picture from above, a perspective that emphasizes the smallness of the

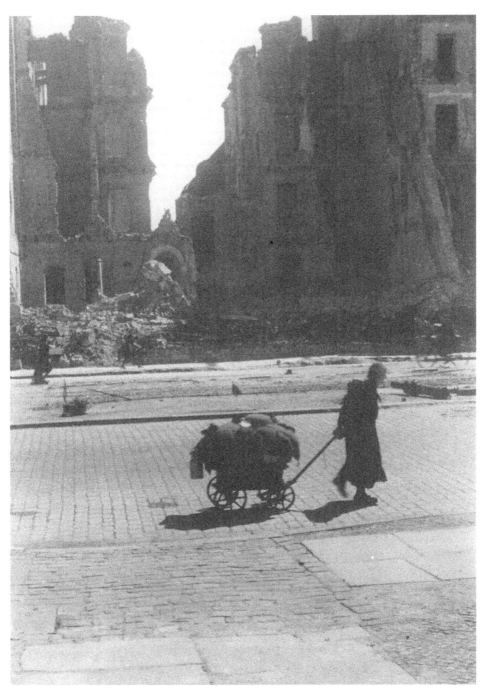

FIG. 4.28

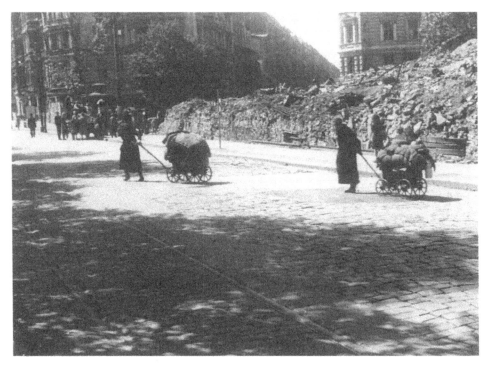

FIG. 4.29

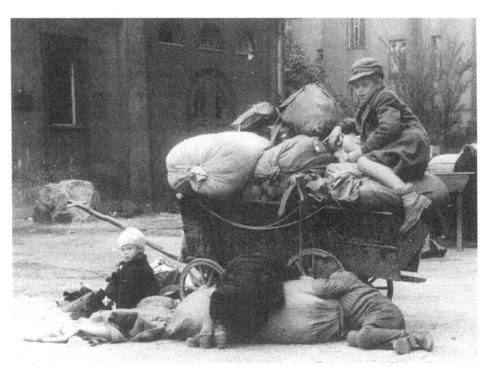

FIG. 4.30

vehicles carrying everything the owners possess. An old woman is looking up at him, unsmiling, about to ladle something onto a large plate; a little girl next to her is waiting expectantly. Their cart is neatly packed, a tarpaulin pulled tightly over the bundles, and there is a basket placed on top of it holding some crockery. She seems to be in control amidst all the chaos, despite her age and her frail looks. Behind her is a cart with a mess of bundles and a very thin teenage girl sitting on top, turned away from the photographer (fig. 4.31). Iglarz seems to have been interested here in both the individuality and the collectivity of these carts—there were, after all, many millions of them—and in the people who had pulled them over such long distances. In a sense, the people belonged to these carts as much as the carts belonged to them.

Abraham Pisarek, perhaps the first press photographer in postwar Berlin, took a picture of one of these carts that clearly emphasized the people pulling and pushing it: a refugee family consisting of an old woman sitting at the rear end of the cart, two younger women, and two little girls (fig. 4.32). Looking with interest at other people in the street, the older girl is holding on to the cart as if helping to push. The younger girl, holding on to the handle, appears tired. The women and the girls look remarkably neat; the girls' identical flowered summer dresses are reminders of past bourgeois propriety, as are the carefully pinned rolls of hair on top of their heads. Walking barefoot on city streets past piles of rubble, the older girl does not seem to break stride as she tries to keep up with the grown-ups' energetic pace. Only the little one, also barefoot, seems to be lagging. The group is shot from behind, moving on. Unseeing, the old woman does not respond to the photographer who, nevertheless, responded to the gallantry of the women's determination to get wherever they were allowed to go and remain whole.[86]

In contrast, Pabel emphasized the difficulties of survival in a series of photos of East Prussian refugee women and their children taken in Potsdam in the fall of 1945. The women, mostly older, are shown gathering acorns in the surrounding forests. Among them is a young woman whom he photographed walking through the forest with her small son, wearing an army coat and with the obligatory rucksack (fig. 4.33). A frontal shot showing her framed by a row of trees in the background as she walks toward the photographer and looks directly at him and the viewer, the haunting image suggests her alienness and isolation. Emerging from the forest—it is not clear whether she walked all the way through the woods instead of along the main roads, whether alone or in a group—she is going to disappear again. She must have been tough to survive that long, but her toughness was not what struck Pabel. It was her strangely beautiful, androgynous face, both rejecting and appealing, damaged and enduring. He included this photo in the 1954 collection where the caption makes her an "everyone" allegory for the millions of migrants who were looking for somebody and some place they could not find.[87]

In all its diversity, the perspective of German photographers on refugees—on Germans in the immediate postwar era—could be called "naively" spontaneous in that it did not address the question of retribution. None of the people they photographed and thereby "redeemed" from the anonymity and oblivion of that huge, chaotic migration seemed to deserve that fate. The images, however matter-of-fact and reticent, were meant for documentation, if not for remembrance, of the very dark

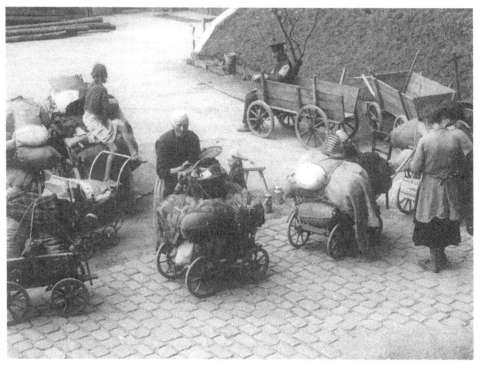

FIG. 4.31

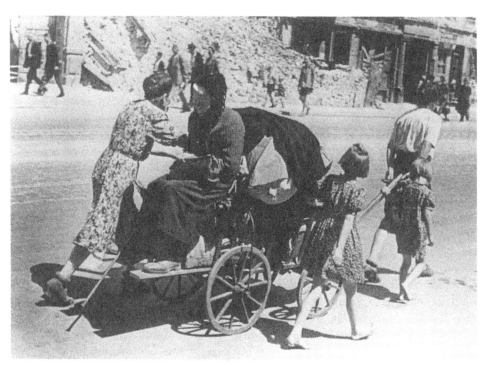

FIG. 4.32

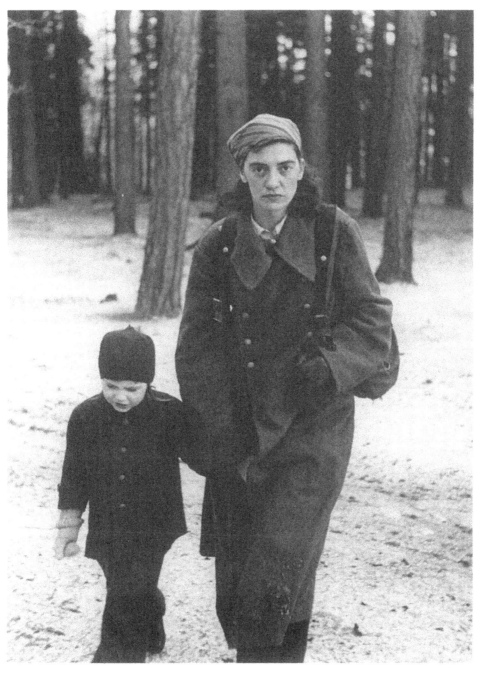

FIG. 4.33

times in which most Germans had to live. Looking and recording, most of these photographers did not respond to the expectation that their perspective be informed by the "German question." Their images did not convey the message that the dark times of war and violence were caused to an unusually high degree by those whom they showed suffering from them. They were intent on seeing and looking at what "was there," at what was and had to remain different from them, no matter how much the resulting picture was shaped by their picturing. The people whose moment of confusion, despair, and dejection they froze in time would perhaps move on, find a place to stay, adjust and integrate. But their future was not the photographers' concern, nor was their past. Remaining different, they also remained, for that enduring moment, innocent—to be looked at before being judged. This is the value of these images for the later viewer: they call attention to what was there to be seen.

Photographs tell different truths that, taken together, do not approach "the" truth but rather retreat from it, leaving the viewer with the provocation of uncertainty. Robert Capa, whose photographs are marvelously appropriate to this violent century (especially where he permitted himself to be gentle with what he saw), did not take any pictures between the Rhine and the Oder in the spring of 1945: "The concentration camps were swarming with photographers, and every new picture of horror served only to diminish the total effect. Now, for a short day, everyone will see what happened to those poor devils in those camps; tomorrow, very few will care what happens to them in the future."[88] He was wrong. But even if he had been right about their future, the documentation of their wretched present would continue to haunt the future of Germans forced by these images to go back, again and again, into their past, which was the past of these, their victims. The "total effect" grew rather than diminished with time. The opposite has been true of the images picturing the dark present of Germans half a century ago because there was no cultural and political motivation for going back to them. Arguably, there was no sense among photographers then of a "total effect" in documenting Germans in distress, and this may be the main reason for their enduring usefulness. They do not allow certainty.

Few intellectual discussions of Germans' responsibility for the war waged by their regime and the acts of violence it committed paid sufficient attention to the concrete postwar experiences of average Germans and the questions raised by them. Intellectuals have always been in the habit of speaking *for* and *at* those who are, by definition, less enlightened. In the situation that existed in 1945 and 1946, when the challenge to intellectuals to prove their worthiness to be included in the future was particularly intense, this tendency went largely unchecked. The essays published by Erik Reger in the Berlin *Tagesspiegel* from the fall of 1945 to the fall of 1946 are a good example. In the foreword to the volume in which he collected them, *Vom künftigen Deutschland. Aufsätze zur Zeitgeschichte* (1947), he perceptively pointed out the mind-numbing rapidity of recent historical developments: a hundred years between 1947 and 1945, a hundred years between Hitler's successes and defeat, a hundred years between Hitler's beginnings and the end of Weimar—if one counted these years of extraordinary events in terms of political and psychological rather than chronological time, one might even end up with Hitler's *Tausendjähriges Reich*.[89]

Reger did not give average Germans the benefit of this perception. Instead, in his

discussion of German guilt he asked them to cope "somehow" with this literally fantastic acceleration of cultural and political transformation and with the expectations that they would accept individual and collective responsibility for what they had let happen.[90] What they had let happen were not so much war crimes as "atrocities," distinguished from war crimes by their unprecedented nature, though they were largely unknown to them while they were happening.[91] In a leader for *Die Zeit*, 12 June 1947 ("Verdrängte Geschichte"), Ernst Friedländer acknowledged the reasons for the failure of such expectations. They had been too general and too absolute, thereby preventing a gradual transformation of the accusing "tua culpa" into a questioning "mea culpa." The opportunity to use the shock of Germany's collapse to prepare for the shock of the uncovered atrocities had been missed.[92] In some ways anticipating Martin Broszat's 1985 "Plea for the Historicization of National Socialism," Friedländer asked for detailed research into the meanings of Nazism in German history.[93] But he was looking at the problem in the more hopeful situation of 1947 (on 5 June 1947, the new U.S. secretary of state, George C. Marshall, had announced the launching of a European Recovery Program, the "Marshall Plan") and from a highly independent position shaped by his own unusually realistic fairness and his experience of exile. In the fall of 1945, when the intellectual journals had begun to appear in remarkable and exciting abundance, in spite of the scarcity of paper, it seemed impossible to see the future as in any way connected with this tainted past. The very names of these journals suggested their contributors' eagerness for new beginnings: *Die Wandlung* (The transformation, Heidelberg), *Der Aufbau* (Building up, Berlin), *Der Ruf* (The call, Munich), *Die Aussaat* (The sowing, Stuttgart), *Die Besinnung* (Reflection, Nuremberg), *Die Neue Ordnung* (The new order, Heidelberg). Many of the essays published in these journals drew on the enduring values of western, Christian high culture while arguing for some kind of "rebirth" into humanistic democracy. Embracing democratic values with a semireligious fervor that was pleasing to the Americans who licensed the journals, little thought was given to the problems of the mass democracy that destroyed Weimar. Still, much of what was being written was in some ways helpful, if only in working through different aspects of the German question. (Perhaps the most successful in this respect was *Die Wandlung*, edited by Karl Jaspers, Alfred Weber, and Dolf Sternberger, whose essays on these issues stimulated a great deal of much needed discussion.)

The "Zero hour," the beginning of something "really" new or different, did not occur, however, in what became West Germany — it did occur somewhat later in East Germany, with the well-known consequences — because it could not be envisioned in 1945 and 1946. The situation was too conflicted and obscure at that time for a sober look at the promises as well as the difficulties of modernity that had arguably made possible the rise of National Socialism. The new journals seemed unable to raise these issues. Perhaps the most honest of them, *Der Ruf*, was edited by Alfred Andersch and Hans Werner Richter. Richter had taken over a journal (called *Der Ruf*) for German POWs in a U.S. prison camp when its previous editor, Andersch, was released; Richter disliked the anti-German rather than anti-Nazi stance of the publication that the Americans had enforced. He too would have difficulties with visitors from Washington, German exiles in American uniforms who had been communists during the

Weimar Republic and now wanted to make the journal a voice in support of German collective guilt. Himself a former Communist, Richter was struck by the failure to deal with the Nazi movement. This was an admission as important as it was rare in the postwar situation, because it acknowledged the complex past actuality of Weimar politics when the victims of the Nazi regime had been political agents: their fate had not been inevitable. He would point out in a later interview that both Communists and Social Democrats had "lost horribly, and now they came back as if nothing had happened. As if it had not been their fault at all; as if it had been only Hitler. And that is not true. They themselves had failed."[94]

When Richter was released in April 1946, Andersch suggested that they edit a journal that retained the name but not the politics of the camp journal, a sort of "Gegen-Ruf," or counter call. The subtitle was "Unabhängige Blätter der jungen Generation," emphasizing the "new look" in culture and politics of the younger generation. Their contributors were young—no one from before 1933, no exiles— and they rapidly built up a large readership. The first issue of *Der Ruf* (August 1946) defined the journal's position in an unsigned front page essay, "Das junge Europa formt sein Gesicht" (young Europe is shaping its looks). A front page photograph of a handsome young soldier in the act of surrendering— "Bedingungslose Übergabe" — identifies Germany's younger generation as shaped by the front experience. The photo's caption is followed by a lengthy quote from a statement President Roosevelt made in the spring of 1945; there he repeated a promise made at the Yalta conference that unconditional surrender would not signify the "enslavement of the German people." But both "the German people" and "the German soldier," Roosevelt asserted, had to accept unconditional surrender as the necessary first step in their rehabilitation: "We do not accuse the German people as such because we cannot believe that God would have condemned any people eternally."

It is unclear from the context whether the editors wanted to emphasize the fact that the promise had been made or draw attention to its ambiguity. The decisions made at Yalta and Potsdam, of enormous concrete importance to a particular people in the immediate postwar period, were based on power politics and showed little influence of God's general good will toward all people. Articulating the position of *Der Ruf*, the essay focused on the challenge of new beginnings for German youth as Europeans: "Young Germany stood for the wrong cause (and it was wrong not just because it lost). But they stood for that cause in the existential spirit evoked by Sartre and his comrades. The thin rope that connected the enemy camps is called stance (*Haltung*). A shared stance and experience, independent of ideology and ethos." The term *Haltung*, with its connotations of all-important manly honor, was not unproblematic in the postwar context; but Richter's scenario was existentialist rather than militarist.[95] Richter was nevertheless right to take seriously the implications for the postsurrender period of the soldiers' physical and psychological experience of battle. They had lived through situations of heightened attention and tension, when good and bad luck decided survival and there seemed no middle ground between heroic courage and abject cowardice, total loyalty and betrayal, obedience and mutiny. These situations of crisis needed to be articulated, their difficulties honestly acknowledged, their meanings

critically questioned. As the editors of *Der Ruf* were to learn, this was not possible in the immediate postwar period.

There was also the generational conflict. In Richter's view, the older generation's uncritical tolerance had contributed significantly to Hitler's rise to power. Profoundly skeptical of Allied general insistence on "reeducation"—a term he found to be not much better than the Nazi "Umschulung"—he thought useful specific American educational experiments that prepared German POWs to join a new democratic German elite (for instance, the programs at Fort Getty and its successor, Fort Eustis.)[96] But he wanted to emphasize the specific problems and potential of that "young German generation, the men and women between eighteen and thirty-five separated from the older generation by their nonresponsibility for Hitler, and from the younger generation by their experiences at the front and in the prison camps." Their dedication to the concept and reality of a new Europe was intimately connected with their front experience of death and destruction. If they listened with some skepticism to Allied sermonizing on rebirth in democracy, they were not so much "nihilistic" as searching for the "*experience* of freedom," for radically new construction rather than reconstruction.[97] Richter's attempts at clarification turned out to be prophetic: after a year of publishing texts that dealt with the experiences, the hopes and fears of that young Generation, *Der Ruf* was accused of "nihilism" and lost its licence. Richter invited the journal contributors to a conference, where they read aloud each other's now unpublishable manuscripts and criticized them. This represented the birth of *Gruppe 47*, a literary group notorious for its practice of open and often harsh mutual criticism that in a sense "created" postwar German literature.

Richter's realism— "nihilism" in Allied perception—came out of his experience of the war: he knew how many young men had died, how confused and disillusioned POWs were, and how their coming "home" to the physical and emotional chaos in a Germany changed beyond recognition had not helped them. Not only the Nazis but also their ineffective political opponents, himself included, were responsible for that German catastrophe. Who, then, apart from those clearly involved in war crimes and atrocities, were the unambiguously "guilty"? Who were the unambiguously "not guilty"? Was it useful, not to mention "right," to criminalize the whole German army?

Richter was not consistent (he was himself from "before 1933") and by no means democratic in his cultural politics. Under his leadership Gruppe 47 dominated the West German literary scene until it was challenged—an act of poetic justice—by the generation of 1968, which used the past in a fight for their own cultural identity. Richter had also believed too simply in the possibility of creating a "really" new Germany, as if the power of the past could be checked. But this mistaken belief had also helped him to see more clearly certain important German questions. In one of his stories, "Pestalozzi oder 'Der Tintenfisch,' " Richter remembered his encounter with the Swiss-American army captain Pestalozzi. Aided by a small number of GIs, he was taking a large group of German POWs back to Germany by boat and had his pedagogical heart set on producing a journal for their further education on that voyage. Richter showed little interest, but blond, stocky Pestalozzi, serene, thoughtful, and expecting the same from his prisoners, was both inexorable and efficient. Richter's leader for the

first number of the *Tintenfisch* (octopus) was about Hitler's suicide and the miserable
end to the war; it was intended to open his readers' eyes to the true nature of the terrible
war they had fought obediently and bravely, and to the pathological megalomania and
cowardice of their *Führer*. He had wanted to inform, not to indict. Not unexpectedly,
his article prompted highly negative reactions from some of his readers who had been
in U.S. prison camps for several years. There were rumors that they saw him as an
American agent and planned to throw him overboard: Hitler had not committed
suicide, the war had not been lost. (Admiral Dönitz, taking over from Hitler, had
presented him as a revered leader who had been killed in action.) Pestalozzi, who very
much liked the first issue, assured him that nobody would be thrown overboard unless
he ordered it and reminded him that he, Richter, was a soldier—not very reassuring
to the quintessentially civilian Richter. After landing in Le Havre, he looked for
Pestalozzi one last time and finally saw him, standing somewhat hidden, high up on an
upper deck: "I don't know whether he was looking down at us or simply at the land. It
was an early day in spring, the April sun was on his face, and I would have liked to
know whether he was glad to be rid of us, or not. I have never known."[98]

He would have liked to know because he was curious about the man, intrigued by
his wholeness and remoteness—attributes of his power, and by his pedagogical deter-
mination. He submitted to Pestalozzi's skillful manipulations and was not thrown
overboard. But looking back at his former, more apprehensive self with kindly irony,
his story admits the sting of an uneven relationship that left him watchful.

Views of the Past

MEMORY AND HISTORICAL EVIDENCE

A YEAR BEFORE the collapse of the Berlin Wall, in the fall of 1988, President Richard von Weizsäcker ended the heated dispute among West German historians about the historiography of the recent past by declaring: "Auschwitz remains unique. It was perpetrated by Germans in the name of Germany. This truth is immutable and will not be forgotten."[1] Judging from the centrality of Auschwitz in public commemorations of the German catastrophe half a century later, this "truth" will remain "immutable" for Germans, at least in the near future. The historians' dispute or *Historikerstreit*, for instance, had little to do with academic questions of historiography and everything to do with the political uses of memory in postwar Germany; it quickly became a highly public issue of general cultural concern in Germany and, to an extent, abroad. Much discussed, the *Historikerstreit* told a great deal about enduring difficulties faced by Germans when trying to look back at their cultural and political past— that is, the present of half a century ago, when observers found it so difficult to understand and document what they saw. Many of the problems of observation reflected in the photographic and verbal documentation of Germany in 1945 appear enlarged and intensified in the debates of memory and history at the end of this troubled century.

Quite appropriately, the *Historikerstreit* was carried out in the two most publicly opposed papers: the liberal Hamburg weekly *Die Zeit* and the politically conservative *Frankfurter Allgemeine Zeitung*. The latter had published Ernst Nolte's "A Past that Refuses to Go Away" (6 June 1986), an argument against the absolute singularity of Nazi crimes; Nolte's article was promptly attacked by Jürgen Habermas in *Die Zeit* (11 July 1986) for its "apologeticist tendencies." In a review article, Habermas reacted strongly against the thesis of Nolte's new book, *Der europäische Bürgerkrieg 1917–*

1945. Nationalsozialismus und Bolschewismus (1987), which compared Nazi genocide to Stalin's *gulag* and proposed a connection in Hitler's mind between the atrocities committed by the Hitler regime inside and outside of Germany with those committed by the Soviet regime. In Nolte's scenario, the persecution and final destruction of European Jewry should be seen in the historical context of the fanatical fight of National Socialism against Communism. In this century of human mass destruction, this would mean that Auschwitz was not, and therefore would not remain, unique.

What might have seemed a problematically selective historical interpretation to most non-German observers, professional historians or not, seemed an unqualified moral outrage to the social philosopher and cultural critic Habermas and, following him, a considerable number of German intellectuals and historians across a fairly broad political spectrum.[2] The politicization of German cultural memory does indeed go deeper than the usual political affiliations and interests, though the Left has established itself as Germany's conscience in this matter, with Habermas as its *praeceptor*. In their eyes, the conservative Nolte and other "revisionist" historians were trying to rewrite history into an apology for Nazi crimes, motivated by their desire to construct now, at the end of the century, an at least partially affirmative German national cultural identity.[3]

In their polemics against Habermas's attack on Nolte, conservative historians emphasized a desirable normalization of the Germans' understanding of their own history, of their *Geschichtsbild*. Such reappropriation by Germans of German history had much to gain from Nolte's argument against the absolute and therefore ahistorical singularity of Nazi crimes as seen by the Left. Arguments for such singularity or "uniqueness" do, of course, raise serious general methodological questions for the historian. But Nolte's specific arguments against it have raised serious questions for the historian of these particular events. As Hans Mommsen argued, Nolte's assumption of a "kausaler Nexus" in Hitler's mind between his own and Stalin's acts, which led Hitler to an ever more fanatical will to destroy, signifies a shift of responsibility away from the ruling elites and institutions that made possible the implementation of "the final solution."[4] Establishing such a connection would make it easier to separate Hitler's fatal obsessions, his "evil" deeds, from the rest of German history—a separation that would mean limiting the question of German collective responsibility for the Holocaust. For a number of conservative historians, such limitation and the ensuing normalization of German history would undoubtedly be desirable, but not so for Mommsen, who has devoted much of his research to this question and continues to be troubled by it.[5]

Although Mommsen the historian tried to sort out the meaning of Nolte's argument in terms of historical evidence in order to arrive at a clearer understanding of the Nazi period, the social philosopher Habermas showed little interest in such detailed examination. His sweeping critique also led him simply to reject as dangerously revisionist the argument of the military historian Andreas Hillgruber in *Zweierlei Untergang: Die Zerschlagung des deutschen Reiches und das Ende des europäischen Judentums* (1986). Arguing against a collective criminalization of the German army—as had thoughtful political commentators such as Ernst Friedländer in *Die Zeit* half a century earlier[6]—Hillgruber used shifts in narrative perspective to make more accessi-

ble the traumatic experiences of German soldiers, many of them adolescents, on the eastern front. Whether or not the strategy of letting different historical agents speak in their own voices produced the desired evidentiary clarification, for Habermas it signified nothing less than the historian's *de facto* identification with a criminal institution and therefore immoral, indeed criminal apologetics.[7]

With its emotional attacks and counterattacks, willful misreadings, and distortions of opponents' arguments on both sides, the *Historikerstreit* of the mid-eighties was a remarkably accurate indicator of postwar German cultural and political self-perception. It was not, however, what Weizsäcker had asked for on 8 May 1985 in a speech to the *Bundestag* commemorating the fortieth anniversary of the defeat of Nazi rule.[8] Delivered three days after President Ronald Reagan's controversial visit to the Bitburg cemetery, this speech seemed to many Germans and observers abroad to be a model of how to deal with the unfinished business of Germany's "unredeemed" past. Weizsäcker acknowledged different perspectives on the significance of this date for the victors and the defeated. Importantly, he juxtaposed it with both 30 January 1933, when Hitler seized power, and 8 May 1949, which saw passage of the *Grundgesetz* of the Federal Republic of Germany, a multipartisan declaration of inviolable human rights in support of worldwide peace and justice.

In making these connections, Weizsäcker presented the total, traumatic defeat as a positive challenge to Germany to enter the comity of nations. In this, his argument was poignantly reminiscent of the pleas made after World War I by the first German-Jewish Foreign Minister, Walter Rathenau, who argued for viewing the bitterly resented reparation payments as a constructive contribution rather than as a punishing imposition.[9] Speaking six decades later, however, and after another, more terrible and more unjust war, Weizsäcker also emphasized, with the vista of a better future, the danger of forgetting and its consequences. Young Germans, he pointed out, though not responsible for the past, had an obligation to remember and thereby understand it. Their history was as difficult as it was real; it could not be pushed aside.

Were the Germans in danger of forgetting? And what did such forgetfulness mean? The Christian Democrat Weizsäcker's emphatic declaration in 1988 of the uniqueness of Auschwitz for German national identity, both now and for generations to come, seemed to support Habermas's position against the historians who were, rightly or wrongly, associated with Helmut Kohl's administration. Indeed, Weizsäcker's address to the historians explicitly set off the moral understanding and use of history against Kohl's in some ways tainted politics of history.

Kohl has been known for his clumsiness where the recent past is concerned; his most mistaken, because in many ways most innocent, statement was the one made in 1984 on a visit to Israel. Referring to the fact that he was the first chancellor of the Federal Republic young enough not to have been entangled with the Nazi regime, he expressed his gratitude for "the grace of having been born later." This phrase caused consternation in the Federal Republic and abroad, but not always for the right reasons. The "grace" invoked by Kohl signified not so much his, and by extension Germany's, tendency to shirk difficult political-cultural responsibilities. Rather, it illuminated Kohl's astonishing naïvité, given the circumstances, regarding well-known, powerful, political-cultural sensitivities. Confusing in this instance the right of the public person

with the privilege of the private person, he also confused the status of German history with that of other histories: the presence of the German past seems more tenaciously troubling than that of other pasts.

Apart from the politically important issue of an enduring German collective guilt, there were other and perhaps for Germans more significant considerations. Peter Schneider, a Berlin novelist and thoughtful commentator on these questions, belongs to the student generation of 1968. In an essay, "Hitler's Shadow: On being a Self-Conscious German," which was written two decades later, he pointed out that even if Kohl and members of his administration had been too young to be responsible for their beliefs or actions in 1945, they were by no means untainted by the Nazi experience, which had been explicitly calculated to shape the young.[10] Schneider's comment is particularly important in the context of emphatic declarations and the often obscure cultural meaning of the "uniqueness" of Auschwitz. Kohl's generation, Schneider noted rightly, "was born too late only in the sense that it didn't have to pay for its enthusiasms as did those who were a generation older." The Hitler Youth does, of course, have the "right to renounce its antecedent. . . . But such renunciation, precisely in the case of Helmut Kohl's generation, can't begin with a declaration of clear conscience. His generation can only make its innocence plausible by confronting its innocently acquired complicity."[11]

Schneider, the novelist, raised a question that had been largely absent from the historians' debates of collective guilt: the fact of different kinds and degrees of involvement in or complicity with a criminal regime—a fact that calls for concrete modifications of the general and often quite vacuous concept of "confrontation with the past." Weizsäcker, a young adult in 1945, has spoken openly and publicly about his actions during the Nazi period, while his Austrian counterpart, Kurt Waldheim, did not. Speaking up has strengthened Weizsäcker's moral authority, while silence has weakened Waldheim's. Both Kohl's notorious lapses and his in some ways curiously unmediated politics of history may be linked to a deeper thoughtlessness regarding this silence.

We are dealing here with the tricky, often deceptively smooth symbiosis of political and moral arguments. Not openly addressed in the *Historikerstreit*, this problematic symbiosis, the result of a conflicted internalization of Allied military-moral victory, has been at the heart of that much lamented postwar German malaise of repressed collective memory. Weizsäcker's speech to the historians was about moral rather than political issues, though its thrust was at the same time political. The position from which he spoke, if largely and importantly ceremonial, *was* political, and in his speech he referred implicitly but quite clearly to the German chancellor. According to the reports on the meeting, there was broad acceptance among the historians of Weizsäcker's statements concerning Auschwitz, and appreciation for his efforts to heal the sharp divisions. Hillgruber, in Habermas's view reprehensibly revisionist, declared himself in agreement with Weizsäcker, stating that he had not intended to "relativize" the past (that is, in this context, question the uniqueness of Auschwitz), "but only to understand its conditions."[12] Fritz Stern, an influential historian of German-Jewish relations, referred to Weizsäcker's speech as "an extraordinary manifestation of a sense of moral authority" that confirmed Weizsäcker "as one of the greatest political assets the

Germans have."[13] Nevertheless, the question of desirable present-day political conduct, which is entangled, in Germany, with the morally potent collective memory of past political conduct, cannot be that easily resolved.

Instructing Germans on the significance of Auschwitz, Weizsäcker was particularly concerned about attitudes toward the past among young people, and in this respect German identity at the end of the twentieth century appeared to be a legitimate, even urgent issue:

> They want to know and have to know who they are, where they come from and who the others are with whom they are to shape and share this world. To them it is vitally important to know how the moral and political disaster came about in the days of their grandparents. Did their nation leave the civilized community of nations only temporarily and has it now returned to its natural position, albeit encumbered by that terrible aberration? . . . For their own lives they need an answer to the question of where we (their parents and grandparents) were, what we did, what responsibility we assumed, and what responsibility we very much failed to live up to.[14]

The addressees of this question are in fact the generation of the grandparents rather than the parents who were, in most cases, born during or after the war. The question is one of access, across two generations, to the experience of those who are asked to explain themselves so that the young can be reassured about their own national cultural identity. Access is a problem historians are trained to appreciate; it is not a problem appreciated by the young—unless they are helped by very thoughtful grandparents who, like Weizsäcker, have worked through their memories to the point where they *can* indeed share them usefully.

But such grandparents are not the people whom the morally outraged critics of the "revisionism," "relativization," and "historization" of the recent past want to hold to the collective task of remembering. Nor can Weizsäcker, in speaking about his own past, assume that he is in any real sense speaking for the majority of Germans of his generation. This is why, in calling an end to the historians' dispute, he did not end it. It is why his moral stance, though personally admirable and, under the circumstances, politically shrewd, did not bring more clarity to the enduring problem of present-day German collective memory of responsibility and guilt. But then, with very few exceptions, neither have the historians' arguments.

The result has been a political-cultural atmosphere that encourages misunderstandings rather than understanding, one that supports accusations of apologeticism rather than critical discussion of differing views. Where Germany's "unredeemed" or "unmastered" past is concerned, the inclination to impose taboos has always been stronger than the willingness to invite questions. In the wake of the resignation of the Speaker of the *Bundestag*, Philipp Jenninger, over the controversy caused by his speech marking the fiftieth anniversary of *Kristallnacht* persecutions, a bemused commentator observed in the *Frankfurter Allgemeine Zeitung* that "writing and speaking about National Socialism and its crimes continues to be for Germans a risky business."[15] In its intention to explain the attractiveness of the Nazi regime in its early stages, Jenninger's speech was strategically inept rather than "revisionist" or "apologeticist."

He had tried to recapture or "historicize" the actuality of the Nazi period—which was not always unambiguous or uniform—rather than to view that actuality merely from the streamlined perspective of the Holocaust. He had done so in order to better understand it, that is, to relate particularities of that past to contemporary experience, to "relativize" it, not to make it appear less dangerous or its results less horrible. After reading monotonously from a long list of Nazi atrocities, Jenninger had explicitly stated his intention of making the past reality of Nazi rule more accessible as history to the majority of Germans too young to remember so that it might be a more powerfully concrete warning for the future.

The *New York Times* published the text of the speech under the impartial headline: "Touching Some Raw Nerves: A German Speaks Out on Nation's Past."[16] The *Times* also quoted a passage from Jenninger's letter of resignation, which expressed his regret at unintentionally hurting so many people's deep feelings; the paper summarized the consensus of politicians, the press, and many Germans that Jenninger could not be accused of pro-Nazi sentiments but that his rhetoric and timing had been terrible.[17] Ian Buruma, in his comparative study, *The Wages of Guilt: Memories of War in Germany and Japan*, is clearly fascinated by the extraordinary reactions to Jenninger's speech: by the audience's great moral indignation, by people walking out in large numbers in protest, by the speaker's instantaneous exclusion and criminalization, and by his sweaty fear. These reactions had obviously been provoked not only by the dryness of his text but by his unemotional, seemingly uncaring delivery.

In a later interview with Buruma, Jenninger himself pointed out that he should never have spoken immediately after the reading of Paul Celan's "Todesfuge" by an older Jewish actress. (The choice itself of this sacral-sentimental poem might seem problematic in view of the secular space and political occasion.) A Social Democrat complained that Jenninger did not once refer to "mourning," whereas Weizsäcker's 1985 speech before the *Bundestag* commemorating the fortieth anniversary of the defeat of Nazi rule had been drenched in mourning and even Kohl, addressing an audience on the fiftieth anniversary of the *Kristallnacht* in a Frankfurt synagogue, had spoken of profound German shame. However, Jenninger was not addressing a group of Jewish mourners in a sacred space but was speaking as a politician to his colleagues in a secular space. How could his sober historical account of Nazi rule fail so dramatically to reach its audience? Buruma's cool perspective makes the hysterical reaction appear more understandable, if not acceptable: in the politically overheated situation of mutual suspicions and accusations—the Right allegedly retouching German history, the Left allegedly imposing its own identification with Auschwitz on all of Germany—Jenninger's speech was denounced by both camps—because he spoke too much about guilt and did not appear to feel sufficiently guilty.[18]

There have been many such misunderstandings on varying levels of complexity. An academic historian who reviewed Arno J. Mayer's *Why Did the Heavens Not Darken? The "Final Solution" in History* in the *New York Times Book Review*, took great pains to prevent his readers from misunderstanding Mayer's combined "intentionalist" and "functionalist" approach. Mayer had drawn on interpretations of the "final solution" as both the general logical outcome of Nazi ideology and as a decision contingent on particular historical developments, for instance the increasingly threatened eastern

front. Dating the crucial decision to as late as the Wannsee meeting in the winter of 1941/42, he looked at bureaucratic coordination in the context of a desperately troubled campaign in Russia and a sharply deteriorating situation in the ghettos and camps in Poland. Moving all Jews to Madagascar or beyond the Urals, the projected "solution" to self-created chaos after a German victory, no longer seemed an option. The reviewer—and this was probably quite realistic given the controversial reception of the Princeton historian's solidly researched study—felt it necessary to comment:

> However, this book is anything but an apology for the Nazis who slithered down the "twisted road to Auschwitz" and who, finding their resettlement plans blocked by the turn of the military tide, opted for Zyklon B in an act of raging revenge. Mr. Mayer's judgments are clear and unambiguous and it would be a grave error to link him to the revisionism of the West German historian Ernst Nolte.[19]

Actually, such linkage seems unimaginable in the case of an unprejudiced reader, if only because of Mayer's introductory statement of intention: to take another look at the Holocaust now that it recedes in memory and to see Judeocide within the context of history. The title of the book quotes Solomon bar Simson's lament in 1096 over the slaying of Jews by Crusaders on their way to Jerusalem in order to

> reveal that the "final solution" was not something providential but profane. I call the reactionary historians who excuse the Holocaust as a part of the cold war retro-revisionists. What I've tried to do in this book is to provide the background and reasoning to how the Holocaust went from expulsion of the Jews to extermination.

Mayer tells his readers in the introduction that he will proceed according to the professional standards of causality and accuracy which have been binding for historians since the Enlightenment. Against the "reflective and transparent remembrances of survivors" now woven into "a collective and prescriptive memory inconducive to critical and contextual thinking about the Jewish calamity," he wishes to stress the questions of history. This is not to take away the authenticity and uniqueness of the survivors' experience but to make it *accessible* to posterity. Accessibility depends on the "polyphonic" mode of historiography, which opens this experience to debate, rather than on the "univocal and uncontested" voice of memory, which closes it; as Mayer writes: "Memory tends to rigidify over time, while history calls for revision." It is necessary to emphasize the historian's professional responsibility particularly in the case of the Holocaust where attempts at reconstructing pertinent historical contexts are at a greater risk of being misread and therefore shut off prematurely.

Declaring the uniqueness of Auschwitz in absolute terms, Weizsäcker argued for the adoption of a moral rather than a historiographical standard and thus silenced rather than concluded the historians' dispute. The *New York Times* report on his speech stated that the reactions to it in the press "were variations on the note struck by the *Wiesbadener Tagblatt*: 'It is high time that clarity was delivered from the highest position into the fog of this historians' dispute.' " Germans were grateful for having been told authoritatively what to think and feel about a morally difficult and politically divisive issue. But educated audiences in Germany and abroad could be expected

to understand that President von Weizsäcker's authority in speaking about the German past was different from that of German historians who share professional standards and thus professional authority with a historian like Mayer. Their responsibility is to provide these audiences with access to the past by means of critically agreed on evidence. At the same time, their attempts at reconstructing past actuality are influenced, to varying degrees, by more comprehensive, abstract concepts of cultural responsibility that join the past and the present, the political and the moral. Yet this connection is as complicated as it is precarious; above all, it is concrete and therefore contradictory and conflicted. It was unfortunate that Habermas was the first one to criticize, and in such absolute terms, what he rightly thought problematic tendencies in some recent historiography. Not himself a historian and from a position quite abstracted from past or present life-worlds, he was interested neither in the various historiographical questions raised by the individual works, nor in the different intentions that had motivated them. Disagreeing with them politically, he assumed that they would all be the same. All of them would look for the wrong evidence in that "unredeemed" past, whereas he (not unlike the young Army Signal Corps photographers half a century earlier) would look for the correct evidence—the signs of collective guilt.

Some effort at differentiation would have been very helpful since all the works rejected by Habermas met certain larger psychological-political needs that probably have contributed significantly to the notorious German collective "inability to mourn." In their 1967 diagnosis of this "syndrome," the psychoanalysts Alexander and Margarete Mitscherlich reprimanded, from the physician's position of absolute authority, all those German "patients" who did not want to engage in the work of mourning on the physician's terms.[20] Applying these terms, one could neatly distance oneself from the majority of Germans who, out of some moral sickness, had simply repressed the past. The desire of the Mitscherlichs and their many followers to encourage and preserve remembrance has no doubt been sincere. But it would have required much more than a psychoanalyst's prescription to realize this desire. After half a century, there is still no psychologically realistic historical discussion of the very real difficulties of such remembrance—difficulties caused by the never clarified concept of collective guilt, shame, and responsibility.

Historians who differ decidedly with Nolte agree with the argument made by him and others that a national obsession with the Holocaust is as undesirable as its repression. The answer to such obsession, wrote Charles S. Maier in the epilogue to *The Unmasterable Past*, "is not forgetting, but overcoming: the basis for consensus is not obscuring but repairing so far as it is possible. Thereafter let the historian insist that Auschwitz was not the end of history; it was not the entelechy of the twentieth century. It alone does not characterize our era; the movements toward emancipation that can be ranged alongside the monstrous repressions . . . are also part of the 20th century record." If Auschwitz is fetishized, this is due not to historiographical method but to the *politics* of history.

If these historians do not seem to fear that placing Auschwitz within the context of the open-ended process of history will threaten its repression through forgetting,

Saul Friedlander remains suspicious. He has consistently argued for retaining a trans-historical remoteness, or for the reverse—the immediacy of Auschwitz: " 'Historisation' aims at cancelling this distance, at reinserting the Nazi phenomenon into normal historical narrative, that is, at minimising or abolishing what still makes it appear as singular."[21] Such transhistorical singularity requires the support of collective memory. In all his writing, Friedlander has emphasized the unquestioned and enduring centrality of the memory of Auschwitz for cultural modernity. Acknowledging that "the interaction between memory and historiography in the representation of the Nazi epoch and its extermination policies is particularly difficult," he sees no problems with the privileged role he accords memory in its relation to historiography. In his scenario, no historiography can solve the enduring "uncertainty surrounding the position assigned to the criminal aspects of the Nazi phenomenon." This can be done only through and in the memory of the persecuted. Since "no amount of factual information" could, as Friedlander argues, "resolve" the issue of a "centrality or noncentrality" of Jewish persecution in "the annals of the contemporary Western world," he thinks inevitable a "proliferation of possible narrations of this past"—narrations offering either "massive apologetic arguments," or serving as a "source for continued confrontation with and reflection about this past."[22]

Friedlander is referring here to the two "camps" in the *Historikerstreit*, and he sees a Manichaean scenario of morally wrong and morally right attitudes to the past rather than historiographical strategies that would be less or more successful in "getting it right." It is true, the debate itself suggested such a split, especially after Weizsäcker's firm closure; but the split appears immeasurably larger in Friedlander's account and, as he himself asserts, "no amount of factual information" will change that. Yet facts are not simply found but are the result of, and motivation for, different and changing ways of searching for and looking at evidence; thus, they are unpredictable and surprising. Friedlander's view of the transhistorical nature of the Holocaust makes the ongoing, unpredictable process of questioning and trusting evidence a moot question. In the introduction to *Memory, History, and the Extermination of the Jews of Europe* (xii), he mentions the possibility that the centrality of the Holocaust in the narration of Jewish history might be viewed differently once the conflict between Israel and the neighboring countries has been solved: "Jewish existence may attain a semblance of normalcy." It would be "tragic" if the "memory of catastrophes and particularly of the Holocaust" were "so deeply ingrained in Jewish collective consciousness as to become an impediment to the progress toward peace. Thus, for Germans and Jews, the representation of this past has a present dimension of major importance."

It does indeed; but it also remains awkwardly entangled. The resolution of this entanglement cannot be found in the realm of privileged memory. Rather, it will have to be sought in the realm of critical historiography and politically responsible conduct—of Germans and of Jews as peoples who have shared with others a modern world, and therefore a history. Yet for Friedlander, the issue of responsible political conduct at the end of this century is clearly defined by the uniquely Jewish experience of the Holocaust. The representation of the Nazi period, Friedlander writes, must remain part of a "relevant historical consciousness," an "imperative knowledge not only for its own sake or for understanding the scope of criminal human potentialities,

but more directly in terms of present-day political responsibility" (xiii). "Relevant" historical consciousness sustains an enduring German collective guilt and therefore responsibility to the enduring singularity and centrality of Jewish persecution.

The interpenetration of historiography and memory in the representation of the Nazi period has indeed created great obstacles to historical understanding. The question of the centrality of Jewish persecution to modern, western culture is a question of interpretation that could be discussed critically within a historical community and then within a larger intellectual community. But such discussion is still made difficult by narrations of the Holocaust that are characterized by a mixed factual-fictional discourse of memory whose authority is located in the survivor's painful experience.[23] No matter how consistent or contradictory, how clear or how confused, how concrete or formulaic, how moving or how maudlin, how believable or unbelievable: these narrations of victimization have commanded belief. They have been accepted on their own terms, and this has made them different in kind from all other discourses, certainly for German readers. Born out of experiences beyond civilized imagination for which Germans were held accountable, these accounts of memory never were and could not have been questioned as to the veracity and validity of the stories they told. Archetypical stories of victimization, they are complete by virtue of their own authority; by definition they cannot and need not be corroborated.

Acceptance of such complete authority of remembered persecution—an authority of poetic rather than documentary discourse—has tended to affirm a radical skepticism regarding all historiographical representation of the Nazi period unless its perspective is centered in the transhistorical Holocaust. Friedlander states the "subtext" that links all the essays collected in *Memory, History, and the Extermination of the Jews of Europe*: "Extricating a 'rational historiography' from the overall field of the history *and* memory of this epoch is an ever-necessary, yet an ever-elusive goal" (x). His witnesses are historians who have "questioned the very possibility of keeping to traditional historical narratives in the case of the representation of the Holocaust."[24] They are also philosophers such as Jean-François Lyotard for whom " 'Auschwitz' has become the paradigm of historical catastrophes which cannot be represented directly by way of our usual 'modern' discourse" (x). Against the perceived growing interest in a more comprehensive, differentiated historiography of the Nazi period, Friedlander upholds the importance, for contemporary Jewish identity, of memory that affirms the centrality of the Holocaust as an "apocalyptic" event. In its apocalyptic singularity, the history of the victims is radically different from the history of "those who were not the victims" and whose "life continued—and continues—its normal flow. The total dissonance between the apocalypse that was and the normality that is makes adequate representation elusive, because the human imagination stumbles when faced with the fundamental contradiction of apocalypse within normality." Most survivors, therefore, "fell into problematic rituals of commemoration. Others, sooner or later, were overwhelmed by the unredeemed past: Tadeusz Borowski, Paul Celan, Piotr Rawicz, Jean Améry, and more recently Primo Levi."[25]

Questions of cultural response to the status of victim raised in this account are underlined by Friedlander's calling as witnesses famous victims of suicide. In his argument, self-inflicted death is the ultimate victimization, beyond other-inflicted

torture and death, since it is caused by terminal damage to the self, the state of being "overwhelmed by the unredeemed past." At issue is not an individual inability to learn, over time, to cope with traumatic experiences that caused particular psychological and somatic damages so severe that they cannot be healed. Rather, Friedlander is interested in general and by definition incurable, irredeemable damage—the result of a profound rupture of conventions of civilized conduct—which transcends individual experience. "Catastrophe" is the sudden and complete overturning of that which is or was normal. In Friedlander's view, after this overturning there is no return to normality, that is, no possibility of a gradual overcoming and healing. The "total dissonance" between past apocalypse and present normality will endure, supported by the assertion of a cultural centrality and uniqueness of Auschwitz.

This argument excludes the temporality of human experience. If the apocalypse of Judeocide signifies past experience of a sudden, traumatic overturning that changed everything, once and for all, present experience of normality means gradual processes of change: present normality never "is," it becomes. As the potential of the past to be partially realized in the future, present normality is something more than, something different from, mere future pasts.[26] One of the possibilities of present normality might be gradual dissolution rather than enduring presence of that "total dissonance." Memory of the apocalypse might change, away from a repeated reenactment that, for better or worse, has reaffirmed its transhistorical sameness and thereby its complete, lasting authority. Instructively, Friedlander is not interested in the fact that for many of those who were contemporaries to but not victims of the Holocaust, life did not flow normally at the time it occurred. Yet it may seem more useful now to conceive the status of victim, and of the memory of victimization, in terms not quite so static and exclusive.[27] The lives of millions of non-Jews, too, were prematurely ended or painfully disrupted and changed by the experience of a total war that they had feared above all and did not want to happen. If recalled, their memories, too, might make present normality seem strange. But they have been individual, not group memories and, recalled into different presents during the past half century of relative normality, they have not remained the same. Their authority has been partial and temporary, to be questioned and corroborated.

Separating Judeocide so radically from "normal" history has kept us from looking at it as part of a complex, contradictory, insufficiently understood historical experience, which in modern times must be the subject of rationally accessible historiographical inquiry. If anything is elusive, it is "normality," past or present. The most difficult-to-understand reaction of Germans during the Nazi period still seems to be their apparent lack of reaction to the Nuremberg Laws during relatively "normal" times, that is, before the ideologically bolstered inversion of morals became pervasive and the politics of separation and exclusion were so rigorously enforced.[28] It seems easier to understand a collective unwillingness to ask questions about the carefully hidden enactments of the "final solution," even though "they might have guessed." These events happened in a situation of total warfare, when German cities were bombed out of existence, the losses at the front were enormous, and the majority of Germans had become "used" to death and dying all around them, numbed by the experience of severe physical and emotional trauma and uprootedness. Such relating of

experiences by no means relieves Germans from the responsibility for what happened. However, it should help to understand how it could have happened by stating the terms of German guilt in historical or relational terms rather than in transhistorical or absolute terms.

The "subtext" of all the essays collected in *Memory, History, and the Extermination of the Jews* is Friedlander's fear that the exclusive and enduring victim status of Jews, and the cultural centrality of the Holocaust might be "relativized" by a more comprehensive historiography of the Nazi period. The term "relativize" dominates his discussion of Martin Broszat's "Plea for a Historicization of National Socialism" (1985).[29] Forty years after the end of the war, Broszat argued for developing a historiographical approach that would include inquiries into the daily social experience of the Nazi period from a perspective more differentiated than that of the final solution. Pointing out the "difficulty of fitting the Nazi period into the overall course of national history," Broszat noted the "cold and distant" narrative "tone" reserved for the historiography of this period. Its history, he thought, "is no longer repressed; it has instead degenerated into dreary required reading."[30] The historical representation of the Nazi past had not achieved a "new objectivity" but continued to be shaped by the "overwhelming impact of the catastrophic end and final condition of the regime," which explained "*a posteriori* the motives, methods, and stages of National Socialism. The fact that this epoch was in general one of infamy should not mean that its many social, economic and civilizing forces and efforts at modernization must be deprived of their historical significance solely because of their connection with National Socialism" (87).

But it was precisely this focus on the entire Nazi period as experienced by Germans at the time that caused Friedlander to fear the "full scope of the crimes of National Socialism" would be repressed.[31] In the earlier version of this argument, written for a different audience, Friedlander expressed more strongly his fears regarding this "kind of 'neutral,' 'objective' viewpoint" with what is, in his eyes, a distancing, diminishing perspective. The viewpoint of the regime's victims should be "as valid as that of the majority to which they belonged until 1933," and for *them* the whole period 1933–1945 meant nothing but "mistreatment . . . at all levels."[32] Broszat's essay by no means disputed that; it merely argued that the history of that period should not be written exclusively from the perspective of extreme victimization during the final stage of the Nazi regime. There was more than one set of valid questions; they should be seen as complementary rather then mutually exclusive precisely because historical understanding of Jewish persecution depended on it. The earlier period had to be researched as much as possible on its own terms for the historian to trace the connections to the later, disastrous events. Friedlander, however, mistrusted these temporal distinctions above all else. "Historicization" of the Holocaust—looking at the events in their broader historical context after the passage of many decades—might initiate processes of "relativization" that in turn might create an "open-ended attitude" toward the significance of Jewish persecution (74). The "historian who considers historicization as some kind of more 'objective' approach to the Nazi era," Friedlander warned, could be confronted with "unexpected outcomes" (79). Unexpected, such outcomes would

then elude the controlling perspective of an unquestioned centrality and uniqueness of Jewish persecution and therefore could not but be undesirable.

By definition, there can never be an "adequate historical place for 'Auschwitz' within the German history of the epoch" because Friedlander does not accept the usefulness of modern historiography as an open-ended process of investigation that might, or might not, contribute to a better understanding of these catastrophic events. He prefers to pose the problem in terms of an unsolvable dilemma, caught between a feared "minimization" of the Holocaust in Broszat's scenario and "reading the history of the epoch backwards" and thereby "placing the whole of it under its most horrendous aspect" (91–92). But this dilemma is largely of his own making since it builds on a misrepresentation of Broszat's approach as restricted to "the positive, nonpolitical, nonideological aspects of the evolution of German society under the Third Reich" (92). Concerned with multivocal historical complexity, Broszat did not suggest that one could understand everyday social reality without looking at its ideological and political dimensions. Friedlander's misrepresentation derives from the fact that he wishes to uphold an enduring, absolute "incompatibility of the daily experience of the Germans with that of the victims of the regime submitted to total exclusion (extermination), the Jews in particular," after 1933 (93).

Insisting on the transtemporal significance of this dichotomy as preserved in memory, Friedlander is not interested in historiography that might shed some light precisely on this issue. Why, for instance, was there no stronger reaction against the Nuremberg Laws? Why, though there was distaste rather than enthusiasm for the events of the *Kristallnacht*, was there not more publicly expressed revulsion?[33] Questions such as these cannot be pursued without studying the tenaciously interconnected energies and inertias of everyday life under a regime whose rule, though increasingly controlling, was not "total" to the same degree at all times and in all places. In Friedlander's view, however, historiographical "multiplicity of perspectives" is beside the point since all detailed historical study of everyday life (*Alltagsgeschichte*) under Nazi rule would have to focus on *Volksgemeinschaft*, thereby inexorably excluding what Friedlander calls "that other history" of the victims (93–94). Yet small-scale studies of everyday life from 1941 on, relying, among many other things, on increasingly anxious Nazi documentation of the changing mood of the German people, have begun to explore different aspects of that "other history"—if not, perhaps, in Friedlander's sense. Arguably, the large enterprise of Holocaust representation with its ritualization of victimization and memory have, if anything, made such a search for historical evidence much more difficult.

Friedlander was disturbed by Broszat's view of the role of memory as potentially detrimental to historical inquiry because he feared that the "historicizing process and the global trend toward normalization would eliminate the memory of the most extreme aspects of the Nazi period" (95). He seemed to agree with certain of Broszat's misgivings in that respect, quoting, for instance, a passage from a letter from Broszat that links preoccupation with the uniqueness and centrality of "Auschwitz" to forgetting rather than remembering its meanings: "The gigantic dictatorial and criminal dimension of the Nazi period also harbors within it the danger that the authenticity of

this segment of history may end up being buried beneath monumental memorial sites for the Resistance—and indeed perhaps also beneath memorials for the Holocaust."[34] But Friedlander did not seem to draw any conclusions from this insight. Where Broszat was apprehensive about the consequences for historical memory of German ritualization of guilt and Jewish ritualization of victimization, Friedlander wished to preserve a memory whose authenticity and authority would be enduringly complete, that is, secure from historical change and changing historical questions. When he referred to the hope expressed at the end of Broszat's "Plea for a Historization of National Socialism," that a more broadly conceived historiographical approach in this area of inquiry might lead to "a moral sensitivization of history, itself inspired by the experience of National Socialism," he immediately warned of the exploitability of this sentiment. In situations of sudden change, Friedlander wrote, "historicization may be misused as a pretext for breaking down the obvious distinction between a more-nuanced interpretation of the Nazi past and increasingly apologetic readings of the events."[35] "Change" meant the collapse of the Eastern Bloc and German reunification. Friedlander was not so much concerned that such change would cause great hardship and therefore great instability for large populations in Europe. Rather, he feared that it might "lead to massive shifts in collective memory" and thereby undermine "moral sensitivization of historical consciousness" to the centrality of Jewish persecution.[36] Broszat was no longer alive when Friedlander expressed these fears and could therefore no longer argue for a more broadly conceived, more inclusive historical sensitivization to the many different kinds of persecution and suffering that claim our attention at the end of this difficult century.

Friedlander does not think affordable such capacious historical memory. The historicization of the Nazi period, he argues, might have been possible "in a prolonged and nuanced debate over a significant period of time," but this debate is now permanently precluded by the rapid changes in Europe, particularly in Germany. He anticipates "the massive and sudden transformation of the world scene and the radical change it brought about in German history" could result in a "rapid and total historicization of the Nazi epoch by the rush of history itself." Would this not mean, he asks, "the derealization of this past in the minds and the memory of our contemporaries?" (100). The defense against this "rush of history itself" is for him obviously not historical understanding, which is fragmented, relational, tentative, provisionary, open to question. It is, rather, "creative" poetic memory, which is complete, absolute, authoritative, exempt from questions. For Friedlander, historical truth is not revocable trust in evidence established through processes of corroborative inquiry; historical truth is the self-evident authority of the victim. The extreme nature of the Jewish collective experience of destruction calls for deferring, for an indefinite time, the detailed critical historiography of the Third Reich envisioned by Broszat.

Memory, Augustine said, is the presence of things past. But what kind of presence? In one of John Updike's elegantly and shrewdly nostalgic stories about time passing, a man is holding, for the first time and somewhat nervously, his newborn first grandchild: "And the child's miniature body did adhere to his chest and arms, though more weakly than the infants he had presumed to call his own. Nobody belongs to us, except

in memory."[37] Precisely this insight limits the power of memory and of belonging. Past presences, called up into the present as memory, are modified, even contradicted by that present—if we permit ourselves to acknowledge our temporality and our transformations. If we do so—and our doing so is central to our modernity—we cannot but perceive these contradictions and explore their meanings. When the older man, holding his new grandchild, remembers how he held another child a generation ago, he experiences the shocking and poignant simultaneity of the sameness and difference of the child's body against his. He realizes his own—his past's—transformation. The past is recalled under the conditions of the present. Since its recall is provoked and shaped by that present, it is no longer the same past. This intertwinement of past and present in human temporality poses serious questions to Friedlander's "infinite" deferral of even the most cautious, critical "historization" of the Nazi period.

In an earlier text, *When Memory Comes*, Friedlander reflected on the power of memory in relation to historical evidence, remembering how, at a certain time in his life, he realized

> how much the past molded my vision of things, how much the essential appeared to me through a particular prism that could never be eliminated. But did it have to be eliminated? A great number of us go through life this way, insensible to a whole range of shades and tones, though, despite everything, the eye still manages to penetrate, in certain situations, far beyond the neutral, aseptic, normal meanings that reality presents. If our reactions may sometimes seem strange, let there be no mistake about it: behind the harmless surface of words and things, we know that at any and every moment abysses await us.[38]

Friedlander's memory is dominated by these "abysses," and his present self is dominated by this memory to the point that others' present, "normal" reality—let alone their memories—can be perceived only as a threat to his memory, to himself.

There are several instructive examples for this, among them Friedlander's reactions to the film based on Joachim Fest's Hitler biography. But the somewhat problematic perspective of the historian Fest in *Hitler: A Career* is also useful in that it illustrates the early seductions of National Socialism, especially the highly controlled orgiastic experience of significant community. For Friedlander, who has never been interested in understanding others' pasts, the film is nothing but destructive to the memory "itself" of the period because it does not make Jewish persecution seem centrally important to the early appeal of National Socialism: "For anyone who does not know the facts, the mystical communion with the brownshirt revolution and its martyrs still remains. Thus is evidence transformed over the years, thus do memories crumble away" (147). But whose facts, whose evidence, whose memories are they? Jewish persecution at the time of that "mystical communion" was something quite different from what has molded Friedlander's identity in memory. More importantly, how can he speak in such authoritative terms about attitudes to the past among viewers of that film in the present and the future? Even without the "fact" of a centrality of the Holocaust to German and European history, the appeal of "mystical communion" documented on the screen might be recognized by many of the film's viewers as potentially very dangerous—to Jews and non-Jews alike.

From a similarly exclusive perspective, Friedlander recounts his conversation with Admiral Karl Dönitz, Hitler's successor for a week—an interview of which he has "a precise memory . . . but it is as though it has been transposed into fantasy":

> He received me at nightfall, sitting at a massive desk. Behind him, large windows overlooked a garden. The daylight was fading; no one turned on the lights in the room, and soon we were talking in twilight.
> "I assure you that I knew nothing about the extermination of the Jews."
> Words, phrases, denials. I was tired all of a sudden, tired in advance. Did one only have to deny the past, deny it steadfastly, in order for that past to disappear forever? What was I doing here, in front of this enigmatic man, who was not going to give me so much as a glimpse of the world I was seeking to unveil?
> It was almost dark now and the narrow halo of light that illuminated the desk gave the figure, the room, the interview a vaguely fantastic quality.
> "Sir, can you give me your word of honor as a German grand admiral that you knew nothing?"
> The response came immediately, clipped words without a shadow of hesitation: "I give you my word of honor as a German grand admiral that I knew nothing." (145–46)

Friedlander's memory of that interview has transposed the impotent, defensive, isolated, bitter old man at his desk into a fantastic fiction, an enigma. (The interview took place in the early sixties, when Friedlander was still quite young and the terrible past more recent; he published the account only in 1978.) As grand admiral, and totally absorbed in the last frantic years of a war effort, Dönitz quite possibly had not known of the "final solution" (the navy's use of 12,000 slave laborers for crash building programs does not necessarily prove the contrary). To all accounts, Dönitz was largely apolitical, a rigid, even limited man whose sole interest had been to build up the navy. As its supreme commander, he was fiercely loyal to the defense of Germany—it was a loyalty that, curiously enough, decided Hitler to name him his successor and prompted Dönitz to disobey Hitler's final orders for Germany's complete self-destruction.[39] He was seriously lacking in political imagination—the cause of his bitterness over the ten years he spent in prison under harsh conditions, and over postwar Germany's complete lack of interest in him when he was released. His punishment seemed unwarranted to some of the Nuremberg judges, but it was politically justified by the fact of Germany's war of aggression—and so was his sinking into oblivion after the war. However, on that evening in late 1962, Dönitz was not the man to threaten Friedlander with the disappearance of the past by denying it. He had nothing to do with democratic West Germany, whose acknowledgment of political responsibility for and to that past was important to Jews for psychological and material reasons. Moreover, Dönitz never denied the past event of the Holocaust; what he denied was having known about it at the time of its occurrence. Considering the circumstances of this denial, Friedlander himself might have benefited from some degree of historical imagination.

It would seem that the time-honored play of perspective in fictional discourse can more readily risk penetrating psychologically painful, politically potent, and therefore heavily protected areas of collective memory. Withholding both affirmation and negation, fictional discourse, in contrast to the poetic closures of collective memory,

may be able to create more space for exploring different positions. It may clarify, but it may also obscure and even distort issues; it may help us toward understanding, but it may also create misunderstandings—it is the reader's role and privilege to negotiate them. In his latest novel *Fima*, the Israeli novelist and journalist Amos Oz traces the intertwined conflicts of Arab-Jewish-German history by making the spaces of memory porous so that they can interconnect and thus resist premature closure. *Fima* deals with the difficulties of the Arab-Jewish question for liberal Israeli intellectuals of Friedlander's generation, people whose fathers built Israel on the memory of the Holocaust as the foundation myth. Oz's journalistic work has been known for its thoughtful, balanced analyses of these issues.[40] But in this recent novel he filters the reader's perspective through an intellectual protagonist whose views on the implications of the Jewish-Arab-German entanglement are allowed to remain emphatically contradictory.

Following the problematic hero for five days in February 1989 through a Jerusalem shaken by the intifada, the reader is deliberately confused by a narrative strategy that oscillates between the author's acceptance and rejection of, his identification with and distance from his character. Efraim, called Fima by his friends, is in his mid-fifties and does not have much to show after early brilliant successes: a slim volume of poetry, a handful of "original" political essays in *Ha'aretz*, a compulsively talkative involvement with Israel's political problems, a part-time job in a gynecologist's office. His more successful loyal friends still expect better things from him and are remarkably patient with the chaotic habits of the self-made outsider. Fima is an experienced, easily aroused lover of aging, "vulnerable" women who mother him, interrupt his monologues, and occasionally clean up his apartment. Are they the victims whom (alone) he can or must love? Are they the ones who are stronger, who make his decisions for him? Twenty-five years before, his ex-wife Yael aborted their child—as she remembers it, though he does not—because he did not want to be a father. But is her memory, her view of Fima, correct? Did he "really" not want the child? What were the "real" reasons for her decision? And can one "really" pose these questions to the past? Can one ever "really" disentangle past events and emotions? The subtext for Fima's political and sexual excitability, and perhaps therefore for his unreliability, is the memory of Jewish persecution he has taken over from the generation of the fathers. At the same time he rejects the fathers' position regarding the Arab-Jewish question—a position that is explicitly based on the authority of that memory.

Memory of Jewish persecution is literally a subtext, since the transmission of memory images as well as Fima's projections of political activity occur in his dreams and fantasies, which he always records. The novel begins with a dream image of a woman of the type that excites him: touching and sexy in the way she shows her age and her vulnerability, the poignant temporal transformations of the flesh.[41] She lures him with the promise to lead him to their daughter, but along the way the child somehow turns into several children and, asking where they are, he is told "Chili"— the name of the daughter(s)? the woman? or a reference to cold? In dream images of nakedness, emaciation, threadbare blankets, and darkness, he embraces the woman who is trembling not with desire but from despair. But she also speaks to him reassuringly:

"Don't be afraid, Ephraim, I know a way and I'll get you safely across to the Aryan side."
In the dream this whispered phrase was full of promise and grace, and I continued to
trust her and follow her ecstatically, and was not at all surprised when in the dream she
turned into my mother, nor did I ask where the Aryan side was. Until we reached the
water. At the water's edge stood a man in a dark uniform, with a blond military
mustache and legs spread wide, and he said: Have to separate.

So it became clear that it was the water that made her shiver, and that I would not see
her again. (3–4)

Upon waking Fima is sad, and the sadness stays with him for several hours.

The dream images are the archetypical iconic memories of Jewish persecution:
failed attempts to escape the persecutor, safety that proves illusionary, rooms that are
closed rather than open, rejecting rather than receiving, nakedness as a sign of (female)
physical and psychological vulnerability, the uniform as a sign of (male) brutality, the
ditch filled with water as a sign of final separation.

Echoes, fragments, variations of this dream can be traced all through the novel,
and the intimate connection between these images of loss and Fima's chaotic life, his
refusal to fit in, is too obvious to be overlooked. Yet precisely this connection is also
highly ambiguous, despite the iconic sharpness of the signs. The dream figure of the SS
man, for instance, refers to the younger, harder, but also more competent of the two
gynecologists for whom Fima works during the day. And even if Fima imagines, with
shuddering empathy, how pointed metallic instruments penetrate into the soft bodies
of women, they are inserted for reasons of preventive examination, of diagnosis, of
healing, or of the abortion that the women have sought—despite the emotional
conflicts the procedure might involve. As an emblem of the relationship between
strength, or force, and weakness, oppressor and oppressed, "Chili" is highly contra-
dictory—as are all the important women in Fima's life, especially Yael and his mother,
who died young. More remote than the vital, practical father, she is most palpably and
happily alive in one of Fima's memory sequences set in an oriental market with all its
stirring smells and colors. They used to go there together to buy food for the Sabbath,
quietly subverting the authority of the father, Baruch, who very much disapproved of
these Sephardic, Arab, penetrations of his Ashkenazic family tradition (277). This
memory, too, points to the "Aryan side."

Walking home on a dark, cold winter evening, Fima sees himself sitting in a warm,
cozy study with his wife; and he is trying to figure out whether his mother or Chili had
this scenario in mind when they called him to the Aryan side. While he is engaged with
this mental image, he is thinking of two letters he wants to write: an open letter to
Günter Grass, and a much belated answer to Yael's good-bye letter of twenty-four
years before. There she had listed all of Fima's highly individual failings which, at the
same time, seemed to her the problems of the typical Jerusalem intellectual. She
reminded him of an evening when he had been particularly inconsiderate, intellectu-
ally and sexually: "a sort of secularized yeshiva student, perverted by sophistry and
casuistry, ebullient and none too bright. You had forgotten yourself completely" (168).
Fima had forgotten himself as a social being in the aggrandizement of the asocial being
who thought he did not have to be accountable to anybody but himself. In Yael's view,
this self-absorbed man-child had nothing in common with the playful lover whom she

had met in Greece. But how reliable had her perspective been at that time, in that place? Was not her disappointment with Fima in Jerusalem colored by her own nostalgic desire for a Mediterranean idyll without the burden of Jerusalem's history?

What are the obligations of this history? Here the novel does not give any answers; moreover, it prevents the reader from looking for even partial, provisional answers. The open letter Fima considers writing to Grass was provoked by a report in *Ha'aretz* on a speech Grass made to students in Berlin: "It was a courageous, decent speech. Grass had denounced the Nazi period and gone on to denounce all trendy parallels between the atrocities of our own day and Hitler's crimes, including the often-heard comparison with Israel and South Africa. So far so good" (176). It is rather surprising for Fima not to know that Grass's speech as it is described in *Ha'aretz* required neither courage nor particular decency, for it provided exactly what public opinion in Germany and abroad expects of a proper German intellectual: the ritualistically repeated affirmation of the singularity of the Holocaust. Beyond that, however, Fima is irritated by the fact that Grass as well as Böll habitually refer to the Nazis as "they," though both had been soldiers in the German army. Talking on the phone to his long-suffering historian friend Tsvi, and getting more excited with every sentence, Fima points out that

> "whenever we write about the occupation, the corruption of values, the oppression in the territories, even about the Lebanon War, [we] always and without exception use the pronoun 'we'. . . . 'Our wrongdoings.' And even 'the innocent blood we have shed.' What is it, that 'we'? Something left over from the War of Independence: We are always at the ready, we are here, we are the Palmach? Who is this 'we,' anyway? Me and Rabbi Levinger? You and Rabbi Kahane? What does it mean, exactly? Have you ever thought about it, Professor? Perhaps the time has come when you and I and all of us should follow the example of Grass and Böll. Maybe we should all start saying, exclusively, consciously, and emphatically: 'they.' What do you think?"
>
> "Look," Tsvi said wearily, "the thing is with them it's all in the past, whereas with us it's still going on, and that's why."
>
> "Are you out of your mind?" Fima cut in with an explosion of rage. . . . "Have you gone crazy, Professor?"

Tsvi, Fima complains, is putting the Germans and the Israelis on the same level; worse, he is implying the Germans' moral advantage because they are finished with their war and "poor old us, we're still at it. Who do you think you are? George Steiner? Radio Damascus? That's exactly the tainted comparison that even Grass, the graduate of the Wehrmacht, decries and calls demagoguery!" (177). He is depressed about the Arab-Jewish situation mainly because the rest of them, including Tsvi, "don't seem to be nearly depressed enough, considering what's going on. . . . I'm suggesting that from now on, at least as regards the atrocities in the Territories, we simply stop using the word 'we' " (178). Tsvi points out that Fima has gotten himself "in a twist" with his "we's": which is the first and which is the second one? But here Tvsi is, and is not, right. On one level Fima seems to be contradicting himself; on another he is entirely consistent. The second "we" signifies a withdrawal from the responsibility of what is being done in their (his and Tsvi's) name now; the first "we" means their withdrawal from Grass's and Böll's alleged withdrawal from the responsibility of what had been

done in their name in the past. The difference concerns the pastness of that part of German history, which the historian Tsvi seems to accept but the intellectual Fima does not. For Fima the German past—and therefore the issue of pastness—is different in absolute and existential, rather than relational, historical terms.

Was it Oz's intention to sort out these differences? The narrative choreography of Fima's telephone call to Tsvi, on whom he imposes his obsession at a very inconvenient time, seems to invite criticism of Fima: his inconsiderate, compulsive loquacity, his irrational fixation on Grass's army past and outburst in reaction to Tvsi's explanation. If one looks at Fima's argument through the perspective of the distance created here by narration, a complementary reading emerges. Grass is able to say "they" because in celebrating the transtemporal singularity of the Holocaust he can more easily disentangle, absolve himself of the concrete, temporal obligations of German-Jewish history. In this scenario, "they," the demoniacally evil Nazis, for whom Grass and his contemporaries (for instance, Böll or Chancellor Kohl) are not really historically responsible, have created paradisaically innocent victims who are not historically real for Fima and his contemporaries. Removed to the realm of mythical memory, this situation will be frozen in time, unchangeable, and nothing is left to posterity but to repeat it ritualistically. All historical comparison is placed under a taboo. Fima's flare of temper in reaction to the friend's rational explanation is shortlived and has no consequences. All he wanted to do was air once more his feelings about Israel's bungled politics regarding the Palestine question.

But does Fima think that distancing himself from what is being done in his name by using "they" (the second "we") would signify a more concretely moral questioning of what he perceives to be bad Israeli politics? Does not the use of "they" defer such questioning in ways reminiscent of Grass's distancing perspective on his German past? What Fima liked in Grass's speech, the ritualization of German guilt, is precisely what has stood in the way of a critical discussion of German-Jewish and Jewish-Arab history. It would be equally important for Grass and for Fima to say "we" and not "they"—not for reasons of an enduring, transtemporal identity[42] but of a changing historical consciousness. Citizens of relatively well-functioning, late twentieth-century democracies, Grass and Fima are expected to share in the responsibility for their groups' political decisions. Looking back at his former self from a situation of relatively great stability, Grass should be able to understand the *past* conditions of responsible political participation, which were, in his case and that of his contemporaries, extremely difficult. Arguably, the experienced and remembered difficulties of the German past have contributed greatly to the rational and responsible politics of a very different German present. By saying "we" rather than "they," Grass and his contemporaries would accept their own historicity as a connection, in difference, to that past.

Whether or not Oz meant the reader to establish this line of thought: it is the storyteller's—and his reader's—privilege not to be held to one particular perspective. Oz also makes ample use of this privilege with regard to the question of generational conflict. If Fima is the archetypical son preoccupied with himself, Baruch is the archetypical father who never stops worrying about Fima. He will always take care of his son because, as he says, Jews are the victims of history and should take care of their

own. Where Fima is always fretting about something, particularly the second-rate status of Arabs in Israel, Baruch, himself a victim, never feels guilty about anything. He will find some good and cheap Arabs to paint Fima's apartment. Auschwitz confirms both Fima's guilt and Baruch's innocence.

Fima resists Baruch's parenting, but not too much, even though he argues vehemently—mostly on the phone—against his father's favorite Hasidic stories of lost but wily old Jews who mistrust the blessings of European humanism. Reminding his father that without this humanism Hitler would not have been defeated, Fima rejects in no uncertain terms the messianic tendencies in Judaism. Jews have to learn to navigate their way through this world with "real, universal" charts instead of "messianic," singular ones: "Apparently we still haven't managed to get it into the famous Jewish head that the Messiah is really our exterminating angel of death," one that Fima does not wish to see glorified (183). Admiring Fima's monologue without having listened to it, Baruch tells him that the Arab painters will come as arranged and hangs up. In this densely inhabited, richly layered city, telephone conversations penetrating everywhere at any time are an important aspect of the novel's exploration of spatial and temporal permeability. Present and past Jerusalem seem to be humming with emotional energies, coming from all angles and bouncing off each other. Angry about his father's meddling, and in a rush of guilt because he did not ask about his health, Fima has the vision of a "frail, myopic East European Jew wrapped in a prayer shawl, wandering in a dark forest, muttering biblical verses to himself, hurting his feet on the sharp stones, while softly and silently the snow fell, a night bird gave a sinister shriek, and wolves howled in the darkness. Fima was gripped by fear" (185).

Fima is gripped by fear that his father might die and take with him the mythically clear stories of Jewish persecution and of the dignity of the victim status—a fear shared by his contemporary Friedlander. These stories have allowed him to remain the intellectual son who is able to draw back from the generation of the fathers without having to question their claims on him. Instructively, his fear provokes one of his "brilliant" insights, namely that it was really Nasser who had won the 1967 war because this war caused the Jewish obsession with the Territories. Come to think of it, he muses, it was

> really Hitler, not Nasser, who had the last laugh. When all's said and done, he continues to persecute the Jewish people ruthlessly. Everything that is happening to us now has its origin one way or another with Hitler. Now what was I going to do? make a phone call. It was something urgent. But who to? What about? What is there left to say? I also am lost in the forest. Just like that old saint. (185)

Is that "really" Hitler's responsibility? When his father dies suddenly and peacefully, Fima's reactions are ambivalent. Taking over the father's comfortably bourgeois apartment and small but profitable cosmetics firm, he also seems to take on some aspects of his father's *persona*, appearing more active and decisive. Remembering his parents' polite and icy distance, he experiences an intense, sad longing—not for the dead in their troubled relationship but for what might have been. But what was it that he had hoped for? The question he asks himself is: "Where was it all leading? Where did that Chili get lost on her way to the Aryan side?" (310). Does this signify

distancing the father—himself in this new situation—from Chili's, the mother's, search? But where was Chili going? Could the dreamer have misunderstood her: had she said "Arab" instead of "Aryan"?

The reader cannot possibly decide whether Fima's question to himself is to be taken seriously. Will he, or will he not, continue to retreat into fantasizing? He promises himself, as he has often done before, that this time he will solve his problems: "But this time it was not his habitual, sad smile of self-deprecation, but the astonished curled lip of a man who for a long time has been seeking a complex answer to a complex question and suddenly discovers a simple one" (311). What is Oz's position vis-à-vis this narratorial comment? Is he authorizing that "simple answer"? Or is Fima's discovery of it the ultimate self-defeat? Or is there nothing ultimate other than death?

Fima thinks that he and his father, now that he is gone, could be like "a pair of surveyors representing two countries in a dispute but themselves working together with amicable professionalism on the precise demarcation of the border. As one man to another. Sorting out at last what has been from what is over with, and what might still be possible here if we only devote ourselves to it with all our strength" (318). For the groups caught in the entanglement of their pasts, the best advice would be to negotiate their disagreements with maximal good intentions for the future and with minimal expectations. But Fima immediately starts worrying about his contribution to this process: "What does he need to prove to the old man? Or to Yael? . . . What does he need to say that is not a quotation, or a paradox, or a refutation, or a clever wise-crack?" (318). Why does he not wait and listen to them for a change? Because, by *fiat* of his author, he is unable to do so, expecting, instead, others to listen to him.

We leave Fima in a movie theater, where he had hoped to escape these vexing questions, as his friends wait for him in his father's apartment to decide on funeral arrangements. Looking at the images on the screen—gliding by as in a dream or fantasy—he wonders

> why on earth the characters in the film kept inflicting all sorts of agonies and indignities on each other. What was it that kept them from taking pity on each other occasionally? It would not be difficult for him to explain to the heroes, if they would only listen for a moment, that if they wanted to feel at home, they ought to leave each other alone, and themselves too. And try to be good. At least as far as possible. At least as far as eyes can see and ears can hear, even in the face of mounting tiredness. Be good, but in what sense? The question seemed like sophistry. Because everything was really so simple. Effortlessly he followed the story. Until his eyes closed and he fell asleep in his seat.

The question "To be good—but in what sense?" is perfectly sensible: good in relation to whom, to what issue? in what situation? at what time in history? How are we to judge Fima's thinking it unnecessarily complicated? He has heard it often enough from Yael's father, a rigid old Israeli pioneer, whose habit of asking this question has survived his losing his mind.

Brooding over the entangled Arab-Jewish-German pasts, Fima remains self-aborbed and ineffectual. Nothing he says can convince his father's generation to give up ritualistic recitation of past persecution for a fresh assessment of themselves in their present relation to others—younger Jews, Arabs, Germans, the world. And so the

fathers who act, loving their own without question, still seem to come out better.[43] Fima is both irritated and seduced by his father's Hasidic stories with their Chagallian allegories of wisdom and lostness, and he draws on them for his own fantastic identifications. If he is moved by the plight of Arabs and women because he has an imagination for others, he also promptly moves them into scenarios of his own making: they become part of his fantasies and dreams which, in turn, become the stuff of memory. In her review of the novel, "In the Promised Land," Patricia Storace praises the ending, Fima's falling asleep in a movie house: "The irresolution is more powerful than any theatrical catharsis would be, a brilliantly deft conclusion by a novelist who has set himself the large task of telling a story that has no end."[44] But stories without an end—the stories of history—come in many different shapes, and some are more useful than others. There are strategic alternatives to this particular irresolution other than a "theatrical catharsis." As a storyteller with historical interests and political hopes, Oz did well not to impose on his fictional protagonist radical if desirable changes. Surprisingly, these have been provided by real-life political protagonists. A differently ambiguous ending might have given us a clue to whether Fima would be able to control the poetic dream-images of memory in order to look more soberly and critically at the history of the Arab-Jewish-German past—once the fathers Rabin and Peres had delivered to him the negotiated Arab-Jewish peace.

One of the reviewers of Charles S. Maier's *Unmasterable Past* concluded with a curiously all-embracing warning:

> Most present-day Germans should not feel directly guilty for the crimes of Nazism. But all present-day Germans bear a heavy historical responsibility for them. Only by accepting this openly and engaging in an honest confrontation with the past can they hope to build a true sense of national dignity in the future.[45]

Allowing for the bathos of closure, especially in this area of inquiry, one still wants to ask what kind of responsibility this reviewer envisions for *all* present-day Germans: personal? cultural? political? Whether or not he was aware of it: his prescription half a century after the events resonates with assumptions of "collective guilt." The chief American prosecutor at Nuremberg, Justice Robert A. Jackson, made it clear in his opening speech that the intent of the tribunal was not to incriminate the whole German people, who had not in their majority voted for the Nazi party.[46] And political philosophers such as Hannah Arendt and Karl Jaspers explicitly rejected the concept of collective guilt since they considered it a hindrance rather than a help in the process of defining guilt and bringing to justice the guilty.[47] For most politically aware present-day Germans, the challenges of reunification and of Germany's European future are much more urgent than the issue of the singularity of Auschwitz, because it is for them in the past, notwithstanding the abundance of commemorative rituals in 1995. The past is the historians' domain; it is their responsibility to make transparent the connection between the cultural meanings of Auschwitz then and a united Europe now. At the end of our troubled century, this connection will support both the ongoing processes

of redefining German political identity and the enduring responsibility to the victims of Nazi crimes.

The question of a uniqueness of Auschwitz cannot usefully be posed in the absolute terms of a moral *fiat*—especially not when it has clearly political overtones. This question requires the relational terms—in the sense of relating and thereby clarifying—of the multivocal discourse of history, despite the inevitable distortions and possible misunderstandings. Fear of being misunderstood has contributed greatly to the notorious cultural silence behind the public loquaciousness of the historians' dispute—a loquaciousness that has suppressed many important, if uncomfortable, questions. The past does not refuse to go away, as Nolte seemed to suggest: it can neither go away nor remain without our willing it to do so. "Confrontation with the past," however, is a largely meaningless phrase in this context since the past itself is a creation of historical time—fluid, porous, and multilayered. Events in the present can be confronted. The past can and must be revisited—but not without critical acknowledgment that these visits, departing for the past from different presents, will not leave it unchanged.[48] Different viewers will see different things because they look at them differently—most literally so in the case of the photodocumentation of this period.

NOTES

1. TO MAKE THEM SEE

1. Gerald L. Posner, *Hitler's Children: Sons and Daughters of Leaders of the Third Reich Talk about Their Fathers and Themselves* (New York: Random House, 1991), 32. Unless otherwise stated, all translations from the German are mine and all emphases those of the authors cited.

2. "War diese Wahrheit nicht zum Verrücktwerden?" Erhard Lucas, *Vom Scheitern der deutschen Arbeiterbewegung* (Frankfurt/M.: Roter Stern, 1983), 182.

3. There were three progressive classes of concentration camps; the labor camps of the mildest form made up Class I; camps with more rigorous living and working conditions formed Class II; and "the mills of death," which prisoners seldom survived, formed Class III. See Eugen Kogon, *The Theory and Practice of Hell: The German Concentration Camps and the System Behind Them* (New York: Farrar, Straus & Co., [n.d.]; translation of *Der SS Staat—das System der deutschen Konzentrationslager* (Munich: Karl Alber, 1946).

4. Erich Kästner, "Wert und Unwert des Menschen," *Gesammelte Schriften, Vermischte Beiträge* (Zurich: Atrium, 1959), 62–63.

5. "Gescheit, und trotzdem tapfer" (January 1946), ibid., 21–24. The essay was addressed to German youth who, for very understandable reasons, lived in the rubble aimlessly and listlessly.

6. "'More Humility, Fewer Illusions,'" *New York Review of Books*, 41/6 (24 March 1994), 24–29. Adam Michnik is Editor-in-Chief of the Warsaw daily *Gazeta Wyborcza* and a former leading dissident.

7. See here Henric L. Wuermeling, *Die Weiße Liste. Umbruch der politischen Kultur in Deutschland 1945* (Berlin: Ullstein, 1981), 53.

8. See American reactions along these lines as discussed in the chapters that follow, especially chapters 3 and 4.

9. There is a large body of literature on the mechanics and meaning of denazification, some of which will be discussed in chapter 4 of this study. For a short introduction, see Earl F. Ziemke, *The U.S. Army in the Occupation of Germany 1944–1946* (Washington, DC, 1975: Center of Military History United States Army), 380–95.

10. The 1920s produced a large number of literary texts, mostly expressionist lyric poetry and drama, dealing with this conflict. For the situation in the 1960s and early 1970s, see the critical accounts in Reinhard Baumgart, "Das Leben—kein Traum? Vom Nutzen und Nachteil einer autobiographischen Literatur," *Glücksgeist und Jammerseele. Über Leben und Schreiben, Vernunft und Literatur* (Munich: Hanser, 1986), 198–228; and Marcel Reich-Ranicki, "Anmerkungen zur deutschen Literatur der siebziger Jahre," *Entgegnung zur deutschen Literatur der siebziger Jahre* (Stuttgart: Deutsche Verlagsanstalt, 1981), 17–35. The second half of the

1960s was a period of growing interest, especially among the young, in opening up the Nazi-past, which in their view had been stored away by their fathers like dangerous waste. This period was promptly followed by the privatization of the generational conflict in the children's *Väter-bücher* (books about fathers) of the 1970s; these books documented the increasingly sterile obsession of intellectual sons and daughters with distancing themselves sharply from their fathers. The children now tended to locate their fathers' criminality in their fellow-traveling, in mass consumption and Christian Democratic "authoritarianism" rather than in fascism. For uncritical Freudian/Mitscherlichian readings of another wave of lugubrious autobiographical fiction in the eighties lamenting the children's heavy burden of collective guilt inherited from their fathers, see Wolfgang Türkis, *Beschädigtes Leben. Autobiographische Texte der Gegenwart* (Stuttgart: Metzler, 1990), 134–232.

11. For historical-technical information on Signal Corps photography, see George R. Thompson, Dixie R. Harris, Pauline M. Oakes, and Dulane Terrett, *United States Army in World War II—The Technical Services, The Signal Corps: The Test (December 1941 to July 1943)*, chapter 13, "Photo by U.S. Army Signal Corps (Jan. 1942 to Mid-1943)" (Office of the Chief of Military History, Washington, DC, 1957), 387–426; idem, *The Signal Corps: The Outcome (Mid-1943 through 1945)*, chapter 17, "Army Photography at Home and Overseas" (Office of the Chief of Military History, Washington, DC, 1966), 540–79. See also Jonathan Heller, ed., *War and Conflict: Selected Images from the National Archives, 1765–1970* (Washington, DC: National Archives and Records Administration, 1990), who bases his introductory remarks on the information contained in these two volumes by Thompson et al. of the multi-volume official history of the U.S. Army in World War II. Heller's selection, though of necessity only a tiny fraction of the huge National Archive Photo Collection, gives a useful glimpse at the extraordinary variety of the photodocumentation of World War II.

12. Thompson et al., *The Test*, 388.

13. Ibid., 387; for Edward Steichen's role in building up the Navy photo unit to document the war in the Pacific, see chapter 2 of this study.

14. Thompson et al., *The Outcome*, 563–66. More than 10,000 photos were received by the APS library every month during the last two years of the war; at the end of the war, the holdings exceeded half a million. Evaluation standards related to the picture's interest for training, intelligence, strategy, and historical significance. The peak month for requests for prints was September 1944, when APS furnished 71,316 prints; despite shortages and rigorous editing of requests, 645,979 prints were produced during the fiscal year 1945.

15. Ibid., 579.

16. See here Norman Davis, "The Misunderstood War," *New York Review of Books* 46/11 (9 June 1994): 20–24.

17. On the achievements and pitfalls of this ethos, see Dagmar Barnouw, "Seeing and Believing: The 'Thin Blue Line' of Documentary Objectivity," *Common Knowledge* 4 (Spring 1995), 129–143.

18. A series of images taken in May 1945 shows the inhabitants of the small town of Burgsteinfurt, Westphalia, being forced to attend a showing of atrocity films. Since at first they had not followed the orders to attend, "4000 of them were paraded and marched to the cinema, led by the Burgomaster and Captain A. Stirling, the District Assistant Provost Marshal. Photo shows crowds entering the cinema." One of the images not reproduced here shows two teenage girls "who laughed when they came out of the cinema showing a film about the concentration camps [and] are ordered back to see the film again": we see the girls going into the door, closely and grimly watched by five British soldiers (U.S. Holocaust Memorial Museum Photo Archives). See also images from this series in *The Face of the Enemy: British Photographers in Germany 1944–1952*, ed. Martin Caiger-Smith (Berlin: Dirk Nishen Publishing, 1988), 76–77, especially that of a group of older women visibly upset by the films. In Bergen-Belsen British troops put together an exhibition of photographs showing the atrocities at the camp and ordered the German population to look at it—their forced viewing of photos also photographically documented (U.S. Holocaust Memorial Museum Photo Archives).

19. The caption on the reproduced photo taken 5 May 1945 reads: "Civilians of Beckum, Germ. [Westphalia] look at display of atrocity pictures, committed by their forces. This is one of

the many ways the German population is being educated on their own military and political scheme."

20. On the GIs' experience of being overwhelmed with the horror of what they had to see, hear, and smell, see Robert H. Abzug, *Inside the Vicious Heart: Americans and the Liberation of Nazi Concentration Camps* (New York: Oxford University Press, 1985).

21. Ibid., 136–37.

22. See ibid., 138.

23. On the training of these "Sergeant-Photographers," see Caiger-Smith, *Face of the Enemy*, 7–8. Guidelines provided by the Ministry of Information's Photographic Division told new recruits: "Note how the picture-papers *Life, Illustrated* and *Picture Post* tackle such stories" (7). They were also admonished to be serious but not too serious, to select the "sturdiest, toughest types" for combat scenes and to be always aware of their photographs' value as "first class propaganda" (8). Photographs distributed by the AFPU were attributed to individual photographers—an arrangement that was largely dropped by the American Army Pictorial Service in 1943 when volume increased dramatically. Photographs and censorship by the Military Authorities—whose bureaucratic tardiness was much lamented by the illustrated magazines (8)—were shared with the Americans.

24. Ibid., 11.

25. Ibid., 14. See the photograph of this scene taken by Captain Malindine (ibid., 48; fig. 1.4); see also the photo taken by Sergeant Midgley of women inmates cooking right next to a huge pile of boots of the dead, which they are using for their fire (ibid., 49).

26. Ibid., 14.

27. Interview of Samuel Glasshow, part of the Fred R. Crawford Witness to the Holocaust Project, Emory University, Atlanta, Georgia; quoted in Abzug, *Inside the Vicious Heart*, 67.

28. Ibid., 67–68.

29. Ibid., 63.

30. Interview of J. D. Digilio, Witness to the Holocaust Project, quoted in ibid., 66.

31. Quoted in ibid., 67.

32. Alan Moorehead, *Eclipse* (London: Hamish Hamilton, 1945), 195–96. "Eclipse" was the code name the Allies had given to the last operation of the European war, the occupation of Germany.

33. Leonard Mosley, *Report from Germany* (London: Victor Gollancz, 1945), 66.

34. On the photodocumentation of Displaced Persons, see chapter 2; on looting, see chapter 3.

35. The caption to the much-reproduced image of fig. 1.15 reads: "German women exhibit varied expressions as they witness atrocity horrors in Camp Buchenwald at Weimar. Taken by General Patton's U.S. Third Army, Citizens from Weimar were put under Military Police escort and marched through the camp by U.S. authorities."

36. For more information on Flossenburg, see Konnilyn G. Feig, *Hitler's Death Camps: The Sanity of Madness* (New York: Holmes and Meier, 1975), 129–32.

37. Children went barefoot even when the weather was not mild because there were no shoes for them—see the photo documentation in chapters 3 and 4. But in this image the child's feet are not shown to be damaged or fragile but firm, in contrast to the skeletal feet of the victims.

38. The photographs reproduced here are in the Foto-Willinger Collection 1919–1945 XX 225-10.A-V in the photographic collection of the Hoover Institution Archive, Stanford.

39. See photographs in chapters 3 and 4: here civilians are mourning their losses and many of them are old people and small children.

40. The liberator-invaders, fighting with the most modern weapons in the narrow lanes of villages and small agricultural towns whose houses, tools, beliefs, and "rootedness" were in many ways still medieval and in that sense important aspects of the Nazi utopia, brings this dichotomy into sharp focus. The caption on the photograph in fig. 1.27 reads: "Soldiers of the 6th Armored Division dodge sniper fire in the captured town of Oberdorla [Saxony], Germany. Note the dead American in foreground. CCB, U.S. Third Army, 4/4/45." The dead American youth has fallen in front of a cart and across a primitive drainage ditch—technologies that had not changed in half a millennium. The tank in the background, barely making it past the walls of

the houses so far untouched by war, is a highly incongruous, shadowy presence. The focus is on the wooden cart in the foreground and on the dead boy.

2. THE QUALITY OF VICTORY AND THE "GERMAN QUESTION"

1. For more information on the image, see the discussion later in this chapter. It is reproduced in John Szarkowski, *The Photographer's Eye* (New York: Museum of Modern Art, 1966), 117; this implicit elevation to the status of art, more than emphasis on the Holocaust, may have been Swan's reason for using it. As part of the MOMA collection, the album has achieved something like art status, though all the photos compiled here are standard SC prints and reproduction rights are in the public domain.

2. Foreword to *U.S. Navy War Photographs: Official U.S. Navy, Marine Corps and Coast Guard Photographs*, compiled by Capt. Edward Steichen (New York: U.S. Camera Pub. Corp., 1945). Steichen also mounted an exhibition at MOMA under the catchy title *Power in the Pacific*. Both the compilation and presentation were Steichen's idea, for which Felix Johnson, Rear Admiral, U.S. Navy, Director of Public Relations, thanked him in a letter that accompanied Steichen's copy of the book (23 April 1947; Steichen Archive, MOMA). Steichen had been an enthusiastic admirer of the Farm Security Administration photography shown at the 1938 International Photography Exhibition in New York. Introducing a number of the FSA photographs to the readership of *U.S. Camera Annual*, he had praised them as a "series of the most remarkable human documents that were ever rendered in pictures," exhibiting "such simple and blunt directness that they made many a citizen wince" (quoted in Christopher Phillips, *Steichen at War*. [New York: Harry N. Abrams, 1981], 16–17). Preparing to set up his own photography unit for the U.S. Navy, Steichen visited the FSA headquarters in Washington and was shown the picture files by the head of FSA photography, Roy Stryker.

3. Ansel Adams noted that Steichen's photographic work was no doubt important to the war effort. But he thought his "gargantuan exhibits" displayed at MOMA, such as *Power in the Pacific* and *The Road to Victory*, "blatant wartime propaganda" that had nothing to do with the "creative and aesthetic aspects of photography, the true province of a museum of art" (*Ansel Adams: An Autobiography*, with Mary Street Alinder [Boston: Little, Brown, 1985], 207). At the time he made that (remembered) judgment, he was probably right. But many of the photographs "shot" in Steichen's unit are indeed beautiful, also beautifully printed—regardless of the nature of the pictured. Adams, no friend of Steichen's and probably prejudiced against that kind of heroic beauty, was perfectly able to perceive and admire beauty in the emphatically documentary photography of his friend Dorothea Lange (269).

4. Phillips, *Steichen at War*, 24. Steichen had been appointed with the rank of captain to build up the Naval Aviation Photography Unit but was always referred to as "Colonel." His "Call to Photographers," sent out 14 January 1942 to "photographers in all parts of the United States" to "help in the war emergency," drew on the authority and the services of the well-known photo collection of MOMA: "The Museum of Modern Art in the present emergency is conducting through the camera clubs of the country a survey of photographers who want to volunteer part-time service to Government agencies. Colonel Edward Steichen, Consultant in Photography to the Office for Emergency Management, points out in the following statement the way your society can cooperate." Steichen suggested that individual camera clubs survey members and nonmembers, professional and amateur photographers at all levels of skill and experience, prepare files according to the categories listed on a card sent out with the circular and return them to MOMA where they would be available to all official wartime agencies. He also strongly recommended "that photographers keep up their club activities and their contacts with the photographic press, for camera clubs all over the country can become the wartime photographic centers of their communities and the direct channels through which our collective effort can swiftly be brought into efficient operation as one of the Nation's many implements of Victory" (Steichen Archive, MOMA).

5. Names of individual photographers could be recorded and preserved in the archives but they were as a rule not noted on the back of photographs released and distributed for publication. When published, these photos were referred to only as "Army Signal Corps" picture."

6. See a letter to the editor, *Life*, 7 May 1945, protesting the publication in *Life* of photos of severely emaciated American POWs from German camps because they were difficult to look at. The photos had appeared in the issue of 16 April 1945, "The Backwash of Battle." The letter writer realizes the need to show the extent of the enemy's brutality but does not understand the "psychology behind the publishing of pictures as these of starved American prisoners of war." She thinks that "there is enough realism and foresight in the average American to convince him that these murderous enemies must forever be silenced. We can do without the pictorial examples until our men have returned. Our hearts have quite enough burdens to carry." See also George H. Roeder Jr., *The Censored War: American Visual Experience during World War Two* (New Haven: Yale University Press, 1993). Roeder acknowledges the "comparative openness of American information policy" in contrast to practices in Germany, Italy, the Soviet Union, Japan, China, and even England. But "intent on providing a sharply focused view of the war, they [the American authorities] restricted publication not only of those maimed in combat, but also of pictures of racial conflicts on military bases, violent confrontations between G.I.s and their foreign allies, and other evidence of disunity within their own camp. They suppressed photographs of shell-shocked G.I.s, of those killed in jeep accidents, and of victims of Allied bombing raids [so did the Germans; see chapter 4 of this study] and U.S. chemical warfare experiments. Most of their efforts went into presenting the war in simple terms of good versus evil" (3). Roeder's examination of censored materials is very useful in explaining precisely those complexities of the war experience that censorship sought to level.

7. SC 210628-S (National Archives).

8. SC 210626-S (National Archives).

9. Another photo in this sequence shows General MacArthur sitting at that table, signing the declaration of surrender as Supreme Allied Commander. MacArthur is seen from the side, the view is directed past him to the rows of standing officers (SC 210629-S; reproduced in Heller, *War and Conflict* [see chap. 1, n. 11], no. 1363; Heller gives the name of the photographer: Lt. C. F. Weeler, Army). See also the photographs of the Japanese delegation, now advanced to the table, taken by *Life* photographer Carl Mydans immediately before and during the act of signing: Carl Mydans, *Carl Mydans Photojournalist* (New York: Harry N. Abrams, 1985), 120–21. In the meantime, the lone small figure with a camera in the gun area has been joined by other observers. The image depicting the delegation immediately before the signing is informal but the photo of the signing itself—an important moment that Mydans clearly wanted to capture effectively—is self-consciously organized. He shot from behind and above the table, facing the Japanese delegation across the perspectively enlarged heads of a group of American officers standing behind the table. General Umezu Yoshijiro is bent over the table putting his signature on the document, with General MacArthur standing to the left and observing the proceeding. The viewer's gaze is directed to the bent figure of the Japanese through the diagonal line-up of the American officers on the left—a line that continues in the direction of a large battleship visible in the right background: a clear suggestion of the reality of power behind the surrender.

10. Max Kozloff, "Photographers at War," in *The Privileged Eye: Essays on Photography* (Albuquerque: University of New Mexico Press, 1987), 205–20. The image is reproduced on p. 217.

11. However, for a variety of interconnected reasons, American occupation tended to be politically more infantilizing in Japan than in Germany where, despite all the problems of denazification, it helped to bring about greater general political awareness and participation. See here *Legacies and Ambiguities: Postwar Fiction and Culture in West Germany and Japan*, ed. Ernestine Schlant and J. Thomas Rimer (Washington, DC: Woodrow Wilson Center Press, 1991); see also Ian Buruma, *The Wages of Guilt: Memories of War in Germany and Japan* (New York: Farrar, Straus & Giroux, 1994) and the review by Gordon Craig, "An Inability to Mourn," *New York Review of Books*, 14 July 1994, 43–45. For a discussion of these issues see chapter 4 of this study.

12. The sympathetic caption on a photograph of a young Japanese captured in German uniform would have been unlikely in the case of a captured German soldier: "Dismay and loneliness is written on the face of this young Jap wearing Nazi uniform, in a roundup of German prisoners on the beaches of France. The Jap is giving his name and number to an

FIG. 2.6

American Army captain. 1944. (Coast Guard)" (National Archives, reproduced in Heller, *War and Conflict*, no. 1286). The expression of the Japanese seems mainly stoic and the young German soldier standing behind him seems to be looking at him with a smile: was not the Japanese perhaps befriended by some German soldiers and his "dismay and loneliness" emphasized by the American observer in order to separate them, distinguish between them?

13. *Carl Mydans*, 120.

14. Imperial War Museum, BU 6708.

15. 6 September 1944, Waks (Army Surgeon General), National Archives, reproduced in Heller, *War and Conflict*, no. 1287.

16. SC 194273-S, and SC 193518-S (both National Archives).

17. SC 196239-S (National Archives).

18. SC 193706-S (National Archives). For contrasting Signal Corps and British Army Film and Photography Unit (AFPU) images of German POWs, see chapter 3 of this study and the Album photo reproduced here in fig. 2.6.

19. Roeder, *Censored War*, 127. Visual and verbal reference to the camps also tended to validate the view of all Germans as bad and in need of punishment, especially deserving of being looted. See the critical eyewitness description: "It was surprising what licence, for instance, the discovery of the horrors of Belsen Camp gave to some of the men with the army. Why, nothing was too bad to commit against a nation which allowed things like Belsen! So you loaded up your car. . . . Surprising people, even staid English officers, began to loot like mad" (Mosley, *Report From Germany* [see chap. 1, n. 33], 46). A "looting fever" (ibid., 45) had seized a good many members of the occupational forces. For Margaret Bourke-White, the high points remembered in her autobiography about Germany 1945 were her photographing in the camps (she took some of the best known pictures of inmates), her billet in the Krupp villa, and the exuberance of

looting raids: "This was my introduction to a very interesting sidelight of war—the world of looting. In other countries through which the war carried me, looting never became the big-time obsession it was in Germany. But now we were in the country of the enemy, the enemy from whom we had suffered so much and who had stolen so much from other vanquished countries.... I suppose it [her desire to loot] should have shocked me, but it didn't. There is a curious psychology about looting. 'To the victors belong the spoils' is only part of it. For weeks, months or years that enemy has been shooting away at you. When you move into his hometown, you feel you own it. You're overwhelmingly curious to see how he lived and what kind of fellow he was. It becomes a fever, highly contagious" ("We Didn't Know, We Didn't Know," *Portrait of Myself* [New York: Simon and Schuster, 1963], 262). Few Allied looters have been as honest—also not quite as creatively greedy—as Bourke-White (see pp. 261–65 of her autobiography).

20. SC 203466-S (National Archives). Heller, who includes this image in his catalogue of the NA holdings, gives the name of the photographer: T4c. Harold M. Roberts (Army); the caption on the album copy does not.

21. See the documentation in Roeder, *Censored War*, 173.

22. (National Archives). The photo had been restricted, showing several dates for special release in late April and early May 1945. The information "(Col. Mitchell)" does not refer to the photographer but the provenance of the image: Curtis Mitchell who screened Signal Corps photographs for public release came to Bergen-Belsen after the British had taken over the camp in mid-April, bringing with him a photographer who also took a photo of him viewing the mass grave (reproduced in Abzug, *Inside the Vicious Heart* [see chap. 1, n. 20], 86). This photograph shows the position from which the powerful picture without viewers was taken.

23. SC-203418-S and SC-203419-S (National Archives); SC 203472-S (National Archives).

24. See a counter-image, as it were, to Germans carrying concentration camp victims in Hanns Hubmann, *Die Hitler-Zeit 1933–1945* (Munich: F. A. Herbig, 1980), 207 (no. H 408/38): "ein KZ Häftling sammelt, nach einem Luftangriff auf Hamburg, verkohlte, nicht mehr identifizierbare Leichen ein" (After an air raid on Hamburg, a concentration camp inmate collects charred, unidentifiable corpses).

25. SC-201456 (National Archives); see Roeder, *Censored War*, 40.

26. Roeder, *Censored War*, 41. Actually, the GIs involved in the task shown here do not seem much bothered—precisely the attitude of indifference that the censor thought objectionable. Depending on the battle and the weather, burial details could be hellish. Roeder quotes from the statement of a member of a burial party after the 1916 battle of the Somme that is more powerful than most photographs can be in its description of the sensations of the living: "As you lifted a body by its arms and legs, they detached themselves from the torso, and this was not the worst thing. Each body was covered inches deep with a black fur of flies, which flew up into your face, into your mouth, eyes and nostrils as you approached. The bodies crawled with maggots.... We stopped every now and then to vomit ... the bodies had the consistency of Camembert cheese. I once fell and put my hand through the belly of a man. It was days before I got the smell out of my hands" (ibid., 17; quoted from Denis Winter, *Death's Men: Soldiers of the Great War* [New York, 1979], 207–208).

27. In contrast, see the SC photograph taken at Landsberg on 29 April 1945 of two German civilians carrying a charred corpse, immediately behind them a GI with a rifle (fig. 2.11). The pressure on the guilty defeated is palpable and is well captured in the photo.

28. SC-203744-S (National Archives). The photograph is marked "restricted" and the name of the photographer is given: "T/5c C. B. Sellers."

29. Quoted in Abzug, *Inside the Vicious Heart*, 76.

30. SC photos included in the album: SC-203772-S and 203773-S (National Archives). *Life* photos of the scene are discussed later in this chapter.

31. This information is quoted from the caption of a Keystone photograph (no. 489958, London Office of War Information; Yivo Institute for Jewish Research, New York, file Gardelegen, 11–16); it shows four GIs from the Ninth Army standing inside and outside the barn looking at the corpses. This caption sets the number of killed prisoners at 1,000 and states that American troops arriving at the scene had learned from fugitives from the camp [there was no camp] that "German troops and Luftwaffe personnel from a nearby airfield" had committed

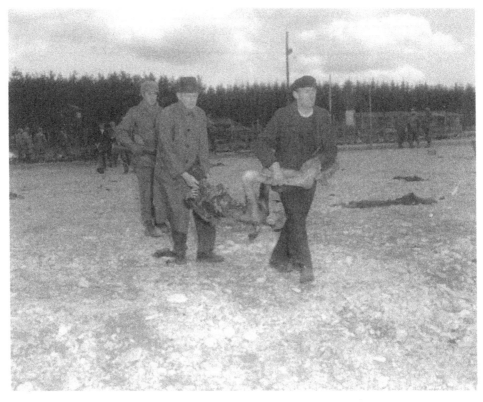

FIG. 2.11

the atrocity. The number 500–1,000 is given in a *Life* photo essay on German atrocities that describes the building as a "warehouse" (7 May 1945; see discussion below). Abzug, *Inside the Vicious Heart*, 72–73 bases his information regarding the SS unit on a "Witness to the Holocaust" interview with David Campbell, who came upon the scene with the 5th Armored Division of the First Army.

32. SC-203478 (National Archives). Abzug, who reproduces the image, gives the date as 16 April.

33. See fig. 1.16.

34. Brandt said later that this much publicized and politically effective gesture was not "planned": "Oppressed by the memories of Germany's recent history, I simply did what people do when words fail them" (quoted in Craig, "An Inability to Mourn," 43). Brandt, like perhaps the three men in that terrible barn in Gardelegen, may have instinctively avoided the archetypical pose of the survivor—standing among the prostrate. One of the most stunningly literal images of the survivor-as-victor pose is Carl Mydans' well-known photo of General MacArthur at the battlefield on Bataan, March 1945 (*Carl Mydans*, 111).

35. Quoted in Ziemke's informative and balanced *U.S. Army* (see chap. 1, n. 9), 98. Eisenhower answered the same day, asking him to assure the President "that upon first appearance of the pictures of American troops fraternizing with Germans, I repeated prior orders against that practice." All commanders had been issued his personal orders "insisting that fraternization be suppressed completely" (ibid.).

36. Quoted in ibid., 97.

37. Ibid., 325. For various reactions, see ibid., 324.

38. *New York Times*, 16 July 1945, quoted in ibid., 325–26.

39. Quoted in ibid., 327.

40. *Nürnberger Erinnerungen* 4 (Nuremberg: A. Hofmann, 1991), 118. The warmth of this summer also meant dangerous problems in places of heavy destruction: see Ruth Andreas-Friedrich, *Battleground Berlin: Diaries 1945–1948* (New York: Paragon House, 1990) on polluted drinking water and the overwhelming stench of the rubble in Berlin, where most of the air-raid dead, inaccessible under the ruins, had been left to rot (40–41).

41. Quoted in Ziemke, *U.S. Army*, 324.

42. See Edgar Bowers, "The Stoic: For Laura von Courten," *New Poets of England and America*, ed. Donald Hall, Robert Pack, and Louis Simpson (New York: Meridian, 1958), 36–37.

43. Saul Padover, *Experiment in Germany: The Story of an American Intelligence Officer* (New York: Duell, Sloan and Pearce, 1946), 37.

44. Walter Hasenclever, *Ihr werdet Deutschland nicht wiedererkennen: Erinnerungen* (Berlin: Kiepenheuer & Witsch, 1975), especially 73–106; see also his chapter on generals (both American and German), ibid., 107–30. The title plays on Hitler's notorious "promise": "Give me five years and you will not recognize Germany"—a promise about which the American occupiers liked to remind the Germans; see, for example, the photograph of a large sign in German and English in Margaret Bourke-White, *"Dear Fatherland, Rest Quietly": A Report on the Collapse of Hitler's "Thousand Years"* (New York: Simon and Schuster, 1946), 87. The perspective of the many German exiles in the CIC was not always unproblematic, especially when concerned with denazification procedures; see chapter 4 of this study.

45. Percy Knauth, *Germany in Defeat* (New York: Knopf, 1946), 224–25.

46. Ibid., 157.

47. See the analysis in Ursula Moessner-Heckner, *Pforzheim Code Yellowfin* (Sigmaringen: Jan Thorbecke Verlag, 1991), esp. 17–28, 78–92.

48. Mosley, *Report from Germany*, 93. This scene was photographed by Sergeant Oakes (see discussion in chap. 1) on 22 and 25 April 1945—one of the male guards dragging a corpse with its arm hooked over his shoulder, women prisoners watch "with interest and suggest that the exhausted SS men should be shot to avenge the loss of the prisoners' relatives" (*Face of the Enemy*, ed. Caiger-Smith [see chap. 1, n. 18], 3, 52, and 53). For a *Life* photograph of the punishment, taken by George Rodger, see fig. 2.26.

49. For a realistic account of some of the more serious problems of being, at least temporarily, the all-powerful occupier, see Franklin M. Davis Jr., *Come as a Conqueror* (New York: Macmillan Company, 1967), 107–17.

50. Stephen Spender, *European Witness* (London: Hamish Hamilton, 1946). In his introduction, Spender explains that his book "is a Travel Book of a conventional kind" written from the journals he kept during his journeys through Germany in July, August, September, and October 1945; any "unusualness" lay not in his perspective but in the "novelty of Germany after the collapse of the Nazi regime." Selected according to his interests, his observations were "nearer to being a romance than an official report" (119). W. Byford-Jones, *Berlin Twilight* (London: Hutchinson, n.d.); Moorehead, *Eclipse* (see chap. 1, n. 32); H. E. Saunders, "The Diary of an Inspection Trip to Europe in October–December 1945" (Albert Richard Behnke Papers, Box 6, Hoover Institution Archive, Stanford).

51. See "We Didn't Know, We Didn't Know," in *Portrait of Myself*, 258–71; see also "*Dear Fatherland*," Foreword, in which Bourke-White thanks "the understanding men and women in *Life*'s darkroom, and especially Edward Stanley for his stubborn patience and expert assistance with the text, and for his fine captions." She wrote the text in a great hurry, feeding the press a chapter at a time so as not to miss out on the waning American interest in the European war.

52. Text of description in Bourke-White, *"Dear Fatherland,"* 149–50; photo and caption in the first section, "Faces" [no pagination].

53. See the Introduction to this study, fig. 1. For the text of the caption, see *Life*, 7 May 1945, 22; for the discussion of its relation to the image, see the Introduction here.

54. For photos documenting the shortages, see chapters 3 and 4 of this study.

55. For German photodocumentation of children and old men in the Reich's official, pitiful "Last effort" against Allied advances, see chapter 4.

56. Percy Knauth, "The German People," *Life*, 7 May 1945, 69.

57. See the photographs in the collection of a defunct German news agency, Foto-Willinger

Collection 1919–1945 XX 225-10.A-V, envelope "Allied Bombing and Evacuation," Hoover Institution Archive, photographic collection.

58. See here the informative introductory remarks about the cooperation of editor and *Life* photographer in *Great Photographic Essays from LIFE*, ed. Constance Sullivan (Boston: Photographic Society, 1978).

59. Knauth's essay has a neatly literal example: asking a civilian with the white armband of the auxiliary police about the population's reaction to the American occupation, they were interrupted by another man: " 'Excuse me,' he said. 'I can answer that question better. If you'll come with me I'll tell you about that,' and he pulled me away down the corridor" (74). He told Knauth that the other man was a Nazi and that he and a small group of friends were trying to "get them [the Nazis] all." Knauth simply believed that the first man was a "bad German," and that the others were "good Germans" and never questioned their information.

60. SC 203572 (National Archives); Heller, *War and Conflict*, no. 1115. Vandivert's photo is better lit, but the slightly different angle in the SC photo produced a more dramatic effect.

61. See George Rodger, *Magnum Opus: Fifty Years in Photojournalism*, ed. Colin Osman (London: Nishen, 1987), p. 52. *Face of the Enemy*, 70. Kohlmann is not among them; and the Yivo archives, which contain information on Volkenrath and Walter, contain nothing on her.

62. Told to David Remnick and quoted in his "News in a Dying Language," the *New Yorker*, 10 January 1994, 41–42.

63. Robert Capa, *Photographs*, ed. Cornell Capa and Richard Whelan (New York: Knopf, 1985), 194.

64. *Nürnberger Erinnerungen* 4, 91.

65. The third photo on this page shows Pastor Karl Goebels' wife, whom we encountered in Bourke-White's double portrait, here unfurling a Confessional Church flag.

3. WHAT THEY SAW

1. Max Kozloff, "Photography and Fascination," *Photography and Fascination* (Danbury, NH: Addition House, 1979), 13.

2. Margaret Bourke-White, *Portrait of Myself* (see chap. 2, n. 19), 258.

3. Margaret Bourke-White, "*Dear Fatherland*," (see chap. 2, n. 44), 166.

4. McCandish Phillips, *New York Times*, 10 October 1968.

5. Reproduced in Bourke-White, *Portrait of Myself*, 268–70—the only photograph in her chapter on Germany—evidently the only "great" image to have come out of that experience.

6. A particularly clear and troubling example is the gorgeously composed, famous image of white-robed, photogenically emaciated Sikh refugees in India in 1947 which, as Timothy Foote wrote in his critical review of Goldberg, "was brutally staged." On her second *Life* assignment in India, Bourke-White saw a constant stream of starving Hindu refugees mourning their dead along the way, a scene that excited her for its striking friezelike beauty and epic grandeur and one that she had to have—as she envisioned it. Quoting the *Life* reporter who accompanied Bourke-White on this assignment, Goldberg lets this sensible woman do the criticizing for her: " 'It was the most painful experience of the trip. She found a group she liked. She told them to go back again and again and again. They were too frightened to say no. They were dying.' " When the woman protested, Bourke-White told her to give them some money, which was, of course, of no use to them in their situation. " 'These people just needed to move on. That's why she was such a good photographer. People were dying under her feet. . . . She thought herself a great humanitarian, but when it came to individual people. . . . ' " Foote rightly characterizes the image as "statuesque but essentially without emotion." See Vicki Goldberg, *Margaret Bourke-White* (New York: Harper & Row, 1986,) 311; see also Timothy Foote, *New York Times Book Review*, 20 July 1986, 7. The image is reproduced in *Bourke-White, Portrait of Myself*, 288–89.

7. This too, of course, is a tricky issue in the context of documentary objectivity but is, in actuality, an approach characteristic of much of the best socially involved documentary photog-

raphy; see Dagmar Barnouw, *Critical Realism: History, Photography and the Work of Siegfried Kracauer* (Baltimore: Johns Hopkins University Press, 1994).

8. See here the documents and photos in *Die Flucht und Vertreibung. Eine Bilddokumentation vom Schicksal der Deutschen aus Ostpreußen, Oberschlesien, Niederschlesien, Danzig, Westpreußen, Ost-Pommern, Ost-Brandenburg u.a. und dem Sudetenland* (Bad Nauheim: Podzun Verlag, 1966).

9. Bourke-White, *Portrait of Myself*, 198.

10. "*Dear Fatherland*," 168. The photo of the boy is in the text, opposite p. 167.

11. See here the images reproduced in "*Dear Fatherland*," section 7, "Berlin: People without Roots."

12. See chapter 4 of this study for images taken of these carts by German photographers, especially in Berlin in July 1945.

13. U.S. Army Military History Institute Archives, Carlisle, PA.

14. "*Dear Fatherland*," section 7.

15. See here a Keystone photograph of "Three Good Germans in political prisoner garb after liberation from Nazi concentration camp; along road near Parchim, 55 miles from Berlin" (USHMM no. 63190). The three men in their striped suits are pulling and pushing one of the ubiquitous handcarts loaded high with bundles while three Russian soldiers look on, one of them holding a "liberated" women's bicycle.

16. *Bibelforscher* was a fundamentalist sect persecuted by the Nazis, as were other sects, for example, Jehovah's Witnesses.

17. Knauth, more interested in postwar German political developments than Bourke-White, might not have found the *Bibelforscher* acceptable as a "Good German" since he and his sect, more exclusively than Niemöller's Confessional Church, resisted because of their religious, not their political beliefs. On the arguments of Niemöller and the Protestant churches in support of the concept of collective guilt and on Niemöller's reservations regarding the practice of denazification, see chapter 4 of this study.

18. See their images in Section V, Bourke-White, "*Dear Fatherland*," "The Future: Children in Germany." See also Anthony Mann, sent to Germany in 1945 by the British *Telegraph*, and observing young British soldiers in a train in the Rhine-Ruhr area who were happy with what he considered the "appalling" scale of destruction in the industrial towns: "Then we came to halt on open track and swarms of dirty little boys and girls, some not more than four or five, clambered up the embankment begging for food. . . . The young soldiers fell silent; at length one said, 'Well, the buggers asked for it, didn't they?' " (*Comeback Germany 1945–1952* [London: McMillan, 1980], 5).

19. On her own looting, see *Portrait of Myself* 261–65.

20. Behnke papers, Hoover Institution Archive, Stanford.

21. See the detailed and well-taken critique of General Clay's concept of denazification in Walter L. Dorn, *Inspektionsreisen in der US-Zone*, ed. Lutz Niethammer (Stuttgart: Deutsche Verlagsanstalt, 1973), 109–23.

22. By the spring of 1947, after an extraordinarily harsh winter during which people in Europe, especially in Germany, died in large numbers of hunger and cold, it had become clear to the Americans that the trauma of war in Europe was not yet over. At a meeting of the Council of Foreign Ministers in Moscow, the new U.S. Secretary of State, George C. Marshall, realized that the Soviet Union was not interested in a general European recovery. In his final report he presented his much quoted diagnosis: "The patient is sinking while the doctors deliberate. So I believe that action cannot await compromise through exhaustion" (quoted in Earl F. Ziemke, "The Formulation and initial implementation of U.S. Occupation Policy in Germany," *U.S. Occupation in Europe after World War II*, ed. Hans A. Schmitt (Lawrence: Regents Press of Kansas, 1978), 39. At the Harvard commencement that spring (5 June 1947), Marshall stated, "in a friendly spirit," a number of proposals for European recovery; these became "the Marshall Plan." As a result of a series of directives following from these proposals (some of which had already been realized by the U.S. Military Governor in Germany in response to circumstances) a report by the President's Committee on Foreign Aid (the Harriman Committee) later that summer recommended substantial economic aid for western Germany. The report also stated

that "all observers have determined that Germany cannot continue to exist without some kind of German Government" (quoted in ibid.). Western Germany was slowly starting on its way to becoming a stable, technocratic, mass democracy; remaking itself, it would remake good and not so good Germans into quite reliable citizens.

23. *"Dear Fatherland,"* section 4, "Urban Germany: What Our Bombs Left."

24. See Philip Gefter's editorial on Bourke-White in *Photo Metro* (November 1987), 14–19. Gefter explores visual connections between her 1945 image of dead inmates along the fence of a camp in the vicinity of Leipzig (an image very similar to the one included in the Army Signal Corps Album discussed in chapter 2) and two images taken fifteen years earlier when Bourke-White photographed industrial objects, "An American Disc-Harrow" and "Plow Blades," both 1930: "The receding repetitive patterns and identical shapes within each picture seem like no coincidence . . . Bourke-White ennobled the materials and patterns of a new and hopeful age in the gleaming geometry of blades and the same sharp, rapid-fire repetition of shapes are found in the picture of the death camp; the dead bodies with legs up like pincers look mechanical in the row that they form within the frame. It would be too simplistic to proffer that the mechanization represented in the earlier pictures led to the machine-gun deaths in the latter. The connection, however, lies in the unwavering vision of the photographer who composed the image" (18). "Unwavering" or not, Bourke-White was intensely visual in her compositional focus; but the views also offered themselves to the photographer's eye—that particular fence with those particular dead was photographed by a number of war reporters, among them the U.S. Army photographer whose image was included in the Signal Corps album. Compare the image of crowding at Anhalter Bahnhof shot along the length of the train, similar to the shot along the length of the camp fence (discussed above).

25. The images are reproduced in *Great Photographic Essays from LIFE* (see chap. 2, n. 58), 41–49.

26. The number of daily crossings was considerably higher and amounted to ca. 12 million deportees and refugees from the eastern provinces; see the documentation—photographs and eyewitness reports—in *Die Flucht und Vertreibung; Deutschland unter den Besatzungsmächten 1945–1949. Seine Geschichte in Texten Bildern und Dokumenten,* ed. Hans Dollinger (Munich: Desch, 1967), 29–63; Thilo Koch, *Fünf Jahre der Entscheidung. Deutschland nach dem Kriege 1945–1949* (Akademische Verlagsgesellschaft Athenaion, 1969), 134–46; Dieter Franck, *Jahre unseres Lebens 1945–1949* (Munich: Piper, 1982), 46–63. For statistics on the human cost of the catastrophe for all sides, see ibid., 32–33. See also Manfred Malzahn, *Germany 1945–1949: A Sourcebook* (London: Routledge, 1991), 127–47; Martin K. Sorge, *The Other Price of Hitler's War: German Military and Civilian Losses Resulting from World War II* (New York: Greenwood Press, 1986), 117–41; Douglas Botting, *From the Ruins of the Reich* (New York: Meridian, 1985), 179–92. In 1945, ca. every second German was on the road—as deportee, refugee, or *Heimkehrer* (homecomer, i.e., released soldier).

27. For German photographs of youngsters returning home from "the last effort" only to find their home gone and all their relations dead, see chapter 4 of this study.

28. *Life,* 15 October 1945, 107.

29. Hans Speier, *From the Ashes of Disgrace: A Journal from Germany 1945–1955* (Amherst: University of Massachusetts Press, 1981), 27.

30. For this photograph, see *Great Photographic Essays from Life,* ed. Constance Sullivan (Boston: New Graphic Society, 1978), p. 43. In another selection of his Anhalter Bahnhof images, McCombe included a shot from the front of the soldier and his carrier that shows the latter straining under the burden of the young man and emphasizes their separateness: Bill Richardson and Leonard McCombe, *Menschen erleiden Geschichte. Das Gesicht Europas von der Themse bis zur Weichsel 1943–1946* (Zurich: Atlantis Verlag, 1948), "Niederlage Berlin 1946" (sic).

31. The pages are reproduced in Caiger-Smith, ed., *Face of the Enemy* (see chap. 1, n. 18), 95–101. The image of the footless soldier is cropped there on both sides, eliminating most of the other people and diminishing the power of the carrier's stride. The caption reads: "Home comes another soldier, one of a group of twenty-four amputation cases arriving at Stettiner Station. Horsecarts will take him and his mutilated comrades to hospital" (99).

32. Mann, *Comeback Germany,* 29–30.

33. Robert Capa, *Sommertage, Friedenstage. Berlin 1945*, ed. Diethart Kerbs (Berlin: Dirk Nishen, 1986).

34. Capa, *Sommertage*, 8.

35. See the images, also of amputees, reproduced in chapter 4 of this study.

36. Capa, *Sommertage*, 15.

37. For photos of people lining up to buy newspapers at improvised stands in the ruins, see Capa, *Sommertage*, 10, 20.

38. See the practical remarks on the situation in W. Byford-Jones, *Berlin Twilight* (London: Hutchinson & Co., 1946), 40–46.

39. Mann, *Comeback Germany*, 18.

40. Gertrude Stein, "'Off We All Went to See Germany': Germans Should Learn to Be Disobedient and GIs Should Not Like Them, No They Shouldn't," *Life*, 6 August 1945, 54. This cutesy extravaganza is introduced with the remark that "Stein admirers will be glad to see that both her literary style and her shrewd insight have survived the war undamaged." Judging from the letters to the editor, *Life*, 27 August 1945, there weren't all that many glad admirers.

41. See also Bourke-White's areal photo of Cologne, "*Dear Fatherland*," section 4, "Urban Germany: What Our Bombs Left."

42. *Life*, 10 September 1945, 52.

43. See also the SC photo of an improvised stockade reproduced in Ziemke, *U.S. Army*, 242 and his quote from the description of one such stockade at Bad Kreuznach by the Army historian Lt. Col. F. Van Wyck Mason: "We arrived at sunset and saw a breathtaking panorama, 37,000 German, Hungarian, and other Axis prisoners roaming in a caged area of about half a square mile. They certainly were not coddled there. They slept on the bare ground with whatever covering they had brought with them. They got two "C" rations a day and that was all. There was a separate enclosure for officers where they were so tightly packed they had barely room to lie down and more trucks kept coming every minute. Adjoining it was another enclosure for about 500 German WACs and non-medical personnel that were surprisingly good looking on the whole. Fortunately for them the weather was good and continued to be good for some time afterwards" (ibid., 242–43). See the picture taken by SC photographer T5c. R. Grant on 8 May 1945 of an extremely crowded enclosure for "female members of the Wehrmacht" reproduced in Jonathan Heller's catalogue, *War and Conflict* (see chap. 1, n. 11), no. 1292. An SC photo of a POW "cage" at Kaiserslautern, shot from above into the crowded enclosure, shows nicely the informal chaos—a huge mass of people standing, sitting, and lying down (reproduced in Franck, *Jahre unseres Lebens*, 19).

44. See figs. 2.20 and 2.21.

45. See the photo reproduced in Ziemke, *U.S Army*, 348.

46. Behnke Papers, Hoover Institution Archive, Stanford. The clever photo of the shadows of planes delivering supplies for invading troops and the photo of the four unsuccessful escapees and their MP captors were in the papers of Frederick Anderson (ibid.), whose special interest was in planes and handsome young aviators. The presence of these materials in individuals' papers is probably the most direct and reliable way to get some sense of their effect on viewers at the time.

47. See Ray D'Addario, *Nürnberg damals—heute* (Nuremberg: Verlag Nürnberger Presse, 1970), and *Nürnberger Erinnerungen 4* (see chap. 2, n. 40).

4. WORDS AND IMAGES

1. Ray D'Addario, *Nürnberg Damals* (see chap. 3, n. 47). Unless otherwise stated, all translations from the German are mine and all are emphases those of the authors.

2. See here the diary of an inhabitant of a Ruhr area town, *Aus schwerster Zeit. Tagebuch des Hagener Bürgers Bernhard Petersen 1943–1949*, ed. G. E. Sollbach (Hagen: v. d. Linnepe, 1986) on the physical and emotional effects of years of heavy air raids. Petersen was an "average" German who recounted in a simple, direct manner the wartime experiences of average Germans. At the end of 1944 he noted: "Looking back one can say that in the lives of all people of the "wild" west [the western part of Germany hard hit by air raids] and many other

heavily bombed areas the year 1944 was the most terrible. Hundreds of thousands have lost their lives under conditions so horrible that one cannot describe them. One after the other our beautiful cities have turned to rubble and ashes. Millions of people were torn from their homes and now have to live among strangers. What in the past would have been the hardest fate, to lose everything one loved, today is the norm. Nameless misery has come over us and with all of that we now have the enemy in our country" (124).

3. Speier, *Ashes of Disgrace* (see chap. 3, n. 29), 26.

4. Collected in Hans Speier, *Social Order and the Risks of War* (Cambridge, MA: MIT Press, 1969).

5. The letters are collected in *Ashes of Disgrace*. In the letter of 4 November 1945, quoted above, Speier gave some Berlin statistics—for example, on infant mortality, which stood at ca. 50 percent; on the mortality rate: 58,000 in August (much higher in the winter months that followed); and on the disastrous black market economy (26). He also mentioned the dynamiting of ruins and noted that "people look dazed, many of them as though they are still walking around in a trance (this is not only *my* observation). There is no class distinction visible anymore. (You remember how we tried to guess the occupation of people in the subway?) Everybody seems to look like everybody else, namely *not* like a member of the occupation forces or of the German police" (27).

6. The political consequences of involving too many exiles in the denazification process are in some ways questionable; here I am interested not in their contribution to policy but in the psychological consequences that colored their perspective.

7. Speier had read the messages posted everywhere that it was not yet cold enough to heat: "Es ist zu warm zum Heizen, mit Kohlen muß man geizen." In a radio address to the German population on 6 August 1945, Eisenhower had warned that there would be severe food and transportation shortages and no coal for heating during the winter months; Germans would have to solve these problems themselves; they would have to work and help each other. But he did not specify how they could do so in the absence of foodstuffs, fuel, materials, and all services. He did promise them that they "would be allowed to form trade unions and engage in local politics when they showed readiness for healthy exercise of these privileges. Bleak as the message was, it was a first—some would later think a false—ray of hope. The war, at last, was over. The enemy commander had become a concerned and responsible administrator" (Ziemke, *U.S. Army* [see chap. 1, n. 9] 346-47). In the eyes of many, and not just German observers, the issue of responsibility remained troubling as Germany slid into deeper and deeper decline during 1946 and the majority of Germans just barely survived the ordeal of the winter of 1946/47.

8. See also Ziemke, *U.S. Army*, 412: "The best fed were the DPs who averaged 2,600 calories a day."

9. For documentation of the problem of rape under Soviet occupation, see Norman Naimark, *The Russians in Germany: The History of Soviet Occupation in Germany 1949-1945* (Cambridge, MA: Harvard University Press, 1995).

10. See the detailed 1947 study of the effects of severe longterm malnutrition and suggestions about how to deal with the problem in the pamphlet *The German Medical Profession on the State of Nutrition in Germany* (stamped "restricted"), a resolution passed at the meeting of the German Chamber of Physicians at Bad Nauheim. It is among the papers of Capt. Albert Richard Behnke, U.S. Navy Medical Corps, scientific director, Naval Medical Research Institute, research project on the effects of severe malnourishment in postwar Germany; the six boxes of papers are filled with charts of troubling data that seem to have had little effect on U.S. food policy (Hoover Institution Archive, Stanford).

11. Karl Jaspers, *Die Schuldfrage. Ein Beitrag zur deutschen Frage* (Zurich: Artemis, 1946; translated into English as *The Question of German Guilt* [New York: Dial Press, 1947]).

12. See chapter 5.

13. Hannah Arendt to Gertrud Jaspers, 30 May 1946; Karl Jaspers to Hannah Arendt, 27 June 1946, in *Hannah Arendt-Karl Jaspers Briefwechsel 1926-1969*, ed. Lotte Köhler and Hans Saner (Munich: Piper, 1993), no. 39, n. 4, and no. 41.

14. See Dagmar Barnouw, *Visible Spaces: Hannah Arendt and the German-Jewish Experience* (Baltimore: Johns Hopkins University Press, 1990), 35-38.

15. In 1932 Jaspers had sought to persuade young German readers that their rabid political

nationalism was destructive by confronting them with the nationalism of a German thinker such as Max Weber; he tried to arouse their interest by emphasizing the (untranslatable) German *Wesen* at the core of Weber's political and social thought (see Karl Jaspers, *Max Weber. Deutsches Wesen im politischen Denken, im Forschen und Philosophieren* [Oldenburg: Stalling, 1932]). In later editions the subtitle was changed to *Politiker—Forscher—Philosoph*. But when he sent his student Arendt a copy of the book, she questioned in a letter of 1 January 1933 precisely Jaspers's focus on "Deutsches Wesen" as essential to the greatness of Weber's cultural nationalism. Why, she asked, had he not tried to present Weber as an important example of an individual "Great German"? (Hannah Arendt to Karl Jaspers, *Briefwechsel*, no. 22).

16. See here his preoccuaption in the summer of 1946 with the project of a book "for America" that would attempt to define the meanings of being German ("in welchem Sinne wir Deutsche sind") (*Briefwechsel*, no. 41). The project was not realized.

17. Arendt was much less optimistic than Jaspers about the chances for serious self-questioning in postwar Germany, especially in the case of the academic establishment. See Barnouw, *Visible Spaces*, 164–67.

18. Martin Niemöller, *Reden 1945–1954* (Darmstadt: Stimme-Verlag, 1958).

19. Eugene Davidson, *The Trial of the Germans* (New York: Macmillan, 1966), 7.

20. Jaspers, *Question of German Guilt*, 51–52.

21. *Question of German Guilt*, 2.

22. Jaspers discussed here in some detail "the political acts of the victorious powers since 1918, and their inactivity while Hitler Germany was organizing itself" (91–93). Europe, too, as Jaspers rightly pointed out, had some responsibility for the catastrophe. Instructively, the French, whose politics during the Weimar period had added to a dangerous polarization, were the only occupying power at the Nuremberg trials to use the argument of collective guilt explicitly.

23. See here Walter Kempowski, *Haben Sie davon gewußt? Deutsche Antworten* (Hamburg: Albrecht Knaus Verlag, 1979).

24. Wilhelm Roepke, *Die deutsche Frage* (Erlenbach-Zürich: Eugen Rentsch, 1945; translated into English as *The Solution of the German Problem* [New York: Putnam, 1947]).

25. Quoted in Jaspers, *Schuldfrage*, 95.

26. Roepke, *Solution of the German Problem*, 85.

27. See chapter 1.

28. See chapter 1.

29. Noting the "unfailing courtesy of German policemen and civilians" (31), Speier had not, as had many other outside observers, simply attributed this pleasant conduct to a general German "insecurity and subservience" caused by the disastrous defeat (12).

30. Victor Gollancz, *Leaving Them to Their Fate: The Ethics of Starvation* (London: Victor Gollancz LTD, 1946).

31. One of his examples was the comparative death and infant mortality rate in the British Zone of Berlin and in Britain in the fall of 1945: 54 per 1000 deaths compared to 12 per 1000, and 230 per 1000 births compared to 46 per 1000 births. The German daily diet of 1,550 calories (before the cut on 27 February 1946 to 1,014 calories for "normal consumers," that is, most women) meant, in terms of food actually reaching the table per person, about "four and a half slices of dry bread, three middle-sized potatoes, three tablespoonfuls of oatmeal or some other some cereal, half a cupful of skimmed milk, a shred of meat weighing three-quarters of an ounce, and half an ounce of some kind of fat, including cooking fat. The sugar ration works out at one dessertspoonful, the jam ration to about one teaspoonful, and most households also get weekly a small piece of cheese. They are supposed to get two and a half ounces daily of some vegetable other than potatoes, but this is a bad time of year for vegetables and such things are scarce. The bread, cereal, and potato ration provides more than 1,200 of the 1,500 calories daily, and the shortage of grain and potatoes is therefore overwhelmingly serious" (12 [quoted from the report by the *Manchester Guardian* correspondent for the British Zone, 25 February 1946]). In the meantime British food supplies had gone up both in quantity and quality: on 25 February the Ministry of Food promised a small ration of bananas, as well as more coffee, tomatoes, onions, raisins, and other fruits and vegetables. It also announced an agreement with Australia and New Zealand, covering 1946–48, for buying the maximum supplies available of butter,

cheese, and other dairy produce, meat, eggs, sugar, and dried fruits. "There is enough refrigerated shipping to lift the whole of the supplies of meat and dairy produce which can be bought. By far the greatest proportion of the commodities will come to Britain" (quoted in Gollancz, 12). The announced German diet of 1,000 calories (which could be cut to 800 if it was thought that grain supplies to Germany might "prejudice the food standard in Britain") would mean two slices of bread, a smear of margarine, a spoonful of porridge, and two medium-sized potatoes. Just an hour after the announcement of the cuts, and "by a beautiful piece of historical irony," there was an announcement that "one and a half million more German refugees had begun to flood into our starvation zone from their homes in what is now called Poland but is really Germany. The first train of 55 cattle trucks carried 1,330 Germans, mainly old people and a number of children; they had brought little with them but what they could hump on their backs" (13). The statement that "Germany must be looked upon as coming at the end of the world's food queue," which concluded the announcement of possible further cuts to below 1,000 calories, contained, in Gollancz's view, British food policy in a nutshell. It became a catchphrase, "repeated in speech after speech and newspaper after newspaper. But *The Daily Express*, which has a flair for headlines, was more original. It preferred the formula 'Must Be Left to Their Fate' " (13-14)—as in the title of Gollancz's critique.

32. Quoted in Gollancz, *Leaving Them to Their Fate*, 16.

33. " 'Even in Belsen at its worst the skeletons seen on the films were being given 800 calories' " (quoted in Gollancz, *Leaving Them to Their Fate*, 17). This image might have been misleading: the living skeletons that shocked the world had not been fed at all during the panicked days of the typhoid epidemic. But 800 calories is a starvation diet—a fact which the speaker wished to emphasize.

34. See note 10 above.

35. All over Germany people were carrying whatever food they could find or share in every manner of container. No child of school age was seen without some sort of large cup, often an old tin can with two holes for a wire handle, to receive their ration of soup distributed at the schools through the *Schulspeisung*. It was started in the British Zone in February 1946 to prevent unrest in the population but was also available in the American Zone. See images of children eating at their desks (wearing coats, gloves, and caps) or outside on a curb in Heinz-Jürgen Priamus, *Die Ruinenkinder im Ruhrgebiet 1945/49* (Düsseldorf: Droste, 1985). Priamus also has good documentation of the sorry state of children's shoes (48, no. 52; in early 1947, during a particularly harsh winter, 40 percent of the school children in Essen did not own a single pair of shoes). There is also an image in Priamus (92, no. 86) of a marvelously reassuring survivor: a boy with a wide grin wearing a grown-up's cap, his hands hidden in his pockets because of the cold, the wire of the tin strung over one wrist, a scrawny, tough, optimistic kid whose face radiates a shrewd kind of good will—the opposite of the boy in D'Addario's photograph.

36. Quoted in Gollancz, *Leaving Them to Their Fate*, 17-19; the quotes are from reports in the *Manchester Guardian* and the *News Chronicle*.

37. For his figures on British calorie levels—by his account almost three times what Germans were getting in the spring of 1946—see page 20 and passim. Rations in the French Zone were cut to 950 calories and in the American Zone to 1,275 (on this cut see Ziemke, *U.S. Army*, 435-37). See the opening paragraph of Gollancz's pamphlet *Our Threatened Values* (London: Victor Gollancz LTD, 1946), written in June 1946: "An hour before I sat down to write this essay I read extracts from a speech made the previous evening by Field-marshal Viscount Montgomery. 'The German food-cuts have come to stay,' he is reported to have said. 'We will keep them at 1000 calories. (Britons get 2,800.) They gave the inmates of Belsen only 800.' These words reveal—they could not have revealed more clearly if they had been written for the purpose—the moral crisis with which western civilisation is faced" (7).

38. *Picture Post*, 1 December 1945.

39. *Picture Post*, 8 September 1945.

40. In contrast to Bourke-White, Speier was continually awed by the horrible scale of destruction, on his second visit even more than the first; every city he saw appeared to be worse than what he had seen before, though he remembered that the previous city had been just as

badly destroyed. For him, the effect was clearly cumulative. For an image of the sort of invisible entrance mentioned, see fig. 3.37.

41. Ruth Andreas-Friedrich, *Schauplatz Berlin: Tagebuchaufzeichnungen 1945–1948* (Frankfurt: Suhrkamp, 1984; published in English as *Battleground Berlin: Diaries 1945–1948* [New York: Paragon House, 1990]). The diary kept during the war was published first in the United States as *Berlin Underground* (1946); the German edition, *Der Schattenmann. Tagebuchaufzeichnungen 1938–45* (Frankfurt: Suhrkamp, 1986), has an appendix which lists the code names of the members of the resistance group "Uncle Emil" and contains documents that illustrate their activities.

42. Quoted in Jörg Drews, Afterword to *Battleground Berlin*, 258.

43. Andreas-Friedrich, *Battleground Berlin*, 4 (unless otherwise stated, all ellipsis points are the author's).

44. Landesbildstelle Berlin. *Notbestattung* was a neologism coined at a time when emergencies had become commonplace; another such term was *Notabitur*, an emergency diploma for young men drafted out of high school so that they would not have to face death without at least being able to go on, in principle at any rate, to the university. The caption says, "Soldatengrab an der Havel."

45. He left the army in Berlin in March 1946 to become the picture editor of *OMGUS-Observer*, an illustrated weekly published by the Military Government. His photos of occupied Germany (shot with a Rolleiflex and a Leica) got him an offer from the *New York Times*, and beginning in November 1946, he was their photoreporter for western Europe, including Berlin.

46. See Henry Ries, *Berlin vor 25 Jahren. Fotos aus der Zeit der Berliner Blockade* (Ausstellung der Landesbildstelle Berlin vom 18. Mai bis 8. Juli 1973), "Die Berliner."

47. They are placed side by side in the catalogue of the Ries exhibition at the Berlinische Galerie 1988 (Henry Ries, *Photographien aus Berlin, Deutschland und Europa 1946–1951* [Berlin: Berlinische Galerie, 1988], 74, 75).

48. Henry Ries, *Deutsche, Gedanken und Gesichter 1948–1949* (Berlin: Argon, 1988), 34 (translation of *German Faces* [New York: William Sloane, 1950]).

49. Ries, *Deutsche*, 7 (my translation).

50. In this section of his book, see also the photo of the POW just returned from Russia after six years of imprisonment, sent back when his legs would no longer work: another frontal shot, lit from the side, that shows the man's resignation and the stoicism reflected in his handsome face. He told Ries that the old woman had just asked him about her son; that he did not hate the Russians whose lives were also very hard and who could not afford to put much value on human life. He had survived because of his love for his wife and son; but having lived in Silesia, they would have been deported, and he was tramping all over what was left of Germany in search of them. However, the photographic perspective in other sections of this collection was indeed informed by the assumption of collective guilt; and a short afterword written in 1950 asserted that "the" German faces shown in the book signified the essence of a people defeated but not really accepting their defeat, accused of the most terrible crimes but not remembering their guilt (118). This assertion, clearly contradicted by the Anhalter Bahnhof series which contains the strongest images of the volume, is also qualified by the remarks, written much later for the German edition, translated above.

51. There are many SC photos of the ecstatic looting of bombed factories and stores—it was a fascinating topic, not the least because it echoed in certain ways the GIs' experience of "liberating" objects. See here also Robert Capa, *Slightly Out of Focus* (New York: Henry Holt and Company, 1947), 235: "From the Rhine to the Oder the shooting war quickly changed into a looting war. The GIs fought their way ahead, meeting less and less resistance and finding more and more cameras, Lüger pistols, and frauleins."

52. See fig. 3.32.

53. There are many entries about the threat Soviet soldiers pose to the civilian population, especially about rape. The other Allies, especially the Americans, did not want to hear about that threat as long as the illusion of alliance with the Russians was upheld; on 29 May 1945, Andreas-Friedrich writes: "During the last months under the Nazis nearly all of us were pro-Russian. We waited for the light from the East. But is has burnt too many. Too much has

happened that cannot be understood. The dark streets still resonate every night with the piercing screams of women in distress. The plundering and shooting, the insecurity and violence aren't over yet" (36). On 18 August 1945 she notes: "Public health officials meet at the Charité hospital. Behind closed doors and without the presence of occupation authorities. Their reports confirm that half of all the women in Berlin have been raped." Ten percent have been infected; drugs that could cure the infection are available only on the black market at prohibitive prices, or, as in the case of penicillin, their use is restricted to the Allies (84). On 14 February 1947 she writes of the Hamburg station, which is still horribly overcrowded with transients (including herself) who are waiting for erratically departing trains. There she comes across a young woman refugee who was raped eight times while trying to cross the border; she has now been left to bleed to death on her filthy mattress in the Red Cross bunker (162).

54. Ernst Friedländer, "Renazifizierung?" 3 April 1947 (reprinted in Ernst Friedländer, *Klärung für Deutschland. Leitartikel in der ZEIT 1946–1950* Munich: Günter Olzog, 1982], 40–44).

55. Harry Pross, *Memoiren eines Inländers 1923–1993* (Munich: Artemis und Winkler, 1993); Pross, despite his common sense and fairness, did not share Friedländer's psychological realism; he was too young during those years not to distance himself much more sharply from the older generation of ordinary Germans whose lack of political insight had caused the horrendous mess that threatened his future.

56. Andreas-Friedrich expressed her doubts about the collective criminalization of party members, regardless of their actual conduct during the rule of the Nazi regime. Caught in the endless maze of denazification procedures, they were excluded from any but the most menial work and, with their families, were put on starvation rations; see her description of the stunningly literal hierarchy created by food rationing in her entries for 21 May (31) and 19 July 1945 (74).

57. Sydney Jacobson, "Europe Cannot Afford This Germany," *Picture Post*, 31 August 1945.

58. The severe shortage of children's shoes may seem relatively unimportant but was indeed a great health problem and much photographed by German and Allied photographers. Photos of children getting new shoes are much rarer, but there is one taken by an unknown photographer in 1947 of a young boy trying on his first pair of real shoes (Archiv Preußischer Kulturbesitz, WII 535K). Smiling, he looks at the sturdy little boot on his left foot—a possession as precious as the boots in Capa's image (see fig. 2.21) of that other little boy who had taken them with him to the foxhole.

59. Victor Gollancz, *In Darkest Germany* (London: Victor Gollancz LTD, 1947).

60. Victor Gollancz, " 'Die Träume seiner Jugend,' " *Berliner Hefte* 2 (1947), no. 11, 801.

61. McCombe photographed that kind of handcart for his photo essay on Berlin (see chapter 4).

62. On 1 July 1945, the Berlin *Magistrat* opened a "Pressebildstelle" for the purpose of the photodocumentation of Berlin; it functioned till the official division of the city. Photographers such as Durniok (first name unknown) who were employed there either had their own cameras or were issued cameras and certainly film. (McCombe photographed refugees waiting endlessly at the *Magistrat* for permission to stay in Berlin or to leave the city to go somewhere else; see chapter 4).

63. See especially the descriptions of the body- and mind-numbing cold of those winters without heat, when everything came to a stop—people, businesses, offices, streetcars, trains: no electricity, no heat, no water (packages of bodily waste were buried in the nearest pile of rubble), no potatoes (140–150). Whoever has the energy sets out for the Grunewald forest with a knapsack, baskets, and shopping bags in search of firewood. There were steadily growing numbers of people over fifty found dead in their beds (153).

64. See the Deutsche Presse Agentur photograph of two young amputees, both of them *Heimkehrer*, standing opposite each other, supported by their crutches, the stumps of their right legs and the slightly diagonal lines of their crutches duplicated as if mirrored, two identical suitcases between their two sound legs. Wearing reasonably neat uniforms, they look like two fairly relaxed people engaged in a conversation while waiting for the tram—the young man whose face is turned to the viewer is almost smiling. The caption reads: "Two amputee

Heimkehrer are waiting for the train in front of the *Hauptwache* in Frankfurt, early 1946. It is a sunny day in early spring and the photographer was obviously interested in the visually intriguing image of duplication, which also signified the "normality" of mutilation (see *Deutschland unter den Besatzungsmächten 1945–1949. Seine Geschichte in Bildern und Dokumenten*, ed. Hans Dollinger [Munich: Kurt Desch, 1967], 129).

65. Archiv Preußischer Kulturbesitz WII 532 K, "Berlin/Bevölkerung/Bettler, Invalide." Like the other photo of an older *Heimkehrer*, this one was not included in Seidenstücker's posthumous collections. (Always an outsider, Seidenstücker died in 1966, leaving many photographs that had never been published.) The young *Heimkehrer*, on the other hand, is included in several of the collections (see, e.g., Friedrich Seidenstücker, *Von Weimar bis zum Ende. Fotografien aus bewegter Zeit* [Dortmund: Harenberg, 1980], 376). There is another photo of the young *Heimkehrer* in the Archiv Preußischer Kulturbesitz WII 539 (2); it is taken from the front and shows the back of the man's head resting on his knees. This is a less powerful image, precisely because in this perspective, the vulnerable neck area, crucially important to the affecting power of the other shot, is visually less central.

66. The photograph is dated 30 March 1945. Wundshammer had been a war reporter with the *Luftwaffe*, shooting some of the best-known photos from the notorious *Stukas* (from *Sturz-Kampf*), fighter planes that literally dove at (*sich stürzen*) their targets. He also shot impressive aerial photos of the smoking ruins of Stalingrad, a symbol of the beginning of the end of the Third Reich. After the war he worked for Erich Kästner's journal for young people, *Pinguin*, and he eventually held important positions with such photo journals as *Revue* and *Quick*. The image reproduced here is one of several shots of the boy in the Archiv Preußischer Kulturbesitz WII 245 (1945/1–29). See also Petersen, *Aus schwerster Zeit*; he describes how a teenage boy from the neighborhood, returning from an American prison camp, finds his parent's house destroyed, his parents gone. He has not heard from them for almost a year, but he finally locates them and is jubilant: "This is all these poor children pressed into army at the age of sixteen or seventeen and now looking like beggars are asking for" (178).

67. His most coherent and emphatic but in certain ways most troubled statement is his series *Der Heimkehrer* (fourteen photos), 1947 (Folkwang Museum, Essen). The photographs are of a young POW, sympathetically ethereal, returning from Russia to his parents and his rural community, a sort of archetypical sufferer made whole again by the embrace of his idyllic community and the love of his mother. Though these are visually impressive images—Pabel who would later work for *Stern* is a very gifted and socially perceptive photographer—they do suggest a religious dimension to suffering: entering his parents' house, sitting down to a first real meal, breaking bread, sleeping in a real bed with his mother beside him, etc. Bestowing such higher meaning and beauty on the status of the sufferer, individual or collective, seems generally problematic where it concerns the consequences of modern warfare; but in the German context there is always an added political dimension. When 81-year-old Pabel was to receive the David Octavius Hill medal in 1992, there was Jewish protest because of Pabel's photo documentation of life in the Lublin ghetto for the Nazi "Deutscher Verlag," and because of his representations of German civilians and soldiers as victims of the war rather than as aggressors; see the exchange between Hanno Loewy and Gottfried Jäger (president of the Gesellschaft Deutscher Lichtbildner), Pabel Archive, Folkwang Museum. Pabel renounced the award.

68. See also the photo taken by an unknown photographer of three *Heimkehrer* who have returned from the Soviet Union. They are shown from behind with their rucksacks and cooking utensils, walking down a street in what looks like a suburb of Berlin, one of them wounded. A woman passing them on the sidewalk has turned to look at them and at the photographer. She sees their faces, the viewer does not. The image captures well the anonymity and strangeness of returning POWs (reproduced in Thilo Koch, *Fünf Jahre der Entscheidung. Deutschland nach dem Kriege 1945–1949* [Frankfurt/M.: Athenaion, 1969], 52–53).

69. See the Foreword to Hilmar Pabel, *Jahre unseres Lebens* (Stuttgart: Constantin Verlag, 1954). This vacuously existentialist response to the questions posed by the violence of war is not Pabel's; the sense of helplessness vis-à-vis historical events is. See also the Swiss collection of photographs by Leonard McCombe with texts by Bill Richardson, *Menschen erleiden Geschichte* (chap. 3, note 30).

70. Pabel, Archiv Preußischer Kulturbesitz WII 193, 9–34.

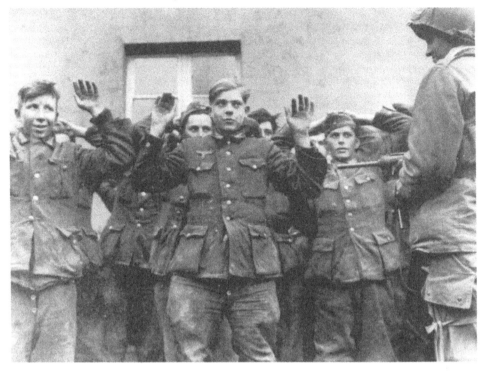

FIG. 4.27

71. Ibid., WII 48–31a (theme 1); 48–21a (theme 2); 48–30a (theme 3).

72. "Großväter und Enkel Seite an Seite. 'Männer von 16 bis 70 Jahren,' bewaffnet oder unbewaffnet, auch dieses letzte erschütternde Aufgebot wurde noch in den Kampf geworfen. Der Volkssturm sollte retten, was vorher intakten Armeen unmöglich war. Rußische Panzer rollten schon durch die Straßen von Berlin" (25).

73. See the photographs reproduced in *Face of the Enemy*, cover, 23, and 34–35.

74. See the SC photo of a group of fourteen- and fifteen-year-olds surrendering to a young American soldier; the soldier is smiling back at a round-faced boy who is smiling at him somewhat uncertainly but clearly in relief (fig. 4.27). See also the photo essay, "Educating Hitler Youth: Young German Prisoners of War, Age 12 to 17, Are Taught Democracy by the Americans," *Life*, 8 October 1945 (the most important subject taught was American history).

75. Sydney Jacobson, in an article titled "Europe Cannot Afford This Germany" (*Picture Post*, 31 August, 1945), had argued a year and a half earlier that in addition to food, housing, and work, Germans needed their young men back. "And above all," he wrote, "they need to know what is going to happen to them."

76. Robert Härdter, "Playdoyer für die Kriegsgefangenen," *Die Gegenwart* 16/17 (August 1946), 9–12; reprinted in *Nachkriegsdeutschland 1945–1949*, ed. Peter Bucher (Darmstadt: Wissenschaftliche Buchgesellschaft, 1990), 202–12. *Die Gegenwart*, a journal published in Freiburg, was edited by Härdter and Benno Reifenberg as a sort of continuation of the respected liberal *Frankfurter Zeitung*, for which they had both worked during the Weimar Republic.

77. A total of 420,000 in the late summer and fall of 1945, among them perhaps the man described by Andreas-Friedrich (Härdter, "Playdoyer," 207–209).

78. For a particularly impressive documentation of the devastating effects of imprisonment in Russian camps, see the photograph of a released 43-year-old POW looking at least thirty years older reproduced in Malzahn, *Germany 1945–1949* (see chap. 3, n. 26), 142.

79. See also the thoughts on the issue in Marion Dönhoff, *Von Gestern nach Übermorgen. Zur Geschichte der Bundesrepublik Deutschland* (Hamburg: Albrecht Knaus, 1981), 36–41.

80. See note 15 above.

81. See the image in Richardson and McCombe, *Menschen erleiden Geschichte*, "Niederlage Berlin 1946." (The date is wrong; McCombe shot the photos collected in this section in 1945; see the discussion in chapter 4 of this study). A refugee couple is shown in the streets of Berlin, an old man pulling a small handcart in which there is a weak old woman propped up on the bundles of their possessions. She is like the woman described by Andreas-Friedrich, "white-haired, in her rural Sunday-best" (53).

82. Ellipsis points mine.

83. Robert Capa, *Photographs* (see chap. 2, note 63), 197.

84. For reproductions of part of his series, see the catalogue of the exhibition *Berlin vor 30 Jahren* at the Landesbildstelle Berlin, 11 September to 8 November 1975.

85. For a visually intriguing variation on the "human bundle" theme, see Pabel's shot from up close into a horse-drawn cart holding at least six bundled-up children and a mother in addition to other large sacks. This is one of a group of carts stopped on a street in Berlin (reproduced in Pabel's *Jahre unseres Lebens*, 34).

86. Pisarek, himself a survivor, would have understood and admired that determination. Pisarek was a Polish Jew who had come to Germany as a young man to study engineering, became a photo reporter for the Berlin Jewish press from 1934 to 1941, and survived the war years as an interpreter for Polish and Russian laborers.

87. Pabel, *Jahre unseres Lebens*, 35: "Und da waren auch die Unzähligen, die umherirrten, um einen Angehörigen zu suchen, den sie verloren hatten und den sie schließlich doch irgendwo wiederzufinden hofften. Nichtswürdig, wer daran zweifelt."

88. Capa, *Slightly Out of Focus*, 235.

89. Erik Reger, *Vom künftigen Deutschland: Aufsätze zur Zeitgeschichte* (Berlin: Lothar Blanvalet Verlag, 1947), 7–8.

90. See particularly "Verantwortlichkeit vor der Geschichte," ibid., 17–25.

91. See Telford Taylor, *The Anatomy of the Nuremberg Trials: A Personal Memoir* (New York: Knopf, 1992), chapters 1 and 2.

92. "Verdrängte Geschichte," *Klärung*, 50–51.

93. Ibid., 52–54. Ernst Friedländer mentions Eugen Kogon's "excellent" study, *Der SS Staat*, which in its sober detailed description of concentration camps is "endlich einmal mehr [. . .] als ein Aufschrei" (at last more than just an emotional reaction) (Martin Broszat, "A Plea for the Historicization of National Socialism," in Peter Baldwin, ed., *Reworking the Past* [Boston: Beacon, 1990], 77–87). In Broszat's correspondence with Saul Friedlander on this issue, Broszat emphasized that he had made a "plea for normalization of the [historiographical] method, not of the evaluation" (Broszat and Friedlander, "A Controversy about the Historicizaton of National Socialism," in *Reworking the Past*, 127). But though he was moved to make this distinction by Friedlander's repeated misunderstanding of his text, he may have believed that it was possible for method not to impinge on evaluation. Friedlander, intent on preserving the absolute singularity of the Holocaust, did not: for discussion of this issue, see chapter 5.

94. "Ein Kriegsheimkehrer—Hans Werner Richter," Henric L. Wuermeling, *Die Weiße Liste. Umbruch der politischen Kultur in Deutschland 1945* (Berlin: Ullstein, 1981), 43. Richter correctly points out that Adenauer's *bürgerliche* party was indeed something new, even though it developed into restoration.

95. Of course, the two are not always easy to separate: *vide* Ernst Jünger's post–World War I celebrations of battle experience in texts such as *In Stahlgewittern (Storm of Steel)*. Richter shares some of Jünger's concerns—Jünger, too, saw himself as a spokesman for German youth returning from the battlefield—but not his highly self-conscious prettification of technological warfare.

96. See the memories of one of the teachers, T. V. Smith, "Diskussion mit deutschen Kriegsgefangenen," in *Amerikanische Rundschau* 2 (August 1946) 9:37–45. Smith, author of *Democratic Way of Life* (1925), *Philosophers Speak For Themselves* (1934), and *Legislative Way of Life* (1940), had been a senator from Illinois from 1934–1938. The two-month courses were run on the honor system—no rank, no attempts to flee, determination to prepare for a

democratic Germany—and they focused on subjects such as English, administration, and transportation. They were mastered by the hard-working students with breathtaking rapidity. Much impressed by their serious desire to learn, their intelligence, and their extraordinarily high motivation, Smith found it more difficult to give his students the right perspective on German history and teach them strategies of constructive conflict in democracy. His optimism, fairness, and accessibility made him an effective teacher: see the letters to the *Amerikanische Rundschau* 2 (October 1946) 10:24-25, in response to his piece.

97. This text was followed by another unsigned essay, "Notwendige Aussage zum Nürnberger Prozess" (2), which juxtaposed the courage and loyalty of millions of young soldiers with the cowardice of such high-ranking officers as Field Marshal Wilhelm Keitel, who had exploited the best qualities of German youth. (In this context, see Taylor, *Anatomy*, 353-58, on Keitel's cross-examination about the treatment of Soviet POWs which, though not approving, he had enforced strictly following Hitler's orders.)

98. Hans Werner Richter, "Pestalozzi oder 'Der Tintenfisch,' " *Reisen durch meine Zeit. Lebensgeschichten* (Munich: Hanser, 1989), 86.

5. VIEWS OF THE PAST

1. For excerpts of his speech, see "Facing the Mirror of German History," *New York Times*, 22 October 1988, International section, p. 4. See also Gordon Craig, "Facing Up to the Nazis," *New York Review of Books*, 2 February 1989, XXXVI, 10-15.

2. The historians' dispute was a boon to publishers; among the many collections of contributions, see Rudolf Augstein et al., "*Historikerstreit.*" *Die Dokumentation der Kontroverse um die Einzigartigkeit der nationalsozialistischen Judenvernichtung* (Munich: Piper, 1987); R. Kühnl, ed., *Streit ums Geschichtsbild. Die "Historiker-Debatte.*" Dokumentation, Darstellung und Kritik (Cologne: Pahl-Rugenstein Verlag, 1987); R. Kosiek, *Historikerstreit und Geschichtsrevision* (Tübingen: Grabert Verlag, 1987); Charles S. Maier, *The Unmasterable Past: History, Holocaust, and German National Identity* (Cambridge, MA: Harvard University Press, 1988); Peter Baldwin, ed., *Reworking the Past: Hitler, the Holocaust, and the Historians' Debate* (Boston: Beacon Press, 1990).

3. Indeed, these historians had supported Chancellor Kohl's idea of giving Berlin a "birthday present" on the occasion of the city's 750th anniversary—a *Deutsches Historisches Museum* to be built close to the *Reichstagsgebäude* and the Wall. With its emphasis on the nation's past achievements rather than problems, this "Mammutmuseum" would serve as a new political center for German history and thereby balance or neutralize East German ambitions in that direction; see Gisela Völger, " 36 000 qm Geschichte," *Die Zeit*, 30 October 1987. See also Hans Mommsen's critical analysis of the plan in his "Suche nach der 'verlorenen Geschichte'? Bemerkungen zum historischen Selbstverständnis der Bundesrepublik," *Merkur* 9/10 (September/October 1986), reprinted in Hans Mommsen, *Auf der Suche nach historischer Normalität. Beiträge zum Geschichtsbildstreit in der Bundesrepublik* (Berlin: Argon Verlag, 1987), 31-47.

4. Hans Mommsen, "Neues Geschichtsbewußtsein und Relativierung des Nationalsozialismus, *Blätter für deutsche und internationale Politik* 31 (1986) 10, reprinted in *Geschichtsbildstreit*, 17-30.

5. "Neues Geschichtsbewußtsein," 22. See also the essays collected in Hans Mommsen, *Der Nationalsozialismus und die deutsche Gesellschaft* (Reinbek: Rowohlt Taschenbuch, 1991).

6. See chapter 4.

7. Mommsen ("Suche nach der 'verlorenen Geschichte'," 42) also thinks that Hillgruber's attempt to establish a connection between German expulsion from the Eastern provinces and the Holocaust indirectly supports a relativizing of Nazi crimes and lays itself open to revisionist misunderstanding. He is probably right, but this does not automatically disqualify all of Hillgruber's arguments. In a footnote to his remark (note 7), Mommsen also points out that Habermas's critique of Hillgruber in his *Zeit* article, "Schadensabwicklung," goes too far.

8. "Zum 40. Jahrestag der Beendigung des Krieges in Europa und der nationalsozialistischen Gewaltherrschaft."

9. See Dagmar Barnouw, "The Threatened Self: Walter Rathenau and the Politics of

Wholeness," *Weimar Intellectuals and the Threat of Modernity* (Bloomington: Indiana University Press, 1988), 73–77.

10. See *Harper's Magazine*, September 1987, 49–54. Schneider quite rightly draws attention, in this context, to Günter Grass's novella, *Cat and Mouse*, which is indeed one of the most economically instructive descriptions of the ambiguous attractions of the Nazi experience. See here also the excellent Hans Staudinger, *The Inner Nazi: A Critical Analysis of MEIN KAMPF* (Baton Rouge: Louisiana State University Press, 1981).

11. Schneider, "Hitler's Shadow," 51.

12. Quoted in "Facing the Mirror of German History."

13. Ibid.

14. Quoted in Gordon Craig, "Facing Up to the Nazis," 10.

15. Quoted in Craig, "Facing Up to the Nazis," 14.

16. 11 November 1988. Jenninger wrote in his letter of resignation that he was "shocked and depressed" by the controversy and that he deeply regretted the misunderstanding and the pain he had caused.

17. The *Times* also quoted Sebastian Haffner: "He had no sense of occasion. He said true things at the wrong moment."

18. Buruma, *Wages of Guilt* (see chap. 2, n. 11), 244–45.

19. V. R. Berghahn, *New York Times Book Review*, 19 February 1989, 29.

20. Alexander and Margarete Mitscherlich, *The Inability to Mourn: Principles of Collective Behavior* (New York: Grove Press, 1975 [first published in German in 1967]).

21. Saul Friedlander, " 'A Past that Refuses to Go Away': On Recent Historiographical Debates in the Federal Republic of Germany about National-Socialism and the Final Solution," *Wissenschaftskolleg-Jahrbuch* 1985/86, ed. Peter Wapnewski (Berlin: Siedler Verlag, 1986), 105–15.

22. Saul Friedlander, *Memory, History, and the Extermination of the Jews of Europe* (Bloomington: Indiana University Press, 1993), ix.

23. Eugen Kogon's *Der SS Staat* (chap. 1, note 3), written in the summer and fall of 1945 after the author's liberation from Buchenwald in April, is a remarkable and admirable attempt to describe the structure of life in the camps from a factual, comprehensive, objective position. The extreme physical and psychological pressures and moral conflicts analyzed here more often than not encouraged highly personal accounts that mixed facts and fictions. They had an important function—for the writers as well as their readers—since they made possible an emotional response to literally unbelievable victimization. But they are products of an openly subjective, self-fictional, nondocumentary imagination. This important distinction has often been disregarded: see, for example, David Remnick's recent portrait of Mordecai Strigler in "News in a Dying Language," (*New Yorker*, 10 January 1994: 40–47). After his release from Buchenwald, Strigler "wrote as if truly possessed, spinning out a vast cycle of semifictional books on the Holocaust, which were among the first eyewitness accounts of horror" (41). (See Strigler's *Maydanek*, 1947; *In die Fabrikn fun Toyt* (In the factories of death), 1948; *Verk Tse* (Plant C), 1950.) Surely, the semifictional nature of Strigler's books qualifies the meaning of "eyewitnessing."

24. Hayden White, "Historical Emplotment and the Problem of Truth," in Saul Friedlander, ed., *Probing the Limits of Representation: Nazism and the "Final Solution"* (Cambridge: Harvard University Press, 1992), 37–53; Dominick LaCapra, "Representing the Holocaust: Reflections on the Historians' Debate," in ibid., 108–27.

25. "The Shoah in Present Historical Consciousness," *Memory, History*, 51.

26. Louis O. Mink, "Philosophical Analysis and Historical Understanding," *Historical Understanding* (Ithaca, NY: Cornell University Press, 1987), 137.

27. See here the redundant, not always clear, but useful arguments in Michael Wolffsohn, *Eternal Guilt? Forty Years of German-Jewish-Israeli Relations* (New York: Columbia University Press, 1993).

28. See Hans Mommsen and Dieter Obst, "Die Reaktion der deutschen Bevölkerung auf die Verfolgung der Juden," in Hans Mommsen und Susanne Willems, eds., *Herrschaftsalltag im deutschen Reich* (Düsseldorf: Schwann, 1988), 374–421.

29. *Merkur*, May 1985, reprinted in Baldwin, *Reworking the Past*, 77–87. Saul Friedlander,

"Reflections on the Historicization of National Socialism" (1987) and "Martin Broszat and the Historicization of National Socialism" (which was first published in German as "Martin Broszat und die Historisierung des National-Sozialismus" in 1991) have both been reprinted in *Memory, History* (64–84 and 85–101).

30. See Baldwin, *Reworking the Past*, 78.

31. "Martin Broszat and the Historicization of National Socialism," in *Memory, History*, 91.

32. "Reflections on the Historization of National Socialism," in *Memory, History*, 73 (the essay was first published in the *Tel-Aviver Jahrbuch für Deutsche Geschichte* 1987).

33. See Wolffsohn, *Eternal Guilt?*, 196–99 on some unacknowledged verbal and pictorial ironies connected with the events of the "Reichskristallnacht." (The term *Reichskristallnacht* was coined by skeptical Berliners to indicate their awareness of the regime's, that is, the "Reich's," staging of the event). The famous Deutsche Presse Agentur photo of the burning Berlin synagogue, the iconic symbol for *Kristallnacht* atrocities, was taken in 1943, after a British air raid on Berlin on February 23. The synagogue, a historic building and therefore designated a legally protected monument, had in fact sustained only very minor damage in 1938. Summoned by neighbors who saw Nazis enter the synagogue, the officer of the local police station and his men drove the mob away with drawn pistols and called the fire department, which extinguished a few small blazes. Wolffsohn relates these facts in the context of his argument against German substitution of "uncritical idealization and beatification of the other side" for historical knowledge: a Jewish magazine had prevented the issue, at the last moment, of a stamp with the 1943 image commemorating the fiftieth anniversary of *Kristallnacht* in 1988, thereby saving the Federal Republic from profound embarrassment and preventing "old and new incorrigibles" from seizing upon such a mistake to distract from the facts of murder and destruction on that night in November 1938. "On that night," Wolffsohn comments, "there were very few who, like Police Lieutenant Lützfeld, demonstrated more than the mere verbal revulsion that the people of Berlin gave expression to with their term *reichskristallnacht*" (198). The search for historical knowledge is certainly relevant for both sides. See also Mommsen and Willems, eds., *Herrschaftsalltag*, 438–39.

34. *Memory, History*, 96; see also Baldwin, *Reworking the Past*, 129.

35. *Memory, History*, 99; see also Baldwin, *Reworking the Past*, 87.

36. *Memory, History*, 98, 100. Friedlander mentions here the resurgence of anti-Semitism in eastern and central Europe, the "frequent linkage of Jews to the Bolshevik revolution and to Bolshevik crimes." But we must ask: Are these linkages justified? How are they to be understood? And by extension: What (if any) impact did the communist sympathies of German-Jewish intellectuals, that were common during the Weimar period have on the rise of the Nazi Party? In Friedlander's scenario such questions are meaningless in light of the overwhelming issue of victimization.

37. John Updike, "Grandparenting," *New Yorker*, 21 February 1994, 97.

38. Saul Friedlander, *When Memory Comes* (New York: Farrar, Straus & Giroux, 1978), 145.

39. See here the balanced portrait in Gerald L. Posner, *Hitler's Children: Sons and Daughters of Leaders of the Third Reich Talk about Their Fathers and Themselves* (New York: Random House, 1991), 135–57, "The Last Führer."

40. Amos Oz, *In the Land of Israel* (New York: Harcourt, Brace, Jovanovich, 1983).

41. Amos Oz, *Fima*, transl. Nicholas de Lange (New York, San Diego: Harcourt, Brace & Company, 1993), 2f.

42. For instance, the alleged identity of the young soldier Grass with the Nazi regime more than half a century ago.

43. See Oz' interview with David Streitfeld, "Amos Oz' Belated Tribute to His Father," *International Herald Tribune*, 11 Jan. 1994, 18.

44. *New York Review of Books* 41/10 (26 May 1994), 18.

45. Richard J. Evans, "A 'Normal' Act of Genocide?" *New York Times Book Review*, 5 February 1989, 28.

46. Eugene Davidson (*The Trial of the Germans* [New York: Macmillan, 1966], 7) points out

that the "French prosecution, alone among the four victorious powers, made no distinction between the Nazis and the rest of the nation."

47. Discussion in Barnouw, *Visible Spaces* (see chap. 4, n. 14), chapter 4, "The Quality of Guilt: The Trial of the Germans."

48. In a recent interview, Jürgen Habermas and Adam Michnik discussed different phases in Germany and Poland in the "process of coming to terms with the past." (See " 'More Humility, Fewer Illusions,' " *New York Review of Books*, 41/6 [24 March 1994], 24-29). Asserting that the Poles, too, could benefit from a public debate of their history, their own *Historikerstreit*, Michnik applauded Habermas's critique of revisionist historians for denying the "uniqueness of Hitler's crimes by comparing them with Stalin's and for promoting a revival of nationalism" (24). In this summary reference, the issues debated by German historians and intellectuals appear rather skewed, especially where the concept of nationalism is concerned. On the whole, though, Michnik comes across in this interview as an admirably circumspect and conciliatory contemporary with regard to past and present dark times in Poland: his "formula" for civilized survival is "that one has to be for amnesty and against amnesia" (29). In contrast to Habermas, he thinks highly dangerous the difficulties now faced by the former Eastern Bloc countries: the Balkans are "challenging Europe in a very fundamental way. What they are saying is: 'That's enough of Auschwitz'; the day of the European democracies is over; what we now have to look forward to is the utopia of the ethnically pure state" (25). Michnik points to a "crisis of multicultural societies in all the Western democracies" (24)—regardless of their democratic pasts. Habermas, he says, has taught him "the importance of being wary and vigilant"—a lesson that caused him to read "the Historians' Debate of the 1980s as if it were a Polish debate" in the 1990s (25).

Relating different groups' experiences, Michnik notes that there was a concentration camp in Poland before Hitler's invasion and that the small number of deaths occurring there does not provide a viable excuse. He also thinks that he is taking a risk with his Polish readership in allowing this piece of information into print:

> On the other hand, we, the Poles, can say that Hitler was really not much worse than Stalin, because we were the victims of both. But that assertion has quite a different meaning when it comes from a German historian like Ernst Nolte. It diminishes the scale of German "achievements" in this area. But if we say that the Poles were basically innocent, this really just means that we are giving ourselves carte blanche for new guilt. What is the meaning of the guilt, the collective guilt of a nation? (25)

But were the Poles "really" the victims of Stalin? Michnik's argument in this passage shows some curious lacunae. Why would there be the threat of "new guilt" if there was no doubt that they were victims? Might they not have been victims and also victimizers? Is not the importance for Poles of the *Historikerstreit* predicated on the fact that it could be used to reconsider claims to the "pure" status of victim and to ask Poles to own up to some kind of responsibility for Stalinist crimes? But would these questions be put to individuals, or to all Poles collectively? And can they really be related to the German situation in 1945?

Habermas denies the validity of the concept of collective guilt: "Anyone who is guilty has to answer for it as an individual. At the same time there is something like a collective responsibility for the intellectual and cultural situation in which mass crimes became possible. And we are equally the heirs of the past" (25). This concept of responsibility is too general and too prescriptive and in that, not much different from collective guilt. In what sense are we "equally" the heirs of the past if our presents and futures are different? It may be reassuring to posterity to demand acknowledgment of collective responsibility and guilt from the contemporaries to the mass crimes since that distinguishes "us" so neatly from "them." But are such demands useful in trying to understand now how it happened then? Insisting on an enduring uniqueness, a transhistorical sameness of Auschwitz, Habermas declares that "the responsibility for the past should consist in a distrust of tradition and cultural institutions as much as of the elites and grandparents" (25). Does this mean all of them, regardless of the past actuality of their lives?

Habermas's position is pure of any interest in such actuality, be it past or present, and Michnik does not accept that. He points out that "the Serbs who support Milosevic are convinced of their own innocence, historically speaking. The Serbs believe that they are the victims of a great injustice: they believe that they have been betrayed by the whole world. With that in mind, I find myself unable to share your triumphalist sense of a unique guilt, even though I can respect your belief in the uniqueness of the German experience" (25–26). Habermas amends Michnik's distinction: his is a "negative triumphalism" (26). It is not clear whether he means to question the exhilaration of sitting in judgment over the past, or to emphasize, once more, his unassailable distance from it.

INDEX

Abzug, Robert H., 8–10, 39–40, 225n. 20, 229nn. 22, 23, 29, 230nn. 31, 32
Adams, Ansel, 226n. 3
African-Americans: photographic images of, from postwar Germany, 55, 123
Agee, James, 8–9, 148
Air raids, Allied: photographic images of effects on German cities, xii, 66, 235n. 41; Signal Corps photographs of German civilians and, 121
Alienness: in photographic images of Germany in 1945, 136–48
Allen, E. R., 80
Allied forces: Neunburg photographic series on relations of, with German civilians, 19–22, 38; attempts to exorcise German militarism and situation of returned POWs, 185–86. *See also* British Zone; Censorship; Denazification; Fraternization
American Army Pictorial Service (AFPU). *See* Army Pictorial Service
Améry, Jean, 208
Andersch, Alfred, 195
Anderson, Frederick, 235n. 46
Andreas-Friedrich, Ruth: description of conditions in Germany from 1945 to 1948 in diaries of, 153–73, 186–87, 231n. 40, 239nn. 41, 43, 239–40n. 53, 240n. 56
Arab-Jewish relations: and fictional discourse in Oz's *Fima*, 215–21
Arendt, Hannah, 145, 221, 236n. 13, 237nn. 15, 17
Army. *See* Allied forces; Army Pictorial Service; British Army Film and Photography Unit; U.S. Army Signal Corps
Army Pictorial Service (AFPU): administration of Signal Corps photography, 6; editing of photographs received by Still Picture Library of, 7; attribution of photographs to individual photographers, 225n. 23
Der Aufbau (journal), 195
Augstein, Rudolf, 244n. 2
Augustine, Saint, 212
Auschwitz: centrality of, in public commemora-
tions of German catastrophe, 199, 201, 202, 203, 205, 207, 222. *See also* Concentration camps
Die Aussaat (journal), 195

Baden-Württemberg: 1945 Allied air raid on, 66
Baldwin, Peter, 243n. 93, 244n. 2, 245n. 29, 246nn. 30, 34, 35
Barnouw, Dagmar, 224n. 17, 233n. 7, 236n. 14, 237n. 17, 244–45n. 9, 247n. 47
Battleground Berlin (Andreas-Friedrich), 153–73, 187. *See also* Andreas-Friedrich, Ruth; Diaries
Baumgart, Reinhard, 223n. 10
Behnke, Albert Richard, 128, 130, 236n. 10
Belfer, Edward, 32
Bergen-Belsen: perspectives of American and British photographic images compared, 25, 28; photographic images of, in Signal Corps album, 52; Rodger's photographs of women guards, 83. *See also* Concentration camps
Berghahn, V. R., 245n. 19
Berlin: photographic images of German people at 1936 Olympics in, 36; Bourke-White's photographs of refugees at Anhalter Bahnhof, 91–98, 101; Capa's photographs of refugees in summer of 1945, 108–21; Speier's description of, in 1945, 138, 140–44; and images of refugees by German photographers, 187–94
Berlin Twilight (Byford-Jones), 69–70
Die Besinnung (journal), 195
Bonhoeffer, Dietrich, 30
Borowski, Tadeusz, 208
Botting, Douglas, 234n. 26
Bourke-White, Margaret: perspective in photographic images of, xi, 234n. 24; photographs of results of air raids on German cities, xii, 235n. 41; as *Life* staff photographer in Germany in 1945, 71, 72, 75–76, 79, 228–29n. 19, 231nn. 51, 52; photographic documentation of German civilians as refugees in 1945, 89–101, 232n. 3, 233nn. 9, 10, 11, 18, 234n. 24; images of refugees compared to McCombe's, 102; images of refugees compared to Capa's, 112; photographic

DAGMAR BARNOUW was Professor of German and Comparative Literature, University of Southern California, untill her untimely death in May, 2008. Her books include *Weimar Intellectuals and the Threat of Modernity*; *The War in the Empty Air*; and *Naipaul's Strangers* (all published by Indiana University Press), among other books of cultural criticism.

Milton Keynes UK
Ingram Content Group UK Ltd.
UKHW020610220324
439822UK00004B/11